MW00826820

KOSTI
RUOHOMAA

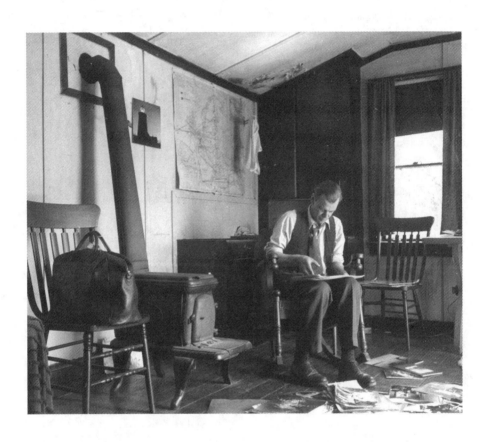

KOSTI RUOHOMAA

The Photographer Poet

Deanna Bonner-Ganter

Down East Books

CAMDEN, MAINE

Published by Down East Books
An imprint of The Rowman & Littlefield Publishing Group, Inc.
4501 Forbes Boulevard, Suite 200, Lanham, Maryland 20706
www.rowman.com

Unit A, Whitacre Mews, 26-34 Stannary Street, London SE11 4AB, United Kingdom

Distributed by NATIONAL BOOK NETWORK

Cover photograph: "Father Going to the Milking," by Kosti Ruohomaa, Dodge Mountain, Rockland, Maine, 1945. (Black Star)

Frontispiece: Kosti Ruohomaa in his two-room dwelling, by Robert M. Mottar, Dodge Mountain, Rockland, Maine, 1952. (Lofman Collection, Maine State Museum)

Back cover photograph: Winter Sunrise over Rockland Harbor from Dodge Mountain, by Kosti Ruohomaa, Dodge Mountain, Rockland, Maine, 1958. (Lofman Collection, Maine State Museum)

Author photograph by Paula Johnson

"Petra's Love Song," copyright © Koivun Kaiku, Pikebone Music, Minneapolis, Minnesota, 1987, lyrics based on poem "Nocturne" by Eino Leino [1878–1926].

British Library Cataloguing in Publication Information Available

Library of Congress Cataloging-in-Publication Data Available

ISBN 978-1-60893-495-9 (cloth : alk. paper)
ISBN 978-1-60893-496-6 (electronic)

♾™ The paper used in this publication meets the minimum requirements of American National Standard for Information Sciences—Permanence of Paper for Printed Library Materials, ANSI/NISO Z39.48-1992.

Printed in the United States of America

For Camille and Didier

CONTENTS

Kosti S. Puohomaa

Petra's Love Song

Song of the blackbird, stilling light
Moon above, field of grain
Happiness of a summer night
All these things are mine.

Bring me the darkest forest
Sky into which the sun takes wing
Blue shadows over the water
From these my heart can sing.

—Jean Sibelius

(based on the poem "Nocturne"
by Eino Leino [1878–1926].)

PREFACE

A mong the hundreds of photographers with whom I have worked in more than half a century of picture editing, Kosti Ruohomaa stands out like a lighthouse. Just why it is hard to say. I met Kosti through his photographs. They told me a lot about the America my folks had come from. I was a big city boy but Kosti's pictures spoke of the countryside—of barns and gravel roads and Model T Fords, of campfires and town meetings and post offices where you went to get your mail.

It was for those reasons that I chose Kosti to photograph two families for the *Ladies' Home Journal* series called "How America Lives." The first was a family in Maine, not far from where Kosti grew up. He must have loved it when I chose a photo of the snow-covered path to the outhouse as a prominent picture in the layout.

The second family could not have been more different—a young couple homesteading in the Arizona desert. For that one I flew to Phoenix with Kosti and rented a car. After a day or so I left Kosti to finish the shoot on his own. I didn't need to worry. He did just fine.

But Kosti was no mere country bumpkin. He had shone as an artist at the Walt Disney Studios in Burbank. He had a grasp of the world, coming no doubt from his Finnish roots. Black Star sent him everywhere. Kurt Kornfeld of Black Star was his foster father. Black Star's Howard Chapnick was like a brother to him.

His early death was a blow to our profession. I am grateful that his work survives in exhibitions such as that at the Maine State Museum in Augusta, and in books such as this.

John G. Morris
Paris

FOREWORD

Kosti Was Here!

Kosti Ruohomaa is the reason I became a photographer. During my senior year at Colby College in 1969, an exhibit of Kosti's work was installed at the Bixler Art Museum. My fraternity residence backed up on the museum, and I spent a significant amount of time there.

I can still remember how those images worked on me. I had made some photographs in grade school, but had never considered the idea of being a photographer. The humanity and honesty of Kosti's photographs engaged me fully, and the thought that I might be able to do something remotely like that was very exciting.

That fall found me teaching second grade in Dixfield, Maine, a self-contained classroom with thirty eight-year-olds. I bought a five-year subscription to *Popular Photography* and began reading about the medium. With my income tax refund I went to Boston and bought a camera and began shooting film, dropping the finished rolls at the drugstore. That summer I bought a film-developing outfit and processed film in the bathroom after dark. I made contact sheets using a desk lamp as a light source.

Fall found me in a master's program in communications at

Fairfield University, where I took my first photography class. As I watched the first enlargement appear in the developing tray, I knew what I wanted to do for as long as I could. I ultimately made my way to graduate school in photography at Ohio University. There I studied with Arnold Gassan, who had been involved in the first year of the Maine Photographic Workshops (now Maine Media Workshops) in Rockport.

I volunteered to be Arnold's teaching assistant for the four weeks he would be there in 1974. At the conclusion of my time there, the founder of the workshops, David Lyman, left open the possibility that I might be able to teach as resident staff the following summer, after finishing my MFA. As the summer approached I contacted a Rockport woman, Polly Gates, about any summer housing she might know of. She replied that a local couple, the writer Lew Dietz and the painter Denny Winters, rented a loft over Denny's painting studio. Correspondence ensued, and we secured the loft for the summer.

Arriving in Rockport we emptied the contents of the wagon into the loft and were invited by Lew to join him and Denny for some fish chowder. As we sat by the window looking out at the harbor, Lew asked me, "So how did you decide to be a photographer?" As I described my discovery of Kosti's work a bemused smile appeared. When I was finished he looked at me and said, "You know, Kosti was one of my best friends. We actually worked on a number of articles together. And the apartment you are staying in was the last place Kosti lived before he passed away."

To this day, even after forty years have passed, I have never forgotten that moment. Lew told me stories about Kosti, including the calling card he would leave if someone he was visiting happened to not be at home: As a sign Kosti had been there, he would leave an empty can of Narragansett beer on the stoop.

A few years later the Black Star Agency in New York where Kosti's work was held decided to publish a book of his photographs, to be called *Night Train at Wiscasset Station*. An exhibit of the work would be held at the International Center of Photography in Manhattan. Lew asked if I was interested in printing the prints for the book, as well as the exhibit prints for ICP. Of course I was.

That experience of working with the negatives of the very images that had inspired me to begin a career in photography was so remarkable, I find it difficult to describe. It is not unlike doing simultaneous translation for someone. You not only know what they are saying, but you begin to understand how they think and feel. So it was for me with Kosti's work. In printing that work I was able to connect with Kosti in spirit, and to say thank you for the wonderful adventure he had started me on.

Craig Stevens, Professor of Photography
Savannah College of Art and Design
Savannah, Georgia

INTRODUCTION

Kosti Ruohomaa, an American born to Finnish parents, grew up on farms in Vermont and Maine. He displayed artistic talent, a deep interest in literature and poetry, and a fascination for taking pictures that began with his mother's box camera, by the time he had reached his mid-teens. A personal motivation to follow studies in art overwhelmed any desire to become a farmer, much to the great disappointment of his father. The Finnish philosophy of Sisu—loosely interpreted, to have courage and guts—may apply to Kosti, who demonstrated an ongoing persistent drive and energy to make a successful career in a creative field. The story of how he reached this goal reflects the influences he engaged and the examples he followed, as one opportunity led to another, to become self-supporting as an expressive artist.

Selim Fredrick Ruohomaa and Sofia Ester Kartano, Kosti's father and mother, both emigrated from the Panelia area of western Finland. His father lifted bales of peat and was successful as an amateur wrestler. His mother grew up on a rented farm, and came to Massachusetts at the age of seventeen. They met in Quincy,

where they married and had their only child. Selim worked as a builder, and Sofia, as a domestic, until they settled together to take up a life of farming.

Selim's personal valued philosophy—to "work with one's hands close to the land"—was portrayed through his son's professional camera, although Kosti would not follow his father's vocation. Despite Kosti's celebrity by his mid-thirties as a New England photojournalist—in particular, in his home state of Maine—whose photographs appeared on the covers and pages of major national magazines, a barrier prevailed between father and son that apparently was never resolved. This, even with his son's self-appointed directive to capture the folkways and to interpret the lore of country people, and to celebrate pastures and farmed fields through his lens.

Mood, atmosphere, and drama—drama in the theatrical sense, meaning to convey the spectacle of a scene—would become characteristic qualities of Ruohomaa's images. His was a deep but quiet passion; a subjective photographer, he viewed the object of his camera with feeling.

Early on, Ruohomaa considered certain of his images to be a form of poetry, as did later curators and critics. Ruohomaa's sense of space can be described or interpreted as mysterious, surreal, or abstract. Composition played a strong role in his outstanding works, especially his command of light and space in a landscape or in an expansive seacoast scene, as if it were a theater stage. His work produced on subzero winter nights call his Finnish heritage to mind.

Kosti Ruohomaa died young, in 1961, at the age of forty-seven, a victim of alcoholism. His last few years represented a change in his camera vision to abstracting from nature and working in color transparency.

Ruohomaa contracted with the Black Star Publishing Company in New York in 1944, a close relationship that lasted throughout his lifetime, and beyond. The work of his lens illustrated editorial material, picture stories, portfolios, essays, and sometimes covers, photographs distributed by his agency that appeared in major regional, national, and international magazines of the 1940s, '50s, and '60s.

It was through Time Inc. publications, however, especially Life magazine, that Ruohomaa and his photographs gained a certain reputation. Peter Stackpole, photojournalist with Life from its beginnings, summed up Kosti Ruohomaa as "the great photographer of the East." While Ruohomaa was never a staff member, for thirteen years he produced assignments for Life, including many sourced in Maine, a number of them based on his own personal ideas. He was not a reporter as a cameraman, but instead created editorial features.

Ruohomaa regularly held in his equipment bags two Rolleiflex medium-format cameras, the Linhof 4x5 view camera, and a 35mm Leica, often shooting an assignment in all three formats. He consistently used a tripod and timed camera settings, and employed filters, flash, and bulbs for lighting, as well as natural light, in interior and exterior situations, at all times of day, night, and in inclement weather. Themes that preoccupied his lens—i.e., the sky, fog, dawn, night, the forces of winter, and inclement weather—set the temperament of Ruohomaa's images.

An early member of ASMP, the American Society of Magazine (today Media) Photographers, he joined in 1946, two years after it incorporated. Thereafter, his photographs and remarks about his assignments and travels appeared in the ASMP Grapevine newsletter, the monthly Infinity magazine, and the annual Picture.

Ruohomaa's last essay, titled "Maine," appeared in the ASMP 1959 issue of *Picture*, along with his rare personal comments. The opening of the piece is expressed in his personal style: "Photographing the state of Maine has been an attempt to portray traditional characteristics within the mood of the terrain or in whatever shack was hiding them at the moment. Much is hidden in the offbeat nooks and crannies, for this is a way of life that is fast vanishing."

One of Ruohomaa's quests, somewhat of a self-assigned mission throughout his photographic pursuits, was to capture the distinguishing humble, genuine qualities of country people, their work and home life, their surroundings and lore.

U.S. Camera, *Minicam Photography*, *Modern Photography*, *Contemporary Photography*, and other professional and amateur photography journals and their annuals, geared toward cameramen and -women, noted Ruohomaa's signature approach to an idea, such as windblown snow swirling over country roads, and rural folks taking time out to chat on the "liars' bench" outside the village general store.

The images Ruohomaa made of work, close to land and sea, were of the outdoor hardy and rugged breed—woodsmen, river drivers, fishermen, farmers, ice cutters—their livelihood dependent upon nature's resources and seasonal weather conditions that would often challenge their harvests.

Ruohomaa knew what he wanted in a photograph. Howard Chapnick, president of Black Star and a longtime promoter of Ruohomaa's images, recalled: "Kosti made pictures to fit an idea."

One example was a photograph titled *To Be Independent as a Hog on Ice*. Long fascinated with the origins of colloquial expressions, he carefully planned the photograph of a hog collapsed on the icy surface of a small pond. The final selected image was printed across two pages of the March 13, 1950, issue of *Life* magazine's "Pictures

to the Editor." It was one of three he created, titled "Reenactments of Old New England Sayings."

His photograph of an elderly couple and a swing hung in the famed Family of Man exhibition curated by Edward Steichen, which opened in 1955 at the Museum of Modern Art in New York. The image was placed with the theme "The Endurance of Love." Actually made by the photographer in 1947 at a Portland, Maine, picnic of the "Three-Quarter Century Club," the exhibition label read: "Edward Rogers Castner, who ran a general store in Damariscotta, Maine, for sixty years, gives his wife a fine ride. Both husband and wife are eighty, and have been married sixty years."

MEETING KOSTI

I first became acquainted with the photographs of Kosti Ruohomaa at the Maine Photographic Workshops in Rockport, Maine. In 1983, Craig Stevens, our inspiring resident program instructor of black-and-white photography, directed his students to carefully examine the framed photographic prints lining the Union Hall classroom walls. He had passed the better part of the summer making the prints from Kosti Ruohomaa's vintage negatives, on loan from Ruohomaa's agency, Black Star, New York. The photographs represented illustrations in the 1977 publication, *Night Train at Wiscasset Station*, and were selected by Howard Chapnick, Black Star's president.

In the preface for the book, Andrew Wyeth recalled the poetic qualities of Ruohomaa's photographs, and Rockport writer Lew Dietz contributed as text his own memories of collaborating with Ruohomaa on magazine assignments in the late 1950s. The Maine Photographic Workshops produced an entertaining slide presenta-

tion based on his photographs, called "The Kosti Show."

That same year, 1983–84, I volunteered to work on a Ruohomaa collection for the Farnsworth Art Museum, a project which would continue until 1989. The museum had received a large collection of Kosti Ruohomaa photographs donated by James Moore in 1978. Reviewing the photographs, most undated, I found they represented images from editorial features Ruohomaa had produced for Time Inc., especially *Life* magazine, in the 1940s and '50s.

It was evident that Ruohomaa had traveled from coast to coast and into Canada for his assignments. The collection also held photographs made for his agency, Black Star, later distributed to popular national magazines of the period. Here innumerable Maine- and New England–based photographs touched upon Ruohomaa's interest in the pastoral landscape, the farmer, fisherman, and woodsman, plus his interpretations of folkways and folklore. The collection featured Ruohomaa photographs that appeared in a few camera-journal monthlies and annuals, placing his work within the spectrum of national magazine photojournalism.

However, there were no actual defined connections within the collection. This was my assignment—to find these connections, and to organize the collection for display. I set about to do just that, placing his photographs into categories.

Examples of his early artwork, most of it signed and dated, reflect Ruohomaa's Boston School of Practical Art assignments and his personal interest in cartoon illustration, which he pursued the year after high school.

One example of Ruohomaa's clever, well-executed cartoons suggests animation; in the drawing, he is a neophyte artist knocking on the door of an outhouse, which shows Mr. Walt Disney seated inside. This cartoon eventually helped convince Disney to hire Ruohomaa as a Disney Studios animator. His drawing and painting

style reveals his strengths in expressive color brushwork, less in understanding the human figure, which probably explains why he was assigned to the Disney Effects Department.

Ruohomaa began serious photography while working as an effects animator for Disney, from 1938 to 1943, and the Farnsworth collection includes examples of this work. While it reflects his amateur beginnings, it also previews his mature, intelligent, sensitive capture of light, his composition of a frame, and the atmosphere he would create in his later photographs. Ruohomaa achieved a level of refinement, including national publication, during this period.

What was missing in the Farnsworth collection was a genuine, clear picture of who Kosti Ruohomaa was—his background, personality, and artistic aspirations, especially the purposes behind his picture-making. My work focused on identifying and displaying this message, which ultimately led to the writing of this book.

Two other references apart from *Night Train at Wiscasset Station* were available to me as I worked on defining the Farnsworth collection: *Maine Coastal Portrait*, which Ruohomaa coauthored in 1959 with James Moore and Carroll Thayer Berry, and his winter night photographs, originally published in 1951, selected for the publication *Great Photographic Essays from LIFE*, which appeared in 1978.

No dates or context accompanied the photographic material. Business records may have solved this problem, but none from his years with Black Star survived the company's moves. The most reliable dating source was Time Inc. and *Life* magazine records, although sometimes publication of his images would come years after he had made the photographs.

Ruohomaa's sense of photographic composition, atmosphere, and mood connect to his long-standing personal interests in poetry and literature, as well as his art studies in advertising illustration.

No doubt he loved and found inspiration in his home state of Maine. He was also influenced by many other facets of his wide-ranging career: his earlier experiences at the drawing board in Walt Disney Studios as an effects animator, surrounded by multitalented artists day and night, and his participation in the Disney Employees Camera Club and its associated Hollywood studios exhibitions; his close observation of filmmaking; and his studies with Will Connell at the Art Center School. Also, not to be underestimated was his own perseverance to self-instruct, especially through studying magazines like *Scientific American* and *U.S. Camera*, and his strong, ongoing, personal self-motivation. All of these elements combined to form the photographic eye of Kosti Ruohomaa.

The Farnsworth Art Museum experience inspired my later research of Kosti's life and work. In 1993 I began to interview Ruohomaa's family members, friends, professional colleagues, and subjects of his camera. That same year I began annual visits to Ruohomaa's collections at Black Star and Time Inc. To aid in the difficult decision-making process of selecting thirty-two images for the plates in this volume, I considered examples of Ruohomaa's themes, his in-depth approach to the essay, the image's proximity to that of a lyrical form, his attraction to abstraction and the surreal, his color vision, and his love for the lore and personality characteristics of country people.

While many important images have been left out, I hope that those selected will clearly represent Kosti Ruohomaa, the photographer poet.

Deanna Bonner-Ganter
Lincolnville, Maine

I. BEGINNINGS

A Finnish Heritage

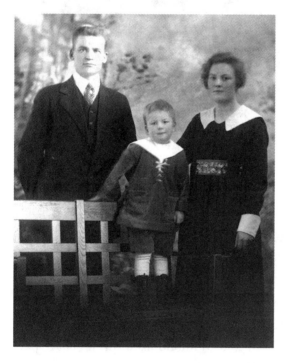

Studio portrait, Kosti at age two with his parents, Selim and Sofia Ruohomaa, Panelia, Finland, 1915. (Lofman Collection, Maine State Museum)

Freelance writer and editor Donald Wayne recalled his first acquaintance with Kosti Ruohomaa in a letter from Russet Cottage, his home in Cambridge, England. The two had been assigned to work together for a *Holiday* magazine feature at a Cornish, New

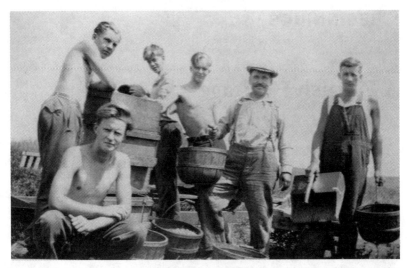

Kosti Ruohomaa in center at age thirteen, working at the blueberry harvest, Dodge Mountain, Rockland, Maine, 1926. (Lofman Collection, Maine State Museum)

Hampshire, location. It was the 1950s, Wayne recollected, and Kosti was an overnight guest.

"I'd never met him before, but we became instant friends. [Being a Finn] he was far from abstemious, but he was so interesting and so likable, and turned out to be one hell of a good photographer. He talked a lot about Maine, a place he adored, or seemed to, where his family were blueberry farmers."[1]

Son of Finnish immigrants and an only child growing up on farms in Vermont and Maine, Kosti Ruohomaa's attachment to pastoral terrain and people who work close to land and sea would be summoned up often as subjects in his mature photographic expression. He continually strove to capture and thus archive through his camera's lens a way of life he saw as disappearing from the backcountry rural farms and seacoast villages, finding in his home state of Maine a major source for this study of many years' duration.

Mainly self-taught in photography, a background of art studies successfully led to a position as an effects animator with the Walt Disney Studios during the production of the experimental feature-length cartoon, *Fantasia*. Ruohomaa's professional lens encompassed atmosphere and mood, and sometimes projected a dramatic edge, visual qualities sensitized in the days of Hollywood studios filmmaking, and which set his photographic expression apart.

Born to Finnish parents, a heritage influenced by nature's forces and its changing seasonal character, the long hours of darkness of a northern New England winter could almost be compared to the Nordic character of Finland. Ruohomaa discovered magic in a winter evening's wanderings, during which he captured moments of snow-blanketed land amid a changing night sky. Filled with feeling, the presence of the photographer is sensed in images that captured light in its flow, explosion, and penetration of ice-covered surfaces and forms, creating landscapes in his lens both surreal and dramatic.

Comfortable in the predawn hours as he waited to photograph at the first rays of sunlight, Ruohomaa would follow this theme throughout many years of travel for assignments. He was inspired by nature's quiet moments: A field of wildflowers alive with moisture-covered spiderwebs, a frog's brief appearance above the water's surface, fog veiling the meadows and waterfront—all would become subjects recorded by his lens.

Both negatives and transparencies reflect the paths he traced along the edge of the sea. He composed close patterns formed of leaves, shells, stones, and broken ice, relics left of a seafaring past. Their shapes, textures, and tones commanded Ruohomaa again and again to release the shutter just as an artist, sketchpad in hand,

would stop to draw. Soft-spoken, tall, lanky, tough-skinned from exposure to the northern New England elements, Ruohomaa was one with his camera, his lifetime companion, the instrument through which he interpreted his world with a poetic eye.

During the mid-twentieth century pictorial communication on the printed pages of news, feature, and special interest pictorials reached peak reception with audiences. Weekly, monthly, and annual magazines and journals filled city-corner newsstands, and were available through subscription to rural areas. The major draw of television (black-and-white) became common in most living rooms only in the 1960s. Ian Jeffrey, photography historian, noted that "Beginning in the 1940s and 1950s, commercial printing developments brought the work of photographers within reach of a large new audience and eventually helped to establish the medium as art."[2]

Kosti Ruohomaa's freelance camerawork appeared on the covers and in editorial features and essays in the pictorial sections of major national newspapers, magazines, and journals of the mid-twentieth century. It was a time when black-and-white and color photographs reinterpreted our surroundings and communicated these visions through the print media.

Ruohomaa left a deep impression on Black Star, his New York agency. They celebrated the work of their loyal photographer— almost an adopted child, who died young—in their 1996 sixtieth anniversary publication: "In his incomparable style, [Ruohomaa] portrayed two decades of a country and its people, especially Maine. Black Star counts him as one of their greatest, yet most unrecognized, photographers."[3]

Beginning with his contract in 1944, for more than seventeen active years and thereafter, Black Star promoted Ruohomaa's camera-

work and distributed his photographs to regional, national, and international journals and magazines, including the ubiquitous Life magazine. Peter Stackpole, one of Life's founding staff photographers, recalled Kosti Ruohomaa as "America's great photographer of the East, especially New England."[4] Carl Mydans, one of Life magazine's master staff photographers, and a peer cameraman with Ruohomaa in the late 1940s, wrote, "Kosti Ruohomaa was not only a splendid photographer but a splendid person too. I remember many of his photographs well, often with envy, because I see them as a fellow photographer, and they were made with such a beautiful eye, and they revealed so much of his feelings."[5]

On September 17, 1945, Ruohomaa's portrait, Rolleiflex in hand, was featured in Life's masthead, along with this short blurb: "Kosti Ruohomaa, who did photographs of Life's visit to New Harmony, [Indiana], was born in Massachusetts. He spent most of his thirty-one years in New England, where he went to art school and worked on his father's farm. In 1938 he went to the West Coast, where he did animation for Walt Disney. After four years he came east, worked on a farm, and decided to turn cameraman. Life offered him his first professional photography assignment, and the result was a Life cover."[6]

Although the editor's story of Ruohomaa's photographic career detailed years of work and study and less of work on the farm, the neophyte photojournalist was given an upbeat promotion to Life's readers early in his second year of photographing for the magazine.

Ruohomaa's life's work was primarily composed through black-and-white film; however, in his last years he made close color studies realized as abstractions from the nature that he loved—the meadows, fields, woodlands, granite quarries, and tidal

ocean waters of Midcoast Maine. He moved on from former pho-
tographic preoccupations, finding new imagery among relics of
weather-worn fishing vessels, hardware of aged surfaces, ice-cov-
ered shells, patterns and textures of granite, broken wood struc-
tures of the past—images that may be likened to an artist's canvas
of this 1950s abstract expressionist period.

Ruohomaa's talent for drawing was acknowledged in the
formative years of high school, and his love of poetry and litera-
ture inspired a direction quite apart from his father's wish that he
become a farmer. Kosti's interest in photography began as a teenag-
er, using his mother's box camera secured to a tripod. During art
school studies he continued to photograph, and once he had
attained his first professional art job, Ruohomaa purchased a seri-
ous camera, a Rolleicord.

At age twenty-five, Ruohomaa won a competitive art position
with the Effects Department at Walt Disney Studios. He further
studied the ways of the camera during the next five years in
Hollywood, developing and printing, refining his compositions.
Ruohomaa augmented his technical skills of lighting and enriched
his artistic photographic perception, especially through observa-
tion of Hollywood moviemaking and his Disney Studios drawing-
board animation experiences. While in California Ruohomaa's
photographs through the New York PIX Inc. agency appeared in
newspaper pictorial sections and camera magazines across the
country, while his images also received attention, winning amateur
competitions on a national level.

By the age of thirty-one Ruohomaa had returned east to work
as a civilian in US Army Signal Corps productions, establishing his
profession as a freelance photojournalist, contracting with the
Black Star Publishing Company based in New York City.

Ruohomaa's associates at Black Star understood his quiet intelligence and sensitive poetic expression. He developed an extensive body of work that revealed his passion to visualize subjects in a context of mood and drama. Through Black Star his personal interest in the folkways and folklore of New England found national publishing venues.

Ruohomaa's Finnish heritage contributed to his individual pursuit to capture man's lonely connections to nature's forces.[7] Ruohomaa persevered to make his personal life's work in photography. He realized an expression in which his lens would become like an artist's palette, composing images to fit his ideas, embedded with mood.

He acknowledged that in his career, he had made "bad pictures, but also some good pictures."

His philosophy was captured in a 1961 taped radio interview in which he spoke of the preparation needed to become a professional photojournalist. He believed it was important "to be well schooled in geography, history, literature, languages, the arts, and the humanities. Anyone can learn to use a camera . . ."[8]

He left a body of work composed of inspired personal photographic ideas, as well as images that reflect thoughtful and imaginative poetic responses to assignments.

A FINNISH HERITAGE

Kosti's father, Selim (Selem) Fredrick Ruohomaa, born on May 31, 1891, left his homeland of Hanko, Finland, in 1911, at the age of nineteen.[9] He arrived in Quincy, Massachusetts, via the ship *Ivernia*, and lived for a while with his sister Amanda Lofman, her husband, and their infant son on Federal Avenue in that waterfront town.[10]

Sofia Ester Kartano, Kosti Ruohomaa's mother, was already in Quincy when Selim arrived.[11] She had left her father's rented farm in Lappi TL, Panelia, in western Finland, at the age of seventeen. Records indicate that she traveled alone from the same port of Hanko, departing February 16, 1910, aboard the *Polaris* to Southampton, England, then, continuing the voyage on the vessel *Adriatic*, to Quincy, Massachusetts.[12] Apart from luggage, official papers, and a one-way ticket, Sofia also brought along a box camera. She made a small photographic record of her New England arrival and kept it in a personal album.[13] Her pictures documented the ship's gangway to the pier below filled with the waiting crowd at Quincy harbor. Later on, she continued to depict on film this first day in America, capturing a Finnish tradition of dancing with pictures of turning, stepping couples outside of the Finnish Hall on Arthur Street. An industrious young woman, Sofia Kartano quickly found work as a housekeeper to ensure that she could support herself in her new country.

Selim Ruohomaa had previously hauled heavy bales of peat near Kiukainen, his hometown, actually located just miles from his future wife's domicile in western Finland.[14] At age eighteen, wrestling was Selim's avocation, a tough and strenuous sport that accompanied the young man to his new country.

Selim must have also possessed a yearning for adventure, as, according to family members, he left his sister's home in Quincy to travel cross-country to Hollywood, California, where he found work constructing stage sets for motion picture productions.[15] Ambitious, Selim became impatient as film after film, his careful carpentry was routinely and expediently broken down to ready the next movie set. After a short stint, Selim returned to Quincy, where he found stage construction work at the Finnish Hall theater.[16] The

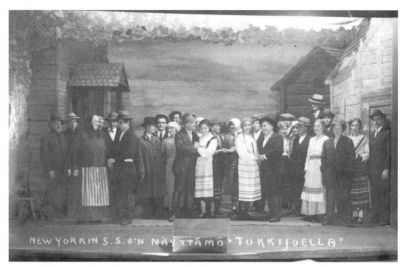

Photo postcard of Finnish Hall stage performance, "New York in S.S.O.N. Nayttamo Tukkijoella." (Lofman Collection, Maine State Museum)

Finnish Hall, a point of reception for arrivals from the homeland, held dances and organized entertaining stage performances in the Finnish language to orient newcomers to their new home.

The Finnish Hall is likely the setting where Kosti Ruohomaa's parents became acquainted. Selim Ruohomaa and Sofia Kartano were married in Quincy on May 25, 1913, by a justice of the peace. The marriage certificate states Selim's occupation as "a stage builder" and Sofia's work as "a domestic."[17] Named after his father, Kosti Selim was born in Quincy on November 25, 1913.[18] He would be their only child.

Four months after officially registering their son's birth, the Ruohomaas returned to Finland, surely to meet respective family members.[19] On August 4, 1914, Kosti Selim Ruohomaa was baptized in his father's church in Kiukainen. The following March 25, 1915, his parents exchanged vows in his mother's parish of Lappi

TL.[20] A studio portrait documented the young family and this homeland voyage before they returned to the United States.[21]

Upon arrival in April of 1915, the Ruohomaas lived in Massachusetts. They moved about as Selim found seasonal employment, such as lugging trunks for a Massachusetts resort hotel, a job documented as a location portrait made of the uniformed bellhop team.

Sofia opened a "Workers Union" bank account in Fitchburg, a center of the Finnish community in Massachusetts, which she kept independently for her lifetime.[22] A Melrose, Massachusetts, savings account traced from these years provides a history of where the family lived during these years.[23]

Selim's carpentry skills proved lucrative. He found employment moving his family to construction sites in New Jersey, Staten Island, and then Brooklyn, New York.[24] In 1919, with temporary financial help from a friend, the Ruohomaas bought 150 acres of land in Andover, Vermont, near Chester, in the heart of the Green Mountains.[25] This new beginning would permanently change and secure the Ruohomaas' future lifestyle pattern.

In Andover the Ruohomaas maintained the farm, grouped with other local Finns, and established a cooperative shingle mill.[26] The two-story dwelling on the property, once an inn, was located on the Old Boston Post Road.[27] Sofia took in occasional guests and oversaw the small farm responsibilities. Designing the structure with red brick, a common building material of the area, Selim constructed the family sauna, the indispensable steam bath essential to Finnish home life, placing it a close walking distance from the homestead.[28] Album pictures show that the Ruohomaas savored the sauna bath after a long week of work.

When Selim returned from New York, the week's end was a

time to dress up and socialize, occasionally inviting Finnish neighbors, the Kangases, and new friends to the homestead inn.

During the Vermont years Ruohomaa's father remained in Brooklyn, New York, where his construction skills continued to offer them a steady income.[29] Taking the train from New York to Chester, Selim, like other locals, returned home to Vermont periodically.[30] During seven years of Vermont–New York residency, Selim joined a Finnish Athletic Club in Brooklyn, where he competed in amateur wrestling, winning several medals.[31] Andover was populated with Finnish families. Signs remain in Andover today, such as one for "Finn Farm," nestled along a high, steep ridge with expansive views of the valley and distant mountains.[32]

When son Kosti was almost seven, he attended the one-room redbrick Pease School, walking the mile or so distance.[33] He had excellent attendance, but did not relish the after-school chores waiting at the farm. One schoolmate's recollection provides a clue as to early thoughts Kosti may have had regarding questions about his future role as a farmer: When the Ruohomaas' few cows became deathly ill, Kosti carelessly replied to sympathetic remarks from school friends, saying that for him, it meant he would no longer have to fetch the animals from the pasture at the end of the day.[34]

The Ruohomaa family's path toward their final destination, the state of Maine, actually began with family connections in Quincy. In 1910, the same year Kosti's mother Sofia arrived in the United States, Amanda Lofman (Selim's sister) arrived in Quincy with her husband Mikko and their one-year-old son Niilo.[35] Mikko Lofman worked as a stevedore on the harbor front until 1914, when the family moved to Rockland, in Midcoast Maine.[36] Here the Lofmans bought land and established a farm on the west side of Dodge Mountain.[37]

Almost ten years later, in 1919, after learning of land for sale—the early-nineteenth-century Dr. Ezekial Dodge estate, located near the Lofman farm—Mikko wrote to his brother-in-law, stating that if Selim did not buy the land, he would.[38] Album photographs document the Ruohomaas' visit to Maine to view the property.

Placed just below the mountain crest, the original granite foundation of the Dodge homestead was situated upon 241 acres of spring-fed hillside land facing east, toward the splendor of Penobscot Bay, providing a spectacular view from the dooryard.[39] A realtor, familiar with this "mountain farm," as it was locally known, noted that an appraiser would describe the expanse of land with its vista a "dream location." [40]

The scene, viewed directly east, envelops the Penobscot Bay islands of Vinalhaven, North Haven, and the open sea. The north faces the Camden hills and beyond, with glimpses of Blue Hill and Mount Desert Island farther down east. To the South, Owls Head and its lighthouse are sighted. On clear days, Matinicus Island, farther out to sea, comes into focus.[41] At the base of the sloping fields lay the clear, pristine Lake Chickawaukie, an active site of annual ice harvests dating from the nineteenth century, documented by Kosti Ruohomaa's camera in the late 1950s.[42] The city of Rockland, the harbor, and its protective mile-long breakwater and lighthouse characterize the coast below Dodge Mountain.

Witnessing the views, the labors of farm life, and the seasonal weather patterns from dawn into night, this site of his youth became a place from which Kosti Ruohomaa could never fully depart, and would play a strong role in his mature photographic imagery. More than mere records, his views dramatically portray the seasonal work that takes place in the blueberry fields, the haying, burning, and harvest.

The actual Ruohomaa move to Maine occurred in 1924. Son Kosti's Pease School records in Andover, Vermont, ended in December of that year.[43] The Ruohomaas lived temporarily with the Lofmans until they closed on the Dodge Mountain acreage in 1926, the same year in which a bulk (but not all) of the Vermont property was sold.[44]

Kosti attended the one-room Benner School located on the Bog Road, situated along the mountain's western ridge.[45] The walks to school—first from the Lofman farm, and then from the temporary two-room dwelling his father had constructed for the family near the woodland crest of Dodge Mountain—were recalled by Kosti years later in a *Life* photographic essay, entitled "Maine Schoolboy."[46,47,48] By 1927, album pictures show that the Ruohomaas began to develop the land to grow low-bush blueberries, a crop indigenous to Maine.[49]

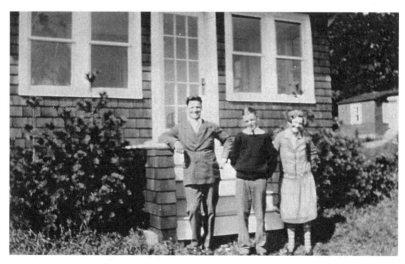

Kosti, age fifteen, self-portrait with his parents at the homestead, 1928. (Lofman Collection, Maine State Museum)

Over the years Selim added a number of buildings to the property. The simple but solid two-story homestead with cedar-shingle siding was constructed upon the original Ezekial Dodge granite foundation.[50]

The sauna was probably built at the same time as the earlier two-room dwelling. As mentioned, the sauna was a most important part of Finnish home life, and this was certainly true for the Ruohomaa family. The sauna steam bath followed the week's hard physical labor on the farm and prepared them for a weekend of leisure.

Woodland on the property provided the trees Selim cut, milled, and cured for building lumber. Perhaps as an element of pride Selim inlaid his initials, "SFR" (for Selim Fredrick Ruohomaa), in the dining-room hardwood floor.[51,52] They later added an enclosed porch lined with windows that faced east, toward Penobscot Bay.[53] Kosti probably helped, as did his father, who most likely with the help of friends constructed the spacious, traditional, two-and-a-half-story, gambrel-roofed New England barn.[54]

In the late 1940s, along the lower hillside near the barn, a multi-vehicle garage was added to house a tractor, trucks, jeep, and family car. Beneath the garage Selim created a full-size woodworking shop. At the time of this writing the homestead alone remains standing.

The only dwelling in those years, "one light" could be viewed on the mountain, a Rockland resident recalled. From this domicile, Ruohomaa made hundreds of images throughout the seasons: a sky's ongoing change day and night, dawn's new arrival at the ocean's horizon, the rising moon, the weather, his father's blueberry fields, and the barn. Although destined to never become a

farmer, Kosti Ruohomaa's photographs would later express a deep attachment to this land.

Despite their differences, Selim appeared in many of his son's photographs after Kosti was contracted with Black Star. Selim's stalwart physique, a powerful, figurative focal point, acted as a statuesque form, an enigmatic silhouette, in photographs that portrayed the artistry and respect of a son but a distant vision of a father.[55]

The barn, a familiar presence within many of Ruohomaa's photographs, stood as a looming structure, a background, or acted as a studio or pictorial stage of imaginative ideas and reenactments.

The Finnish language was spoken at home, and the Ruohomaas regularly received Finnish-language newspapers. Selim was active in a Finnish relief group in Vermont, and then later in Maine.[56] He learned to speak, read, and write the English language more fluently than Sofia. When she spoke English, Sofia retained a heavy Finnish accent. Sofia never learned to write English fluently; her limited correspondence was in Finnish, and it is doubtful she could read English well.[57,58] Selim read English-language newspapers, and by the 1940s began to invest in stocks.[59] Kosti learned English in school and remained bilingual throughout his life.

Relatives sent a guestbook as a gift from Finland in 1946 that provides insight into the homestead lifestyle on the mountain. Hand-bound in thin wooden panels, the cover was engraved with the word *Vieraskirja*, a word loosely interpreted as "Welcome—write a greeting."[60] Its blank pages were intended for messages from visitors to Dodge Mountain.[61] From April 1946 until March 1962, four months after Kosti's death, eighty pages of handwritten notes reveal that the Ruohomaas received many friends at their home, including their son's professional acquaintances.[62]

The Ruohomaas shared the spectacular view from the Dodge Mountain homestead with overnight and day guests, somewhat of an early version of bed-and-breakfast hospitality often practiced by other Finnish Midcoast farm families. This provided an off-season income for the farm, especially appreciated by frugal Finns.[63]

Visitors signed, wrote, and dated their remarks and thanks in the *Vieraskirja*. Local friends—along with others made during their years living in Massachusetts and Vermont, and Midwestern people the Ruohomaas met during their seasonal stays in Lantana and Lake Worth, Florida—wrote in both the Finnish and English languages.[64]

"Thank you for your hospitality—this view is a feast in itself." —Eino and Virginia Heikkila, Norwood, MA, August 11, 1946

"Such a beautiful sight again I shall never see; I'm sure I'll never forget it. It was nice to meet you." —Sigrid and Francis Malaguti, July 5, 1955

"How lovely to sit here and soak up your view, a sanctuary on the busy coast." —Ann Hughes, New York / Searsport, August 6, 1961

"After touring and inspecting Finnish settlements in the Penobscot Bay area, we were entertained and became overnight guests of our gracious host, Selim Ruohomaa. Thank you for your hospitality." —Oliver H. and John H. Laine, April 11, 1950

An undated message in the Finnish language from Frederick Payne, then governor of Maine: Kiitoksia paljon Suomalaiset.[65]

Although seemingly isolated on the mountain, the guestbook reflects the fact that the Ruohomaas benefited from and used the

spectacular view from their home as a shared point of interest for their visitors.[66,67]

"All the farms took in summer guests, mostly from New York City. The sauna, by the lake (where we stayed in Union, Maine, in 1938), was heated every day, with afternoon coffee served on the terrace afterwards."[68]

In 1927, at the age of fourteen, Kosti Ruohomaa moved on to attend ninth grade at Rockland High School. He walked to school, meeting up with a classmate named Ernest from the Blackington dairy farm at the foot of the mountain.[69] The next four years were to be transformative, strongly influencing his development, especially his intellect and values. According to family, he was considered somewhat privileged, as usually sons of farmers were expected to leave school after eighth grade to work at home.[70]

By the time he graduated in June of 1931, Ruohomaa's interests contrasted greatly with those of his parents. His love of literature and poetry had become firmly entrenched. However, as a high school general course major, not a language or classics major, he was not prepared to go on and attend college, a loss that would somewhat haunt his life.[71]

The Rockland High School yearbook, *The Cauldron*, verifies senior Kosti Ruohomaa's active participation in extracurricular activities for four years, such as the cross-country ski team, his work as an editor on the newspaper, then the yearbook, and as stage manager of the senior class play. His public speaking abilities were acknowledged with a tenth-grade debating club award.

Former classmates remembered the "one-person" assembly Kosti Ruohomaa gave to the student body, an event that revealed his emerging talents: drawing, entertaining, public speaking, and awareness of an audience.[72] Center stage, with a large drawing pad

set up on an easel, Kosti improvised personal views of seacoast life in hometown Rockland, applying rough, bold charcoal strokes, creating sketches, page after page, as he commented on them to his delighted peers.[73] One student recalled her classmate's humor: "He left the first page empty and called it a bird's-eye view of Rockland. Then, on the next page he drew the harbor breakwater and lighthouse and another sketch of the waterfront, and alerted his audience to beware of seagulls' droppings."[74]

Though it is not known how he came to be invited to perform an assembly, a personal book, *Chalk Talk and Crayon Presentation*, flamboyantly signed "Kosti S. Ruohomaa" inside the front and back covers, fully illustrated how artists could teach from easel sketchpads, suggesting it was the source for this idea.[75]

According to the yearbook, Kosti was characterized as one who on wintry days made his way to school, skiing from his isolated home. His favorite movie was *Snowbound*; his song, "High, High in the Hills." This rhyme was also included: "K is for Kosti, we all know his last name, he lives upon the mountain, to be an artist is his aim."

A friend recalled the after-school hours when they met on the steps outside of the Rockland Public Library and Kosti would speak of his future, of art and literature. He tended to reflect seriously, "to be philosophic" in his views on life. But there is no doubt that the greatest influence during these years was that of his English teacher, who urged him to continue to study art and was, according to his cousin Leah, "a teacher he adored."[76]

The year following high school graduation, Kosti remained at home and worked on the farm. It was a difficult year during which he most likely felt isolated from the intellectual stimuli provided by his classes. He began to distance himself from his father's fixed

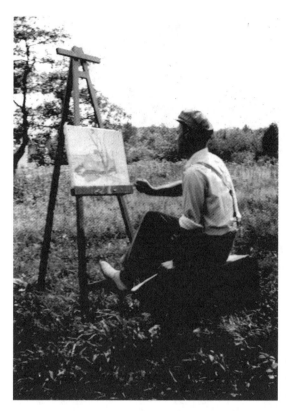

Kosti paints at an easel set up on the Dodge Mountain hillside above the homestead during his graduation year of 1931. (Sofia Ruohomaa, Lofman Collection, Maine State Museum)

ideas and ongoing message that the most important thing in life was to "work with one's hands close to the land."[77] That year at the homestead he followed the routine daily chores of farm life, attended to the draft horses, cows, sheep, and chickens, and assisted with the maintenance of the blueberry fields.

But he also kept in touch with his friends at Goodnow's Pharmacy on Main Street in Rockland, where he worked part-time as a clerk's helper. Perhaps to gratify an inner calling, he set up an easel in the corner of the barn where during his free time he would sketch and paint, following assignments from a subscription to a Midwestern school that taught artists how to create cartoons.[78]

Kosti Ruohomaa's first camera belonged to his mother.

Self-portrait with cousin Neelo, his father, and Uncle Mikko. (Lofman Collection, Maine State Museum)

During high school he used this box camera to photograph con-
torted facial expressions and gestures created by his friend, Ernest
Blackington, who recalled that later, these pictures were applied to
cartoon ideas.[79]

Kosti also began what would become a lifelong habit of
securing the camera to a tripod. Thus, with his mother's Kodak, he
began to photograph coastal scenery and to create self-portraits
with his family.

Sometime during this postgraduate year, Kosti convinced his
parents to send him to art school. It was most likely his mother
who not only provided understanding and sympathetic support to
her son, but also financed his studies.[80]

Beginning in the fall of 1932 and through the summer of
1935, Kosti attended art school and lived in Boston. He shared an
apartment at 514 Beacon Street while earning a three-year certificate
in advertising illustration at the Boston School of Practical Art. His

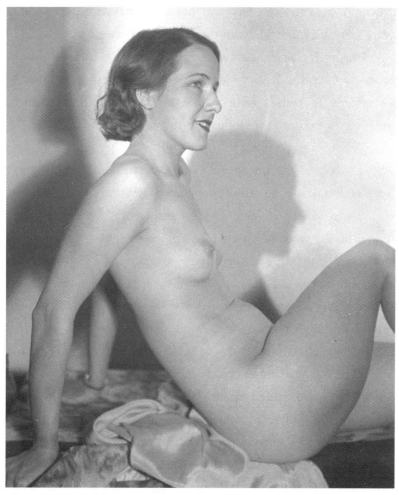

Kosti composed this studio photograph simply, through light and shadow, on a partially draped, unidentified nude woman model, 1932. (Lofman Collection, Maine State Museum)

artwork from these years demonstrates a free yet self-assured ability to handle pencil, chalk, and painting media, although his figurative work remained somewhat schematic and rigid, perhaps a carryover from those step-by-step cartoon lessons. Projects saved from the art school years reveal the careful attention he gave to presenting fin-

ished, polished artwork. His thoughts occasionally turned to Maine as themes for posters, drawings, and character types.[81]

During his years at art school, Ruohomaa continued to take photographs. A single surviving diacetate negative indicates that he assembled a makeshift studio with lights, tacked-up drapery, and a table-height podium for studio lighting and camerawork.

Though not pictured in this image, a former art school peer who also posed for his studio camera recalled that Ruohomaa's work encompassed an atmospheric approach to the female figure with a pictorial style, such as the translucent, flowing, kimono-style robe she wore while holding a globe-like glass.[82]

After completing the three-year program in 1935, Ruohomaa stayed on in Boston where he found his first job, however short-lived, selling department-store window-display supplies with Feine Trimming Company, Inc.[83] Following this job, he was hired by the well-established Forbes Lithographic Manufacturing Company, his first professional employment as a drawing-board artist. He moved to 182 Spencer Avenue, Chelsea, near the company's twelve-acre plant site. Located on the Charles River, this long-established company prepared and printed fine illustrations, calendars, advertisements, labels, and packaging designs sold nationally.[84] Though it is not known exactly what type of art or media he produced during the next two years, Kosti Ruohomaa greatly admired his peers' talent, and commented fondly of one Forbes artist who "always praised my work to the boss."[85]

During the fall of 1937, a career-changing opportunity presented itself when Ruohomaa responded to a Disney Studios talent scout advertisement.[86] Earlier that year, Walt Disney had received accolades and Hollywood awards for his first color feature-length cartoon, *Snow White and the Seven Dwarfs*.[87] There were forthcoming

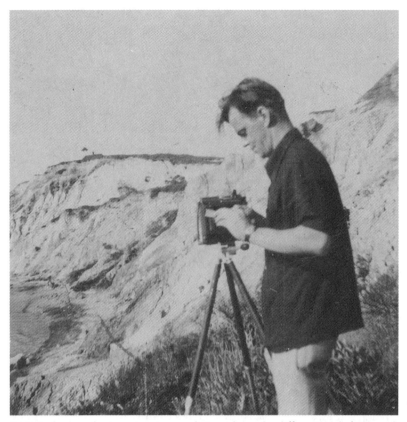

Kosti Ruohomaa, about age twenty-one, photographs at the cliffs on Martha's Vineyard. (James Moore Collection, Farnsworth Art Museum)

plans on the Studios' storyboards, including an experimental film to be accompanied by classical music. New artists were needed to create the full-length motion picture cartoon production, to be titled *Fantasia* upon release. Disney sent Phil Dike and other master artist-animators to scout major cities of the country, looking for bright, fresh talent.[88]

"In those post-Depression years, for anyone with art ability, Disney Studios was the place to be!" recalled Norman Tate of Port

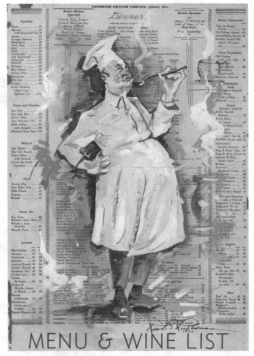

Artwork prepared for Disney tests while in New York, 1937: "The chef," a character-type painted on a current menu cover of the Essex House Casino in the Park Restaurant, reflected, in part, Kosti's skill and ingenuity. (James Moore Collection, Farnsworth Art Museum)[91]

Clyde, Maine, a former Disney character animator of the 1930s and '40s, whose name appeared regularly in the credits of major Disney cartoon features. According to Tate, if applicants made it past the portfolio interview, there followed two weeks of art projects, and lastly, a "final" to be viewed by Mr. Disney himself.[89]

Taking a temporary leave from Forbes, Ruohomaa traveled to New York City where he rented a room on West Fourth Avenue in Lower Manhattan.[90] He had a successful Disney portfolio interview, and continued on for the next weeks.

The final art project would be sent to Mr. Disney for his personal review. The test apparently had to suggest animated movement in a two-part cartoon, include a Disney character, and be entertaining. It is not known whether Ruohomaa knew that Walt

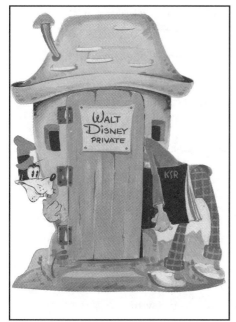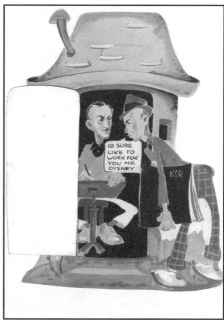

Two-part Ruohomaa color illustration for Disney final test, 1937. (James Moore Collection, Farnsworth Art Museum)

Disney had grown up on a Missouri farm, but in any case, he incorporated a graphic idea he had used before, in a new setting: a self-portrait with portfolio in hand.[92] In his two-part cartoon sequence, he chose Goofy as his Disney character. He portrayed himself as a fair-haired neophyte job hunter sporting a stylish fedora hat but ill-fitting clothes. Art portfolio in hand, he opened the door to a backcountry outhouse to announce to the caricature of Walt Disney seated at an undersized drawing table, "Gee, I'd sure like to work for you, Mr. Disney."[93] Typical of a dog's behavior, Goofy was curiously checking to see if this was a visitor or an intruder.

While in New York, Ruohomaa purchased a new camera, a medium-format twin lens Rolleicord.[94] It was to become a con-

stant companion in the immediate years ahead, eventually acting as an instrument of study and expression. "The popular Rollei" offered fine-quality lenses in both its high-end Rolleiflex and in its less-expensive Rolleicord type 2 model, Ruohomaa's choice in 1937. This medium-format camera with its full composing screen and controls for exposure was a great advance from using his mother's reflex Kodak, which she had later acquired. The resulting two-and-a-quarter-inch framed pictures could be easily contact-printed as small but clearly viewable photographic images.[95]

About this time, Ruohomaa assembled his first scrapbook. He would create many of them in the years ahead, and several would become albums of magazine tear sheets, documenting many of his finest published photographs, both in the United States and abroad. These early pages contained black-and-white prints made with the Rolleicord. Using natural light from nearby windows, Ruohomaa photographed his Forbes' colleagues at their drawing and painting stations. These interior location portraits hinted at Ruohomaa's self-assurance when it came to directing a scene. Each artist appeared to reflect momentarily from his drawing table or easel, pencil, pen, or airbrush in hand.

In early 1938, Ruohomaa learned that he had been accepted for a preliminary ten-week apprenticeship with Disney Studios. In the scrapbook, next to a farewell portrait caricature by Bob Moore, a fellow artist he greatly admired, he wrote in 1930s fashionable jargon that Moore was a "crack artist," adding: "Compared to Moore's stuff, I'm no damn good as a commercial artist."

He kept a photographic print of the monumental riverside Forbes building, a massive, factory-like, ivy-covered brick struc-ture. Clearly ready to move on, Ruohomaa's brief penciled com-ments next to the photo inserted in this album spoke volumes. "It

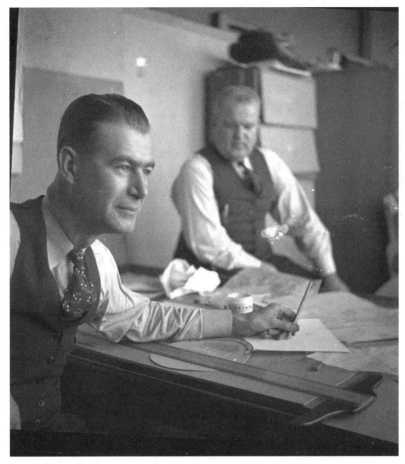

Location portrait of Forbes peer artist. Bob Moore / Kosti Ruohomaa, 1937. (Lofman Collection, Maine State Museum)

looked like a medieval prison, and felt like one too!"

After leaving Forbes, Ruohomaa returned to Rockland. On February 19, 1938, an announcement appeared in the local newspaper with his picture. The caption read: "Rockland Limner Will Join Disney Studio, Hollywood." According to the brief article: "Walt Disney, creator of Mickey Mouse and Donald Duck, two of America's greatest screen celebrities, has chosen the son of Mr. and

Forbes Lithographic Company on Charles River, 1937, mounted in Ruohomaa scrapbook of this period. (Lofman Collection, Maine State Museum)

Mrs. Selim Ruohomaa of this city, to join the art department of the Walt Disney Studios in Hollywood. The selection of Ruohomaa by Disney was a distinct honor to the local artist inasmuch as he was one of the few selected out of hundreds throughout the country who have applied for similar positions."[96]

Although the news suggested the excitement of a new challenge, Kosti Ruohomaa realized at age twenty-four that he was clearly distancing himself further from his father's hopes and expectations. In addition to disappointing Selim's wish that Kosti would manage the family blueberry properties, Selim was also mistaken in believing that his son's art studies would lead to a father-son partnership, with Selim building the houses that his son would design.

Selim had become an area developer of sorts. He had constructed a few small oceanfront cottages in nearby Owls Head and Spruce Head, including the Ruohomaas' getaway spot, traditionally known in Maine as a "camp," where they entertained friends

with bayside picnics of lobster and beer, followed by coffee and Finnish cardamom bread.[97] Selim had hoped that perhaps following art school, his son might design homes that he, Selim, could then construct, adding to his property development projects.

But there was another more troublesome issue that concerned his father deeply. The family had never really reckoned with Kosti's strong attraction to alcohol, beginning with the cider barrel in the family cellar. When his parents were away Kosti invited friends to the mountain homestead for a taste of brew, and later, while studying in Boston, he continued with more serious drinking bouts at weekend parties. It didn't help that he had a roommate with similar passions.[98]

This issue apparently exploded before Kosti departed for California, when one night he stumbled into the homestead dooryard, heavily inebriated. Though he was furious that night, Selim later joked about the incident with neighbors, telling of how he had dragged his thin, lanky, twenty-four-year-old son to the woodshed where he took a leather strap and attempted to beat some sense into him.

Nonetheless, by February's end, Kosti was on a train, heading for California.

NOTES

1. "New England Ghosts," *Holiday*, vol. 14, no. 3, November 1953, pp. 50–51. Letter received in response to my ASMP alumni magazine query; interview: Donald Wayne, Cambridge, England, 1994.

2. Ian Jeffrey, introduction, *Photography: A Concise History* (London: Thames & Hudson, 1981).

3. Hendrik Neubauer, "Ordinary People, Extraordinary Lives," *Black Star: 60 Years of Photojournalism* (Koln, Germany: Koneman, 1997), 437–39.

4. Letter, Carl Mydans, December 4, 1994, Larchmont, NY.

5. Ibid.

6. "*Life* visits New Harmony, Indiana," *Life*, vol. 19, no. 12, September 17, 1945, pp. 133–39.

7. See Appendix III for Time Inc. listings of Kosti Ruohomaa's assignments completed in Maine and elsewhere.

8. Radio interview, Rockland. Late January, 1961. Discussing photojournalism while paging through *Life* magazine 25th anniversary issue.

9. Mikko and Amanda (Ruohomaa) Lofman emigrated in August 1910 to Boston with their one-year-old son, Niilo. Institute of Migration, Register Library of Akademi, Turku, Finland. Selim Ruohomaa emigrated under the name of Anselm Ruohomaa, May 24, 1911. Heimo Outula, family historian, Forssa, Finland, provided Selim Ruohomaa's immigration information.

10. Sofia Ester Kartano (March 16, 1892–January 29, 1966).

11. Tapio Rosendahl, Harjavallan, Kaupunki, Finland, nephew to subject, provided copies of records, June 26, 1996. Institute of Migration Register: Sofia Kartano, Passport: February 3, 1910. Departure from Pori Province, Finland.

12. Album assembled by Sofia Ruohomaa, Lofman Collection, Maine State Museum.

13. Scrapbook. Kosti made photos of Swiss wrestlers published while he was in California. "Wrestler as Artist," a story he photographed for Black Star, published in *Parade*. Venues through which Kosti attempted to seek acceptance by his father of his career choice to become a freelance photographer.

14. Interview: Sevari Aalto, cousin (deceased 2004), at the Porin Taidemuseo, Pori, Finland. 1996.

15. Ibid.

16. Record of Marriage, Commonwealth of Massachusetts Vital Records, Quincy, MA, vol. 620, no. 107, May 21, 1913, p. 98.

17. Record of Birth, Commonwealth of Massachusetts Vital Records: Reg. No. 898, vol. 616, p. 98. Kosti Selim Ruohomaa, November 25, 1913, Quincy, MA.

18. Ibid: Date of Record, February 28, 1914. Heimo Outula, "I have seen these records."

19. Heimo Outola, Ruohomaa-Lindeman family historian e-mail response to my query, December 17, 2006. "I have seen the original records." Forssa, Finland.

20. In 1949, Sofia's niece, Saga Ambegaokar, brought a spinning wheel to her aunt when she came to live in this country. Sofia participated with two other local Finnish women wearing native costumes in a live spinning scene at the Farnsworth Art Museum's Finnish-American exhibit. *Portland Herald*, February 12, 1952. Staff photo by Moore. Lofman Collection, Maine State Museum.

21. Fitchburg Historical Society, Fitchburg, Massachusetts. "Strong, Finnish cultural origins."

22. Melrose account notated in Sofia's will. Ruohomaa family records held by Crandall, Hanscom & Collins, PA, Rockland, ME.

23. "Rockland Limner Will Join Disney Studio, Hollywood," published *Rockland Courier-Gazette*, circa 1938, Lofman Collection, Maine State Museum.

24. Deed: Knox County Reg., vol. 15, May 24, 1919, p. 208. Selim Ruohomaa and John Heimo purchased 150 acres, Andover, VT, land from Charles E. and Ella A. Conder, $1,300.00.

25. Manuscript: *The Farmer's Club* by Edwin Fossi. Article is undated, and based on personal recollections. "After the turn of the century, Finnish immigrants settled in Andover on East Hill, commonly known as 'Finn Hill.'" "A Mr. Ruohomaa was named as a member of the Finnish Farmers Club, a cooperative established before 1918."

26. Visit to Andover and the Inn site was hosted by Peter T. Farrar, historian, Chester, VT, August 1997.

27. Visit to Ruohomaa homestead, Andover, was hosted by Peter T. Farrar, historian, Chester, VT; viewed the inn and brick remains of the sauna, August 1997.

28. In 1926 in Brooklyn, New York, Finns lived in rooming houses. Selim was still in Brooklyn when he signed the purchase papers for Dodge Mountain. David W. Dunlap, "For Want of a Letter (and a Map), Finlandia Street was Lost," *New York Times*, July 23, 2011, p. A14. "A stretch of 40th Street Brooklyn was renamed Finlandia Street in 1991 to honor an era in the early 20th century when blocks around Sunset Park from Fifth Avenue to Ninth Avenue had as many as 5,000 residents."

The neighborhood was known as "Finntown." Black Star possesses the photographs Kosti made of this community after he joined the company in 1944.

29. Interview: Peter T. Farrar, Chester, VT, August 1997. Local people who worked in New York took the train from Chester station (today a shop). Story confirmed by Neelo (Niilo), Kosti's cousin. Interview, Rockville, ME, 1994.

30. Ibid: Interview with Neelo (Niilo) Lofman, 1996, Rockville, ME. Photograph: "Koluva," fifteenth anniversary of the New York athletic club. Selim appears as one of sixty athletes. Finnish area of Brooklyn. Kosti respected his father's athleticism and wrestling achievements, seen through his published photographs of Swiss wrestlers taken in California ("Focus on an Athlete, also an Artist").

31. Peter T. Farrar, Historical Society of Chester, hosted visit to Andover, VT, August 1997.

32. Ibid. Andover, VT, visit. Saw the Pease School, built in 1829 of red brick, one room, held about thirty students. Kosti attended from July 1919 until late autumn session 1924. Not listed in January 1925. School records, Chester, VT, vault.

33. Ibid: Peter T. Farrar, hosted visit to former classmate of Kosti, John Davison, Andover, VT, August 1997.

34. Interview: Neelo Lofman, Rockville, ME, 1994. Christened Niilo, but his schoolteacher in Maine told him to spell his name "the way it sounded."

35. Ibid.

36. Interview: Neelo Lofman, 1995.

37. Registry of Deeds, Book 199, p. 548, Rockland, ME. The first owner, Dr. Ezekial G. Dodge, formerly of Thomaston, was a contemporary of William King, Maine's first governor, in 1820. Willis and Susie T. Snow sold the property known as "the mountain farm" on October 1, 1923, to Selim and Sofia Ruohomaa.

38. Interview: Bruce Gamage, Thomaston, ME, realtor and collector of Kosti Ruohomaa photographs, 1993. Used these qualifying words in recollection: The appraiser of Dodge Mountain Farm in 1966, after Sofia's death, wrote "probably the finest view in all of Knox County." Also see, "Dodge Mountain Unparalleled Mountain and Ocean Vistas, home for sale," *The Free Press*, Real Estate, April 12, 2012.

39. Phone interview: Bruce Gamage, Thomaston, ME, 1996.

40. Ida E. Crie, d. 1920, photographed in 1890 from Dodge Mountain what she called "a bird's-eye view of the city. (Rockland.) The air was so clear we

could see Matinicus." Brian Hardon, ed., *Shore-Village Album: A Photographic Tour of Rockland, 1880–1930* (Rockland, ME: Penobscot Press, 1977, 2004), p. 11.

41. Lake Chikawauka (Chickawaukie). Probably the Bartlett Ice House, F. J. O'Hara, proprietor. The south end of the lake was Kosti's photographic subject in 1959.

42. School records kept in town vault, Chester, VT. Kosti left the Pease School in the fall of 1924; his name was not recorded after 1925. Vermont property finally sold in 1926.

43. Registry of Deeds, Rockland, ME. Selim retained his Brooklyn, NY, work until 1926, as seen with his signature notarized from that location on the deed.

44. Located through an early map at the Rockland Historical Society, according to a former neighbor who walked with him, Kosti attended one year only. Records of this year show all "1's," except for a "1-" for language. Courtesy of the Rockland, Maine, Historical Society.

45. "Maine Schoolboy," cover and essay, *Life*, February 2, 1948.

46. Kosti Ruohomaa school record: all perfect "1's" for this year. Courtesy of the Rockland, Maine, Historical Society.

47. The apt description of "aerie" for Kosti's adopted quarters after 1948 was coined by author Lew Dietz in *Night Train at Wiscasset Station* (New York Graphic Society, 1978).

48. Selim kept forest acreage and partnership in the Andover mill. Years later he purchased hundreds of blueberry acres west of Rockland—the Hannah Mountain barrens, located in Washington, Maine—and dispensed of the Vermont property.

49. No buildings are described in the deed.

50. Visit in 1994 to see homestead with Ruohomaa family friend, fellow Finn, David Hamalainen, Rockport, ME. Floor inlaid with SFR recollected by Hamalainen.

51. Interview: Larry Bird, Owls Head, ME, 2010. Selim demonstrated an interest in the trees of Maine. Most likely the floor initials were inset with contrasting wood grains, as he had crafted a picture frame owned by Mr. Bird using this approach and seen by author.

52. Interview: David Hamalainen, 1994. According to Mr. Hamalainen, since Selim was not the oldest son, he would not have had an opportunity to acquire his father's property in Finland. This achievement, owning land and having a lucrative business as a farmer, must have held the highest impor-

tance for him. As the years passed, it became a huge disappointment to Selim when he realized that his only son would not carry on the tradition.

53. The deed did not note the existence of any buildings on the property in 1923, neither in photographs made of the land and workers, these pictures only included the two-room dwelling built by Selim in the background.

54. Obituary: Selim F. (Fredrick) Ruohomaa, Portland Press Herald, April 1963. The opinion stated: "He was partly responsible for his son's success."

55. Manuscript: "In Remembrance of Sisu," a paper by Arthur Jura, of Union, ME, c. 1994. One initial support effort sent care packages to the homeland after the Finnish-Russian Winter War, 1939–40.

56. Error written on Selim's death certificate in 1963; details given by his wife Sofia while still in Louisiana, becomes telling, as "Dodge's Mountain" was recorded as "Dutchess Mountain."

57. Letters to Sofia found were in the Finnish language.

58. Records of Ruohomaa investments: law offices of Crandall, Hanscom & Collins, PA, Rockland, ME.

59. The guestbook held dated messages written by family in Seinajoki, Tyvoskala, and Rauma, Finland.

60. Kosti signed on Christmas, December 25, 1946, and upon return from Europe in 1948. His acquaintances and professionals' dated remarks are included later in the text.

61. Letter to Lew Dietz from a sister-in-law of Mrs. Marie Hakola, East Chatham, NY. "The couple at whose farm we boarded at $8.00 a week, had about eight guests, and the food was sublime," July 17, 1973.

62. Beginning with Fitchburg, MA days, friends of Finnish roots came to visit. Letter from Alan Bird, neighbor and family lawyer, to the Ruohomaas at Lake Worth, Florida, 1953.

63. Frederick Payne, governor of Maine. As an assignment, Kosti photographed the Paynes at the Capitol when they adopted a Chinook puppy.

64. The Vieraskirja guestbook was found in 1996. Upon the passing of Neelo Lofman that year, a trunk was located in the pantry to the kitchen of his Rockville farmhouse. It had been packed by Kosti's mother not only with personal family items but also with Kosti's photographic prints, negatives, slides, albums, and files. The trunk was brought to the Lofman home in 1966 and never opened since. The contents, including the guestbook, essentially provided factual information of Kosti's adult life and career, making this biography possible.

65. Circa 1950, when Kosti photographed the governor, his wife, and their new puppy, a Chinook, on the Blaine House grounds, Augusta. Lofman Collection, Maine State Museum.

66. Letter to Lew Dietz from Marie Hakola (sister-in-law), March 17, 1973. Lew Dietz, "The Maine Finn," *Down East* magazine, January 1973.

67. Interviews: Ernest Blackington, former classmate and neighbor, Portland, ME, 1993, 1994.

68. Interview: Neelo Lofman, 1994.

69. *The Cauldron*, yearbook of Rockland High School, Class of 1931. Not attending college remained a painful absence to Ruohomaa throughout his life. He documented this loss while on assignment in a 1944 self-portrait taken on the campus of Bowdoin College (most likely where he would've chosen to attend), posed with a pained expression. Black Star president Howard Chapnick recalled this in his memoir of Kosti. Kosti's library indicates he enjoyed American, English, and Irish literature and poetry, throughout his life.

70. Assembly recalled at Rockland Historical Society, 2010. Letter, Helen de Rochmont Cole, Millbrook, NY, November 1, 1993, a former Rockland High School student. "That was the only time I remember that a student furnished the entertainment for an assembly." Mrs. de Rochmont Cole noted when she saw Kosti last in 1961, at age forty-seven, "He was lying on a couch in the glassed-in porch and apologized for not being able to get up." Interview: Assembly recalled by a historian at Rockland Historical Society 2010. "It was the only time in Rockland High School that a one-person assembly was given by a student."

71. Charles Bartholomew, *Chalk Talk and Crayon Presentation* (Chicago: F. J. Drake, 1922). Signed "Kosti S. Ruohomaa." Book purchased by this author at ABCD Books, Camden, ME. No doubt this was his idea source or reference for the easel talk.

72. Courtesy of the Rockland, Maine, Historical Society, administrative member.

73. Bartholomew, *Chalk Talk and Crayon Presentation*.

74. Interview with cousin Leah Lofman, Union, ME, July 1994. Kosti's English teacher Evelyn Butler Phillips left Rockland High School to teach at the University of Iowa after 1931.

75. Letter: Recollections of Dr. Donald Hawkins and his wife Sylvia, December 24, 1994. This was verified by Kosti's doctor as late as 1961. Selim

expressed this opinion again to his wheelchair-bound son at a dinner to which the doctor and his wife were invited.

76. Interview: Blackington, 1994. Farnsworth Art Museum holds one study sheet from the Landis Company, the Illinois Cartoon Subscription School. Personal sketches reveal his fine-lined style.

77. Interview: Blackington, 1994.

78. Sofia Ruohomaa retained a personal savings account through the Workers Union, Massachusetts.

79. See Farnsworth Art Museum Collection and Joan Blanchard Collection, Carrabassett Valley, Maine.

80. Portrait of an unidentified standing nude against a deep blue field. Collection of George Holman, given to his mother by Kosti Ruohomaa.

81. Courier-Gazette, Rockland, 1938 photo. Kosti Ruohomaa wears fedora hat in brief announcement. Lofman Collection, Maine State Museum.

82. Forbes Lithograph Manufacturing Company, Chelsea, MA, 1884–1960. Jay Y. Last, The Color Explosion: Nineteenth-Century American Lithography (Santa Ana, CA: Hillcrest Press, 2005), p. 78.

83. Kosti Ruohomaa scrapbook, 1936–37.

84. Interview: Norman Tate, Port Clyde, ME, 1993, 1995. Disney sent artist-seeking ads to major newspapers throughout the country and Canada.

85. George Amberg, The New York Times Film Reviews: A One-Volume Selection 1913–1970 (New York: Quadrangle Books, 1971); Richard Schickel, "Walt Disney: Myth and Reality," American Heritage, April 1968, p. 94.

86. Phil Latimer Dike (1906–1990). Having a fine arts background, Dike worked with Walt Disney Studios for ten years (1935–45).

87. Interviews: Norman Tate, Port Clyde, ME, August 18, 1993, May 16, 1995.

88. Address found on Ruohomaa 1937 artwork. Collection of Farnsworth Art Museum, Rockland, ME.

89. Menu cover of "The Essex House: Casino in the Park, 11 Central Park West," collection of the Farnsworth Art Museum, Rockland, ME.

90. Original "Portfolio in Hand" Ruohomaa artwork, collection of Joanne Blanchard, Carrabassett Valley, ME.

91. Original cartoon held by Farnsworth Art Museum.

92. He probably made the purchase while in New York.

93. Dr. Walther Heering, The Rollei Book: A Manual of Rolleiflex and Rolleicord Photography (Harzburg, Germany: 1939); Rolleicord II Type 2, 1937–1938,

Schneider-Kreuznach Xenar f3.5 lens.

94. Rockland, Maine, *Courier-Gazette*, February 19, 1938.

95. Interview: Myron "Mike" Nevelson, sculptor, close friend since high school, North Fairfield, CT, November 19, 1993.

96. Photographs in Sofia Ruohomaa's album, beginning in the 1920s. Lofman Collection, Maine State Museum.

97. Interview: Former Boston School of Practical Art students Edwin Witham, Samoset Point, Rockland, ME, May 14, 1994, and Lynwood Alyard, Owls Head, ME, May 16, 1994; Ruohomaa scrapbook, 1937–41.

98. Letter to Lew Dietz, Rockport, ME, from Mrs. Waldo Adams, December 26, 1978. Her parents were former neighbors of the Ruohomaas. She discusses Kosti's father, his behavior and philosophy as an immigrant used to hard labor in the peat fields, and this event. "I have felt that such a relationship may have been a vital factor in Kosti's downfall."

Self-portrait with tripod, Mojave Desert, California, 1938. (Lofman Collection, Maine State Museum)

II. DRAWING BOARD TO LENS

The California Years (1938–1943)

osti Ruohomaa's negatives from February 1938 to March 1943 lead one to conclude that far from a "stint," those five years were to influence and finalize his decision to become a freelance photographer. His scrapbooks' contact prints and clippings captioned with penciled notes reveal biographical tidbits, along with how his experience with effects animation and the ubiquitous creativity of the Hollywood moviemaking environment contributed to his art and sensitized his future perception. His personal growth as a cameraman took root and began to blossom during these California years, with serious self-instruction, experimentation, participation in the Disney Employees Camera Club, winning national amateur photography contests, study with West Coast editorial photographer Will Connell (1898–1961), and other inspirations, considered here.

WALT DISNEY STUDIOS, MICKEY MOUSE, AND SILLY SYMPHONY SOUND CARTOONS

During his trip cross-country by train, Kosti Ruohomaa passed through seemingly endless Midwestern flatlands, the Rocky

Mountains, the Mojave Desert, and the St. Gabriel hills bounding the grand, low-lying expanse of the city of Los Angeles and its surrounding rural towns. Negatives of deserted train depots and variegated landscape suggest that Ruohomaa, new Rolleicord in hand, photographed from the outside deck of the last railroad car. "March 1938" was penciled in his scrapbook as the date he arrived in Hollywood at the three-story, white stucco, ivy-covered building located at 2719 Hyperion Avenue. Landscaped with towering palm trees, the building's tile roof was topped with a sign supporting a neon figure of Mickey Mouse and these words: "Walt Disney Studios, Mickey Mouse and Silly Symphony Sound Cartoons."

It was sunny—shirtsleeve weather. Back home in Maine the ground was still covered with snow, the lakes frozen. Three new

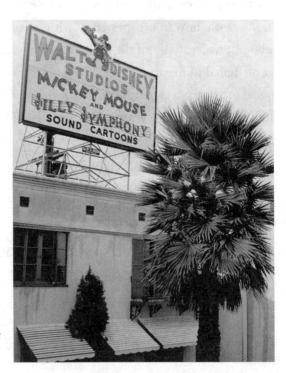

Rooftop sign on the Hyperion Avenue Studio, with neon Mickey Mouse figure, 1938. (Lofman Collection, Maine State Museum)

New colleagues: Don Tobin, Jerry Brown, and Noel Tucker, Hyperion Avenue Studio, 1938. (Lofman Collection, Maine State Museum)

acquaintances posed for Ruohomaa's camera from the studio's open window: Don (Donovan) Tobin, effects animator whom he would assist for the next five years; Jerry Brown, a peer artist who shared an interest in picture-taking; and Noel Tucker, veteran Disney animator. Ruohomaa's new colleagues beamed and waved for his lens, signaling a true California-style welcome.

One of fourteen recent recruits in a new training class selected from applicants throughout the United States, Canada, and South America, Ruohomaa penciled in his scrapbook: "We called ourselves the 'sleezies,'" a phrase suggesting the tongue-in-cheek tone of the group.

He first shared an apartment at 1910 Franklin Circle, Hollywood, with a young married couple and two other bachelors, Wilbur Streech from New York and John Fraser McLeish from Canada. It was just a brief walk to Disney Productions on the Hyperion campus. "We had many a weekend spaghetti dinner party to forget the misfortunes of the studio," Ruohomaa noted under a photograph of the apprentice group's antics during a casual dinner at their kitchen table.

The first ten weeks comprised intensive training. The Disney Art School called "the Annex," also located on Hyperion Avenue, was unparalleled in the Hollywood studio milieu, with its separate building for art instruction originally under the direction of Don Graham, hired by Disney from the Los Angeles Chouinard Art Institute.[1] Morning schedules for the new artists included principles of art, art history, life drawing, design, composition, and lectures. "Hands-on" animation work filled the afternoons, with each new artist apprenticed to an experienced animator. Talented, and from varied geographic roots, Ruohomaa's studio snapshots indicate the new creative group of trainees discovered that they shared common ideas which they brought to fruition with pencil and pen at the drawing board.

Ruohomaa noted in his scrapbook that he was assigned to the Effects Department under the direction of Joshua Meador.[2] He assisted Don Tobin in this department throughout the next five years at Disney. As a result, he participated in the making of Pinocchio; the all-consuming, three-years-in-production, full-length, experimental cartoon, Fantasia; and most likely, other shorts and cartoons animated by Tobin.[3] As an effects artist's assistant, his drawing board and studio experiences centered on completing the created atmospheric surroundings of an animation sequence. These

tedious visual "in-between" studies required slight alteration to each frame. The drawing elements were modified to suggest believable natural change of positions, movements, or events within a surrounding atmosphere. Assistants did not receive film credits.[4]

Effects artists prepared mood-filled animated settings for the characters' story-bound actions. Rendering the elements with graphite pencil, colored pencil, watercolor, and gouache, effects animators were concerned with visualizing features such as the downpour of raindrops, billowing smoke, a bubble's iridescence, snowflake patterns, the acrobatic turning of a leaf falling to the ground, and the hollows, hills, and surging foam of waves breaking in a turbulent sea. As Disney himself later recalled of the effects animators: "A ray of sunshine as it gradually touches a cloud and making a bolt of lightning flash, were all in a day's work for these inventive artists."[5]

The magic of a star-filled evening sky, dawn's first rays, a veil of fog, figurative deep, long shadows of late afternoon, a mirroring pool of water, a last light receding into the night—all of these elements would be interpreted during long hours at the drawing board devoted to the experimental chapter sequences of *Fantasia*. Demanding intense concentration, artists imaginatively and convincingly configured with drawing tools the natural surroundings of the story-bound subject.[6]

Disney's senior animator Arthur (Art) Babbitt emphasized as he lectured to the newcomers, "Study how a tree moves in the breeze, observe carefully the tempo of an old woman's walk; keep your mind open and receptive—no matter what you see, an animator must have fine taste and sensitivity." Babbitt urged the animators to continue sketching from life and to study another perceptive art: music. "Music has the power to create mood, to touch

the feelings and mind of the listener; similarly animation, like act-
ing, moves the audience to participate in the imaginary."[7]

In their off hours the artists poked fun and posed in melodra-
matic vignettes for Ruohomaa's lens. These captured moments
reflect the theatrical personalities of his talented peers. Saved in a
scrapbook, black-and-white contact prints reveal a ubiquitous tem-
perament of creativity, an environment of gifted artists, where it
was natural to express, entertain, dramatize, and perform.
Ruohomaa fit comfortably into this group endowed with diverse
cultural backgrounds and exceptional artistic abilities.

Not only did the Rolleicord pictures convey his peers' varied
appreciations, his camera's views also offered rare glimpses behind
the scenes at Disney Studios, such as artists at their drawing tables,
sometimes seen in focused discussions.

*Andy Engeman, Disney effects
animation assistant, wraps him-
self in film, 1938. (Lofman
Collection, Maine State Museum)*

Housemate John Fraser McLeish, Canadian theatrical personality and Disney story researcher, was an artist "with a manner of John Barrymore," who narrated Disney cartoons.[8] (Lofman Collection, Maine State Museum)

Ruohomaa kept a personal memoir through his photographs, including such tidbits as the daily "Coca-Cola" breaks, and a view of his desk strewn with cigarette butts, pencils, a crumbled memo, and a Coke bottle. Saved in his scrapbook were views taken in the infamous "sweatbox," the stuffy projection room in the Hyperion Studio where "the powers that were" critically reviewed the animators' filmstrips, as Ruohomaa explained. He documented scenes of himself and others as their animators' filmstrips were reviewed by the hand and eye of Joshua Meador in the small, cramped auditorium. Although smoking was allowed elsewhere in the studio,

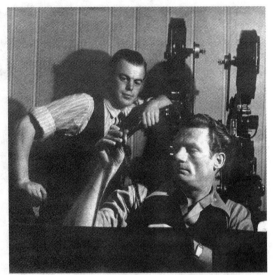

"Sweatbox" projection room:
Ruohomaa, movie projector oper-
ator of his personal strip, awaits
Meador's critique, 1938.
(Lofman Collection, Maine State
Museum)

because of nitrate-based movie film, animators were forbidden to smoke in the sweatbox.

Weekend ventures became opportunities to seek character types of people and observe their behavior. Disney himself encouraged the use of the camera for visual study. Negatives reveal that Ruohomaa explored local neighborhoods and streets, the nearby Griffith Park and its zoo, railroad stations, bridges and the waterfront, photographing people of all ages and temperaments at work or leisure. His camera documented performers as well as spectators at the circus, parades, rodeos, horse races, field competitions, and shows at the Hollywood Bowl. He walked the pier to observe family picnics and sunbathers at Venice Beach, and discovered the Los Angeles "Plaza," where locals sang, danced, preached, and found audiences for their impromptu orations. One emotional African-American speaker "who drew a good audience" appealed to Ruohomaa's lens.

Apart from camera work and maintaining sketchbooks,

"Vociferous talker, Git the spirit, O the Lord in Yo soul, Ye hea-thens." (Lofman Collection, Maine State Museum)

Disney artists also enriched their scope of vision through the study of popular newspapers and pictorials. Ruohomaa's negatives captured piles of magazines, including copies of *Fortune, National Geographic, Time,* the *Saturday Evening Post,* and *Stage* on the floor of the shared, sparsely furnished living room, and in the hands of animators during their off hours.

Ruohomaa taught himself the ways of photography found in the pages of *Scientific American* magazine.[9] Jacob Deschin's monthly ten-page illustrated column, "Camera Angles," provided the latest approaches to improve one's picture making. Pages were devoted to showing photographs that represented the growing national community of camera-bearing amateurs. Deschin's columns detailed technical advances, classifieds, exhibitions of salon photography,

and national amateur photography contests, including a *Scientific American* annual competition.[10] Through the study of Deschin's columns and the composition and lighting of the reproduced photographs, Ruohomaa gathered visual and technical ideas, a few of which he would revisit in the future. Deschin and Ruohomaa would later connect and become respected colleagues in photojournalism when each moved on to new professional roles.[11]

Ruohomaa surely noted a winter night scene made by photographer George W. French, taken in Maine. The scene captured a snow-covered street at night in a small town similar to Rockland, reproduced in *U.S. Camera* magazine.[12] He must have noted the early portfolios of emerging camera masters such as Ansel Adams and editorial photographer Will Connell in the rich, ink-saturated printing of *Fortune* magazine's gravure pages.[13]

As early as 1939, a year after he had arrived in California, Ruohomaa received a spark of encouragement. His photograph, the idea inspired by a "*New Yorker* magazine cartoon satire of club women," won first prize in a national amateur photography contest sponsored by *Minicam Photography*. The photography monthly, directed to both amateurs and professionals, focused on work produced by the miniature camera, i.e., 35mm (or 2.25-inch film).

Titled *Oomph*, Ruohomaa made numbers of exposures and consumed rolls of film to satisfactorily compose and light this imaginative creation. His concerns were the materials, lighting the form, and finally, determining the right camera angle to properly set a mood. In other words, he worked many hours to get the final photographic image. The close, up-front view, figurative, yet edged with abstraction, was composed to entertain, but demonstrated the photographer's interest to control the formal elements from the studio-based exposure to the finished print. Reviewed by a *Life*

Oomph, 1939. (*Lofman Collection, Maine State Museum*)

editorial associate, the judge complained of the "image's crop-
ping," but remarked positively on what he viewed as "the highly
intelligent lighting of a surreal comedy."[14]

Another important experience that impacted Ruohomaa's
development involved the formation of the Disney Employees
Camera Club in April 1939. Out of a thousand artists, eighty-five
originally responded. The goal was for camera buffs on the ani-
mators' staff to have a central forum in which to discuss and
exchange ideas, develop and print their photos, and to learn
more about composition and lighting techniques. The Club held
exhibits and participated in inter-studio competitions offering
informal awards of recognition in fields such as human interest,

The Water Tower, Burbank, 1939. (James Moore Collection, Farnsworth Art Museum)

portraiture, landscape, and a group-developed "Disney Club Popular Award."[15]

Ruohomaa's photographic prints remaining from the Camera Club reveal his careful composition, his command of the processes, and

his ability to oversee the quality of the final black-and-white print.[16] However, it was through his photographic ideas that Ruohomaa began to receive recognition for his originality.[17]

Todd Walker, a former Hollywood photographer and artist-printmaker, recalled in a 1970s interview: "I was in a couple of inter-studio salons, one of which displayed the work of a man named Kosti Ruohomaa, who later on became a very well-known photographer in the East. He was at Disney working as one of the animators, and his work was really quite different from the others, most of whom did just stock portraits. His work really fascinated me."[18] Though we do not know the specific pictures Walker recalled, images of this period, a few of which found publication or received awards by the Disney Club, included close study portraits of farm animals, and animals he found in the zoo that he could successfully beckon to his lens. Other images—*The Water Tower*, *The Pool*, *At Rest*, and the already-noted *Oomph*—all represent poetic or symbolic literary titles one associates with photographs of the pictorial movement. His named works suggest an awareness of this contemporary pictorial approach that reemerged in the Hollywood studio milieu.[19]

The last vestiges of the "California Pictorialism" era, rooted in the turn of the twentieth century, appeared in a renewed form as the Hollywood Studio amateur photographers clubs' exhibitions of the late 1930s.[20] The Disney Club photographers were "independent individualists" who preferred to venture out on their own rather than participate in group photography sessions, noted an editorial feature in *U.S. Camera* in October 1940. This issue featured Ruohomaa's portrait of *Crooning Pigs, Mo and Jo*, selected by peer Disney photographers as a winner of the Disney Club's Popular Award. The article's editor noted that the Disney Club cameramen

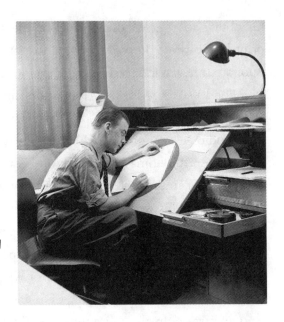

Kosti Ruohomaa at drawing
table, Walt Disney Studios,
1939. (Lofman Collection,
Maine State Museum)

won the majority of the competitive prizes, including the "Gold
Cup," awarded annually for the most outstanding photography in
Hollywood studio competitions.[21]

About two years after he arrived at the Disney Studios,
Ruohomaa's portrait appeared in the hometown newspaper. He
appears seated at his drawing table, working. The article was titled:
"Helps Make Walt Disney Pictures."

The article included excerpts taken from a rare letter
Ruohomaa had written home, apparently to be published in the
local newspaper. His tone revealed maturity and self-confidence as
he carefully explained the particular challenges of the effects
artists' drawing-board creative process.[22] "It is our job to animate
oceans, smoke, give animation to scenic effects, and, in fact, any-
thing that isn't a character."

Ruohomaa had just completed work on the feature cartoon,
Pinocchio. He explained: "The tremendous smashing of waves against

rocks, rolling waves, terrific splashes . . . these are probably the most grandiose animations attempted to date. Whether or not they impress the public, I don't know, but they involved such detailed drawing and intricate work that it was very expensive." He mentioned the still-unnamed cartoon in progress, featuring classical music, and that he was working on the Stravinsky strip sequence, "Rite of Spring." "This is very dynamic strong music, and lends itself to the pictorial interpretations which it is desired to present."

He described the recent move to Burbank. "It is difficult to get used to the place. It is modern in every respect, with a bit of Hollywood showmanship added. All the buildings are not completed, but we are to have a theatre, restaurant, and all that sort of thing."

The article noted Ruohomaa's hobby, photography. Camera in hand, he searched to find subjects in parks, fairs, and places "where people are at their worst, funniest, most dramatic, and so on." The article mentioned "his recent award as having best print of the year in the Disney Camera Club."[23]

The Disney Studios actually moved in August 1939, to new, expansive premises located in Burbank. Ruohomaa composed a photographic self-portrait at his new spacious workstation. Dressed in jacket and tie, he is seated in a contemporary Scandinavian-style chair with a modern telephone centered in the background; a model sculpture of the Pinocchio character, Jiminy Cricket, is seen on an upper shelf above his drawing table.

Meeting West Coast editorial photographer Will Connell (1898–1961) would be the most important factor in encouraging Ruohomaa to change professions and become a freelance photographer. Years later, Ruohomaa recalled how he had embraced the remarkable photographer's strong teachings, noting that Connell had made a deep, long-lasting impression on him.[25]

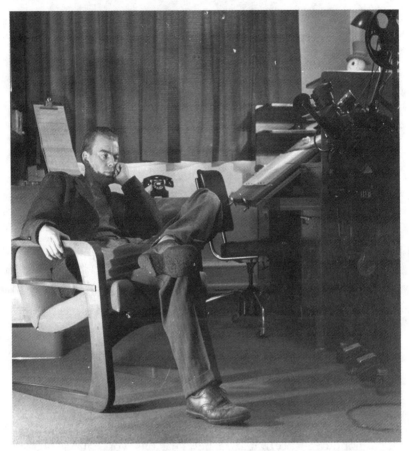

Self-portrait at new Burbank studio. Ruohomaa wrote in his scrapbook: "Pondering how to pay the rent and make car payments."[24] (Lofman Collection, Maine State Museum)

He first met Will Connell, fifteen years his senior, sometime in 1939. Perhaps Connell was invited to appear as a guest speaker by the Disney Employees Camera Club. Connell was no stranger to Disney Studios; his location photographs of Disney surrounded by top animators had appeared in a 1936 Fortune magazine feature concerning the business of animation.[26]

Connell founded the Department of Photography at the Art Center School, originally in Los Angeles, today, the Art Center School of Design in Pasadena, where he taught editorial photography and photojournalism. The Art Center established the first complete program of professional undergraduate training in photography in 1931, and it was here that Ruohomaa "studied for a while with Will Connell."[27] Also, Connell held weekly rap sessions at his home to discuss the "stuff" of photography for serious students, making it clear that only committed photographers interested him and need attend.[28]

Consulting editor for *U.S. Camera*, Connell created what became a popular instructive question-and-answer column, "Counsel with Connell." Under the guise of the credit "Roye," Ruohomaa's photograph *The Pool* appeared as a full-page print in the October 1940 issue of the photography magazine.[29] He focused on the wet, chilled skin of an unidentified nude model, nymph-like and asexual as she stepped from a swimming pool. Silhouetted against a dark background (perhaps using an orange or red filter?), it is one of Ruohomaa's early sensitive mood pictures.

To have one's photograph appear in *U.S. Camera* marked a clear professional connection. It was probably Connell who directed Ruohomaa to the New York–based PIX Inc. agency, with which he associated and first found nationwide distribution for his photographs, while still in California.[30]

Connell's personal images sometimes held a surreal or melodramatic edge.[31] It was an influence that attracted Ruohomaa, who explored this approach now and years later. He made an unusually extreme close-up portrait of his former art school roommate, Kirk Bailey, who drove west in his MG sports coupe from Connecticut to visit in 1939. The picture, *Kirk Shaving*, presented an almost tactile

The Pool (original deteriorated in storage) appeared as a full page, bled to the edges, signed "Roye," from a tear-sheet reproduction of U.S. Camera, 1940. (James Moore Collection, Farnsworth Art Museum)

close-up of Bailey's shaving cream–covered face, the angle taken from below as Bailey lifts his nose and tilts his chin for the razor. The photograph won second prize in a national *Mechanix Illustrated* amateur photography contest.[32]

It was Connell, himself a professional industrial advertising photographer, who brought students and models to photographic

Kirk Shaving, *Los Angeles,*
1939. (*Lofman Collection,*
Maine State Museum)

locations such as the high cliffs of the Pacific Coast beaches, the work-
ing waterfront, and the railroad station. He probably made it possible
for them to photograph on the movie production set of Lewis
Milestone's *Of Mice and Men,* filmed at the William Randolph Hearst
ranch on the Mojave Desert.[33] Here Ruohomaa not only pho-
tographed the actors on stage as stills, but also behind the scenes,
where, for example, he captured close moments of private consulta-
tion between director Charles Bickford and actress Betty Field.

Negatives Ruohomaa kept of the film's "lighting man," as he
titled the envelope of negatives, indicate that he observed the com-
plicated function of light to control balance within a scene's com-
position, to sculpt a form, or to lend a certain atmosphere to a sub-
ject or setting. Mastery of these technical tools was an important
factor in Ruohomaa's later mood images. One of the film's innova-
tive approaches was the "extreme long shot," a novel viewpoint at
the time, and one which Ruohomaa revisited years later as he

Actress Betty Field on the set of
Of Mice and Men, *Randolph
Hearst Ranch, Mojave Desert,
1939. (Lofman Collection,
Maine State Museum)*

directed and photographed children playing in a barn.[34]

After two years Ruohomaa found his photographic ideas were starting to be appreciated, and lucrative, contributing a modest, supplementary income to his California livelihood. He embellished this work with studio and location portraits of aspiring actors and actresses for use in their professional portfolios, as well as of notables such as cowboy actor Tom Mix and African-American composer William Grant Still. Neighbors and acquaintances, many unnamed or only attributed with their first names on envelopes, appeared to be at ease and cooperative, suggesting that his talent had earned him a certain measure of respect among his colleagues. His subjects' poses and the barely discernible lighting sources confirm his advances in studio work, lighting technology, and ability to use light, shade, and shadow as part of the pictorial content.[35]

Ruohomaa ventured out at night to capture the city lights, the

Portrait of William Grant Still,
classical composer, Los Angeles,
1939. (Lofman Collection,
Maine State Museum)

grand expanse of Los Angeles viewed from the St. Gabrielle hills, neighborhoods featuring neon signs, and nightclubs staging jitterbug contests.[36] On one occasion, apparently only this one, street violence motivated his instantaneous photograph of a blood-spattered gang-beaten victim, the moment he fell to the curb's edge, an audacious reportage he personally printed. He would never again revisit the subject of violence in his work.[37]

In the spring of 1940, Ruohomaa noted next to newspaper tear sheets pasted in an album, "my first published pictures." Photographed at the Griffith Park Zoo, the picture of a visitor's responses to an elephant appeared in the gravure pictorial section of the *Los Angeles Times*. This freelance work was noted by the editor as that of an "an enterprising photographer."[38] It was a beginning. Ruohomaa found that his published freelance photographs earned not only objective recognition, but gradually became a source of

Harry Hamsel (1899–1966), "with whom I shared a house on Panorama Terrace," plays the fiddle, 1940. (Lofman Collection, Maine State Museum)

ongoing pocket money.[39] Newspaper pages he kept that included his photographs indicated the going price paid for each published picture averaged $5.00. Financial independence would always be a prerequisite for Ruohomaa when it came to making a decision to change professions, but he had not yet reached this level of audacious entrepreneurship.

Ruohomaa moved in August of 1940 to 2224 Panorama Terrace, where he shared a house with Disney colleague Harry Hamsel, a talented fiddler and an animator credited in "The Pastoral Symphony" sequence of *Fantasia*.[40]

That same month he undertook a project that would eventually have a marked impact on his future. To thoroughly study a subject was one of Connell's solid philosophic teachings, adopted by Ruohomaa. He traveled east to the annual Native American Ceremonial powwow located at Gallup, New Mexico.[41] For three days he followed the formal events—the ceremonies, parades, and dancing—and also visited leisure moments in between performances. The pictures, a combined group of carefully composed and

casual shots, indicate that he established a congenial relationship with the Natives. The location portraits made of Native men, women, and children reflect human temperaments, their individual personalities, from the serious and stern, the shy and timid, to bubbling laughter, all viewed behind the scenes in settings apart from the ceremonies.

Ruohomaa titled this body of work "First Citizens." Perhaps as an introduction, and to gain their trust, he explained to the Natives, who historically had derived their personal names from nature and wildlife, that his unusual-sounding Finnish name, "Ruohomaa," translates into the English word "grasslands."[42]

Ruohomaa sent prints to the PIX Inc. agency, whose editors distributed views that appeared in the September 1, 1940, rotogravure section of the New York Times, followed by three in November of that year in the Los Angeles Times. In 1941, nine of his Native portraits appeared in the Chicago Sunday Times, all distributed by the agency.[43] No doubt his thoughts of career change were in the making.

The year 1941 forecast dramatic changes in the Disney Studios, to affect all the animators and artists immediately. Disturbing incidents, such as the May 17 "anonymous" memo circulated to 1,200 employees, to inform them that only 900 qualified artists would be eligible for job security, evidenced a new lack of transparency.[44] Employees soon expressed dissatisfaction related to unfair wages, unreasonable hours, lack of animators' and artists' credits, their employer Walt Disney's opposition to an artists' union, and other issues in conflict with Disney and his intimate, somewhat secretive, administrative circle of associates.[45]

On May 28, the bulk of Disney employees walked out to initiate what would become a bitter strike, lasting over ten weeks, well into August.

Disney Studios employee walk-out led by Art Babbitt, May 28, 1941. (Lofman Collection, Maine State Museum)

A striker, Ruohomaa assembled a separate scrapbook with ephemera and pictures drawn from his ongoing reportage. Day and night, he documented the strike events. The strong emotional ups and downs expressed during the unpleasant and acrid turns within the Disney Studios and its relationship to its talented employees were evidenced within the scenes Ruohomaa captured.

Most employees left following Disney's firing of twenty-two of his top artists, including the highly regarded Art Babbitt, designer and master animator of *Fantasia*'s "dancing mushrooms sequence," who was, at the time, chairman of the Screen Cartoonists Guild. "Leaflets appeared all over Hollywood demeaning Babbitt and others as Communists."[46] This unprecedented move represented Disney's personal rebuke to his unfaithful employees.

Over the duration of the walkout, Ruohomaa's photographs documented the striking artists as they marched with hand-

"4 Years of College, 2 Years of
Art School, 5 Years at Disney =
1 Hamburger Stand." Woman on
horseback readies parade of
strikers, 1941. (Lofman
Collection, Maine State
Museum)

painted signs bearing creatively designed but brash and emotional
messages, such as "Genius Against 1,200 Guinea Pigs"; "Disney
Unfair to Artists AFL Local 852"; "Disney Studio on Strike"; "4
Years of College, 2 Years of Art School, 5 Years at Disney = 1
Hamburger Stand"; and "Michelangelo, Raphael, Leonardo da
Vinci, Titian, Rubens, Rembrandt—all belonged to Guilds."

One night he captured the unique flare of the strikers dressed
in evening tuxedos and gowns picketing theaters opening The
Reluctant Dragon. The new film opened June 20, and was unique in
that it combined both real people and animated figures. The film
portrayed the Disney Studios in the current unlikely role of a
"happy family of artists."[47] One night, the employees picketed the
Carthay Circle Theater, whose marquee was emblazoned with the

Fantasia marquee, Carthay Circle Theatre, Hollywood, 1941. (Lofman Collection, Maine State Museum)

title of Disney's latest release: "Walt Disney's *Fantasia*, with Stokowski and the Philadelphia Orchestra in Technicolor."

From the onset of the strike, Ruohomaa moved with his camera, following speech-makers' at their meetings, artists sketching and painting for bystanders, and behind-the-scenes events, both day and night. The strikers set up headquarters, a food kitchen, and a child-care center on a nearby knoll, which acquired the name "Camp Cartoonist."[48] These insightful pictures revealed the strik-

*March of guillotine bearers,
Burbank, 1941. (Lofman
Collection, Maine State
Museum)*

ers' changing moods as the days stretched into weeks. Ruohomaa's photographs of strike events appeared in the June issue of *Screen Actor Magazine* and in the Labor section of the July 22nd issue of the magazine, PM.[49]

Disney artists were experiencing a bitter time of uncertainty. By the strike's final days, the Disney endgame had resulted in multiple departures.[50] Employees left Disney to seek animation, art, and film careers in other Hollywood studios, and moved on to new locations.

Ruohomaa, however, stayed on at Disney.[51] In future months,[52] after studio hours, he became preoccupied with personal photography projects. One such endeavor—a study of hobo settlements—eventually tapped into a new opportunity. At first,

Homeless man on property of Mrs. John H Child, Santa Barbara, California, 1942. (Lofman Collection, Maine State Museum)

negatives show that he sought out the homeless entrenched under bridges and living in the streets in and around Los Angeles. But it was in Santa Barbara that Ruohomaa located the estate of a wealthy landowner, Mrs. John Howard Child, whose property provided a sanctuary for homeless men. Within the walls of Child's land, the homeless carried on a communal way of life sheltered in fabricated cardboard shacks.[53]

It was through this extensive group of location portraits that Ruohomaa moved from storytelling to journalistic commentary, evidenced not only in his personal photographic coverage, but also in his personal handwritten captions. He titled this portfolio "Hobo Haven," but would have to wait to see its publication.

Then, sometime in late November of 1941, Ruohomaa traveled to New York. He stayed with Wilbur Streech, one of the members of the original gang with whom he had shared a house in 1938, and who would become a lifelong friend. Streech had

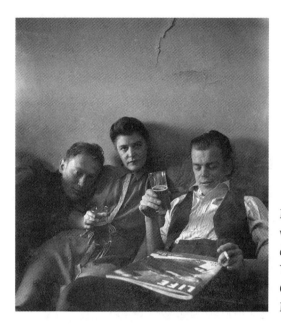

Kosti Ruohomaa views Life *with Art Gates and wife five days before Pearl Harbor, New York, 1941. (Lofman Collection. Maine State Museum)*

appeared often in his scrapbook scenes. After the strike, Streech had moved on to produce films in New York City.[54] Most likely it was Streech who introduced Kosti Ruohomaa to police-story comic-strip artist, Art Gates, married at the time to a former Disney employee.[55] A picture taken in Gates's apartment shows Ruohomaa with his friends, paging through an issue of Life magazine, dated December 2, 1941, five days before the Pearl Harbor attack.[56]

Possibly, Ruohomaa had learned of the Black Star Publishing Company through Will Connell. He brought along a portfolio (actually, a simple paper folder) holding a small representative number of prints to the New York City agency. He included examples of both the Native American portraits and the Santa Barbara homeless settlement pictures to show Kurt Kornfeld, president of the company. In those days, hopeful photographers could simply knock on doors, even though they were most likely prepared to

Self-portrait on Black Star stationery, pencil, by Kosti Ruohomaa, 1942. (Lofman Collection, Maine State Museum)

wait. Ruohomaa must have waited, as during this period he made a number of sketches in his fine-lined pencil style on Black Star stationery, including a few self-portraits, visualizing himself as a photographer.

Ruohomaa left samples of the New Mexico Native photographs and studies made at the Santa Barbara hobo settlement with

Kornfeld. Favorably received, it apparently was agreed that Black Star might seek publishing venues for these photographs; however, no official association was made this year, in 1941, as Ruohomaa remained under the Disney Studios contract, and his photographs were still represented by PIX Inc. This new opportunity required immediate decisions concerning both, either while still in New York or upon his return to California.[57]

Within days of the Black Star meeting, the catastrophic December 7 Japanese attack on Pearl Harbor would change the entire nation. Overnight, the US Navy took over the Walt Disney Studio spaces. Disney immediately was under contract to produce training films that focused on aircraft, warship identification, and numbers of animated cartoon shorts to effectively and rapidly teach new enlistees widely diverse issues ranging from personal hygiene to arms technology.[58]

The Studios became completely focused on the war effort.[59] Ruohomaa probably fit in as one of the artists who "with commercial art background would most likely be assigned to training films where experience with an airbrush was more important than expertise in character animation." The Special Effects camera department held the task of "combining live action and animation photography." The ability to show the metamorphosis of an object into a new image, an inventive illustration skill already regularly employed by the Disney creative artists, was thus applied to film sequences such as "war savings certificates that dissolved into planes, ships, and tanks."[60] Animated films such as these, intended for instruction, were sent to training sites, while others, instilled with a patriotic bent, were distributed to movie theaters throughout the nation. The shorts were shown in advance of the *March of Time* weekly news review film briefs that usually previewed the

main feature.[61] "We've been working on training and technical films for the Navy here, doing very little straight cartoon production," Ruohomaa wrote to friends.[62]

Perhaps still unsure of his future during 1942, Ruohomaa chanced to create and draw his own personal comic-strip cartoons, a few of which did find publication: Koo Papers, Penniless Pauper, and the six-page strip, Case of the Petrified Poet, were published by Star-Spangled Comics in July.[63]

He returned again to New York, this time to meet with Art Gates in the summer of 1942. The two new acquaintances coauthored a limited series of black-and-white cartoon strips titled Boxcars by "Art Gates and Kosti." The idea and title certainly stemmed from Ruohomaa's experiences interviewing the itinerant homeless while photographing them at the Santa Barbara estate. The drawings—not Ruohomaa's style, evidently—were made by Gates. A published strip has not been found.[64]

During the 1942 New York trip, Ruohomaa returned to Dodge Mountain. A self-portrait made as he imbibed a highball on the Rockland-bound train suggests the ambivalent, less-than-self-assured feelings he must have had in expectation of this reunion. He hadn't been home since 1939. He knew his career at Disney would be ending.

However, as revealed in album pictures, whatever unsure feelings he may have harbored about his father, and Selim's hopes for his son's future, possibly to return to the farm, son Kosti was comforted with a warm welcome home after three years' absence.[65]

However brief the stay, it provided Ruohomaa with an opportunity to photograph familiar sites of his youth. He drove around the Midcoast area, photographing the Rockland waterfront and along winding backcountry dirt roads with fields and ancient worn

Boxcars by *Art Gates and Kosti*, 1942. (*James Moore Collection, Farnsworth Art Museum*)

farmhouses. Pictorial in style, he lightly titled the images pasted in his scrapbook "pretty pictures."

He met up with a friend, Mona, an attractive local woman of Finnish descent, and made portraits of her in a field of wildflowers.

During his stay in Rockland, Ruohomaa, probably on impulse, drove to Portland with his cousin John La Cross, both of them intending to enlist in the navy. Ruohomaa was rejected.[66] A few months later, La Cross met up with Ruohomaa, who photographed his uniformed cousin in Hollywood before he was sent overseas to an assignment in the Pacific.[67]

Ruohomaa turned his camera to the blueberry harvest. Inspired perhaps by the moment, the feelings in his heart overwhelmed

Blueberry harvest packaging,
Father building crates, 1942.
(Lofman Collection, Maine
State Museum)

any former familial abrasion. His love of the place, the Dodge
Mountain homestead and farm, lent his vision much more than a
reserved and cool documentation of the annual summer event. His
impassioned lens captured as orchestration the rows of men,
young and old, raking the berries. Their energetic actions appeared
choreographed as they cleaned the hillside fields of the low-bush
blueberry and then returned with filled baskets on their shoulders
to the winnower, the blueberry-cleaning machine. Smiling, his
father, wielding a hammer, secured wooden shipping crates sten-
ciled with the name "Ruohomaa," while his mother led the pack-
aging operation, filling the boxes with clean berries and readying
them for shipment.[69]

The views embraced scenes of fields laced with rakers, their
body language somewhat symphonic, dramatizing the high energy
and mood of the long-awaited harvest. This experience at the

Dodge Mountain farm portrayed a philosophy of honorable respect, but for son Kosti, the physical work and land ownership still didn't match up with his own personal goals.[70]

The return voyage to California aboard the West Coast–bound train, the El Capitan, held an ambiance of its own.[71] Ruohomaa moved through the train's cars, filled with new recruits; he captured a lone individual gazing wistfully out of a window, and then, in contrast, a group of servicemen and -women, drinking, playing cards, smoking, and appearing somewhat jubilant as they headed for their last western destination before being sent overseas.

Upon his return to the Studios, Ruohomaa found new restrictions when it came to accessing the buildings and studio spaces. Identification cards were needed for entry, and a changed tone of employment status was enforced, such as having to check in at the entry desk before passing on to one's workstation. Laminated, numbered identification cards were issued to employees, complete with a fingerprint and a portrait photograph, signed "Walt J. Pfeiffer," and imprinted Walt Disney Productions, Motion Picture Employee.

On January 7, 1943, Ruohomaa wrote a rare letter home from his last California residence at 1929 Whitley Avenue, to friends in Owls Head, Maine.[72] The letter was both insightful and somewhat cynical, communicating the deflated atmosphere at the Studios, and suggesting feelings of isolation.

> I'm leaving Disney the last of this month to go to work for the Army Signal Corps at their studios in Long Island City. Have a couple of other propositions which I'm going to investigate, which may be better than the Signal Corps spot if they don't pan out.
>
> My draft board has ignored me completely, a fact

which is OK with me, but I certainly feel very out of place in this country in civilian clothes, for I think every soldier west of the Mississippi comes to Hollywood over the weekend. They come to breathe in this glittering glamour of Hollywood; what they never seem to realize until they've spent all their money is that Hollywood is probably the most overrated hick town in the world—it actually is. I much prefer the East myself. In Hollywood everybody tries to kid everybody else; the people one meets seldom become real friends. Everybody is palsy-walsy for a month or so, then you never see them again, unless one is in a position to do them some good.

His closing was bleak, reflecting on an unlikely option: a return to the Dodge Mountain homestead. "Can you imagine me being stuck up on the mountain under the present setup, the dog and I and a barrel of cider sitting next to the radio for the duration, and then about five years from now, the news would come over the air that the war was over, so off to town we'd drive and not have a friend left."

At the end of February 1943, five years after his arrival at Hyperion Avenue in 1938, Ruohomaa met personally with Mr. Disney in his office to submit his resignation.

Road to the Mojave Desert, 1938. (Lofman Collection, Maine State Museum)

NOTES

1. See "Donald W. Graham: A Passion for Drawing," www.donaldwgraham.com/biography.html, December 2007.

2. David Johnson, "Inside Animation: The Disney Art School Part One," pp. 1–4, www.animationartist.com/columns/DJohnson/School01.html.

3. "Joshua Lawrence Meador (1911–1965) was "head of the [Effects] Department," letter, David R. Smith, archivist, Walt Disney Archives, November 5, 1993.

4. U.S. Navy Training film production started immediately following December 7, 1941. Tobin left Disney after the 1941 strike (*Lambiek Comiclopedia*, 2007).

5. Letter: Smith, Walt Disney Archives, November 5, 1993. Smith explained that "assistants were never credited." The Walt Disney Archives originated in 1970; according to Mr. Smith, records from the 1930s were "unavailable."

6. Walt Disney, "Animation and the Disney Studio," *The Encyclopedia of Photography*, Volume One, Willard D. Morgan, ed. (New York: Greystone Press, 1965, 1968), p. 152.

7. Later Ruohomaa would become preoccupied with similar effects in photographic images he titled "poetry."

8. Manuscript: Training Course Lecture Series by Arthur (Art) Babbitt (Arthur Harold Babitzsky) (1907–1992). Derived from Art Babbitt's lecture of September 23, 1936. Courtesy of Norman Tate, Port Clyde, Maine.

9. John Culhane, *Walt Disney's Fantasia* (New York: Abradale / Harry Abrams, Inc., 1983), pp. 36, 207.

10. The publication introduced Kosti Ruohomaa to Jacob Deschin (1900–1983). After the war Deschin became an editorial reporter, covering the world of photography in a column for the *New York Times*. "*Maine Winter* by Kosti Ruohomaa. Taken on his father's farm during a snowstorm, [the photograph] is convincing because it is authentic and the approach is straightforward," *U.S. Camera*, 1948; *New York Times*, January 18, 1948, p. X13.

11. Mounted photographs found in the Farnsworth Art Museum collection represent the *Scientific American* annual contest.

12. After the war Ruohomaa's photographs more than once acted as the lead picture to Deschin's photography column in the *New York Times*. Deschin was the recipient of greeting cards from Ruohomaa, and after Kosti's death Deschin memorialized the photographer with a double-page pictorial, "The

Country Photographer," in the *New York Times Sunday Magazine,* January 1962.

13. Paul J. Woolf, "Night Photography," *U.S. Camera,* circa 1939, pp. 55–76. George French (1882–1970), more than thirty years Ruohomaa's senior. No evidence was found of the two photographers meeting personally, though by the late 1950s, both had work appearing in *Down East* magazine, produced in Camden, Maine.

14. *Fortune.* See issues of the late 1930s.

15. Alexander King, editorial associate, *Life* "Contest Winners," *Minicam Photography,* c. 1939. See tear sheet in Ruohomaa album. The first prize, $100, represented almost four weeks' salary.

16. Disney Club Popular Award, noted *U.S. Camera,* October 1940.

17. See Farnsworth Art Museum, Kosti Ruohomaa Collection, for examples of California work.

18. *Crooning Pigs, Mo and Jo,* Disney Club Popular Award, *U.S. Camera,* October 1940.

19. Thomas F. Morrissey, "An Interview with Todd Walker," c. 1978. Todd Walker website, July 26, 2000, p. 3; Drew Heath Johnson, ed., *Capturing Light: Masterpieces of California Photography, 1850 to the Present* (Oakland, CA: Oakland Museum of California, London and New York: W. W. Norton, 2001). See biography of Todd Walker (1917–1998), p. 355. Walker was with RKO Scenic Department, 1934–42, Tradefilms Inc., 1941–43.

20. Stacy McCarroll, Introduction by Kim Sichel, *California Dreamin': Camera Clubs and the Pictorial Photography Tradition* (Boston: Trustees of Boston University / University of Washington Press, 2004).

21. Margery Mann, *California Pictorialism,* exhibition organized by Margery Mann, San Francisco Museum of Modern Art, January 7–February 27, 1977, Catalog © 1977; Michael G. Wilson and Dennis Reed, *Pictorialism in California: Photographs 1900–1940* (Malibu, CA: J. Paul Getty Museum and San Marino: Henry E. Huntington Library and Art Gallery, 1994). See "Southern California," pp. 81–83 and plates 43–92.

22. "Hollywood Hobby," *U.S. Camera,* October 1940, p. 33.

23. "Helps Make Walt Disney Pictures," *Courier-Gazette,* Rockland, Maine, February 8, 1940.

24. Ibid. "Kosti S. Ruohomaa making good in Hollywood, but good old Dodge Mountain, where his parents live, is his first love."

25. However, the newness apparently wore off, especially for assistant animators, who were isolated with in-betweeners on the first floor of the ani-

mation building, and had to go through a receptionist to contact others. Richard Schickel, *Walt Disney* (London: Weidenfeld & Nicolson, 1968), pp. 248–49.

26. Radio interview with Kosti Ruohomaa, mid-January 1961, Rockland High School, WCRB, Rockland, Maine. Ruohomaa recalled a clever, insightful Connell quote that suggested he made the angora rabbit series while studying with Connell: "When the rabbit's nose twitches, click the clicker."

27. "God of a Plastic Celluloid World," *Fortune*, 1936, photographs by Will Connell.

28. *The Art Center School Catalog*, 2544 W. Seventh Street, Los Angeles, 1941. During 1940, Ansel Adams taught photography at the Art Center School. ". . . my first photographic teaching experience was in 1940 at the Art Center School, Los Angeles. I agreed to teach there because I felt it had much to offer; the industrial design division remains without peer to this time." See *Ansel Adams: An Autobiography*, with Mary Street Alinder (Boston: Little, Brown & Co., 1985, 1996), pp. 264, 265, 267, 284.

29. Editors, "American Aces," First of a Series—Will Connell. *U.S. Camera*, No. 1, Autumn 1938. "Remembering Will Connell" (1898–1961), *U.S. Camera International Annual 1963*. Pages 100 to 115 devoted to Connell, who passed away on October 25, 1961. Page 114: "Will Connell—what a loss, and how we have gained from that huge heart of Will's through all of these years . . . no wonder it stopped beating. It was doing the work of six." John G. Morris.

30. *The Pool*, Roye, "Human Interest Gallery," *U.S. Camera*, no. II, October 1940, p. 20. Courtesy Farnsworth Art Museum.

31. PIX Inc. Agency, Park Avenue, New York City. Copyright stamp found on verso of photographs Ruohomaa made at the Native American Gallup, NM, congregation and hoboes of Santa Barbara, and other prints verify this connection. "Photo by Ruohomaa, PIX Inc." Founded by Alfred Eisenstaedt in 1936. Eisenstaedt continued to use PIX when he became one of *Life* magazine's first staff photographers. In 1932 Eisenstaedt photographed a younger-looking Disney in his studios. An undated note, "To Kosti from Eisie," was found in the Lofman Estate Ruohomaa holdings, suggested some acquaintance between the two.

32. Will Connell, *In Pictures: A Hollywood Satire* (New York: T. J. Maloney Inc., 1937).

33. *Mechanix Illustrated* tear sheet in Kosti Ruohomaa's scrapbook of this period.

34. Agoura, CA. One of the locations for filming *Of Mice and Men*, 1939,

William Randolph Hearst Ranch. William K. Everson, *The Films of Hal Roach* (New York: Museum of Modern Art, 1971), pp. 75–78.

35 Charles Higham, *The Art of the American Film* (New York: Anchor Books, 1974), pp. 129–30. Article discusses Lewis Milestone, including *Of Mice and Men*.

36. African-American classical composer William Grant Still (1895–1978) moved to Los Angeles in 1936. Ruohomaa photographed Still at home at his piano. Negatives, Lofman Collection, Maine State Museum.

37. Los Angeles jitterbug dance contest photos, distributed by Black Star, published in *Liberty*, February 12, 1944.

38. Photograph taken moments after Marc Ruff, Hollywood film executive, was brutally mugged. July 4, by Kosti Ruohomaa.

39. *Here's Looking at You*, *Los Angeles Times*, April 28, 1940.

40. See Stefan Kanfer, *Serious Business* (New York: Scribner, 1997), p. 127. Disney artists earned about $18.00 to $25.00 a week.

41. Harry Hamsel (1899–1966), Walt Disney Studios animator, actor, dancer, and violinist.

42. Native American intertribal powwow occurs annually in Gallup, NM, to this day. It seems he shared the expenses of this trip, but unable to determine with whom.

43. *Life* assignment #44945, 1955. A Minnesota reader remarked in a letter to the editor of Kosti Ruohomaa's essay for Walt Whitman's "*Leaves of Grass* Centennial" that "The name 'Ruohomaa' in Finnish translates to 'grasslands.' " The editor responded, "A happy coincidence."

44. PIX Inc. founded by Alfred Eisenstaedt; note his *Life* credits. Eisenstaedt photographed Disney many times between 1932 and 1939 (http://disneyandmore.blogspot.com/2008/11/walt-disney-studios-in-1938-1939.html)

45. Marc Eliot, "Strike," chapter 10, *Walt Disney, Hollywood's Dark Prince* (New York: Birch Lane Press, 1993), pp. 131–52.

46. Ibid; Regina Cornwall, "Emperor of Animation," an examination of Disney's preoccupation with whitewashing sexuality and his undue preoccupation with anal-based cartoons, including scenes found in *Fantasia*. Commentary on strike issues: *Art in America*, no. 10, December 1981, p. 46 cont. pp. 113–20; Richard Schickel, "Walt Disney: Myth and Reality," R.S. *American Heritage*, vol. XIX, April 1968, pp. 94–95.

47. May 17, 1941, week: Cartoons responding to Disney and vice president

Gunther Lessing's accusations captioned "Everybody's red," "There's a girl in red tights," were circulated among strikers. Kosti Ruohomaa, scrapbook of Disney Strike ephemera. Lofman Collection, Maine State Museum.

48. *The Reluctant Dragon* opened June 20, 1941.

49. "Strike at Disney: Screen Cartoon Guild Walks Out on Mickey Mouse, Donald Duck," *Screen Actor Magazine*, June 1941, p. 18.

50. "Strike at Disney," Labor, *Screen Actor Magazine*, June 1941; "Disney Strike Picket Signs Pack a Punch," Labor, PM magazine, July 22, 1941; "Strike at Disney," Richard Shale, "Prelude to War," *Donald Duck Joins Up: The Walt Disney Studio during World War II*. Studies in Cinema, No. 16. UMI Research, Ann Arbor, MI, 1976, 1982, pp. 20–21.

51. Shale, *Donald Duck Joins Up*. "The year 1941 proved [financially] dismal for the Disney Studios. By the end of the year, fewer than half of those employed by the Disney Studios were still on the payroll," pp. 20–21.

52. Ruohomaa left no explanation as to why he stayed on. A typed page, titled "My ???," would possibly solve this mystery, but it had been torn out of his Disney Strike scrapbook.

53. "Hobo Jungle on a Wealthy Californian's Estate," *St. Louis Post-Dispatch*, January 18, 1942. Estate of Mrs. John Howard Child, Santa Barbara. Five Ruohomaa pictures credited to Black Star.

54. Wilbur Streech (1914–1986). Left Disney after the strike to go to New York; joined US Army Signal Corps. Later created films, Wilbur Streech Productions, NY; lifelong friend. *New York Times* obituary, September 3, 1986. E-mail note c. 2002 from daughter, Karen Streech.

55. Art Gates's second wife, Helen Gates, New York editor, with whom this author met in New York, 1995, 1996. Helen Gates's remembrances gave insight into this period of Art Gates and Kosti Ruohomaa's friendship.

56. *Life* cover shows underside of bomber, December 2, 1941.

57. "Hobo Jungle on a Wealthy Californian's Estate," *St. Louis Post-Dispatch*, January 18, 1942. First Kosti Ruohomaa pictures (five) credited to Black Star Publishing Company. However, there would be no contract until February 1944.

58. Shale, *Donald Duck Joins Up*, pp. 23–26. "It was one day after Pearl Harbor and the Disney Studio . . ."

59 Ibid, pp. 15–26. "Shortly after six o'clock in the evening of December 8, 1941, Walt Disney received a call from Washington which would substantially alter the course of the studio's history."

60. Ibid, p. 18.

61. Ibid, pp. 15–26.

62. Letter, January 7, 1943. To friends, Winslow and Economy, from Owls Head, ME; signed, Kosti.

63. See "Who's Who of American Comic Books, 1928–1999," www.bail-sprojects.com; "The Grand Comics Database Project, www.comics.org/search.lasso; "Case of the Petrified Poet," Star-Spangled Comics #10, Series 1941, July 1942. DC Comics, 6 pp. See also research results by Finnish author Ilpo Lagerstedt.

64. Examples of the Gates–Kosti collaborative *Boxcar* strips are held by the Farnsworth Art Museum, Rockland, ME. This author suggests the drawings were done by Gates; ideas by Kosti.

65. Album, 1939–1944. Letters, if any, acknowledged to be from Kosti to his parents, or from them to him during the California years, have not been found. The 1939 Rockland *Courier-Gazette* article could have been sent directly by him to the newspaper. This album also holds published photographs he made of wrestlers while in California, and after 1944, of a boxer who was also an artist, leaving open the question of his inner need to find acceptance from his father, a medaled wrestler, for his profession.

66. No records have been located concerning Ruohomaa's attempt to enlist in the navy, and his rejection.

67 Interview: John La Cross, Rockland, ME, 1995. Narrator of this event.

68 Ruohomaa later described the annual blueberry operation in Black Star captions: "The blueberries which grow in Maine are the low-bush variety. This type does not grow successfully if transplanted, so all the berry farms in Maine have this wild growth of berry, about four inches high, which is developed by keeping the land clean of other growths. Burning the fields every second year develops a better-quality berry. The fields are sprayed early in the ripening stage to prevent disease and maggots."

69. Dodge Mountain Farm, Inc., belonged to the Midcoast Maine Blueberry Cooperative, based in west Rockport, an organization founded by local Finns. The winnower, invented by Enil Rivers, another local Finn, separated the chaff from the berries. Several of Kosti Ruohomaa's photographs of the business in 1942 were used that year to illustrate a UM *College of Agriculture Bulletin.* Lofman Collection, Maine State Museum.

70. Selim Ruohomaa and Maurice Stanley Powell together gave Kosti land in Washington, Maine, December 19, 1940, possibly for a New Year's gift.

Powell worked the blueberry land. Kosti still owned it at his death.

71. El Capitan was named for Yosemite Park's peak in California, made famous by master photographer Ansel Adams.

72. Interview: Edna Wooten, Owls Head, ME, April 1997. Mrs. Wooten owns the original letter, witnessed during the interview. She also know friends Economy and Winslow, to whom Ruohomaa wrote the letter, and received it from them. Copies are held by the Farnsworth Art Museum.

Kosti Ruohomaa with the Signal Corps gang, Wilbur Streech apartment, New York City 1943. (Lofman Collection, Maine State Museum)

III. TEAR SHEETS

Return East to New York City (1943)

No doubt Ruohomaa learned of the Astoria, New York, US Army Signal Corps through Art Center School connections.[1] The Art Center School had designated classes to prepare Hollywood animators and photographers for Signal Corps opportunities in headquarters located in Astoria, New York, and Denver, Colorado. With his place assured in the Astoria, Long Island, US Army Signal Corps, Ruohomaa moved to New York at the end of February 1943, where he lived for a time at 143 East Thirty-Ninth Street, Manhattan, across the East River from the Signal Corps Center.[2]

The US Army had purchased the Astoria Long Island studio in 1942, renaming it the Signal Corps Photographic Center.[3] Film animation, a highly successful visual teaching instrument, expedited the rapid training of inductees. The Center produced instructional as well as still films and graphics that illustrated training manuals. Ruohomaa photographed himself along with fellow Hollywood studio artists reunited in former Disney colleague Wilbur Streech's New York City apartment, a group portrait he

called "the Signal Corps Gang."[4] He alone appeared in civilian clothes at this event, which somewhat documented Hollywood's role in the Astoria Studios Signal Corps productions.[5]

The one known assignment attributed to Kosti Ruohomaa was a filmstrip he later described to Rockland, Maine, friend Jim Moore. The project goal was to explain, with artwork, the steps of how to properly take apart and reassemble a .45-caliber automatic pistol. According to Moore, the strip was commended, although if he had been given the weapon, the "core of Ruohomaa's being dictated" that he could not shoot this handgun, let alone put one together, even using his personally sketched instructions.[6] Although exact dates are unclear, Ruohomaa probably participated as an animator-illustrator in the Astoria headquarters of the US Army Signal Corps program until he contracted with the Black Star Publishing Company in February 1944.[7]

Ruohomaa's professional thoughts regarding freelance photography remained a priority. He continued to learn more about the intricacies of making an image through studying published photographs found in news magazines and monthly periodicals. He preserved an August 21, 1943, *Collier's* magazine editorial page in his scrapbook that included a cartoon by former Disney colleague artist Virgil Partch, who had moved on to commercial illustration after the strike.

More personally important to Ruohomaa was the issue's cover color photograph made in an airplane manufacturing factory interior. Made by photographer W. Eugene Smith, the image captured a newly cast "propeller as it was hoisted out of a furnace." The editorial detailed Smith's "five-hour" preparation before he released the camera's shutter for less than a second to make the picture. The vivid description reinforced an approach Ruohomaa had

adopted through the teachings of his former mentor, Will Connell: to pre-visualize a final photographic image and then to take the necessary steps to reconcile the details of its formation.[8]

In his apartment, Ruohomaa initiated a new personal photographic project. His idea was motivated by what he had observed since the start of the war: people's complaints and bad behavior toward lifestyle changes that required civic sacrifice and personal responsibility. The project endeavored to interpret these attitudes as critical commentary. He would start by creating three-dimensional caricatures; therefore, humor was elemental to the concept.[9]

Assembling the likenesses with found materials—commonplace objects such as a cup, saucer, pitcher, and other items found in kitchen cabinets and drawers—he placed the household objects with a "less is more" approach, sculpting a 3-D form. The project would require a stage-like platform, table height, with lights positioned as for studio portraiture. The final pieces were intended to be entertaining but thought-provoking. A gesture of the head, the turn of shoulders, etc., gave a convincing demeanor to the constructed three-dimensional figure. The slant of light, a subtle adjustment to a curve in a rubber band, or the tilt of a saucer, transformed an assembled character to suggest an individual personality's bias, a technique poignantly used by Disney animators.

Ruohomaa titled the photographed caricatures *Teapot Tempests*, and sent a selection to *Life's* "Pictures to the Editor."[10]

They appeared on two *Life* pages on June 7, 1943.[11] His personal introductory letter appeared at the end of the reproduced photographs:

Teapot Tempests

 Sirs: These photo caricatures were suggested by the

Teapot Tempests, *interpretive caricatures as visual puns.*
Left:The Patriot: Wrapped in American Flag, 1943. (*Lofman Collection,
Maine State Museum*)
Right: Rumor-Mongers Talk over the Back Fence, 1943. (*Lofman
Collection, Maine State Museum*)

clattering teapot, which makes so much noise in doing so
little. The teapot and its associates, the humble cup, saucer,
and cream pitcher, become symbolic caricatures of some
people in this wartime world. They are made of common
kitchen crockery and could be broken and thrown away.
Too bad the same cannot be said for the persons they're
designed to resemble.
—Kosti Ruohomaa, New York City, 1943[12]

One might classify these first photographs published in *Life* as
caricatures derived with the scavenger mind-set of the Dada artist and
the re-envisioned ordinary objects of Surrealist photographers.[13]

Former studio experiences influenced the technical ease Ruohomaa demonstrated in creating three-dimensional objects as ideas intended to entertain. Five years embedded in filmmaking techniques developed by Disney's feature cartoons and the active movie-production environment of Hollywood studios contributed to their successful realization.[14] Ruohomaa's directed light enhanced the sculptural form of each figure, and its expression is clearly seen in each photograph. Each caricature acted as an individual personality endowed with a bent of satirical humor.[15]

Life picture editors' pages were surely noticed by Black Star's Ernest Mayer and Kurt Kornfeld, both of whom diligently paged through daily newspapers and periodicals to seek stories for their photographers. However, it would be the following year that the status of Ruohomaa's relationship with the agency would become a formal commitment. Kornfeld, Black Star's president, not only brought Ruohomaa on board on February 7, 1944, but he also apparently proposed that they share an apartment.[16]

Ruohomaa thus moved to 30 Parcot Avenue, in New Rochelle, Westchester County, New York, just north of the city. This co-share would be a permanent residence until mid-1948, although Kornfeld would move on before that time. From the third-story window Ruohomaa photographed his two-door coupe, his first personal automobile, and one he would have for at least nine years.[17]

At Parcot Avenue, he set up studio space where he photographed portraits for professional portfolios. Pearl Primus, his New Rochelle neighbor, became an early subject. At twenty-three, Primus was matriculating for her master's degree at New York University as she performed modern dance. The captured poses reflect her individualized, expressive dance modes. Ruohomaa

wrote in Black Star captions, "These photos show the telling movements in Pearl's newest and most discussed dance creation, 'Hammer Dance.' Based on an old Negro folk song, it tells of the dream of a Negro convict on a chain gang longing to be free."[18]

Kurt Kornfeld later recalled a personal side of his new roommate: "Kosti was quite a womanizer—often had girlfriends visit him, during which time I would have to step out for a long walk."[19] Kornfeld was very fond of Kosti Ruohomaa, and as the months and years passed, Black Star shaped the professional career of their photographer, who in turn remained fully committed to the agency. Existing letters found, although few, exchanged between Kosti Ruohomaa with the founders of Black Star confirm the professional and personal support the agency provided to their contracted cameraman.[20]

Black Star Publishing Company—A Brief History

Off-assignment and after-assignment, Ruohomaa's lens retained the sensitivity of his poetic eye. Realizing a magical photographic moment when he saw one, he did not allow it to escape. Such was the case with a couple he encountered in close moments before they left each other at a corner of a New York City subway station entrance. The veil of heavy fog, a late-winter afternoon darkness, and peering streetlights combined to create a surreal

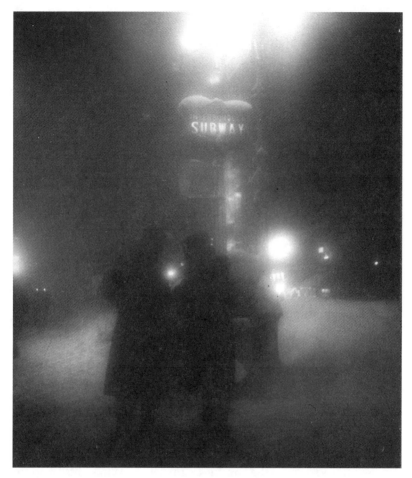

Evening Fog, Subway Station, *New York City, 1944. (Black Star)*

scene suggestive of a cinematic setting for this unpublished city street image. This moment in time foreshadowed future occasions in which Ruohomaa would appropriate existing atmospheric elements to create images filled with mood, feeling, and drama.[21]

When Kosti Ruohomaa was signed on February 7, 1944, the Black Star Publishing Company was located in the Graybar Building

at 420 Lexington Avenue, New York.[22] Eight years old, the agency had established a highly regarded reputation in the photojournalism arena, including connections to Life, which immediately impacted Ruohomaa's career.

The Black Star Publishing Company was founded by three émigrés from Germany who fled the threats of Nazi terrorism in the 1930s.[23] The eventual partners, Kurt Kornfeld, Ernest Mayer, and Kurt Safranski, each contributed a unique blend of innovative journalism experience, Germany being at the forefront of publishing, especially with the extensive use of strong, expansive-size photographs on pages of major popular periodicals.[24]

Ernest Mayer had previously solicited photographs for distribution through his business, Mauritius, located in Berlin and Munich beginning in 1929. Eventually Mayer found other agencies competitive, and after a visit to the United States—where he met Safranski, who wanted to start a picture agency—he was convinced to emigrate in 1935.

Kurt Safranski came from a high management position with the German company Ullstein (Herman Ullstein), publisher of numerous pictorial magazines. He emigrated first to England after the Nazis took over the business in 1933. While in London, Safranski was introduced to representatives of the Hearst Corporation, who urged him to come to New York.[25] Safranski became Black Star's idea man and picture editor.[26]

Before coming to the United States, Kurt Kornfeld acted as a literary agent in Germany. He ultimately became Black Star's picture agent, and with his "gentlemanly personality and charm," handled such clients as Time Inc.'s Life magazine, "as if they were working for him."[27] The name "Black Star" was Safranski's creation.[28]

Black Star hired Kosti Ruohomaa at a time when the publishing

company was a recognized "rising star" in the business of photography agencies. When first interviewed in late 1941, the agency was barely six years old. Within three years the company had grown to become one of the most solicited private photograph distribution agencies in New York City. Black Star Publishing Company retained strong connections to *Life* magazine, established in 1936, evidenced with an April 3 letter of that year incorporating a "first refusal" of Black Star photographs by Time Inc. The newly formed picture agency particularly valued this early offer of a contract, and its acknowledgment of the publishing quality of pictures produced by its photographers.[29]

During the ensuing years, Black Star accrued the work of many notable photographers of twentieth-century photojournalism, who came not only from the United States and Europe but from throughout the world. Black Star's credentials became highly esteemed in the photojournalism field, and an influential, prominent photography agency to call one's own. Perhaps during the 1940s and '50s, its single biggest competitor was to be a staff photographer with the prestigious *Life* magazine.[30]

Black Star selected its photographers not only from portfolio interviews, to which it was always open, but also eventually from agencies across the globe—an enterprising approach to enlist new talent into its files, the images of outstanding photojournalists representing diverse backgrounds.[31]

Among Kosti Ruohomaa's Black Star contemporaries whose work appeared concurrently in 1940s and '50s issues of *Life* were photographers Ralph Crane, Fritz Goro, Ron Partridge, Joe Covello, and Werner Wolff.[32] Kosti Ruohomaa remained unique, represented only by Black Star from his first contract until his premature death in 1961,[33] and was remembered in Black Star's 1996 sixtieth-

anniversary volume as "one of their greatest but most unrecognized photographers."[34]

KOSTI RUOHOMAA

PHOTOGRAPHER

BLACK STAR
420 LEXINGTON AVENUE
NEW YORK CITY

Kosti Ruohomaa's Black Star professional card. (Lofman Collection, Maine State Museum)

Shaping the Professional

A fter contracting with Black Star, Ruohomaa's photographs appeared in major national newspapers, magazines, and photography journals. This work represented his Black Star assignments, his self-assignments motivated by influences experienced while in California, plus his ingenuity and passion for the camera's ability to convey his ideas.

The February 1944 Black Star Publishing Company contract would become the second major positive force bringing new influences and challenges to Ruohomaa's life, the first having occurred six years earlier, when he was hired by Disney Studios.[35] Motivation to succeed, to achieve financial self-support with the independence it offered, would continue to influence Ruohomaa's personal life.[36] Correspondence with Kurt Kornfeld, Ernest Mayer, and, after the war, Howard Chapnick—who would later serve as Black Star's president—verified a solid, trusting, and highly supportive relationship developed between photographer and agency.[37] Black Star in turn distributed Ruohomaa's photographs to notable publishing venues where he was credited as "Kosti Ruohomaa from Black Star."[38]

The 1944 Kosti Ruohomaa–Black Star contract stipulated "Black Star [will act as] the sole and exclusive Kosti Ruohomaa agent; will promote the sale and disposition of his photographs all over the world, and do everything possible to enhance Mr. Ruohomaa's reputation and financial success." The credit line under his photograph in print media would read *Kosti Ruohomaa from Black Star*, or, if a leading publication wished to use only one credit, it would be *Kosti Ruohomaa*. A total of seventeen points detailed each party's responsibility regarding guardianship of the photographs, work ethics, and financial percentages of "sold" assignments to go to each. The contract further conditioned that "Mr. Ruohomaa will devote his entire time and attention to fulfilling his obligations under this agreement and to keep Black Star furnished with adequate supply of good saleable photographs."[39] This phrase suggested the open opportunity to freely follow one's intuition and to pursue personal ideas within and beyond the context of an assignment, a path that Ruohomaa followed throughout his photographic journey.

As an amateur, Ruohomaa studied camera magazines and journals to gain technical knowledge of cameras and lighting equipment, i.e., lamps and bulbs, as well as the use of natural light. All factored as atmospheric and compositional elements throughout Ruohomaa's picture-making. A hand-penciled zone system chart found between pages of a 1942 scrapbook depicted Ruohomaa's awareness of the ten steps of light and dark in the "zone system" invented by Ansel Adams. The chart acted as a shaded table of a black-and-white scene observed through the viewfinder. Ansel Adams's zone system aided the photographer when making decisions about camera aperture and exposure time to achieve the desired white-to-black tones to be viewed in the negative and final print. It was regarded as a valuable tool for a photographer to preview a scene's dark and light relationships, such as skin tones and sunlit snow, and one that Ruohomaa applied to his own independent study.[40]

Preempting first assignments, Ruohomaa invested in his equipment, upgrading the level of sophistication. The 120 roll film Rolleicord, the "workhorse" camera he had used for the last six years, was exchanged for the Rolleiflex, of similar twin-lens, reflex design, but a more complex instrument that offered more controls and greater manual choices for exposure, speed, and depth of field. Eventually, by the early 1950s, his camera bag held two Rolleiflex cameras.[41] The "Rollei," as it was known among dedicated owners, became an integral part of his work.

Within a year, when he was assigned architectural sites and interiors for Time Inc., Ruohomaa acquired a large-format Linhof Master Technika 4x5 view camera.[42] Eventually he regularly applied the view camera to landscapes. Before his 1948 trip overseas he purchased a "miniature" camera, the 35mm lightweight,

handheld Leica. An instrument dating from 1924, the Leica had the reputation of being able to quietly capture instant candid views, key to the demands of 1940s world photojournalism. The Leica and Linhof complemented the Rolleiflex, as Ruohomaa often photographed subjects with all three cameras. The "Rollei," however, remained Ruohomaa's preferred instrument.[43] Though black-and-white film was his steady choice, as early as 1944, due to the increasing number of magazine editors who desired "natural color" for their pages and covers, Ruohomaa added color negatives to his repertoire.[44, 45]

A Black Star obligation to record concise, definitive picture captions required a change from the storylike paragraphs he had formerly composed, such as the California work submitted to newspapers and contests. As an amateur photographer, Ruohomaa's pictures were intended to document and entertain; however, he titled his photographs in order to provide human interest for his audience, such as *Hobo Haven*, his pictorial studies of the Santa Barbara homeless commune. Other titles followed a Disney-cartoon prerequisite, such as Ruohomaa personalizing a pair of crooning pigs, *Mo and Jo*, in his prizewinning photograph, or choosing a title that suited the Hollywood salon pictorial style reflected in *The Pool*.

Black Star required accurate, clear identification to document the journalistic details of the who, what, where, when, and why of an assignment. Occasionally assisted by researchers' material, Ruohomaa added personal studies to his files as well. He titled the captions' narrative and then followed with an introductory paragraph or two.[46] Listed captions identified the camera used (e.g., Leica, Rolleiflex, Linhof), the roll number, and each frame. View-camera exposures separately noted the subject portrayed. Original

penciled notes, comments, and caption material, sometimes made on hotel stationery or index cards during travels, were sent to Black Star, where they were then transcribed by office typists.

All stages of a picture-making assignment were thus later filed together: the penciled manuscript, typed captions, negatives, prints, and contact sheets of all photographs. Tear sheets of Ruohomaa's published features were added to files later by Black Star. Black Star had created its own cataloging system. "RU" for Ruohomaa, plus an assignment number, was penned on the verso of all his Black Star contact sheets, prints, and marked on negatives. Prints either received the Black Star stamped logo with his name, or, if a Time Inc. image, that company's stamp appeared on the verso of prints, with the assignment number, date, and location.[47] The Black Star transcribers never dated Ruohomaa's material.[48, 49, 50]

To break in their new photographer, Black Star assigned New York City venues that included location portraits, studies of architecture, interior views, and glimpses of theater performances.[51] During these first months, Ruohomaa's lens captured several future celebrity performers of dance, stage, screen, music, and art. This work included dancers at the Metropolitan Opera House ballet and informal pictures made at producer Sol Hurok's party, held, to use Ruohomaa's words, at "New York's swank Sherry's." Captions noted premier ballet dancers Alicia Markova and Anton Dolin viewed onstage and later as they celebrated. He described the neophyte choreographer Jerome Robbins, who headed the dance company of Sol Hurok's recently opened Broadway success, *Fancy Free*, a production which introduced a novice Leonard Bernstein as conductor and a young ballet dancer, Janet Reed, who later became a Hollywood actress.[52]

Saved news clippings document Ruohomaa's assignment to

photograph contralto Marian Anderson at her radio debut, a contact that led to further portraits at Marianna, her Danbury, Connecticut farm.53 His captions introduced Margaret Webster as "one of the most intuitive, contemporary interpreters of Shakespeare." His camera's impressions portrayed the actress–theater director in her library at home in Greenwich Village, viewing a folio from her private Shakespeare collection, and later, Margaret with Billy Rose, then co-producer of Central Park's seasonal theater program.54 During the summer months he continued this coverage at Tanglewood, the site of a seasonal classical symphonic series at the Lenox-Berkshires, located in western Massachusetts.55

An early architectural challenge was to photograph New York City's new asphalt plant located at Ninety-First Street and East River Drive. The building was critiqued by the Museum of Modern Art as a work of architectural "progressive design." Ruohomaa wrote in his caption that he had viewed the new structure's elliptic curves as dark and light abstract shapes, and noted that his was a "precise and artistic perspective of a building that combined both utility and beauty."56

Minicam Photography magazine's August 1944 issue featured a special section on the Museum of Modern Art, New York City, as the museum celebrated its fifteenth anniversary with an exhibition called "Art in Progress." During World War II, the MoMA's war effort included the theme "Artistic Freedom," and they hosted events for servicemen.57 For this assignment, Ruohomaa tightly directed a scene in the museum's interior. He positioned two sailors so they appeared to debate two abstract works—a non-objective painting on canvas of grouped swirls of oil color brushwork that acted as a background, and in the foreground, a carved wooden sculpture perforated with open spaces, a piece of

smoothly finished solid wood. The storytelling vignette, the sailors'[58] baffled expressions and gestures, played to mirror their bewilderment, became Ruohomaa's first published color photograph, and was featured on the cover of *Minicam Photography*. Composed in the style of a Norman Rockwell lighthearted illustration, at the same time, the scene's ambiance recalled experiences nurtured in the Hollywood studio, enhanced by his Disney colleagues' antics to "ham it up."[59]

In fact, Ruohomaa was familiar with and admired Norman Rockwell's approach to illustration. He wrote of the man and his art in the narrative to the several-day photo shoot he executed in Rockwell's Stockbridge, Massachusetts, studio and local haunts about town.[60]

When *Parade* started in 1942, it was a newspaper pictorial magazine insert into weekend editions syndicated across the country. Black Star was a major distributor for its photographs.[61] Saved tear sheets show that Ruohomaa assumed a straightforward documentary approach to *Parade* assignments. The weekly features provided journalistic experiences, such as the return of servicemen and -women to civilian life. He covered veterans with their families, with their doctors, during educational training courses, doing rehabilitation exercises, establishing new businesses, and entering new jobs. *Parade* features were designed to appeal to a general public. These were down-to-earth location views set in homes, neighborhoods, college campuses, and in this wartime year, new career training sites.[62] The varied assignments required skillful communication to successfully and sensitively introduce oneself and one's camera to diverse subjects upon arrival at a photographing location. Each held technical challenges when it came to lighting and composition in order to make eye-catching,

Fully directed by Ruohomaa, two uniformed Museum of Modern Art visitors act puzzled as they appear to debate a nonobjective painting by Richard Pousette-Dart and a nonobjective sculpture by an unidentified artist. Minicam Photography, cover, August, 1944; tear sheet in KR Album. (Black Star, Lofman Collection, Maine State Museum)

publishable pictures. The Parade editors provided experience and steady narrative camerawork to Ruohomaa, his bread and butter, into the 1950s.[63]

Time Inc., Life, Magazine Photojournalism, and the Home Front

A memo dated March 27, 1944, tucked in Ruohomaa's scrapbook of this period, signaled the personal importance of a first Life assignment. It was about a month into his Black Star contract. The memo scheduled Ruohomaa to "photograph a returning Navy pilot at 3 PM at his brownstone home in Woodside, Long Island, New York."[64] Clearly Ruohomaa preserved this memo because one picture from this initial shoot, *Navy Airman's Homecoming*, appeared as a Life cover on May 1, 1944, establishing his work as a professional photojournalist. The credit "Kosti Ruohomaa, from Black Star" noted in the magazine's masthead as cover photographer, gave initial credence to his breaking into Life's formidable photojournalism national outreach.

By the 1940s, Life had become the most popular weekly news pictorial commonly found in American households. It was available by subscription, and its boldly formatted cover easily attracted customers at street-corner newsstands. Profusely illustrated with engaging, sometimes powerful photographs, Life's features brought the names of its photographers to the forefront of contemporary professional photojournalism.[65] When the weekly first went to press in 1936, Life employed four staff photographers: Margaret Bourke-White, Alfred Eisenstaedt, Tom McAvoy, and Peter Stackpole. Ten years later, the magazine had thirty-six full-time staff photographers.[66] Plus, the enormous demand of Life's broad interest-based reportage, editorials, and special features opened opportunities for freelance cameramen, as well.

Ruohomaa with Robert P. Tristram Coffin, Brunswick, Maine, 1945. (*Courtesy of Mrs. June Coffin and the* Life *Magazine Archives*)

Time Inc. had news bureaus located in major cities of the United States from Washington D.C. to Seattle, Honolulu, and overseas in London, Algiers, and Rio de Janeiro at the time Ruohomaa made his first photographs for the corporation.[67] During his years working for Time Inc., particularly in the 1940s, there were three special *Life* editions apart from United States distribution: *Life* Espanol (Spanish language, editions sent to South America); *Life* International, and *Life* Overseas (editions sent to military bases).[68] Radio commentary and newspapers were the major daily sources for news reportage. Photographs made by incredibly courageous photojournalists stationed in the centers of the war zones were reproduced in *Life*'s expansive layouts, and graphically communicated to homeland readers the painful realities of World War II

conflicts rooted in Europe, Africa, and the Pacific Island theaters.[69]

In his book *Photojournalism*, published almost thirty years after *Life*'s debut, Arthur Goldsmith reflected on how society viewed the cameramen who pressed the shutter release for the weekly: "The *Life* staff photographer, glamorous, far traveling, and presumably highly paid, became an archetypical figure in the magazine publishing field. He was often envied, usually respected, and sometimes even resented, but he became the idol of thousands of aspiring young photojournalists."[70]

To be clear, although he was referred to as a "*Life* photographer" in editorial features, Kosti Ruohomaa never became a contracted *Life* staff photographer. However, beginning in May of 1944, for the next twelve years, until the end of 1956, he photographed regularly for the magazine and other Time Inc. publications, including *Time*, *Fortune*, *Artforum*, *House & Home*, the *New York Times*, and in the 1950s, *Sports Illustrated*.[71] September 1, 1946, through August 31, 1947, Ruohomaa photographed exclusively for Time Inc.[72]

It was a professional advance to have one's photographs appear on *Life*'s pages, and through Black Star, Ruohomaa's energies were directed to this end. He followed assignments, but as he gained more self-confidence, he also created and submitted his own ideas to *Life*'s editors.[73]

During the war, Ruohomaa's assignments were based on "the home front," a phrase later coined by Black Star's Howard Chapnick to identify his camerawork during this period.[74] An early home-front photo shoot directed by *Life* sent Ruohomaa to the Allentown, Pennsylvania, State Fair, an annual event that featured many facets of country life. The agricultural fair setting was familiar to this photographer, who grew up on farms, but its bountiful subjects were yet to be seriously captured with his camera's eye.

Ruohomaa spoke in his captions of his assistant, Carolyn Jean Polachek, who accompanied him on this trip: "It was a delight to have a beautiful researcher sent along," to be "my business manager, faithful assistant, seeing eye dog, and spiritual advisor."

Anticipating that this celebration of the annual harvest would have large visual audience appeal, Ruohomaa made close, almost intimate portraits of selected farm animals. His use of daylight flash enhanced their proudly displayed qualities, and his patience and natural feelings of compassion were revealed in the closely approached subjects. Though he left no clear notes, his cameraman's manner was certainly enhanced with personal knowledge of a farmer's linguistic commands as practiced in childhood, experiences tending to cows, horses, chickens, sheep, and other domestic farm animals.

In a contrasting mode, at a fairgrounds sideshow Ruohomaa found a human home-front scene and photographed it.

Under carnival-like nighttime skies, Ruohomaa turned his Rollei lens to make timed exposures created by the movements of illuminated amusements. He titled the studies made of the Ferris wheel "light patterns." This work appeared in a *U.S. Camera* feature that discussed unusual photographic light imagery.[75]

Before a year had passed with the magazine, finding that his strongest expression would be the essay, Ruohomaa proposed to *Life*'s editors what would become his first pictorial composition for the magazine: *Winter in Maine*.

Maine, a distant, somewhat remote, and rural New England state with northern borders shared with its Canadian neighbors, was a geographic territory he knew well. And he was familiar with the challenges of winter months; enduring daily life when the temperatures fell to thirty degrees below zero, with ice and heavy snow,

Light Patterns, Fairgrounds at Night, *Allentown Fair, Pennsylvania, September 17, 1944, contact sheet. (Black Star)*

became the norm rather than the exception. The proposal agreed to, the essay would be both personal and open to interpretation.

Wilson Hicks (1897–1970), a major editorial voice of Life's published pictures, who headed Life's photography department beginning in 1937, later recalled the occasion. "Kosti once said, 'How about Life's doing a Maine winter essay?' As Life's picture editor, I told him O.K., and his idea went on from there. Other editors and writers also liked it. As I recall, it was Dan Longwell who suggested Pulitzer Prize–winning Bowdoin College professor, Robert P. Tristram Coffin, write verses as captions.[76] When we laid out the essay we found we'd like to go additional pages, the pictures were so good. Mr. Coffin accommodatingly composed poems for two more pictures."[77]

Introduced as "an experiment" by the editors and titled

"Maine Winter: A Native Son and a Poet Interpret Its Moods," the fifty-two-year-old professor accompanied the photographer to sites in the Midcoast area of Brunswick, Maine. Coffin noted in the masthead portrait of the two, "It was a most exciting experience working with Kosti and doing these poems." Elegantly designed as a formal nine-page layout, a poem accompanied each lead theme, its interpretive photograph enclosed with bold outline, opposite full-page photographs bled to the page's edges. Ruohomaa's lens depicted outdoor work, home life, the tidal waterfront, backcountry roads, the landscape, the coastal train, and the main street— scenes that reflected the contrasting moods of winter and its accompanying weather—titled "The Coast, The Land, The Town, and the People."[78]

Beginning in 1945, Ruohomaa traveled for assignments to cover the arts, history, literature, poetry, and country-life features with titles such as "Life visits" and "Life sent photographer." Life sent Ruohomaa to New Orleans to focus on the Mardi Gras, newly reinstated since the end of the war. For the celebrative occasion Ruohomaa turned his lens on the exuberant parade floats and people dancing in the streets. To capture[79] the ambiance of a Dixieland jazz club, he directed his camera into the smoke-filled nightclub audience from behind the playing musicians. He studied the city's decorative wrought-iron-graced balconies and historical buildings, this, his first real work effort with the 4x5 view camera.[80] But his camera's real success came with capturing the varied moods expressed by the people during the holiday activities and within the city's venues.

Following this, Ruohomaa accepted an architectural assignment on the West Coast, not only for Life, but for Time Inc.'s Architectural Forum. Ruohomaa made exterior and interior views of

the renowned California Thomas Wolfe house for the feature "Evolution of American Architecture."[81]

About one year after the 1944 agreement, March 27, 1945, Black Star renewed Kosti Ruohomaa's contract. The updated version indicated a certain professional boost, with a detailed addendum. His weekly guarantee increased from $40.00 to $60.00.[82] Black Star thereafter covered his expenses, including for Life magazine's now-steady assignments.

Ruohomaa would receive "50 percent on all overseas publications and advertisers stock of the company." Plus, from assignments he received 60 percent, unless the process took over a month, then it would be 70 percent. Life not only entered the scene with his expenses covered, but Black Star acknowledged that Kosti Ruohomaa would get 75 percent of an assignment that he suggested, and which was accepted by Life. This contract would "remain in force" for nine years, until December 31, 1954, and thereafter, for "subsequent one-year periods unless terminated by Mr. Ruohomaa."[83]

Reflecting a growing acceptance within the "family" of Black Star, at this time Ruohomaa was given the significant opportunity to become a Black Star stockholder. The contract entitled a "voting power for each Black Star share. Also, when stockholders decided to sell, if members of the corporation did not wish to purchase the stock shares," then "Kosti Ruohomaa and Alfred Kornfeld (Kurt Kornfeld's son) had equal opportunity to acquire this stock, and, if "Alfred Kornfeld refused, then Kosti Ruohomaa had the opportunity to purchase all of the stock from the stockholder or his heirs respectively."[84]

Chapnick later verified that Black Star not only had an interest in promoting Ruohomaa's photography, but also his total

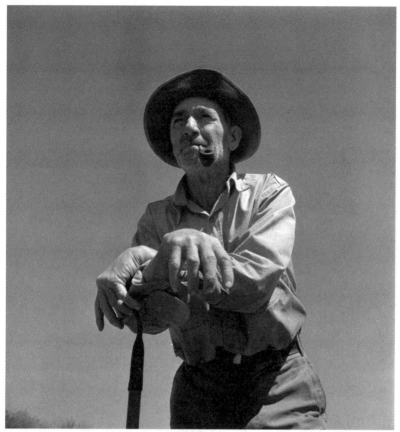

Portrait of Tom Moss; Ozark Farmer *became a* Life *cover,* May 27, 1946: "Life
Visits the Ozarks, Life *photographer Kosti Ruohomaa shows the look of plain people and
familiar things Hall writes about."*[87, 88] *(Black Star)*

success and well-being. This emerging paternal relationship took
root early on.

"Though I was very close with Kosti," Chapnick said, "Kurt
Kornfeld was like a father to him—very protective, very concerned
about his welfare—and the relationship was always more than the
traditional photographer-agent relationship."[85]

By 1946, Ruohomaa's "home-front" coverage captured the

rich bounty of America's farmlands with photographs expressive of the American farming family's self-reliance.[86] In South Missouri he found a subject that would become the May 27, 1946, Life cover and feature. The bold likeness of Ozark farmer Tom Moss drew attention to his oversize, roughened hands, his easy smile through a weather-worn expression, and his body language, dignified and statuesque—a down-to-earth portrayal that reflected both his subject's humanity and strength of character.[87]

In pursuit of pastoral scenes, Ruohomaa's files reflect his driving tours across backcountry hills from New England to the South Missouri Ozarks[88], alongside planted fields, passing farm complexes of homestead, barn, and silo, following hand-hewn split-rail fencing and stone walls. This work somewhat archived farmers still working with their horse teams, oxen-pulled plows, and horse-drawn wagons—old technologies that would soon be replaced in the years following the end of the war.

In June 1946, Life gave Ruohomaa an assignment titled "God Made the Country," a phrase taken from eighteenth-century poet William Cowper, who wrote about everyday life in the English countryside.[89] For this agenda Ruohomaa located remote Vermont sites such as Maidstone, Guildhall, and St. Johnsbury. At North Danville, he encountered newlyweds Lee and Marjorie Chickering on their dairy farm, where they posed under a blossoming apple tree; at Peachum he placed his tripod to receive an image of the pair of "grays," work horses approaching his lens from over the hillside, the plow driven by Philip Kinerson on the farm owned by his family for 150 years.[90]

Among the rich visual distractions found along the route of tiny villages, farms, mountain streams, and valleys, he stopped to photograph a covered bridge, a village store, a series that viewed

stately elms, and to make three exposures of a hillside meadow carpeted with common dandelions. After his passing in 1961, Ruohomaa's vision—to capture the wealth of the pastoral landscape and people at home in the rural countryside—earned a favorable acknowledgment by his longtime Black Star associate, Howard Chapnick: "God made the country and Kosti Ruohomaa photographed it."[91]

Cape Hatteras, North Carolina, proved highly inspiring for Ruohomaa's lens. Just after the war, Hatteras village could be described as a rural, somewhat undiscovered seaside site with centuries of maritime history embedded in its paths and sand flats. Here he visualized forms as art in this rugged seacoast setting during his several days of exploration. The coastal location had earned a reputation over many years for its hazards to mariners. The Hatteras people, its tidal landscape, half-buried relics of cape storms, forgotten gravestones, shipwrecked remains, broad sand barrens, dunes and scrub trees, provided a treasure trove for Ruohomaa's camera, allowing him to express the essence of the place and its people.

The June 16, 1947, Life cover featured his portrait of six-year-old Wallace Royce Haywood, descendant of generations of Hatteras fisherman.[92]

Ruohomaa's camera traced the Coast Guard rescue boat battling "high waves off Hatteras' Oregon Inlet;" he discovered long johns drying on a line, blown by the wind to their fullest forms; and sculpture-like remains left by the demise of storm-wrecked schooners. His lens recorded the recently abandoned yacht Nautilus as it lay on its side along the sea's edge. His studies closely examined aged gravestones half buried by blowing sands. His love of moments found during dawn and sunset gave him the patience to

wait with his camera in order to grasp the sun's descriptive light as it fell across the expansive desolate sands, a photograph that became the lead image in "*Life* Visits Cape Hatteras."[93, 94]

Critic David Burkett acknowledged the enduring appeal of a portrait Ruohomaa made of an elder Cape Hatteras woman, an image selected years later for a Smithsonian exhibition. "He photographed a village elder in an ankle-length skirt as she supported herself with a crude handmade cane." Her full stature was embraced with aged tree limbs and driftwood, an image that to Burkett "had called up passages of a Dylan Thomas poem which spoke of weathered fishwives." "To most of us it would only have been an old woman, weathered with time and living, a dead tree and a few leaves on spindly branches, but to one man it was more. To Kosti Ruohomaa it was an essay; something that could speak out and make a man reflect, and so he photographed it."[95]

Howard Chapnick recalled Ruohomaa's closeness with Kornfeld in an interview in 1993, recalling, "It was Kornfeld who pushed his work at *Life* and did battle with Wilson Hicks [*Life*'s picture editor] on Kosti's behalf." Ruohomaa in turn would eventually refer to Kornfeld as "Papa," sometimes making Kornfeld's Beekman Place home, his New York City pied-à-terre.[96]

Both the powerful executive editor Wilson Hicks and then, later, *Life*'s managing editor Edward K. Thompson, "who had a special interest in him," gave Kosti Ruohomaa opportunities to pursue his personal ideas. Hicks was said to groom his photographers, many of whom later became famous. Ruohomaa's quiet, reserved demeanor may have contributed to a welcome basis for an exchange of thoughts with the demanding editor. In a 1962 memorial, Hicks recalled: "When I was on *Life* I was always glad to see Kosti Ruohomaa come into my office because of his smile.

Almost everybody else smiled too, but Kosti's smile was special because it lighted him up inside and outside. He was a very gentle fellow."[97,98,99,100]

Hicks acknowledged Kosti Ruohomaa along with twelve others in his 1952 publication, *Words and Pictures: An Introduction to Photojournalism*, as one of the photographers with whom he discussed "the mentals of photography."[101] Howard Chapnick, who rose quickly in Black Star after the war, noted: "It was Wilson Hicks who gave credence to Ruohomaa's ideas and a forum for these images to flourish."[102]

Former *Life* staff picture editor John G. Morris, today, based in Paris, also shared this view. According to Morris, "Howard Chapnick was Kosti's greatest fan." Morris, who moved on to become executive editor of Magnum Photos in Paris, was at the heart of 1940s and '50s New York, at the time, the center of the international photojournalism world. Recalling the Black Star–*Life* connection, Morris noted, "Chapnick kept *Life* abreast of Kosti's interest in the New England character, folklore, and folkways." Today a recognized notable figure in photojournalism, in the early years of his career, Morris was employed by Time Inc. as picture editor, from 1938 through 1945, before moving on to *Ladies' Home Journal*. Morris recalled that he had selected Ruohomaa for two of the "How America Lives" feature series he edited for the latter, adding that they were considered "plum assignments."[103]

Ruohomaa preserved these tear sheets from the *Ladies' Home Journal* assignments. In one, he photographed a family with five young girls that lived in a log cabin in Old Town, Maine, in the midst of winter. In the second story, titled "Horizon Hunters," he created a study of the desert cavern home base of a Cave Creek, Arizona, couple, Bill and Clara Parks. While the geographic contrasts

created a pictorial dichotomy of moods, the variegated settings and subjects proved to nurture Ruohomaa's interest in storytelling. His artist's eye would be reflected in the composition and lighting of scenes such as the Arizona cave-dwelling couple preparing their fire in the cavernous interior.[104]

Life sent Ruohomaa to Nova Scotia in 1949 to photograph gill fishing in the Bay of Fundy. For days he directed his lens to a fisherman's family working the gill-net catch attached to poles that extended far into the flats of the grand tidal basin. A horse-drawn wagon sent to retrieve the fishermen and equipment at the beginning of the rapid onrush of the tide proved challenging, scenes he later described in captions as "grand adventure." Made with a rising backlit sun, Ruohomaa's images of the fishnet construction and gathering of the fish stand among his most dramatic and stage-like photographic compositions.[105]

The Museum of Modern Art opened the landmark "Family of Man" photography exhibition in 1955. A scene from Ruohomaa's Life feature, the "Three-Quarter-Century Club," made at an annual outing in Portland, Maine, was selected to hang in the section of the exhibit which spoke of "the endurance of love." The caption read: "On a child's swing near the picnic grounds, Edward Rogers Castner, who ran a general store in Damariscotta, Maine, for sixty years, gives his wife a fine ride. Both husband and wife are eighty and have been married sixty years."[106]

That same year, Life sent Ruohomaa to Fraser, Colorado, where he observed woodsmen at work in the tall forest covered with a knee-deep blanket of snow, and snowbound ranch cattle, grazing from armfuls of tossed hay. He worked into the night to capture atmospheric images of the frigid hamlet. He found that the rays of dawn sunlight sculpted an unusual path of snow-covered forms.[107]

In 1955, Life's editors assigned Ruohomaa another essay, this one, to celebrate the centennial of American poet Walt Whitman's *Leaves of Grass*. For this project he traced the sites of Whitman's life and poetry. He photographed Whitman's Huntington, Long Island, birthplace, and his last home and gravesite in Camden, New Jersey. He composed an intimate scene for "When Lilacs Last in the Dooryard Bloom'd." He captured the Brooklyn ferry as it approached his vantage, and wandered dunes to compose studies of the grasses at Montauk Point, Long Island, New York. He traveled to the great spaces of the Far West where his lens framed a narrow road that seemed to extend to the horizon, an aged monumental tree in Wyoming, and wildflowers cast against snowcapped mountain peaks extracted from Colorado's natural grandeur.[108] Twelve photographs were selected to illustrate the feature, titled "The Paths Whitman Walked: Poet's Leaves of Grass Has its 100th Anniversary."[109]

Long-distance travels for *Life* in the Northwest continued for eight months in 1956. During this period Ruohomaa covered features and events rooted in the states of Alaska, Washington, and Oregon, including political coverage of the primaries. The subject material varied, i.e., Hell's Canyon, the Boeing Aircraft Corporation, the Seattle Jesuits, the crash of a Northwest Airlines flight off Vashon Island, and in Alaska, an elk migration and the Gulf of Alaska.[110] Contact sheets reflect the fact that making these photographs required athletic adventure, such as photographing Alaskan elk herds from a small plane, and in close proximity on land. His files indicate that he documented vast celebrative tulip gardens and the heavy shipping docks on the working Seattle waterfront, in color, and returned to a familiar subject: a Jesuit monastery in Seattle, during his time in Washington State.[111] These

were Ruohomaa's last extensive Time Inc. and *Life* assignments. Following 1956 Ruohomaa changed his contract with Black Star to reflect a new desired independence.[112]

He accepted an assignment to contribute to a proposed Bruce Catton book, *The American Heritage Book of Great Historic Places*. This project was personally important to him, and for Black Star. He was nervous when he first met with editor Richard M. Ketchum, Chapnick recalled, as before the meeting that morning, Ruohomaa had already indulged in a libation or two. In August 1957, when the book was published, Ketchum wrote to Ruohomaa: "A copy of *Great Historic Places* is on its way to you with our great thanks for the help you gave us in putting it together. All of us here are very much pleased with the final result, which could not have been accomplished without the enthusiasm of people like you. We are very grateful indeed, and hope when you see the book you will be glad to have had a part in it. Sincerely, Dick Ketchum."[113]

Twelve Kosti Ruohomaa photographs appear in *Great Historic Places*. The "Atlantic Corridor," in which Ruohomaa's Civil War battleground images were made in black and white and in color, included Gettysburg.[114] Ruohomaa had acquired a copy of Matthew Brady Studios' illustrated pictorial that documented views of the actual battleground sites, made by Brady and others during the days following the hostilities. There's no doubt that Ruohomaa took this assignment very seriously.

The American Society of Magazine Photographers

Kosti Ruohomaa highly valued his membership in the American Society of Magazine Photographers (ASMP). No matter where his home base or travels took him, he kept abreast of any changes or developments in the profession through ASMP publications. After he suffered a stroke in February 1961, he would depend in part on income from his ASMP disability insurance.[115] He actively wrote editorial letters to ASMP concerning the profession, the last, dated 1961, in which he noted the importance of having a photographer's name credited to his/her published image.[116]

Ruohomaa joined the newly formed freelance photographers' organization in 1946, two years into his Black Star contract.[117] He appeared sporadically at the early meetings, recalled Kay Reese, former ASMP executive secretary and honorary member.[118] In September of 1946, the fledgling organization hosted a "big cocktail splash" at New York's Waldorf Astoria Hotel for editors, art directors, and members of ASMP. Kosti Ruohomaa was very upbeat, partying with ASMP's first president, prolific *Life* magazine portrait photographer, Philippe Halsman, and photographers Ylla, Jerry Cooke, Betty Dick, and Andreas Feininger. A photo documenting the event appeared in the *SMP Bulletin*.[119]

The organization's mission supported photographers' responsibilities, rights, and credits. One early action on critically sensitive social issues included "an avowed disapproval of photographs promoting racial or religious prejudice."[120] In a 1944 meeting, ASMP

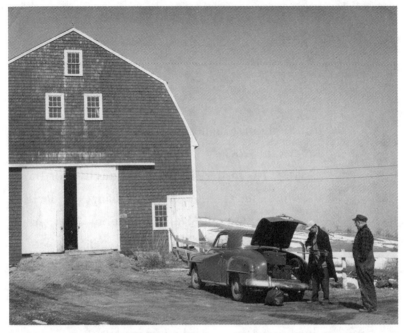

Ruohomaa packs his car while his father looks on, April 1952. (Robert Mottar)
(Lofman Collection, Maine State Museum)

organized "photojournalists" as a "new breed of concerned visual communicators."[121]

ASMP's monthly publication, first available in 1945 under the name *SMP Bulletin*, was renamed *Infinity* in 1952. *Infinity* became a valuable resource for members, with editorial features that opened doors for photographers, discussing the expanding market for published photographs. *Infinity* editorials focused on new photography publishing venues, such as advertisements, annual reports, nonprofit foundation brochures, book publishing, posters, record album covers, regional magazines, special interest periodicals, and national company magazines.[122]

Over the next seventeen years and thereafter, under Black Star's distribution, Ruohomaa's photographs would be represented in the above periodical types, and his whereabouts noted occasionally in the publication's "Grapevine" column.[123] Picture, ASMP's annual, a glossy magazine, first appeared in 1957. Picture reflected the latest techniques, reported on strides made toward picture format, and noted ideas developed by magazine photographers, especially the new "picture story printed without captions." In the 1959 issue, Kosti Ruohomaa introduced his feature, "Maine," with his photographs following on the next ten pages.[124]

Freelance photographers—whose nature and work ethic embraced independence and individuality—kept abreast of their contemporaries' addresses, assignments, travels, published works, exhibitions, competitions, and discussions of important professional, legal, and ethical issues through ASMP seminars and publications.

The Printed Image

Ruohomaa visualized how he wanted each of his photographs to appear in published form. Study of his photographs reveals that he was cognizant of his audience, and he wielded his skill and sensitivity with the use of existing light sources, reflected light, backlight, lamps, flash, blue bulbs, and strobe photographic lights to create or capture the mood of a subject's image. In addition to using natural light, he

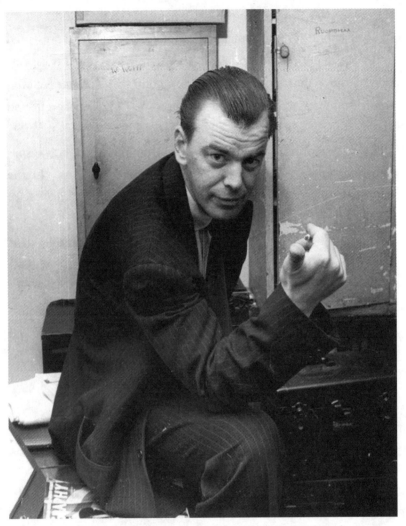

Kosti Ruohomaa at Black Star lockers, by Werner Wolff, 1956. (Black Star)

also "used a lot of bulbs,"[125] especially to dramatize and control the ambiance of a scene.

Personal notes reflect that he communicated with film processors, the second force to control the outcome of exposures. Though

magazine picture editors made the last call on the design of pages, contact sheets indicate that Ruohomaa outlined the composition of preferred frames to editors, directed how images should be printed, and employed red crayon marks on contact sheets to indicate composition and "burn in"—meaning to "bring out" certain elements, such as the sunlight of a dawn.[126]

An alternate and lifelong source of film processing for Ruohomaa was Modernage, a professional film processing and printing lab located in Midtown Manhattan and retained by Black Star.[127] Though he developed and printed personal projects in his simple darkroom on Dodge Mountain, beginning in 1957, Ruohomaa retained Modernage services for professional processing, and always included a trip to Modernage when he was scheduled to be in New York.

Founded by Ralph Baum, Modernage had a longtime connection to Black Star.[128] Former head manager Harry Amdur recalled the days when Black Star had its own darkroom. Once, when the "darkroom man was out," Ernest Mayer phoned Amdur to ask Modernage for "a favor," to develop and make prints for the company. Black Star, exceptionally pleased with the "beautiful quality" of the prints, closed down its darkroom labs and kept the services of Modernage. Amdur reflected as he recalled Kosti Ruohomaa's photographs: "I felt his stories were done with great taste and sensitivity; some almost poetic. I often wondered how this rough-looking six-footer with the leathery face could take pictures as sensitive as the ones I saw."[129]

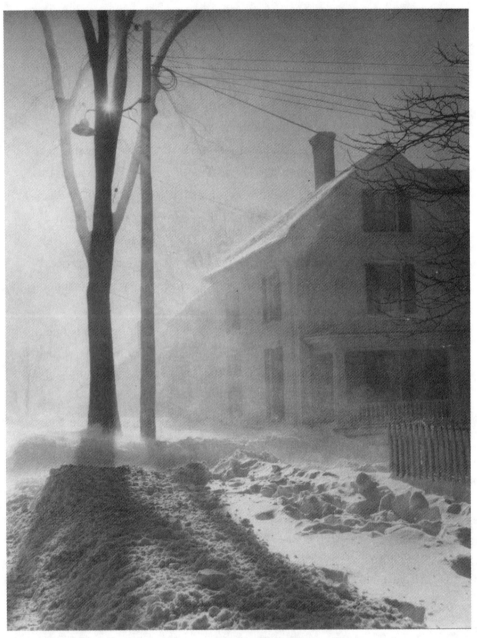

Reproduced in "A Superb Chronicler of the American Scene, Maine Winter," U.S. Camera Twentieth Anniversary Edition 1955, The Year's Best Pictures, American International, edited by Tom Maloney. (Black Star)

NOTES

1. Catalog, *The Art Center School* 1950–51, "History and Purpose": "furnished teams of instructors who supervised the training of personnel in military photographic establishments including Denver, Colorado, and Astoria, Long Island, New York," p. 15.

2. Though not returning to live at home in Maine, Kosti probably urged his parents to become citizens, a feat they accomplished on February 11, 1943. Ruohomaa citizenship records are held by the law offices of Crandall, Hanscom & Collins, PA, Rockland, ME.

3. Today, it is known as the Museum of Film. *A History of the U.S. Signal Corps.* "At the Signal Corps Photographic Center, Astoria, the animation was good, the work of skilled artists, many of whom were employed in Hollywood cartoon-comedy studios," pp. 168–73.

4. Wilbur Streech, former housemate and drawing-board colleague at Disney, left for New York after the strike to create his own films.

5. See Note 3.

6. Letter: James Moore, December 1, 1993, Ruohomaa's friend and *Portland Press Herald* photojournalist based in Rockland, ME. Moore noted the filmstrip had been "highly commended."

7. Contract between Kosti Ruohomaa and Black Star. Copy held by law offices of Crandall, Hanscom & Collins, PA, Rockland, ME.

8. "The Week's Work," *Collier's*, August 21, 1943, p. 68. The editorial described the thoughtful planning that went into the making of the cover picture by W. Eugene Smith (1918–1978), which Kosti surely studied. Smith's cover image focused on a newly manufactured propeller as it was hoisted out of a blazing furnace. Black Star contracted Smith beginning in July 1938, until he became a *Life* staff photographer in 1944. A Ruohomaa photograph made in Cape Hatteras, 1947, found in the W. Eugene Smith archives, suggested the two men crossed paths sometime in the late 1940s.

9. He had created such a clown-like caricature-type as early as 1939, the photograph held by the Farnsworth Art Museum. The process would be similar to the creation of *Oomph*.

10. "Still-Laffs," *Minicam Photography*, 1942; feature found in Ruohomaa's papers. These photographed 3-D figures were simply flat, as features applied were pasted; however, the saved article suggests a source that may have

inspired Ruohomaa's *Teapot Tempests*. Applied light and suggested malleability gave his caricatures a lifelike three-dimensionality. Christopher Finch, *The Art of Walt Disney* (New York: H. N. Abrams, 1973), p. 67. "Disney artists had learned to produce mood shifts in their characters' facial expressions and with just a slight alteration of a physical attitude."

11. "Pictures to the Editor," *Teapot Tempests* by Kosti Ruohomaa, New York City. *Life*, June 7, 1943.

12. Most likely, the Black Star Publishing Company knew of these caricature pictures submitted to *Life*, but Ruohomaa's enclosed published letter from New York verified it was a personal, independent move.

13. ". . . photographers fabricate, arrange, illuminate objects and their settings in order to create synthetic realities." Naomi Rosenblum, "Photography and Modernism: Surrealist Photography," *A World History of Photography* (New York: Abbeville Press, 1984), p. 431.

14. A 1939 Ruohomaa photograph of a 3-D characterization he constructed and photographed is held by the Farnsworth Art Museum.

15. Interview: Howard Chapnick, 1993, Black Star's president (1964–89). Years later Howard Chapnick remarked that the caricature photographs were "brilliant anthropomorphic personalities, the work of genius." Black Star holds negatives of this series, plus figurative interpretations of Hitler, Mussolini, and other clever creations. Three-dimensional still life and animation continued to fascinate Kosti; Black Star files reveal animated scissors, eyes, and forms made with camera accessories.

16. Tear sheets kept in Ruohomaa's scrapbook of this period document that Black Star distributed photographs of the caricatures to periodicals such as *Illustrated*, *New World Illustrated*, and *Minicam Photography*. Kurt Kornfeld, a widower faithful to the memory of his wife, never remarried. E-mail Yukiko Launois, September 12, 2009.

16. This and other cars owned by Ruohomaa sometimes appeared in the backgrounds of his pictures.

18. A portrait client, Pearl Primus (1919–1994), African-American modern dance artist, Hunter College instructor, lived in New Rochelle until her death. Black Star captions: *Pearl Primus* by Kosti Ruohomaa, undated. He photographed Primus after her performance was critiqued by *New York Times* reporter John Martin, who called her "the most exciting dancer of the year."

19. Yukiko Launois, New York City, served as Black Star assistant to Howard Chapnick. Launois e-mail, September 12, 2009. Yukiko, a longtime friend of

Kurt Kornfeld's, recollected: "He was very fond of Kosti." and "Kosti Ruohomaa was one of Howard's passions and great loves." Yukiko assisted Howard Chapnick in the 1970s with archiving Kosti Ruohomaa's photographs.

20. Letters from Ruohomaa files held in Lofman Collection, Maine State Museum.

21. Album 1944–45, Kosti Ruohomaa, Maine State Museum.

22. The Graybar Building skyscraper encompasses the New York City Grand Central terminal, its entrance on Lexington Avenue. Its Art Deco design embodies cables that represent a ship's mooring ropes complete with figures of rats creeping up the line. Dead Programmer's Café: "NYC Buildings You've Never Noticed: The Graybar Building," www.deadprogrammer.com, October 13, 2009.

23. Hendrik Neubauer, *Black Star: 60 Years of Photojournalism* (Koln [Cologne]: Konenman, 1996).

24. The original Certificate of Incorporation of the Black Star Publishing Company, Inc., was filed on December 23, 1935, in the New York Office of the Secretary of State.

25. Hearst published *Harper's Bazaar, Cosmopolitan, House Beautiful, and Good Housekeeping.* Safranski left Hearst for Black Star, where his ideas and business sense proved fruitful. C. Zoe Smith, "Émigré Photography in America: Contributions of German Photojournalism from Black Star Picture Agency to *Life* Magazine, 1933–1938." Unpublished thesis. PhD ILL8869. Graduate College of the University of Iowa, December 1983.

26. Smith, "Émigré Photography in America," p. 120.

27. Ibid., p. 119, quoted Howard Chapnick.

28. Ibid., pp 113–15; December 22, 1959. Howard Chapnick became secretary, Ernest Mayer, president. Black Star Publishing Company, Inc. Department of State, Albany, NY. *Certificate of Amendment to the Certificate of Incorporation.* Chapnick became president in 1969. Benjamin J. Chapnick, Howard Chapnick's cousin, became president of the company in 1993, and currently holds this position. Black Star moved to 116 East Twenty-Seventh Street at this time. In 2010, the company relocated to Westchester, New York.

29. Zoe C. Smith, "Black Star Picture Agency: *Life's* European Connection," *Journalism History*, XIII/1 (Spring 1986), p. 115.

30. Black Star photographers that appeared in 1940s *Life* magazine issues included F. Eugene Smith, Ralph Crane, and Fritz Goro.

31. Neubauer, *Black Star: 60 Years of Photojournalism*. See introduction, pp. 6–37, by Neubauer; also "Ordinary People, Extraordinary Lives," *Maine* by Kosti Ruohomaa, pp. 436–39.

32. *Life* fully credited the photographers and sources of its published images in the issue's masthead. Included were its staff and agencies such as Black Star, Pix Inc., Acme Pictures Inc., and other sources (e.g., AP [Associated Press] and WW (World Wide).

33. See Kosti Ruohomaa records. Crandall, Hanscom & Collins, PA, Rockland, ME.

34. Neubauer, *Black Star: 60 Years of Photojournalism*.

35. "I got into photography because I was completely bored with the movie cartoon-animation work I had been doing in Hollywood." Kosti Ruohomaa in picture caption: "Finest Photographs," *U.S. Camera*, 1947. Edited by Tom Maloney, "Yankee Farmers," p. 280.

36. March 27, 1945: A more-comprehensive contract indicated Ruohomaa's growth and success. Included were: weekly guaranteed raises and increased percentage earnings for all assignments. Upon the death of his mother this agreement was cut off from any estate, Black Star remaining the sole beneficiary of sales of Ruohomaa's photography. See letter of inquiry from Ruohomaa lawyer, Larry Bird. Kosti Ruohomaa files held by the law offices of Crandall, Hanscom & Collins, PA, Rockland, ME.

37. Letters: Kosti Ruohomaa personal files. Lofman Collection, Maine State Museum.

38. Kosti continued assembling scrapbooks and albums, now including tear sheets from published pictures in US and overseas magazines.

39. Ruohomaa contracts are held by Crandall, Hanscom & Collins, PA, Rockland, ME.

40. Ansel Adams taught at the Art Center School during the period Ruohomaa studied with Connell, suggesting he learned the zone system exposure method early on. A pencil-shaded copy made by Kosti found in his scrapbook. See catalog from the Art Center School 1939–40. *Ansel Adams: An Autobiography with Mary Street Alinder* (Boston: Little, Brown & Co., 1985), pp. 264–65. This author does not agree with the Black Star theory that Kosti Ruohomaa had little technical training, and that is why he tried techniques with the camera that others would not. Ruohomaa always knew what he was doing.

41. See "Remembering Kosti: A Memoir," manuscript by Alfred Gescheidt, New York City; appears in Appendix II.

42. He acquired a Linhof Master Technika in 1944 (it may have been a used model; see self-portrait, c. 1947), and later updated the model in the 1950s, as seen with the portrait made with this camera. Using packages of sheet film, it took hundreds of 4x5 outtakes to master large-format. Examples left from his first architecture *Life* assignments in New Orleans confirm this. Negatives are held in the Lofman Collection, Maine State Museum.

43. He actually always had two Rolleiflex cameras in his bag. In 1957 he acquired the Contax, and then a Pentax. For certain assignments, such as views of river drivers, fishermen, and aerials, Ruohomaa applied the 35mm.

44. Color negatives date from the 1944 *Minicam Photography* magazine work, but he used this film overseas, especially in Finland, 1948. Color transparency work dated from 1948 overseas. Slide transparency film, Anscochrome, which he sometimes used has discolored with time compared to his Kodachrome and Ektachrome.

45. By the mid-1950s, he ordered 8mm movie film from Black Star; receipts kept in his papers. He was noted in *International Harvester* editors' column as carrying a movie camera on his shoulder, but these films have yet to be found. One Port Clyde interviewee recalled seeing one of his films at a Tenants Harbor Library meeting. This author has yet to locate the films.

46. Occasionally buffered with researchers' notes, Ruohomaa sometimes included personal comments in his narrative, presented with the subject's history and factual information. Caption sheets were undated. Assignment dates had to be tracked down through publications. The 1950 coverage of artist-illustrator Norman Rockwell, titled "Norman Rockwell, The Man Who Laughs at Americans," is an almost-three-page, single-spaced biographical narration Kosti composed for twenty-three rolls of 35mm film captions.

47. A full row of double-height four-drawer file cabinets housed Ruohomaa's photographs in all media at Black Star. It was necessary to access the upper drawers with a ladder. This body of work compared to a single drawer or a few files attributed to housing the remaining Black Star library of photographers' files.

48. Typed pink sheet copies of captions made from original penciled notes are undated. Ruohomaa's financial accounts held by Ernest Mayer were lost, apparently due to the company's moves, by the time this author began Black Star research in 1993. Dates were found through Time Inc. and magazine page turning, though of course one assignment would sometimes appear in more than one publication over a year's time.

49. Ruohomaa apparently was delighted to have "a pretty researcher," Carolyn Jean Polacheck, on board for assignment locations. There are a number of pictures of the two taken together in New York, Connecticut, Massachusetts, and Pennsylvania.

50. His personal library held a notable collection of the WPA series "American Guidebooks" to individual states. They included Vermont, Virginia, Massachusetts' Berkshires, Colorado, New Mexico, Washington, and Oregon, all locations for assignments.

51. Ruohomaa covered the Finnish community in Brooklyn, though it appears this work was never published.

52. *Time*, May 22, 1944. "Jerome Robbins with Janet Reed." Kosti Ruohomaa from Black Star. Selected images from this early material appeared years later in 1959, *Amerika Illustrated*. Tear sheets in Ruohomaa's scrapbook. *Fancy Free* recently returned to stage, *New York Times*, 2012.

53. University of Pennsylvania, Philadelphia. "Marian Anderson Collections." Anderson's farm, named "Marianna," a Finnish name, may have nurtured Ruohomaa's interest in the singer.

54. Margaret Webster (1905–1972), actress, producer, director. Margaret Webster Shakespeare Co, her book: *Shakespeare without Tears*, 1942. Through this meeting Ruohomaa also photographed Paul Robeson, who was engaged by Webster for a major role in her Shakespeare production of *Othello*.

55. Tear sheets kept in scrapbook of this period.

56. *Technology Review*, November 1944, cover, one interior view, a design. Tear sheet in Ruohomaa scrapbook.

57. MoMA.org/archives. James Thrall Soby and US Navy servicemen chat in a gallery at a Museum Servicemen's Party, fall of 1943.

58. Richard Pousette-Dart. By 1944 Pousette-Dart was included in MoMA's Abstract Painting and Sculpture survey. *The New International Illustrated Encyclopedia of Art*, vol. 16 (New York: Greystone Press, 1970), p. 3381. Carved finished wood sculpture, unidentified artist.

59. Cover tear sheet kept in Ruohomaa's scrapbook. A copy of the August 1944 *Minicam Photography* issue also found in the Will Connell Archives at the University of California, Riverside.

60. Kosti Ruohomaa captions. "Norman Rockwell in Massachusetts," undated Black Star files.

61. Letter: photography editor Warren Trabant, Paris, France, January 25, 1994.

62. Ibid: "*Parade*, which started about 1942; Black Star provided almost all the pictures for the first few issues. It was a sort of offspring of the newspaper PM. I met Kosti when Mr. Kornfeld brought him into the agency [Black Star], where I was an editor."

63. See Ruohomaa scrapbook of 1944 period for *Parade* tear-sheet examples. Lofman Collection, Maine State Museum.

64. Memo documenting the assignment was pasted in Ruohomaa's scrapbook of this New York period. Lofman Collection, Maine State Museum.

65. Time Inc. assignment cards provided by Robert Stevens, formerly Time Inc. overseas editor, and *Life*'s former librarian's records, plus personal page-turning of *Life*, *Time*, and *Fortune* magazines, provided this information.

66. See *Life* vol. 21, no. 22, November 25, 1946. "Tenth Anniversary Issue," Table of Contents.

67. *Life*, tenth anniversary issue, vol. 21, no. 22, November 25, 1946. First staff photographers were Margaret Bourke-White, Alfred Eisenstaedt, Peter Stackpole, and Tom McAvoy.

68. This information provided by the *Life* librarian to the Farnsworth Art Museum, Rockland, Maine, solicited after the Kosti Ruohomaa donation by James Moore in the 1970s. Time Inc. also published *Time*, *Fortune*, *Sports Illustrated*, *House & Home*, and *Artforum* magazines, the *New York Times*, and later, *Silver Burdett* (science, history, and nature) education books. Ruohomaa's photographs appeared in all of these publications.

69. To movie audiences, in advance of the main feature, "The March of Time" gave weekly film updates of national news and overseas warfront actions.

70. Arthur Goldsmith, *Photojournalism* (Westport, CT: Famous Photographers School, 1965), pp. 80–127.

71. See *W. Eugene Smith and the Photographic Essay*. Note 68. "Several Black Star photographers also worked for *Life* and later found to move on to become *Life* staff photographers," p. 316. Note 68: For one year *Life* contracted Kosti Ruohomaa, September 1, 1946 to August 31, 1947. Until 1957 he was introduced in the feature as *Life*'s photographer "goes to" or "*Life* sent photographer Kosti Ruohomaa" in major features. December 22, 1961, a month after his death, *Life* memorialized Ruohomaa with his photograph of the western mountains as a two-page spread to accompany the editors' message of the Special Edition exploring the magnitude of America's land. The photograph had been taken for the Whitman 1955 essay, *Leaves of Grass* centennial. He was featured twice in the *Life* masthead biographical photo insert from

1944–1961, had five covers, and was noted for his cover material in three "Life's Cover" notations.

72. Time Inc. record furnished to this writer, summer 1994, by Robert Stevens, overseas editor, Time Inc., Currently with the International Center of Photography, New York.

73. See Appendix III for an inventory of Kosti Ruohomaa's Time Inc. photography assignments.

74. Kosti Ruohomaa applied to the US Navy, summer of 1942, in Portland, Maine, but was rejected. This record has not been found.

75. "How these pictures were made," *U.S. Camera*, vol. IX, no. 1, February 1946. The editors commented of the sixty-second exposure, "Black Star's ace photographer Kosti Ruohomaa of New York." He revisited this idea when out west covering California's Mount Rose skiers. He captured the skiers at night as they moved in patterns downhill, flaming torches in hand. See Speaking of Pictures, *Life,* January 5, 1948 (photographed in 1946).

76. Robert P. Tristram Coffin (1892–1955), at the time, Bowdoin College professor and poet; Dan Longwell (1899–1968).

77. Manuscript sent to Wilson Hicks in early 1962, to add to Chapnick's 1962 narrative, "Farewell to a Gentle Fellow." Wilson Hicks taught photojournalism at the University of Miami. The tribute was first published for the New York Camera Club, Kosti Ruohomaa Memorial Exhibition, January 1962.

78. Robert P. Tristram Coffin with Kosti Ruohomaa in the masthead portrait of this issue, on location in Brunswick, Maine. *Life,* vol. 18, no. 7, February 12, 1945, p. 21.

79. From August 1946 until September 1947, Kosti photographed exclusively for Time Inc. See Appendix III for Time Inc. record, including *Life* magazine titles and dates, and the Time Inc. Ruohomaa index card record, a copy generously provided by overseas editor Robert Stevens.

80. *Life,* March 25, 1946. New Orleans Mardi Gras. Negatives reveal he made many "outtakes" or "unusable films" before his success with the view camera.

81. American Architecture, and Evolution of American Architecture. Photographed 1945, appeared in *Architectural Forum*, February 1957, December 1957; *House & Home,* April 1957.

82, During 1945, Ruohomaa covered thirty *Life* assignments; the "Fall Landscape," October 29, 1945, cover.

83. Kosti Ruohomaa and Black Star actually agreed to stop guarantee pay-

ments on April 2, 1959. Ernest Mayer letter of response to Alan L. Bird, lawyer representing Selim Ruohomaa, Rockland, Maine, January 9, 1962.

84. Evidence of these shares, if indeed Kosti Ruohomaa purchased them, has not been found.

85. Chapnick letter (copy) to Richard M. Ketchum, *Country Journal*, and Doubleday & Company, August 23, 1971.

86. "the home front, as it was called" (also by Howard Chapnick, to describe Ruohomaa's work) of wartime; *Life* assignments, June 1941, Jim Hughes, *W. Eugene Smith: Shadow & Substance: The Life and Work of an American Photographer* (New York: McGraw-Hill, 1989), p. 64.

87. *Life,* May 27, 1946, p. 139. "The sixty-year-old country philosopher on this week's cover by Kosti Ruohomaa is Tom Moss, one of the Ozark characters Leonard Hall talks about in his widely read *St. Louis Post-Dispatch*. Tom is a farmer and lives with his wife on a remote 120-acre patch deep in the Ozark hills of southern Missouri, eighteen miles from the nearest store. Life on Tom's farm is not easy. It has generated in him, as in most of his neighbors, a fierce and abiding spirit of independence."

88. Cover, *Life,* May 27, 1946. "*Life* Visits the Ozarks," pp. 138–41.

89. http://en.wikipedia.org/wiki/William_Cowper (1731–1800), October 28, 2009.

90. See "God Made the Country" captions by Kosti Ruohomaa. Black Star.

91. Howard Chapnick, "Farewell to a Gentle Fellow," 1961. Manuscript prepared for a memorial exhibition at the New York Public Library, January 1962.

92. *Life,* June 16, 1947, cover, feature, pp. 132–137.

93. Ibid.

94. Selected by Studio One for its published mounted photographs in the 1980s. See Plates, Surrealism.

95. David Burkett, "The Lively Arts: The Image-Maker," *The Washington World.* "Kosti Ruohomaa died in 1961, leaving a legacy of expression through photography that is startling in its brilliance."

96. Kosti's closeness to Kurt Kornfeld was described in a 1993 interview with Howard Chapnick. Interview: Mike Nevelson, his longtime friend from Dodge Mountain days, noted that after a dinner together in the city, Kosti would take a taxi to stay at "Papa" Kornfeld's.

97. Letter from Carl Mydans, December 4, 1994. See Appendix III for Kosti Ruohomaa's Time Inc. assignments, both published and unpublished.

98. Ruohomaa was nationally recognized for his New England photography (New York State to Maine) and the "high quality" of his work, imbued with the approaches of an artist and poet to photographic subjects made across the country and in Canada.

99. "Farewell to a Gentle Fellow," Narrative by Howard Chapnick and Wilson Hicks at New York Public Library exhibition and published in *Contemporary Photography*, January 1962. Manuscript held in Kosti Ruohomaa archives, Black Star.

100. Ibid.

101. Wilson Hicks, *Words and Pictures: An Introduction to Photojournalism* (New York: Harper & Brothers, 1952).

102. Somers, New York: Interview with Howard Chapnick, retired president of Black Star, December 3, 1993. Wilson Hicks was one of a few for whom Kosti Ruohomaa printed personal New Year's postcards, 1959–60.

103. Interview: John G. Morris, Paris, France, 1995.

104. *Ladies' Home Journal,* 1948.

105. Shad Fishing, Bay of Fundy, 1949. *Life*, May 21, 1951, *Life International*, June 4, 1951.

106. Eric J. Sandeen, *Picturing an Exhibition: The Family of Man and 1950s America* (Albuquerque: University of New Mexico Press, 1995), p. 55.

107. *Life*, February 14, 1955. See Appendix III for Time Inc. listings, 1944–57. He also covered civic events in Denver, but the Fraser story was published.

108. "The Paths Whitman Walked: Poet's 'Leaves of Grass' Has its 100th Anniversary." *Life*, June 20, 1955, pp. 114–121.

109. The month following Ruohomaa's death in 1961, *Life* used the Colorado photograph of the western mountains on the editors' introductory two-page essay, "The Land," December 22, 1961, pp. 14–15. This could be considered a memorial to the photographer who had died in November of that year.

110. See Appendix III for *Life* records.

111. Guides he no doubt devoured before this trip: *Oregon, End of the Trail* (Oregon State Board of Control: American Guide Series, 1940), and *Washington: A Guide to the Evergreen State* (Washington State Historical Society: WPA, 1941). Author has not reviewed all slide sheets and contacts from this extended trip.

112. Letter to Selim Ruohomaa from Ernest Mayer in 1962 gave the date of April 1959. Crandall, Hanscom & Collins, PA, Rockland, ME.

113. Letter: Richard Ketchum, American Heritage, 551 Fifth Avenue, New York 17, New York. To Mr. Kosti Ruohomaa, Dodge Mountain, Rockland, ME, August 28, 1957.

114. Ruohomaa's library included a copy of Matthew Brady's and Brady Studios Civil War Battleground photographic studies.

115. Letter: Selim Ruohomaa to ASMP, the day after his son's burial, November 8, 1961.

116. Letter: Response to Kosti Ruohomaa from Yvonne Freund, ASMP secretary, 1961.

117. First ASMP meeting, with thirteen photographers in attendance, was held on October 13, 1944, at "Ewing Krainin's penthouse at 538 Fifth Avenue." Original idea was that there was a need for "a club" born out of a 1942 conversation between photographers Bradley Smith and Ike Vern and critic John A Knight. www2.asmp/hist.html#anchor 12/12/96. Ruohomaa was included in the photo of the September 1946 party, published in "The Good Old Days," Infinity, Christmas 1957, pp. 20–21.

118. Letter: Kay Reese, New Rochelle, NY, in response to this author's inquiry, August 19, 1996. Reese was a founding member and former executive secretary of ASMP, and today is an honorary member and historian.

119. Ibid.

120, Ibid. "I know that Kosti was a 'founding member,' and I still regret that I did not have a chance to meet him"; "The Good Old Days," Infinity, Christmas 1957, p. 21.

121. Ibid., p. 22.

122. Sixty years of ASMP (https://asmp.org/pdfs/bulletins/2004/fall04.pdf).

123. Kosti was among those members whose travels were traced in the ASMP newsletter "Grapevine"column. The SMP Bulletin was created in 1948.

124.. "Mardi Gras, New Orleans," Life, March 25, 1946, pp. 136–38, 141.

125. "Maine" by Kosti Ruohomaa. Picture, ASMP annual, 1959. See Appendix II.

126. "Remembering Kosti," manuscript by New York City photojournalist Alfred Gescheidt, 1994, in response to my ASMP Alumni Newsletter inquiry. See Appendix II.

127. Richard Rose and Bernard Quint were among the designer-printers of Ruohomaa's images for Life.

128. Unfortunately, neither Ruohomaa nor Black Star dated caption sheets.

Financial records were lost during Black Star moves. Dates were matched later through research of published magazine pages and the Time Inc. library records. Ruohomaa regularly corresponded with Howard Chapnick, who had advanced to an administrative position in Black Star after the war. Life printers and designers of Ruohomaa photos included Bernard Quint, Richard Rose, and George Karas.

129. Modernage processed the photographic prints for the 1998 Kosti Ruohomaa / Porin Taidemuseo exhibition in Pori, Finland.

IV.

Folkways and Folklore

Kosti Ruohomaa was always in contact with his New York agency via phone and mail, even when he was home in Maine, settled in his mountaintop aerie on Dodge Mountain, with new projects occupying his mind.

The language of folklore had long held Ruohomaa's interest.[1] In 1948 he added to his library the first edition of *A Hog on Ice and Other Curious Expressions* by Charles Earle Funk, an anthology of "sayings and expressions used in everyday language over the years." In the introduction, Funk discussed the origins of "to be independent as a hog on ice." Fascinated, Ruohomaa planned to interpret the saying in a reenactment with his camera. On March 13, 1950, the image was published across a double page in *Life's* "Speaking of Pictures."[2]

Orchestrating the project, a self-assignment at tiny Benner Pond in west Rockport, Maine, Ruohomaa remembered, "All went well except for the factor that our friendly hog needed considerable help to get on the ice. Thereafter, he just went into this spread-eagle pose, completely helpless and unable to move." He wrote:

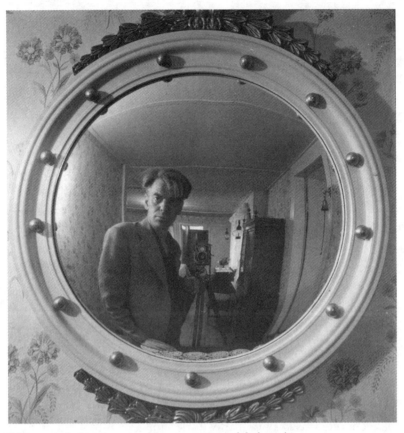

Self-portrait: looking into girandole mirror, 1946. (Black Star)

Independent as a hog on ice is a term often misused, in that it is at times used to mean that one is cockily independent and overly confident. To prove that such a translation is completely wrong, I, and some astute operators who will never receive awards for their interest in this type of scientific research, decided to prove or disprove the axiom once and for all. We prevailed upon a friendly hog to let us chauffeur him to a little skating pond near Rockville, [Maine], and partake of the joys of a Sunday on ice.

All went well, but our friend was in need of considerable assistance to get on the ice, and for that matter, in need of considerable assistance to be escorted off the ice. Our helpful friend the hog found himself completely helpless, and if there was any independence, it was not made apparent. Lest the SPCA worry about this, our friend lived comfortably to a ripe old age, completely cured of this neurosis of wondering, just how "Independent is a Hog on Ice," it ain't![3]

Life's editors titled the feature, "New England Folklore, Enactment of Sayings, A Study of Utter Helplessness."[4] Alfred Gescheidt, twenty-four, at the time a Black Star photographer, had just come east to New York City out of the Art Center School in Los Angeles. Gescheidt expressed his admiration for Ruohomaa's photography. By then, in 1950, Ruohomaa had earned a reputation as Black Star's "ace" photographer. Though Gescheidt's account mistakenly assumed it was a *Life* editors' assignment, he remembered the hog image as a "wonderful photo that ran as a double page."[5]

Fascinated with the folklore and folkways of New England country people, Ruohomaa continued to make photographic interpretations of both over the years. In this body of work he demonstrated the motivation of an artist and a poet. These enterprising self-assignments revealed Ruohomaa's literary imagination as he interpreted his ideas through his camera's lens.

Ruohomaa made his first folklore photographic reenactments in 1945. He was invited to spend the weekend with New York author and film producer Phillips H. Lord and family on his seasonal estate in Bartlett Island, Maine. Like his minister father, Bowdoin graduate Phillips Lord had a longtime interest in, to use

his words, "the rustic sentiment and virtues" of Down East folks. This became the resource material for Lord's radio character, "Seth Parker."[6] Years earlier, Lord had produced a book and movie, *Way Down East*, based on the Maine country life of his character, Seth Parker, whom he played, with then sixteen-year-old Bette Davis.[7]

Ruohomaa embarked on the weekend stay, taking the private ferry-barge from the mainland with his host, Phillips Lord, his three New York City companions, the island caretaker, and two cows bound for new grazing land. It appears that as soon as the ferry touched shore, Ruohomaa's ideas materialized.

The four days with Lord and his entourage of New Yorkers inspired picture after picture at the nineteenth-century island farmstead. Ruohomaa's camera appeared to be ever present, composing scenes that captured the changing moods and spirit of the talented New York City–based group, enjoying a weekend hiatus. Ruohomaa explored the island's working farm and its historical sites with Lord, following sunlit paths against the distant background of Mount Desert seen resting beyond the bay.

The island's caretaker assisted Ruohomaa in depicting the expression "to look a gift horse in the mouth." With seeming ease, probably well aware of the saying, the caretaker urged the horse's jaws to open, revealing a full set of teeth at just the right angle for Ruohomaa's shutter release.

In his ongoing quest to reenact and interpret local folklore and folkways, Ruohomaa, a subjective photographer, felt comfortable with family, friends, and people of his region. He looked to Maurice Stanley Powell, a longtime Dodge Mountain farmhand and family friend, to become his first "actor." Powell was from South Liberty, Maine, sometimes noted as nearby Washington, Maine. At this point in his seventies, Powell had been appearing in Dodge

To Look a Gift Horse in the Mouth. *Caretaker assists Ruohomaa in creating the scene, Bartlett Island, Maine, 1945. (Black Star)*

Mountain photographs since 1926, portrayed in Ruohomaa's early haying and blueberry-raking pictures, taken when Kosti was a teenager.

Powell's personality, appearance, and obvious patience and willingness to cooperate, fulfilled a quest for several folkways characterizations. In Jacob Deschin's 1945 book based on the roles the Rolleiflex camera plays in photojournalism, in the caption to a scene he directed and composed for *Bluer'n a Whetstone*, Ruohomaa wrote fondly of farmer Powell. Ruohomaa expressed his philosophy and respect for those who work close to land and sea:

> The day of photographing the farmer as a hick passed a
> long time ago. I have not tried to make a hick out of him,

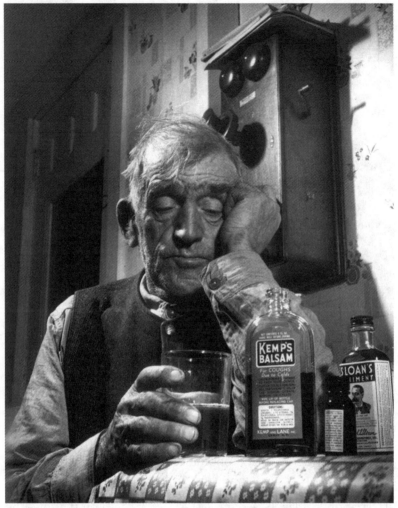

Bluer'n a Whetstone, *Maurice Stanley Powell,Washington, Maine, 1945*
(*Black Star*)

though I have gone out of my way to try to catch what is
left of the old character and his ways. Some of my pictures,
such as that of Stanley Powell of Washington, Maine, a New
York editor would caption, "typical Maine farmer." This is
not so at all; he is a rarity, the exception. He is among the

last of a breed. When this type is gone they will not come again. . . . The world as we know it is forcing out individuality. The only ones left resisting this change are creative people—artists, writers, sculptors. The farmer and the fisherman also fight hard to be individuals, and it is my feeling they are more successful at it than the creative person.[8]

Stanley Powell up in Liberty (abutting Washington) was one of the last of that fast-disappearing breed, the old-time Yankee. I used to call on Stanley whenever I was in that neck of the woods, for he was full of good stories, witticisms, and observations gathered in three-quarters of a century in those parts. This particular day when I drop in, I see Stanley looking like this and ask, "What is the matter?" Stanley replied he felt "bluer'n a whetstone" and had to stick to "spoon victuals" until he got rid of this cold, and to be rid of it was "harder than haulin' a hog out'n a scaldin' tub," or, in other words, he was having a hard time getting rid of the cold and had to stay on a soft diet, and the whole affair made him feel extremely dejected. But having a potion of that medicine obtainable at Green Front stores in Maine, we tossed down a few hefty slugs and before the hour was up, Stanley was no longer in a "blue funk."[9, 10]

Ruohomaa observed people at work and leisure, but also listened attentively to their manner of expression and choice of words, noting on index cards their short, pithy comments sometimes edged with a philosophic bent. For example, while sardine-seining off Vinalhaven, a seaman commenting about the heavy fog said, "It's so durn thick y'un can't spit."[11]

Ruohomaa's undated narrative, "Down East Sayings and Yankeeisms," touches on this subject: "In the course of years it has been my privilege to wander hither and yon around the state [of Maine]. The language and apt phraseology has intrigued me, as well as the philosophy of weather poetically diagnosed. As someone has said, 'Everybody talks about the weather, but no one does anything about it.' I think it goes further than that in Maine, for they not only talk about it, they curse and praise it in rich and colorful language, and this language is applied to many other subjects, which I have tried to portray in this set of pictures."[12] Ruohomaa had done his homework and gathered ideas for "Weather Lore." Unfortunately, most of the pictures remaining in his papers are unclear, although a few can be identified.

Ruohomaa discovered situations and also planned reenactments that sometimes became productions of sorts, such as his photograph of the general store in Weston, Vermont. In 1946, while stopping by the Vrest Orton village store, he convinced two elder gents to pose at a game of checkers, the game board set up on an oversize wooden barrel. His careful lighting included the players, the building's character, its its posters and signs hanging from the ceiling, and the old Yankee village store's lavish display of offerings.[13] The setting—long an itinerant photographer's fare, as seen in the framed pictures on the store's walls—and Ruohomaa's careful lighting of the subject matter creates a full-scale production shot.[14]

Ruohomaa proposed a "Vermont Yankees" series of location portraits to Black Star that he would track down in the state "near St. Johnsbury." The goal would be to "symbolize the down-to-earth Yankee individualist," the "few who are devoted to old methods and old traditions." He explained that the complete set of photographs "would give the feeling of vanishing Americana."[15] He

suggested men pictured at work in their craft, couples in their shop or general store, and at home. He returned to visit a town from his childhood, Chester, Vermont, where he covered people gathered at a country auction.[16]

Guildhall, Vermont, a shire-town village located in the northeastern part of the state, with gravestones that dated to 1764, was the site of a photograph that Ruohomaa made at the general store and post office, titled *Yankee Farmers*. The 1946 view appeared across two pages in the hardcover annual, *U.S. Camera 1947*, in the section titled "Finest Photographs," selected by Edward Steichen.

Ruohomaa made a study of folkways while photographing a full day of the town meeting in Washington, Maine, 1945. Meetings take place throughout the state in early March. At Washington, his work revealed his patient ability to wait for a significant moment to release the camera's shutter, resulting in a series of poignant visual records. He portrayed the unselfconscious expressions of these people,[17] from their studied attention to the seriousness of the meeting's agenda to their peculiar ability to buffer the important with jocular exchanges.

After 1957, when he had changed his Black Star contract to have more personal freedom to pursue a wide range of projects, Ruohomaa began to coproduce folklore interpretations with his friend, sculptor and pilot George Curtis. He had earlier enlisted Curtis's flying skills for assignments such as the "Fish Spotter" story for the herring industry, seen as a 1953 *Life* feature. Curtis flew Ruohomaa in an open-cockpit Piper Cub to photograph a preplanned scene of fishermen posed while attending a herring seine in Penobscot Bay.[18] They also flew a nearby side trip over Dodge Mountain to capture the homestead properties.

Personal files indicate Ruohomaa cooperated with Curtis to

reenact phrases to be photographed. The ideas were not all success-ful as images, but when the composition, atmospheric elements, and light combined successfully, several resulted in convincing por-trayals of the folklore expressions. Some of the titles attempted were: *To Eat Crow, Thumbs Down, The Itch to Travel, To Fish or Cut Bait, Fat is on the Fire*, and *Hair of the Dog that Bit You*. Curtis played the central sub-ject in these images, composed to dramatize and entertain. Each scene was thought out as either a studio or location shot, in which the surrounding atmosphere was controlled with lighting, compo-sition, and the easy acting skills of George Curtis.[19] Both creative, the two had a natural rapport, were equally inspired with ideas, and were able to provide open and honest feedback with each other.[20]

Ruohomaa's subjective folkways depictions were of the peo-ple he knew, country types from the rural Midcoast Maine area. He depicted his sitter for a portrait, whether indoors or outdoors, in a closely composed view that contained only the attributes necessary to realize the uniqueness and character of the subject. This had come to represent his signature approach to a location portrait.

In his 1962 remembrance, "Farewell to a Gentle Fellow," Howard Chapnick recalled a critic who referred to Kosti Ruohomaa as the "Boswell of the New England Character."[21] In these location portraits, Ruohomaa arranged his composition in order to place the subject comfortably within familiar settings. He used light-ing—sometimes many bulbs from a number of different sources—to control the subject's poise and attitude, to keep an easy, familiar atmosphere, but also to permit the nuances of the subject's person-ality to be visible. He began this work before 1950, making a modest number of sensitive, thoughtful, character-type portraits of local people.

Elder Helen York posed in her sitting chair at home in

Rockland, an image Ruohomaa first titled *Maine Matriarch*, then, later, *New England Matriarch*, suggesting his broader objective. The contact sheet of this shoot indicates the care taken to direct the sitter and the lamps, to capture the natural poise, even charm, in this reserved portrayal. Both gesture and demeanor became overriding elements in this representation.

Longtime seafarer Captain Hawkins still retained his robust, authoritative bearing, seated in his Owls Head study, surrounded by personal and historical relics. Edward Matthews, farmer and town of Warren selectman, posed while reading the newspaper; behind him loomed a grandfather clock marking noon, the time to stop work for a hot country dinner. Sid Barrows, west Rockport farmer, was photographed atop his reaper as if he had stopped for just that moment, a flash illuminating his deeply lined, tanned face framed in a wide-brimmed straw hat.[22]

Like an archivist with a mission, Ruohomaa created views of his subjects that would lock their image into their time period.[23] He even singled out a close-up view of Maurice Stanley Powell, corncob pipe in mouth, focusing his look at the camera's lens.

Throughout his journalistic work, this intimate approach captured a material culture linked to the portraiture.[24] Ruohomaa valued the peculiarities embedded in the everyday behavior and posture of people, whose home life and daily work brought them close to the land and sea, their lives dictated by the uncertainty of weather. Seasonal climate alone guided their daily concerns and activities.[25]

Among Ruohomaa's serious folkways studies were children. His essay, "Maine Schoolboy," which he felt was strongly autobiographical, became a *Life* cover and essay, published on February 2, 1948. His storytelling pictures recalled his many personal experi-

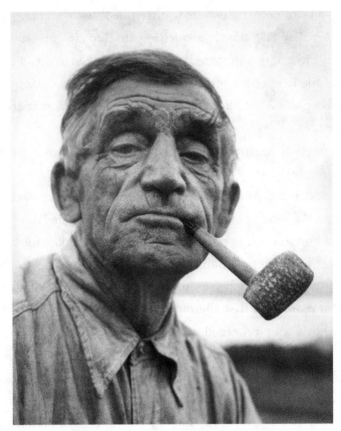

Maurice Stanley Powell, farmer, South Liberty, Maine, 1958.
(Black Star)

ences walking to and from school through rural countryside as a young boy. The idea apparently jelled during a visit in January 1948 to the Dodge Mountain homestead.[26] After a review of contact sheets, one can visualize an animator's storyboard sketched out in advance, indicating sites and stops to be made on the boy's trek. The storyboard pad, a planning tool acquired from the Disney Studios animation exercises, was applied by Ruohomaa when planning in-depth photography assignments.[27, 28]

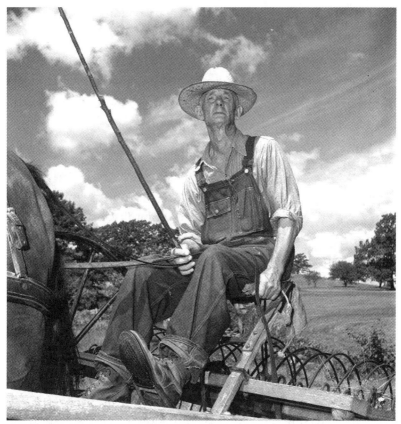

Sylvester "Sid" P. Barrows, farmer, West Rockport, Maine, 1950. (Black Star)

Ruohomaa photographed one full day at a one-room country schoolhouse in the small village of Rockville, Maine. Most likely his personal memories guided his camera as he followed the day's schedule. A general audience, human interest assignment, his lens focused on ways of teaching, learning, and play that had almost vanished from the contemporary cultural scene.[29] His studies revealed careful lighting in order to maintain a natural, unselfconscious atmosphere as he photographed with his quiet 35mm Leica.

His youthful subjects, multiage elementary children in their wood-stove-heated classroom, seemed unfazed by the camera's presence. He documented the young students as they presented their work, read, discussed, worked on lessons, ate lunch, and played outdoors during recess.[30] He began with morning exercises and views in black-and-white and color of the children saluting the flag. Scenes from this work appeared as a piece in the *Boston Globe Sunday Magazine*.

Each of the thirteen scenes in Ruohomaa's series, *Children Playing in a Barn*, tapped into his imaginative ideas and technical skills. In a "directorial mode"—a viewpoint discussed by photography historian and critic, A. D. Coleman, in a 1976 article—"A photographer consciously and intentionally creates events for the express purpose of making images, thereof. This may be achieved by intervening in ongoing real events or by staging tableaux . . . causing something to take place which would not have occurred had the photographer not made it happen."[31]

In the case of this series, the action took place in the Ruohomaa family barn. Ruohomaa controlled the making of the image by directing the coordinated motion, timing, and immediate foreground to distant background, as well as controlling the shutter speed, aperture, and exact moment of shutter release.

These personal pictorial studies of rural people and his memoir as a schoolboy were Ruohomaa's last before leaving on an overseas trip for eight months, where he would travel on assignment in the United Kingdom, Europe, Scandinavia, and North Africa.

NOTES

1. Ruohomaa's interpretive photographs actually began in 1945 during a photo-shoot weekend at the Phillips Lord estate on Bartlett's Island. Here he made *To Look a Gift Horse in the Mouth* and *To Know the Ropes*, photographs kept in his files. Lofman Collection, Maine State Museum.

2. New England Folklore, Enactments, "Speaking of Pictures." *Life*, March 15, 1952, pp. 22–23.

3. Ruohomaa noted in his files: *A Hog on Ice* by Charles Earle Funk (New York: Harper, 1948); and *A Treasury of New England Folklore* by B. A. Botkin (New York: Crown, 1944).

4. The photography was actually initiated three years earlier, in 1947. *Life* index card #25283, March 13, 1950, pp. 22–24.

5. "Remembering Kosti: A Memoir," by Alfred Gescheidt, August 1996: A valuable personal narrative sent to this author in response to an ad placed in the ASMP alumni newsletter. With the gracious permission of Mr. Gescheidt and his estate in 1996, the full four pages are included in Appendix II.

6. Phillips H. Lord, *Seth Parker and His Jonesport Folks: Way Back Home* (Philadelphia: John C. Winston Company, 1932).

7. Ibid; Seth Parker, created and played by Phillips H. Lord, RKO Radio Pictures; also starring Bette Davis, produced by William LeBaron, screenplay by Jane Murfin, directed by William Seiter.

8. Published in *Rollei Photography: Handbook of the Rolleiflex and Rolleicord Cameras*, 2nd ed., by Jacob Deschin (San Francisco: Camera Craft, 1945), "The Rollei at Work: Farm," by Kosti Ruohomaa, p. 108.

9. Kosti Ruohomaa's 1958 file, " N.E. Folklore and Folkways." Maine's Green Front stores sold liquor. Lofman Collection, Maine State Museum.

10. His layout on a storyboard sketchpad kept from his days at Disney suggested photographs to complement sayings. From his collection, Lofman Collection, Maine State Museum.

11. Index card: Vinalhaven, Fishing, noted by Kosti Ruohomaa. Lofman Collection, Maine State Museum.

12. One selected weather-inspired photograph portrayed a full moon passing through cumulus clouds, seen here and in the foreword. This set related to weather lore found in Kosti's personal papers. Lofman Collection, Maine State Museum.

13. Ruohomaa's photograph remains one early image of many made later

over the years at the Weston Center Store. His caption gave a history of family ownership that dated to the nineteenth century.

14. Personal visit by this author in 1993 revealed later magazine tear sheets framed and hung at the shop still offering country wares.

15. Undated caption by Kosti filed at Black Star of a "Vermont Yankees" proposal that included his suggested itemized picture series, compiled in an undated letter to Howard Chapnick, Black Star.

16. Kosti's introduction gave the history of the Weston, Vermont, village store, still owned by the Orton family and in business today, with several props still hanging from the ceiling.

17. Personal library: *Yankee Yarns: Stories from the Northeastern States*, 1st ed., compiled by Wilhelmina Harper (New York: E. P. Dutton, 1944); *Vermont: A Guide to the Green Mountain State*. Federal Writers Project, WPA (Boston: Houghton Mifflin, 1937).

18. *Life*, #40352, 1953: "Fish Spotter, Sardine Industry, Maine."

19. Interview: Lucille Curtis, August 25, 1998. Curtis's self-made character, "The Commodore": He dressed in a derby hat and black cape, and occasionally appeared in a monthly *Yachting Magazine*, a humorist-illustrated column. "They [Kosti and George] had a lot of fun together."

20. Interviews: George Curtis, Cushing, Maine, 1993, 1994.

21. "Farewell to a Gentle Fellow," manuscript by Howard Chapnick, 1962; contains Boswell quote. Black Star files.

22. The Matthews study won first prize in Chevrolet's *Friends* magazine, 1958.

23. How choices for this work were found remains unclear; for others, he called upon people familiar to him.

24. See "Farewell to a Gentle Fellow" by Howard Chapnick, 1962. Although their names are lost, their images last.

25. Ruohomaa kept files of notes related to the weather and notes he jotted on index cards during assignments. Lofman Collection, Maine State Museum.

26. By January Ruohomaa had obtained his passport prior to a planned and extended trip abroad, and could have reasonably started moving out of his Parcot Street, New Rochelle, New York apartment.

27. Ibid.

28. A storyboard pad from Disney Studios days found in Ruohomaa's archives contained sketches of proposed folklore sayings, illustrated with his photographs, for an article or book, suggesting his continued use of this handy animator's tool.

29. Exceptions may be schools on Maine coastal islands, such as Vinalhaven and Monhegan.

30. Ruohomaa switched to the Rolleiflex to photograph the children in color as they saluted the flag during morning exercises.

31. A. D. Coleman, "The Directorial Mode: Notes toward a Definition." *Artforum* Vol. XV, No. 1. September 1976.

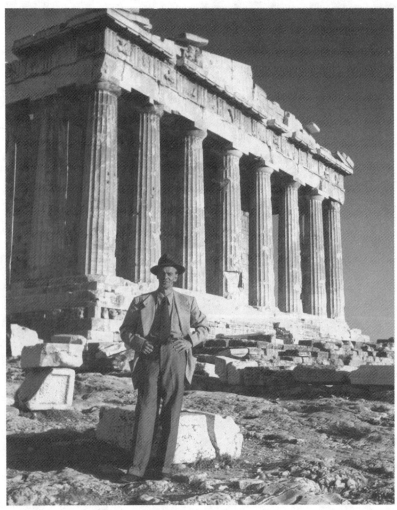

Self-portrait: photographing at the Parthenon, built between 447–432 BC, *Acropolis, Athens, Greece,* 1948. (Lofman Collection, Maine State Museum)

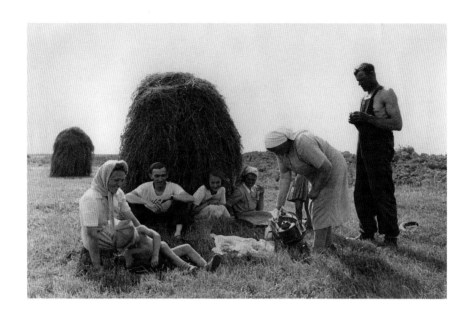

Coffee Break, *Panelia, Finland, 1948. (Black Star)*

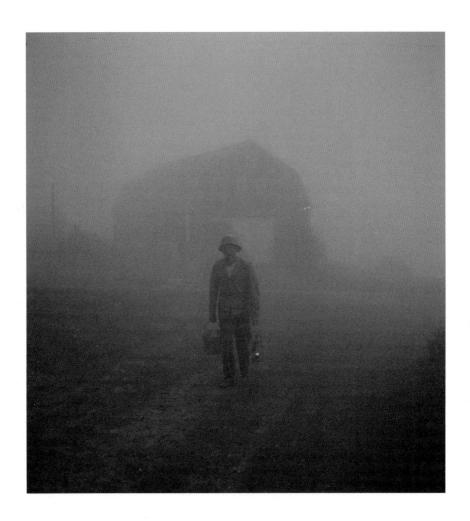

Fog, *Dodge Mountain farm, Rockland, Maine*, 1947. (Black Star)

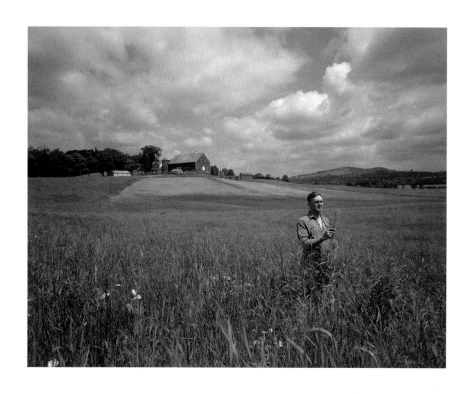

Poetry, Farmer Herbert Hawes in a field of brome grass Union, Maine, 1950. (Black Star)

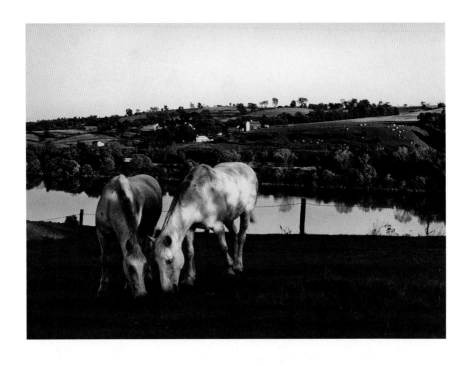

Grazing Pair, Mohawk Valley, New York, 1945. (Black Star)

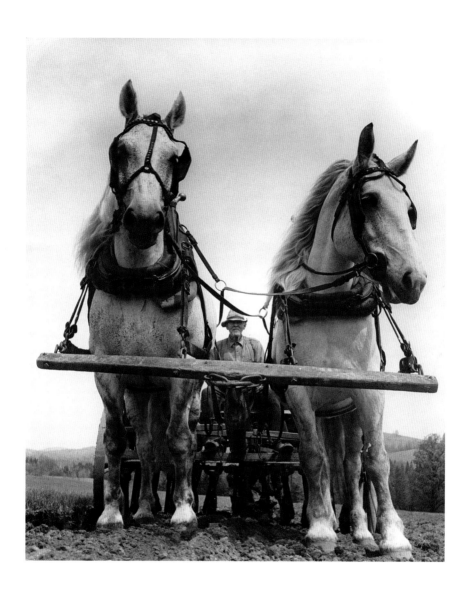

Two Grays Approach, *Peachum, Vermont, 1946.* (Black Star)

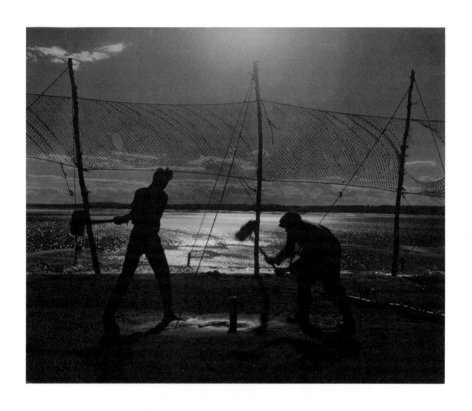

Installing Gill Net Stakes, *Bay of Fundy, Nova Scotia, 1949.* (Black Star)

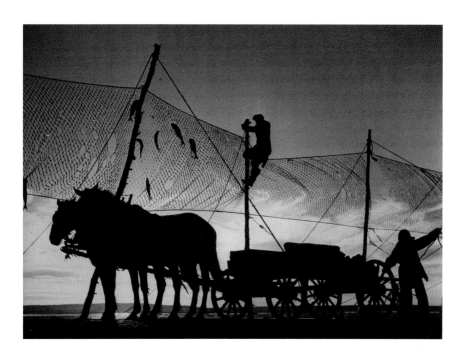

Gill Net Fishing, Bay of Fundy, Nova Scotia, 1949. (Black Star)

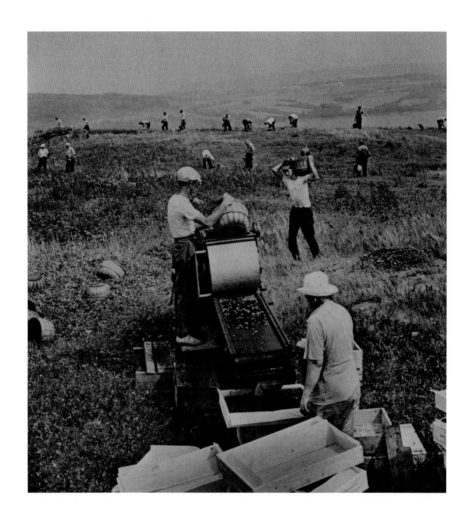

Blueberry Harvest, *Dodge Mountain, Rockland, Maine,* 1942. (Black Star)

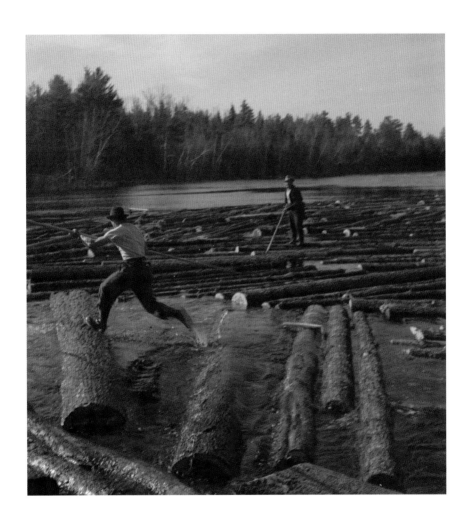

River Driver Leaps, St. Regis Paper Co., Machias River, Maine, 1954. (Black Star)

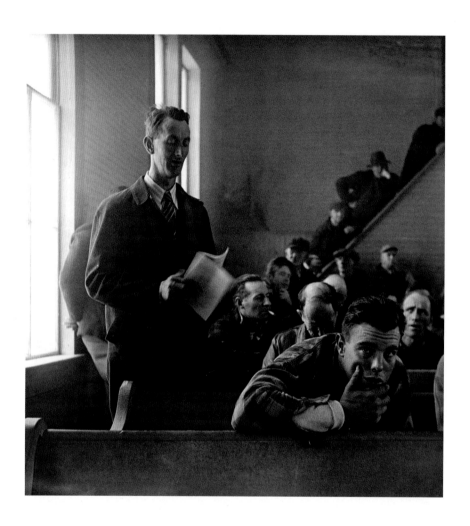

Town Meeting, *Washington, Maine, 1945*. (Black Star)

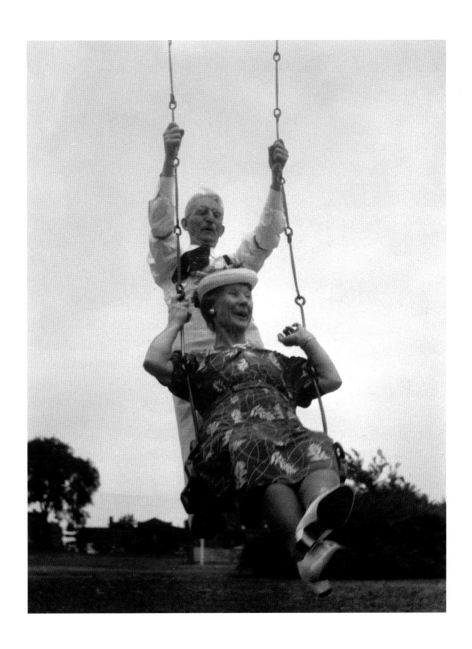

Picnic, "Three Quarter Century Club," *Portland, Maine, 1947. (Black Star)*

Andrew Wyeth, *Cushing, Maine, 1951.* (*Black Star*)

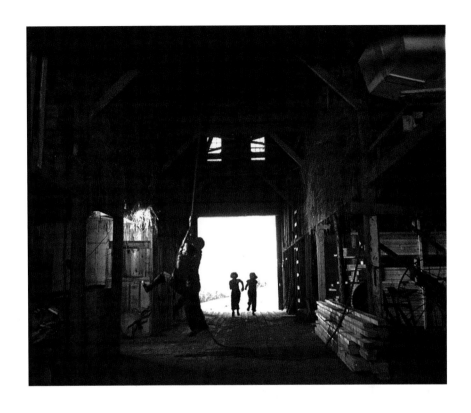

Children Play in the Barn, *Dodge Mountain, Rockland, Maine,* 1950. (Black Star)

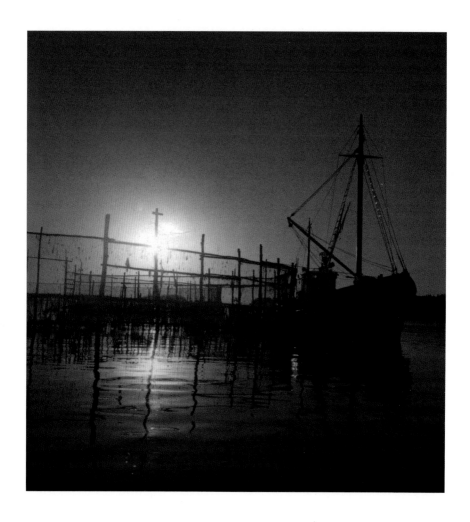

Weir at Dawn, *Penobscot Bay, Maine, 1958. (Black Star)*

Moody's Diner, *Waldoboro, Maine, 1949.* (Black Star)

Pulley, *Trawler Quincy at the Grand Banks*, 1957. (Lofman Collection, Maine State Museum)

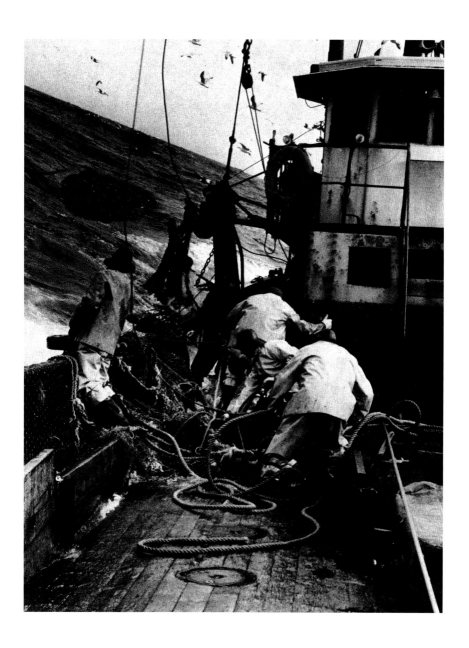

Trawler Quincy at the Grand Banks, 1957. (Black Star)

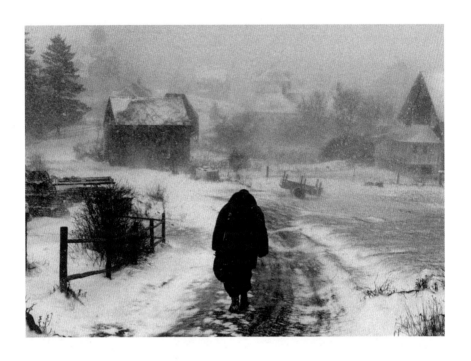

Island Moods, *A blizzard arrives on Monhegan Island, Maine*, 1957. (Black Star)

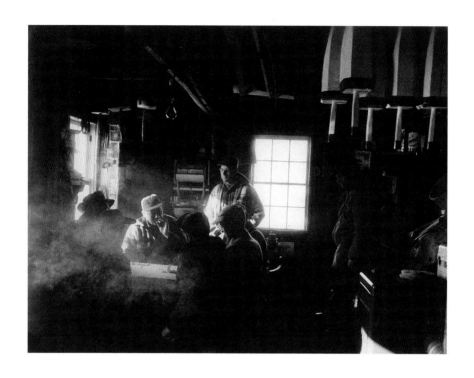

Dwight Stanley's Fish House, *Monhegan Island, Maine, 1957.* (Black Star)

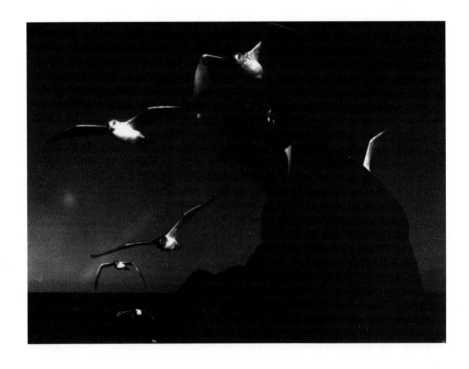

Gulls Hover, *Lobster fishing off Monhegan Island, Maine*, 1957. (Black Star)

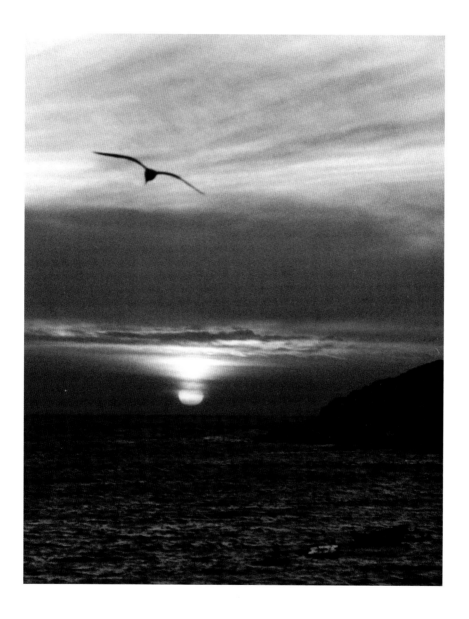

Evening Return, *Monhegan Island, Maine, 1957. (Black Star)*

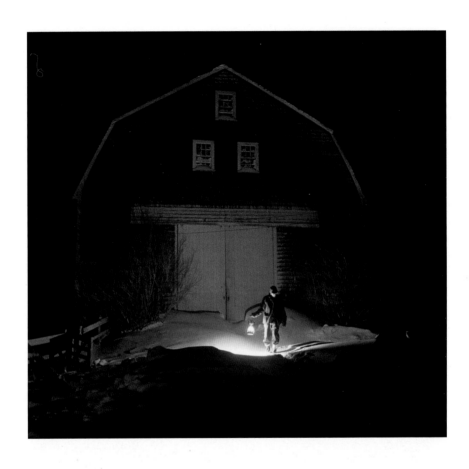

Photographer Reenacts Farmer, Winter Night, Dodge Mountain, Rockland,
Maine, 1949, from "Winter Night" essay, Life Magazine, May 21, 1951. (Black Star)

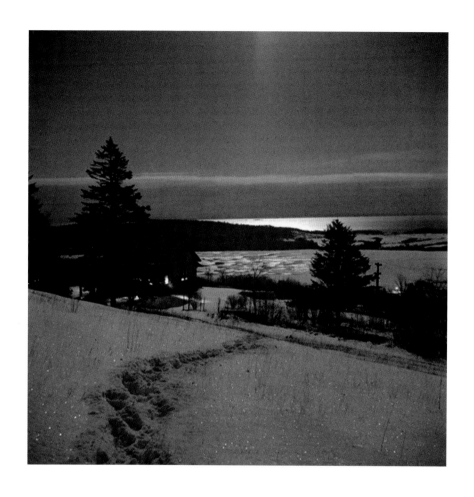

Homestead, Footprints, Moonlight, *Dodge Mountain, Rockland, Maine,* 1949,
from *"Winter Night"* essay, Life Magazine, May 21, 1951. (Black Star)

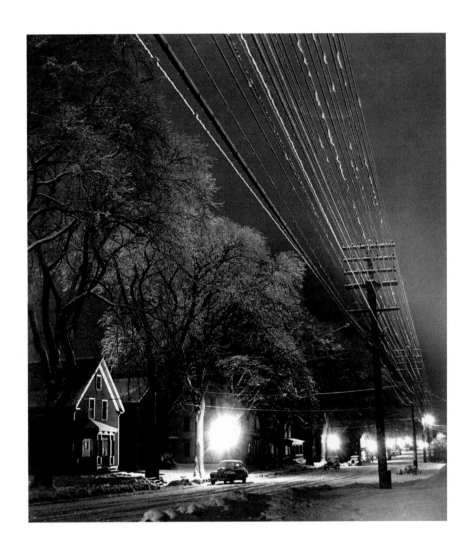

Park Street, Winter Night, Rockland, Maine, 1949,
from "Winter Night" essay, Life Magazine, May 21, 1951. (Black Star)

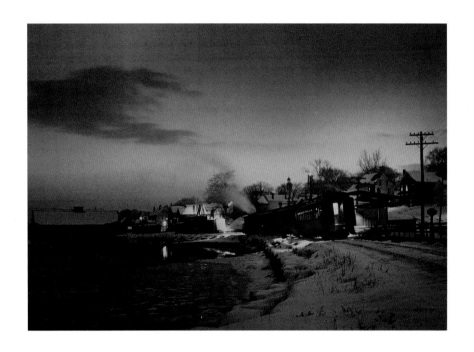

The 6:15 A.M. Pauses at Wiscasset Station, *Wiscasset, Maine, 1949*,
from *"Winter Night"* essay, Life Magazine, May 21, 1951. (Black Star)

Icicled Ledge, Pemaquid Point, Maine, 1949,
from *"Winter Night"* essay, Life Magazine, May 21, 1951. (Black Star)

Acapulco Sunset, Mexico, 1942. (*Lofman Collection, Maine State Museum*)

Dawn, *Fraser, Colorado*, 1955. *(Black Star)*

Dooryard, *Abstract study*, 1959. (Black Star)

Poetry, *Abandoned House, Waldoboro, Maine,* 1947. (Black Star)

Maine Schoolboy, *Bobby Lofman, Rockville, Maine,*
from Life *Magazine essay and cover February 2, 1948. (Black Star)*

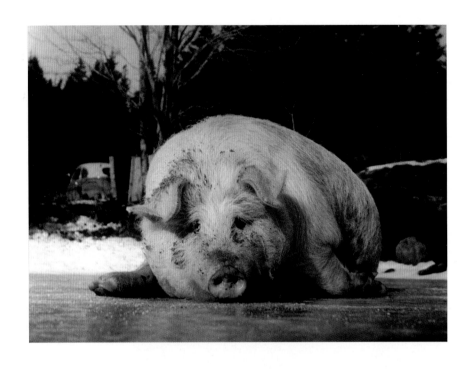

Hog on Ice, "To be independent as a hog on ice" Benner Pond, Rockland, Maine
from "Speaking of Pictures—Re-enactments of Old New England expressions,"
photo essay, Life Magazine, March 13, 1950

V. FREIGHTER TO LIVERPOOL

Overseas Assignments
(April–November 1948)

Kosti Ruohomaa's passport, dated December 29, 1947, suggested the overseas trip was anticipated. It is not clear whether Black Star sent their photographer abroad or if the travel idea was suggested by Ruohomaa. Evidently it was to be a working voyage. This was the postwar period, still close enough to the end of World War II for Ruohomaa to realize that he would be encountering urban and rural societies still in a state of repair, both culturally and physically, from occupation and the devastation of bombing and ground warfare.

During five days in early March, 1948, Ruohomaa applied for the visas necessary to travel in postwar Europe. Scheduling visits to New York City offices, he acquired visas to travel on business in the United Kingdom from the British Consulate, Ireland from the Irish Consulate General, in Finland from the Finnish Consulate, and in France, from the Consulat Général de France.

Having acquired an American Express card long before, his passport verified bank exchanges for currency upon entering individual countries. Though apparently he did not plan to adhere to a

Kosti S. Ruohomaa passport, 1947. (Lofman Collection, Maine State Museum)

strict itinerary, during the next ten months he traveled from Scandinavia to the North African coast. He would photograph people, landscapes, historical sites, industries, and celebrative events in the United Kingdom, Finland, Denmark, Sweden, France, Switzerland, (occupied) Germany, (occupied) Austria, Italy, Greece, Turkey, and Libya. His photos and captions were wired to Black Star. The agency distributed features to the periodicals *Life*, *Parade*, *Pageant*, and *Illustrated*. Ruohomaa's first published photographs from abroad appeared in *Weekend*, the US magazine in Europe.[1]

Ruohomaa traveled first-class as one of four passengers on the cargo freighter SS *American Importer*, departing from New York

Harbor on April 11, 1948. While at sea, Ruohomaa wired photographs and wrote in detail of his five-day trip across the Atlantic. He photographed and interviewed the crew, the captain, and the steward, and inserted some of his personal impressions, noting, "My fabulous Irish roommate was seasick most of the trip." He captured passenger Denise St. John-Ives, returning to London after two years in Singapore as a BBC announcer, and her companion, Elizabeth Vick, returning home to Liverpool after visiting her sister in New York, as they reclined, covered in blankets on deck chairs on a sunny but windy day.[2] This was one of eleven images he made during the ocean voyage, syndicated by Black Star and credited as "Metro Photos by Kosti Ruohomaa."[3]

Occasional photographs Ruohomaa made would today be considered propaganda, intended to promote the "American way" or "American values." In Salzburg, Austria, he photographed young people comfortably at study and leisure while matriculating in Harvard's summer school abroad, housed in an elegant traditional building that had survived wartime bombings. Here English-speaking foreigners observed the casual, easygoing American lifestyle through the camaraderie of US students.

Though it was three years after the war had ended, throughout his European travels, Ruohomaa's lens still could not avoid background imagery that included areas of cities with crumbled buildings and roads littered with rock piles, waiting to be repaired and rebuilt in England, France, Austria, Italy, and Germany.

Black Star files and scrapbook clippings of this year recorded Ruohomaa's travels abroad, especially to Ireland, an experience and place he came to revere and wished to return to later in his life. Valuable in scope, the Ireland photographs offer a clear view of the range and depth of Ruohomaa's approach to the overseas projects.

His captions include his joy over Irish coffee served during his flight, and afterwards, his first arrival at Shannon Airport. It was a layover flight, so he followed the airline crew's venture into the countryside. He encountered a cattle market in "Grange, County Sligo," and visited the Denis Kennedy family at home in Dalkey, near Dublin. Here he portrayed Denis, his Irish-American wife, and their five musical children performing Irish step dancing at home, and later, at a family picnic on the grassy knolls of the Irish countryside.

Ruohomaa stayed as a guest at the Mount Melleray Abbey, where he photographed individual devotees, men of the cloth, the order of industrious Trappist monks sworn to a lifetime of silence.[4] Except to their superiors, the monks communicated with sign language. His lens followed their daily activities from gardening to kitchen duties to chapel, where during vespers he photographed with his quiet Leica. He stayed in a guesthouse reserved for alcoholic men on repentant retreats, an experience he facetiously acknowledged in his letter to Black Star: "Of course you understand that the only one who was not an alcoholic staying at the guesthouse was your very sober friend Kosti. But I assure you, gentlemen, if I had to stay in that guesthouse another few days, it would have driven me to drink!"[5]

Ruohomaa portrayed lifestyle-based stories—a Finnish factory worker at home, an Italian street vendor, Irish peasant farmers, and the silent devotees of the Mount Melleray Abbey, their American brotherhood situated in the state of Iowa.[6] One set of contact sheets reflect Ruohomaa photographed at an Irish country chateau. Here the unidentified landowner, possibly a Guinness family member, lived privately within the expansive grounds of an estate called "Farmleigh," contoured with manicured gardens.[7] The interior walls of the chateau were faced with pieces that represented the

Maud Gonne at home, age eighty-two, 1948. (Black Star)

world's great painters, rooms furnished with possessions that reflected the finest traditions.[8]

When in Dublin, in an unusual picture series, Ruohomaa's camera documented ale processing at the Guinness stout brewery. His photographs and captions explain the step-by-step handmade process of making the rich, distinctively flavored, dark ale from its barley base to the "cooperage," to "blazing the cask," in sometimes

dramatic pictures, praised years later by Black Star's Howard Chapnick.[9]

In the countryside Ruohomaa turned the Linhof view camera to clay homes set under heavily thatched roofs, peasants at work in potato fields, and to a landscape seamed with stone walls. He located the poet William Butler Yeats's widow, at her place of work, a bindery of special books, and his daughter, an abstract painter, in her studio. But most significantly he found and made a portrait of Yeats's dear friend, Maud Gonne, then eighty-two years old, in the sitting room of her home. Yeats, many years before, had written a poem to Maud Gonne, "When You Are Old."

To photograph the re-interment of William Butler Yeats (1865–1939), a poet whom Ruohomaa personally esteemed, would be a high moment of the Ireland visit. Life's editors titled the essay, "After Years in a Foreign Grave, Yeats Comes Home Again to Ireland." The layout incorporated views of Yeats's grave in the ancient churchyard of County Sligo along with the surrounding landscape, with selected lines that included his words describing this final gravesite.[10] Ruohomaa composed one scene of the revered Drumcliff Cemetery so that the burial site rested under the silhouetted crest of Ben Bulben in the distant background. Yeats died in southern France, but due to the war, it took nine years to bring him back to his own country.

Ruohomaa continued on to Copenhagen, Denmark, and Stockholm, Sweden, where he did a piece for Holiday magazine on the skiing history museum, "Svenska Skidmuseet," with views that documented the rustic museum site and illustrated forms of antique skis.[11]

Early in July, Ruohomaa arrived in Helsinki, Finland. His first pictures appeared that month in Europe's Illustrated. He emphasized

Posing with relatives, Panelia, Finland, July 1948. (Lofman Collection, Maine State Museum)

to Black Star the importance of Miina Sillanpaa (1866–1952), whom he described as a "great Finnish patriot." "Sillanpaa was a leader for women's rights and was responsible for a woman's right to vote becoming law in Finland, in 1907. He noted, "A member of Parliament since that time, Miina Sillanpaa represented the best in Finnish democracy."[12]

Ruohomaa traveled westward to Panelia, where his parents were born and family traditions were rooted. His extended stay with relatives would be a reunion with those who may have remembered him as a two-year-old, and a chance to get to know others he had never met.

Over the next weeks Ruohomaa photographed in black-and-white, in color negatives, and in Kodachrome films, working in all three camera formats. He composed individual location portraits of

his aunts, uncles, cousins, nieces, and nephews to capture views of their home life, images that sketched their daily activities, views made to convey the rustic and simple life of a farmer. Location portraits documented their activities, including cooking meals, churning butter, sewing a dress, laundering, weaving, and doing needlepoint; and then yard work, splitting logs, haying, fetching water—chores of field and pasture. He studied a meal's simplicity at the table, the hardy Finnish bread, and, in another mode, the tradition of a weekly sauna steam bath.

He set up his tripod to capture "break for coffee" in the hayfields, and wrote affectionately: "Coffee is the Finnish national drink, and without it the Finnish morale would go to pieces." These intimate portraits captured the character of the people even as they conveyed an immediacy and warmth familiar to blood attachment.[13]

His landscapes framed farmland, woodland, and lakes where horses waded freely along the shore. One landscape, its coastal view bordered by ledges and fishing docks, must have recalled similar scenes of Maine's piers constructed beside the edges of tidal rivers. His cousin Sevari Aalto years later recalled that "Kosti saw his homeland through his camera's lens, as he always had his camera."[14]

Near the eastern city of Jyvaskyla, a contrasting picture-story was created. Ruohomaa's married cousin, Eino Vainio, who worked as a machine-tool designer for the metal industry, lived in a rented home with its own separate sauna. These pictures reveal a "typical [family] of the young progressive middle-class." But Kosti's captions also spoke of rations, i.e., leather shoes,[15] children's clothes, cigarettes, and coffee. It was a common daily necessity for women to have to sew and knit clothing. "Eino read the papers, listened to the radio," explained Kosti, so they were able to discuss world

affairs together, and even "American politics." "Were it not for the fact that we spoke Finnish, I could easily imagine [that I was] talking with someone back home."

The longer visit of weeks encouraged personal exchanges that can emerge in conversation among cousins. For one, his younger cousins, Saga M. Vuori Ambegaokar and Terttu Sievi, were curious why he had not yet chosen to marry, at the age of thirty-five? Ruohomaa's response revealed an indifferent, cynical side; his comment that "one doesn't need marriage for sex" apparently was never forgotten.[16] He suggested his distaste for the fact that once married, men changed; they stopped expressing their opinions, and their conversation was lost within a woman's dominating presence.[17]

Cousin Kosti's appearance and behavior were remembered years later by Saga, who recalled, "He looked like some Frank Sinatra with a fedora hat slightly crooked on one side of his head. His tie was loosened, and it flew every which [way] in the wind. When he sat in a chair he slouched and carelessly put his feet up on the coffee table, shoes and all! I was terrified. That sort of thing was not done at our house."[18]

But Saga also attested to the value of Ruohomaa's work, calling his photographs "historical documents of the postwar times; members of the family were thusly immortalized."[19]

On July 18, 1948, Ruohomaa wrote of this treasured reunion in the *Korpilahti* guestbook before he departed, keeping his professional New York address in the forefront: "It was a great pleasure to spend these few days here, and I only hope that I will be able to return someday. Anyway, I have hundreds of photographs to keep my memory fresh about this happy occasion. Kosti S. Ruohomaa, New York City."

In early August, Ruohomaa moved on to Salzburg, Austria. Here, composer Wolfgang Amadeus Mozart was celebrated at the Landestheater opera festival, an event he followed with the Leica. While in Salzburg, Ruohomaa photographed the "revival" after the war of the traditional Austrian folk dance. His detailed captions explained the controlled dance steps, costumes, and the musical accompaniment of wind instruments. He noted in captions to Black Star that afterward, "a fitting end was a good glass (or rather, several . . .) of excellent bok."

Ruohomaa continued on to Germany, covering both the 700-year anniversary of the Cologne Cathedral and the Munich zoo for *Life* magazine.[20] While in Munich, he met Warren Trabant, an editor for *Heute*, the American military government's Germany-based magazine, making a contact through which he would later see several of his own stories published in the monthly, including "Maine Schoolboy."[21]

While photographing the fountains and city squares of Italy, Ruohomaa met Captain Donald H. Kehlir, an Army Air Force chaplain from Ryan, Iowa.[22] Thereafter he accompanied Kehlir to Greece and Turkey. In Libya, North Africa, he made views of the people, foods (pretzels in particular), and wares sold in the street markets. He followed the chaplain as he performed weddings, visited servicemen in hospitals, and offered spiritual counseling. In between they did some sightseeing, traveling together within the cavernous fuselage of the US Army aircraft.[23]

These last few weeks encompassed the final days of Ruohomaa's extended overseas travels. By the end of October he had arrived at the port of Rouen, France, where he had arranged his return trip to the United States, arriving back home on November 7.

Having moved permanently out of his New York apartment before the European trip, upon his return, he settled into the two-room studio camp, his former childhood dwelling, located up the hillside near the Dodge Mountain homestead. His immediate project was to print a personal memoir made during the Finland visit for his own scrapbook, and an expanded album of smaller photographs for his parents.

Although he probably didn't realize it at the time, his return to the mountain would become permanent. Nonetheless, the oncoming dark winter months of 1948–49 would inspire new and poetic photographic work for Ruohomaa.

NOTES

1. See Ruohomaa's scrapbook of this period. Kosti filled his scrapbook pages with periodical tear sheets from overseas assignments.

2. Captions: Kosti Ruohomaa captions for the voyage. Black Star.

3. Ruohomaa's scrapbook of tear-sheet clippings, June 6–8, 1948. Metro Editorial Service and Metro Group. "Across the Atlantic by Freighter" (twelve pictures); "Ocean Trip on a Freighter" (ten pictures).

4. Mount Melleray, brotherhood in state of Iowa, "New Melleray Abbey."

5. Mount Melleray, scrapbook of the voyage, 1948. Lofman Collection, Maine State Museum.

6. Today, the chateau is a tourist site, called "Farmleigh." As Ruohomaa contact prints follow with views of the Guinness Brewery during the manufacturing process, this person could have been Rupert, the Second Earl of Iveagh, or his brother, Benjamin Guinness, the Third Earl of Iveagh, who lived here (http://gallot.co.nz/Guinness_surnames.htm).

7. Contact sheet: Castle estate, Farmleigh, owned by the Guinness family. Lofman Collection, Maine State Museum.

8. Interview: Howard Chapnick, Somers, NY, 1994.

9. "The Burial Of Yeats: After Years in a Foreign Grave He Comes Home to Ireland," *Life*, October 25, 1948, pp. 147–50, seven photographs. Ruohomaa thought highly of Yeats, judging by titles in his personal library.

10. *Holiday* magazine tear sheet, Ruohomaa scrapbook.

11. Black Star files. Kosti Ruohomaa captions; *Illustrated*, July 24, 1948.

12. Family members recalled that although he stayed for weeks, "Kosti never offered to work in the fields." Many pictures show that his cousins wore watches; perhaps gifts from Kosti?

13. Interview: Sevari Aalto, Vaasa, Finland, 1994.

14. Interview with younger cousins Kosti met while in Finland, Owls Head, ME, 1995, at a family reunion: Saga M. V. Ambegaokar, Ithaca, New York, and Terttu Sievi (d. 2011), Vaasa, Finland.

15. Interview: Owls Head, ME; Ibid. In contrast to his written captions of Vainio photographs, for example.

16. *Seura-Helsinki* newspaper, 1948, p. 8. Kosti pictured in Helsinki with fashion photographer Paul Melander.

17. Manuscript: Saga M. V. Ambegaokar, niece, presented at the Porin

Taidemuseo opening of "Kosti Ruohomaa, Photographer as Poet," 1998.

18. Ibid. Manuscript: Public words of remembrance given at the Porin Art Museum by Saga M. V. Ambegaokar. Text in Finnish and English translation, graciously given to this author, 1998. Opening: "Kosti S. Ruohomaa: Photographer as Poet." Guest curator and speaker, Deanna Bonner-Ganter. Porin Taidemuseo, Etelaranta, Finland, April 21–May 31, 1998.

19. Ruohomaa's penciled notes, Black Star files.

20. Archives: Ruohomaa's papers, programs of events. *Life*, 1948, Munich zoo.

21. *Heute*. News periodical originally started during World War II as a propaganda magazine for distribution in occupied Germany. Warren Trabant, editor from September 1957–November 1959. Letter: W. Trabant, September 29, 1994. Kosti's photographs of "Maine Schoolboy" were published in *Heute*. Tear sheets appear in Ruohomaa's album of this trip. Lofman Collection, Maine State Museum.

22. Kosti Ruohomaa photographed by Pieter Piesch in Rome. Story published in *Parade* magazine.

23. For entry to these countries Ruohomaa was immunized against typhoid, typhus, smallpox, and yellow fever. Stories from this work published in 1949, in *Illustrated* and weekend news magazines. A color slide made of the Greek monument, the Parthenon, against a deep blue sky was later distributed in illustrated school history books.

Self-portrait, Farnsworth Art Museum, 1959. (Lofman Collection,
Maine State Museum)

VI.

The Photographer Poet (1949)

R uohomaa had set up bachelor's quarters in the simple, two-room clapboard dwelling built by his father in 1926, situated about twenty-five yards up the hillside from the main homestead. One wall held a large map of the European hemisphere over which bold lines traced the route of his recent voyage. Shelves held a library of literature and photography titles, recordings, and assorted camera accessories. Here Ruohomaa displayed his small collection of contemporary paintings.[1] A tall figurative wood sculpture carved by friend Myron "Mike" Nevelson accompanied the arrangement of a single bed, a rocking chair, and a long table pushed against the windows that accommodated a portable type-writer. A radio, record player, and later a reel tape recorder–playing system and a television set were added, along with modern chairs. The little house was heated with a traditional New England wood-stove, later updated with a stylish Scandinavian stove.

This simple domain would be Ruohomaa's home base and point of departure for his assignments for the rest of his life, except for two brief periods—once, when he rented a summer loft in Lew

Graveyard, West Rockport, c. 1959. (Lofman Collection, Maine State Museum)

Dietz's barn in Rockport, and later, a house near Beech Hill, West Rockport. Here he read from his growing personal library and reviewed contact sheets, slides, and photographic prints. He typed letters and prepared his reports for Black Star. Ruohomaa also set up a simple darkroom with an enlarger, probably in the kitchen space.[2] This permitted him to make test and experimental prints, and small, carefully printed studies.

The year 1949 initiated a rich, audacious period that would

add to Ruohomaa's photographic palette. His home base was secured on Dodge Mountain after months of traveling overseas, and a frigid winter had set in, with subzero temperatures and ample steady snow cover in Maine. During the inclement weather patterns of January and February, once the late-afternoon darkness set in, Ruohomaa would step out of the comfort of his home to compose through his lens. He discovered images and created ideas from the transformed landscape at sites on the mountainside terrain of the homestead.

It is unclear how long, in terms of days or weeks, he continued to photograph at night. His thoughts seemed to lead naturally to scenes created by the movement of icy precipitation, forms of the night sky as a storm passed, and hillside roads bathed in freshly covered snow. Sources of light played an important role in his compositions: streetlights, windows, a vehicle's headlights, the moon, and, not to be overlooked, his own lamps that he would set in snowbanks. At some point, slipping behind the wheel of his car, Ruohomaa drove down the coast as far as Pemaquid Lighthouse, stopping along the way to create studies that in their subject, composition, and lighting would act as poems of winter.[3]

He composed one scene at the double-door entrance of the Dodge Mountain barn. Trekking downhill from his camp to the barn dooryard site, he immersed photo-lamps in high, deep snowbanks before the barn's entrance to create a stage-like illumination. He is the figure in this quizzical pose, oil lamp in hand, appearing to step out onto the ice-encrusted proscenium space. The shingled facade of the barn swathed with fresh windblown snow creates the background to this shallow, surreal setting. With this photograph a question arises: Could this be a son acting in his father's image? Life's editors, who later produced an essay from these explorative

photographs, claimed they could not "lose" this one, and placed it in the corner of the opening essay page.[4]

Although the sequence of their making is unclear, the major subjects for the winter night essay begin at the Dodge Mountain farm site. Set in the snow-covered hillside above the homestead, tripod and camera facing east, Ruohomaa composed in the long exposure to include his singular footprints advancing toward the camera against the background of moonlight breaking through clouds, a light that illuminated the expanse of ice-covered Lake Chickawaukie below, and the textured surface of the distant Penobscot Bay. One window light glows from the homestead interior. The ambiance of this image touches the viewer, who can feel the photographer's presence.

One night, under the silence of heavily falling snowflakes, his tripod set on deserted Park Street in downtown Rockland, Ruohomaa's shutter-release allowed sufficient time to capture the angular movement of precipitation streaming through the darkness, lit by a singular streetlamp. He later gave a pictorial title to this photograph: *Winter Lace*.[5]

Maneuvering his coupe through unplowed back roads, he stopped along the way to photograph early-evening skaters on a small pond, a moonlit, snow-blanketed hillside, a farmhouse, its single lighted window suggesting at least one wakeful presence. Then continuing down the coast, on a steep hillside he captured the streaming pattern of a car's headlights.

It is unclear how many late afternoons and nights Ruohomaa continued to seek these images, but he turned miles south to find a path of existing light illuminating and reflecting off ice-covered ledges at the rocky coast of the prominent Pemaquid Lighthouse. He noticed patterns of snow along its lengthy paths of rock, and a

transparency of ice, forms created by melting and refreezing, all playing a role in each image as he stepped, secured the tripod, composed, stepped closer, and composed again. His incredibly thin negatives barely reveal a surreal scene of silhouetted natural structures and explosions of reflected light bursts from the frozen surfaces. The tip of an oversize icicle seems to touch the edge of the distant horizon. Clearly delineated at the upper edge of the frame, the lighthouse shape rests atop the high coastal rock shelves, but in the overall set, the photographer envisions the landscape as an otherworldly, poetic, almost surreal scene.

Ruohomaa stopped at the village of Wiscasset, near the end of another cold night where he found the 6:32 a.m. train stopped momentarily at the icebound station. The early dawn light provided just enough encompassing atmosphere to capture the steaming train as an ethereal form. The *Life* designer spread the image across two full pages, bled to the edges. The few moments of a stopped train, steaming in the cold, can perhaps be interpreted here as an icon of recalled moments captured from life.[6]

At Waldoboro, miles north, Ruohomaa composed an abstraction from a string of lights directed from the windows of Moody's, the twenty-four-hour diner, a still-familiar site along coastal Route 1. The final print reflects the vision of an artist, the sketched path of reflections, swathes of light as if brushed on ice-covered surfaces.[7]

Life editors kept this series of night studies on file for two more winters, after which, in February 1951, five selected frames appeared as "Winter in Maine: Its Frozen Nights Evoke Poets' Praises." On the printed pages, works by New England poets complemented the photographer's inspiration.[8]

Life's "Letters to the Editors" received a response to the winter-

night essay from a Minnesota man: "Sirs, photographer Kosti Ruohomaa is to be congratulated for his 'Winter in Maine.' Never before have I seen photographs so expressive of the majestic solitude of a winter night in the country. Every one of these scenes, from the homely realism of the diner near Waldoboro to the glacial splendor of the Pemaquid Light, is a masterpiece of sensitivity."[9]

Almost thirty years later, *Life* editor Maitland Edey discussed Ruohomaa the photographer and the man in a critical narrative that accompanied the reprinted 1951 "Winter in Maine" essay, selected for the 1978 publication *Great Photographic Essays from Life*. "A dour countryman to his marrow, Kosti Ruohomaa did not fit the *Life* photographer mold at all. He was a rawboned, lanky man with a lifetime of exposure to the elements engraved on a deeply seamed face. Laconic, black-humored, he lacked the brashness, the energy, the desire to promote himself, the drive for glitter and success that propelled many of the better known *Life* staffers."

Edey's biographical details and his understanding of Ruohomaa's career were flawed, indicating his lack of research and verifiable sources. However, his description of the cameraman's demeanor and appearance has merit, especially in his last active years, looking much older than a man in his forties. He commented that Ruohomaa's photography for *Life* was sporadic, which his record (1944–57) of producing features contradicts; nonetheless, Edey did value Ruohomaa's output, noting, "the quality, however, was very high. . . . [H]e shot a beautiful photo essay, 'Maine Winter,' in 1945. . . . The second Maine essay speaks more strongly than the first of the iron frigidity of that frozen land."

Edey concludes: "Ruohomaa's pictures of people were almost exclusively of his Maine neighbors: farmers, lobstermen, seiners, and other country types with whom he felt at home. Many are fine

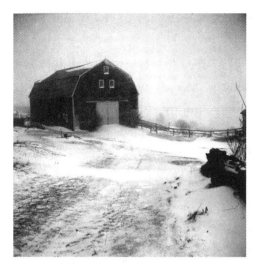

Winter, Dodge Mountain,
1949. (Black Star)

pictures, but they are really only footnotes to his true preoccupation: Maine itself. It is there, in a hard cold country, come to by immigrants from another hard cold country, that he found his greatest expression in a small output of truly exceptional pictures."[10]

The poetry of Kosti Ruohomaa's photography was recalled in Howard Chapnick's 1971 publication, *The Illustrated Leaves of Grass* by Walt Whitman (introduction by William Carlos Williams).[11] In 1960, when the project was just beginning, Williams (1883–1963) wrote about the art of the photograph and the visual impact of those selected by Chapnick for his interpretation. "When I first caught sight of the photographs that had in turn sprung from a revised understanding of Whitman's *Leaves of Grass*, I was swept off my feet."[12] Although Williams never lived to see the published book, his remarks appeared in essay form: "Every photograph is a reaffirmation of life's permanence into which you may step to discover new details of flower and cloud, new details of icy barnyard

snow swept under a lowering sky—as Whitman saw it, and we in his tracks see it today."[13]

During the summer of 1949, Life sent Ruohomaa to Nova Scotia, where he documented the unusual method of gill-net fishing against the extreme, rapid-running tides at the Bay of Fundy. His report affirmed the dangers: "I did not hit fog, but can assure you that when it comes, life is dangerous on the flats, for it is three miles of shore flat as a pancake, and if lost in fog with the fast tide coming up, it is one helluva situation. We went down one clear day just before tide rising, and it started coming up and it came fast; within a half-hour the eighteen-foot nets were covered, and we had all we could do to keep ahead of it toward shore. There is a slight rise for three miles toward shore, and this is the only reason we could keep ahead of it."[14]

This assignment realized Ruohomaa's sensitive response to nature's forces as dramatic, poetic images. He followed the Edmund Brine family's daily quest for shad, spending several days on the seemingly boundless tidal flats. His tripod secured in fast-arriving tidal waters that became knee-deep in no time, Ruohomaa captured the wagon driven by Brine's wife as she led workhorses at a driving pace to transport fishermen and tools across long, low sand flats. He photographed the extensive labor of net building that started as the sun cracked the horizon, creating bold, background lit images. These and a series of night abstractions were not used in the Life story, but have an artistry, a theatrical staging, created by Ruohomaa's interpretation of the scene. Photographs from this experience retain their pictorial drama, imbued with an air of high romance of another era.[15] Ruohomaa remarked at the end of his captions, sent to Life's editors, "This was grand adventure!"

Ruohomaa created an undated file with negatives of singular

Maine Matriarch, *Helen York, Rockland*, 1950. (*Black Star*)

pages of poetry or stanzas from poems. He had selected pieces by Thomas Bailey Aldrich, William Cullen Bryant, Richard Henry Dana, Emily Dickinson, Ralph Waldo Emerson, Robert Frost, Henry Wadsworth Longfellow, Edna St. Vincent Millay, James Whitcomb Riley, John Godfrey Saxe, Henry David Thoreau, and John Greenleaf Whittier. A storyboard sequence sketched on his animator's pad indicated that he had selected photographs that would accompany

phrases from the poems, although this project was never com-
pleted. This personal endeavor tells us Ruohomaa realized his
photographs would marry well with poetic expression and serve as
an art form.

Ruohomaa's poetic eye for the land was acknowledged in an
exhibition at the Museum of Modern Art in 1963, "The
Photographer and the American Landscape." Nineteen photogra-
phers were selected by John Szarkowski, director of photography,
their inclusive dates spanning one hundred years, the 1860s to
1963, from Timothy O'Sullivan to the young forthcoming master,
Paul Caponigro. This exhibition expressed the vision of men who
not only documented but, as Szarkowski wrote, "in part defined
our changing concept of the land." Szarkowski continued:

> Some of the nineteen photographers have been pivotal fig-
> ures, of decisive influence; others represent ideas as broad-
> ly based as photography itself. Some have been conscious
> artists, fully aware of their aesthetic art; others, approach-
> ing their work as craftsmen of sensibility and intelligence,
> have perhaps been better artists than they have known. But
> all have shared in some measure a common interest and a
> common concern: each has attempted to define what the
> earth is like. Among them they have helped peel away, layer
> by layer, the dry wrapper of habitual seeing, and have
> presented new discoveries concerning the structure, the
> beauty, and the meaning of our habitat.[16]

Ruohomaa's seven photographs in the exhibition stemmed
from both assignments and self-directed ideas based in the geo-
graphic areas of the Mohawk Valley, New York; Fraser, Colorado;

and Midcoast Maine. Ruohomaa had personally titled some of the undated photographs "Poetry": one, of a large puddle struck with sunlight, captured on a hilltop gravel road; and another, of a farmer in Union, Maine, posed in a field of brome grass.[17]

Howard Chapnick, Black Star president during the years 1946 to 1961, was close to Kosti Ruohomaa, encouraged his ideas, and edited his photos. "He broke every rule, tried using the camera in a way others would not attempt. An inveterate user of the tripod, Ruohomaa photographed into backlighting, created halation in his negatives, but compensated with a sense of beautiful composition," Chapnick recalled in a memorial statement in 1962. "He was not a traditional photojournalist, but found pictures to fit an idea."[18]

Ruohomaa's lens was inspired by moods of inclement weather, stormy seas, a veil of fog, a midwinter blizzard. But his vision was also sensitive to the delicate tenderness of a pastoral landscape, the feeling of dawn's appearance as it followed a path across snow forms, the surface of water, and sandy flatlands, or as it illuminated each morning's uniqueness. The limited light of night's darkness became an opportunity to compose and to create, as did the transforming power of snowfall to nature and man's structures.

Ruohomaa's photographs remind us of his presence, and his subjective sensibility to the world. In his last years he narrowed this sensibility to close views from nature and man-made structures that act as abstraction.

NOTES

1. An audio reel made in the late 1950s includes his friends' comments, questioning the meaning of an abstract painting on the studio-camp wall.

2. Interview: James Moore, 1994; *Spoon River Anthology* by Edgar Lee Masters, new edition, thirtieth printing (New York: Macmillan, 1952), in Ruohomaa's personal library. .

3. "Winter in Maine: Its Frozen Nights Evoke Poets' Praises." Photographs by Kosti Ruohomaa, essay designed by Bernard Quint. *Life*, February 26, 1951, pp. 55, 57–61. Appeared twenty-seven years later in *Great Photographic Essays* from Life, commentary by Maitland Edey, pictures edited by Constance Sullivan (Boston: Little, Brown and Co., 1978), pp. 96–103

4. Ibid.

5. Mounted this on a finely printed greeting card, signed "Kosti" on the interior. Copy in scrapbook of this period. Lofman Collection, Maine State Museum.

6. Bernard Quint, designer, *Life* essay, February 21, 1951.

7. Ruohomaa also photographed Moody's Diner in Kodachrome.

8. Contact sheets mirror the stepped movements of Ruohomaa's inspired experiences. In the *Life* layout, the photographs were visualized as oversize, in the dark end of the zone system, and lavishly printed.

9. *Life*, March 12, 1951; Letters to the Editors, signed, Bill Oyler Jr.

10. Maitland Edey, *Great Photographic Essays* from Life, p. 96.

11. *The Illustrated Leaves of Grass*, ed. Howard Chapnick, introduction by William Carlos Williams (New York: New Directions, 1971), A Black Star Book.

12. Dijkstra notes of Williams's essay, "This version not previously published" (1960), and references Chapnick's publication, p. 231.

13. "Whitman's *Leaves of Grass* and Photography," *A Recognizable Image*, by William Carlos Williams, edited by Bram Dijkstra (New York: New Directions, 1978).

14. Shad Fishing Report by Kosti Ruohomaa, Black Star files.

15. "Life Goes to a Shad Harvest," *Life*, May 21, 1951. Six images from this work were published in 1951 in the Netherlands' *Zondagsurend*. See Kosti's scrapbook.

16. Press release, September 24, 1963. "The Photographer and the American Landscape," The Museum of Modern Art, New York City, curated by John Szarkowski, director of the Department of Photography, Museum of Modern Art archives.

17. This particular recognition placed Kosti Ruohomaa in the company of eighteen other American photographers, such as Timothy O'Sullivan, Ansel Adams, Harry Callahan, Eliot Porter, Brett Weston, Edward Steichen, Alfred Stieglitz, and Paul Strand.

18. "Farewell to a Gentlefellow," 1962, commemorative exhibition, New York Public Library, and essay, *Contemporary Photography,* Jan. 1962.

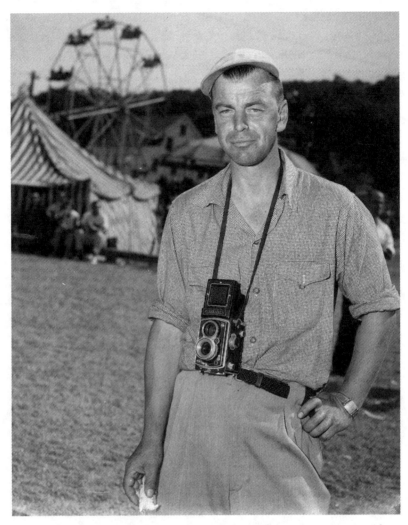

Kosti Ruohomaa at the fair, Union, Maine, 1952. (Photographer unknown, Lofman Collection, Maine State Museum)

VII.

Beloved Maine, My Hometown

n early autumn of 1951, Black Star assigned Ruohomaa overseas to Paris, France.[1] Contact sheets indicate he photographed General Dwight Eisenhower observing troops on the outskirts of the city. The focus of this brief trip, however, was UNESCO.[2] This was the year the US representative acted as president of UNESCO's Sixth General Conference.[3] Working with his Leica, Ruohomaa documented the active assembly as well as dignitaries of individual countries.[4]

The trip was also significant because while in Paris, Ruohomaa met ASMP photographer Robert M. Mottar (1909–1967), at the time represented by Scope Associates and resident of Orgeval, Seine et Oise, Paris, and New York.[5] The meeting of the two professionals would foreshadow an invitation to Maine.[6] The following April, in 1952, Mottar traveled to Ruohomaa's hometown of Rockland, where he followed the cameraman to make a series of portraits in settings ranging from Dodge Mountain to other locations that encompassed Ruohomaa's life in Midcoast Maine and Boston, Massachusetts, providing an insightful view of the photographer at work on his home turf, as well as at leisure.[7]

The humble, two-room camp on Dodge Mountain, built by his father in 1926, had become Ruohomaa's rooted point of departure for assignments ever since his return from Europe in November 1948. He never cooked at home on the mountain, and only rarely took meals with his parents.[8] Apart from seeking the company of artists—the only people with whom Ruohomaa seriously associated, according to Port Clyde painter, William Thon—more than occasionally he could be found ordering his favorite Lobster Newburg from a seat at the popular bar in Rockland's Thorndike Hotel.[9]

At the Thorndike, meals could be had in the dining and mural rooms, and in the "Parrot Cage" cocktail lounge. There, on the wall behind the bar in the lounge, local legend Kosti Ruohomaa was the subject of a mural painted by Camden artist and friend, William Shevis. Shevis depicted Kosti with camera and tripod photographing at the Rockland waterfront amid fishing vessels and friendly seagulls.[10]

At the Thorndike Hotel on Main Street, Rockland, Ruohomaa would fire up conversation among the patrons at the bar, some of whom recalled that Kosti "could sometimes get testy." Often his imbibing peers were local fishermen, stopping by after a day's work, and not up to deep provocative discussion.[11] Ruohomaa was well acquainted with hotel owner Nate Berliawsky, uncle to long-time friend, sculptor Mike Nevelson, son of Louise (Berliawsky) Nevelson. In the 1950s Louise Nevelson was regarded as a notable rising star of contemporary American sculpture.[12]

Berliawsky had installed one of his sister's recent wall-size works in the Thorndike's dining room. This piece, photographed by Ruohomaa, represented Nevelson's unique, innovative nonobjective assemblage composed of wooden furniture parts, found

William Shevis, Camden artist, designed this linoleum block print and painted a similar mural of Kosti in the Parrot Cage Lounge, Thorndike Hotel, Rockland, Maine, c. 1959. (Courtesy of Estelle Shevis)

objects arranged in box-like compartments and placed along a wall. Painted in one tone, when joined, the deeply designed units formed an almost environmentally proportioned, visually absorbing bas-relief sculpture.[13]

Paris-based Robert Mottar captured a view of Kosti Ruohomaa's lifestyle during his visit in April 1952. Mottar followed Ruohomaa to his favored photographing sites, such as a Rockport maple-sugaring farm, the Port Clyde harbor front, a Rockland lobster-canning factory, and the Owls Head Lighthouse beach.[14] Mottar portrayed a personal side, the cameraman with a Rollei slung casually over his shoulder walking down Main Street, Rockland, chatting with friends and making stops at the studios of

Wall sculpture assemblage (title unidentified) *by Louise Nevelson, installed at the Thorndike Hotel dining room, Rockland, Maine. Photograph by Kosti Ruohomaa, c. 1959. (Lofman Collection, Maine State Museum)*

sculptor Mike Nevelson and Rockport painter, Denny Winters.[15]

At the Dodge Mountain homestead Mottar apparently planned storytelling scenes, such as Ruohomaa seated casually at the kitchen table, drinking coffee as he watches his mother at the spinning wheel; in gunning cap and long black Chesterfield coat, packing camera gear into the car trunk as his father looks on; and even a view made taking a sauna bath with his father.[16] All of these scenes suggested a congenial home life on the mountain, a personal, subjective look at Ruohomaa's presence in the community, planned as a picture story for a Finnish audience.[17]

Kosti drinks coffee as his mother Sofia spins. Robert M. Mottar, 1952. (Lofman Collection, Maine State Museum)

Concurrently, on April 3, 1952, the regional newspaper, the Rockland *Courier-Gazette*, featured Ruohomaa with the headline ROCKLAND PHOTO-JOURNALIST, MAINE'S AMBASSADOR TO THE WORLD AT LARGE.[18] He is seen in his two-room camp, posed as he appears to prepare to photograph, and in a rocking chair, paging through one of his scrapbooks.[19] The subhead reads: "Kosti Ruohomaa's Career behind the Camera Has Brought Him National Recognition and Served Maine Well in the Publicity Field," and a photograph caption reads: "Poised for a shot, Kosti has been seen from this angle by thousands of people who have been subjects of his career in photo-journalism. He uses a Rolleiflex and a Linhof camera in his

Ruohomaa chats with Senator Margaret Chase Smith while on assignment in the governor's mansion, the Blaine House, Augusta, Maine, 1952. Photograph by Robert M. Mottar. (Lofman Collection, Maine State Museum)

work. Above he is using the Linhof, which is the finest in the press camera field. He puts his skill as an artist into the picture, as well as those of the top-flight cameraman."[20]

The article noted that Ruohomaa was recently the subject of a film produced by the United States Information Agency (USIA). Made at the homestead site on the blueberry fields of Dodge Mountain, the story portrayed Kosti Ruohomaa as a person of Scandinavian background who had made a successful career in the United States.[21, 22]

The article noted that Ruohomaa's photographs made in Maine were "seen in publications nationally and beyond." His scrapbooks and albums' clippings and full magazine pages provide a glimpse at his geographic range. Black Star ardently sought to

distribute Ruohomaa's images far beyond US borders in this mid-century era. Foreign-language publications such as *Heute* out of Munich, and American-sponsored news pictorial and feature magazines such as the Netherlands' *Vi;Vu* in Paris; and *Illustrated* and *Picture Post* based in Great Britain, carried Ruohomaa's photographs of America's bountiful rural life, country people, their villages, and pastoral landscape.

The USIA publication *Amerika Illustrated* selected a cross section of his career work, and four separate features over the years appeared in the handsome, tabletop glossy magazine pictorial published in the Russian language and sent overseas.[23] Having had paper industry assignments in Canada—a 1948 *Life* feature titled "Age of Exploration," which he covered in Montreal—by the end of this decade, Ruohomaa would be shooting major assignments in the Canadian Maritimes for the *Toronto Star*.[24]

Ruohomaa produced over 165 assignments for Time Inc., from 1944 to 1957, of which at least 32 were photographed in Maine.[25] He created picture stories on such places and events as Mount Katahdin Reserve, the Maine State Fair, and the Woodsmen's Weekend at the Orono Campus, University of Maine. He covered Camden's Harpist Colony and their summer concerts at the amphitheater, and the city of Rockland's first festival that celebrated its lucrative product, the lobster.[26]

These were bonanza years of magazine publishing, and in keeping with the trends, Black Star expanded Ruohomaa's pictorial files beyond Time Inc. His themes, many self-assigned, sourced in Maine, New England, and Canada, appeared in national consumer publications as well as regional, special interest venues, company magazines, i.e., the *Ford Times*, Chevrolet's *Friends*, and International Harvester's *Harvester World*. His black-and-white and

color work appeared during these years in *Parade, Collier's, Holiday, Look, Ladies' Home Journal, Yankee, Saturday Evening Post,* and *True: The Man's Magazine.* His portrayal in color of the oxen-pull competition at the Fryeburg Fair in western Maine ran as a double-page spread in the *Saturday Evening Post* series, "Face of America."[27, 28]

It was a time when Ruohomaa's camerawork "rode the wave" of lucrative pictorial magazine publishing, before the onset in the 1960s of the ubiquitous television audience—when TV advertising gradually absorbed photographic pictorial material from printed matter. Photojournalist Ruth Orkin lamented years later in her 1981 biographical monograph, partially quoted here, that "all those general interest picture magazines, like *Life* (as a weekly), *Look, Collier's, Saturday Evening Post, Pageant,* and *Coronet* are gone, as well as all the big picture essays that used to appear regularly in *Ladies' Home Journal, McCall's, Cosmopolitan,* and other magazines, because TV has taken all the advertising from the magazines . . . but you can't hold a TV picture in your hand and study it on your own time!"[29]

Yankee, Pageant, and *Coronet,* pocket-size monthlies, all published portfolios of Ruohomaa country-life photographs. Ruohomaa had an opportunity to explore one of his favored themes, "Weather-lore" for *Collier's,* and "Small Town Christmas" in color, made in Camden, Maine, for *Metro.*[30]

In January 1952, on assignment for *True: The Man's Magazine,*[31] Ruohomaa covered a story on Mr. L. L. (Leon Leonwood) Bean, the entrepreneur of the successful Freeport, Maine, outdoor and sporting business bearing his name. Ruohomaa photographed employees crafting the famous "hunting boot," as they were then called, and as Bean shared his first published book of hunting and fishing with thirty-year customer, Jack Williams from Leicester, Massachusetts.[32]

A hometown self-assignment centered on Perry Greene, breeder of a unique sled dog, known as the Chinook. Greene's Chinook kennels were located in Waldoboro, Maine. His top Chinook dogs, Bering and Riki, were celebrities at this time of the Chinook's peak popularity throughout the nation.[33] Ruohomaa's work included portraits of the dogs for publications, but he also composed two dramatic images on a winter afternoon, with an early-setting sun. Like metaphors for winter's solitude, Ruohomaa composed two images with the sky's illumination as backlighting: first, the dogs' uphill trek, pulling cargo across a high snowbank; and then a near-silhouette view of Bering, head raised as he bayed.[34]

Ruohomaa accompanied Greene with his entourage of dogs and companions on a trip to Maine's highest peak, Mount Katahdin.[35] The group snowshoed from Millinocket to Baxter State Park gate camps near Togue Pond, then waited for the weather to clear. Peter Richards, Greene's grandson, then thirteen years old and tall for his age, agreed to be the singular figure in a photograph. Richards recalled Ruohomaa directed him as he snowshoed out across the snow on the frozen pond, leaving a path of imprints that traced his steps until he heard the photographer's call out to halt.[36]

Ruohomaa's summer of 1952 was largely occupied with making photographs that highlighted Maine's coastal sites for author Arthur Bartlett's *Holiday* magazine story of a New England schooner voyage. An extensive work assignment, the first views were made at dawn in Cape Ann, Massachusetts. Ruohomaa traced the schooner stops along the coastal way from southernmost Kittery to Mount Desert and Eastport, Maine. The multiple ports of call included coastal landscapes, lighthouses, cliffs, rocky ledges, tidewater streams, harbor villages, scenic coves—views that cap-

Self-portrait: Kosti Ruohomaa chats with local rabbit hunter, West Rockport, Maine, 1958. (Lofman Collection, Maine State Museum)

tured the flavors of the Maine coast and people, a treasure trove of lucrative images he documented with detailed captions.

Ruohomaa's artistry and thoughtful planning created a few exceptional images that appeared in the final published essay. Such was a color photograph made at dawn for which he climbed a ladder to the rooftop of the Prout's Neck Yacht Club. Securing his tripod, Ruohomaa waited for the exact moment to release the shutter, to ensure that the rooftop weathervane would be silhouetted against the rising sun. *Holiday* printed the image as a full page, bled to the edges.[37]

During the summer of 1954, Ruohomaa moved out of the mountainside camp temporarily to live in a garage apartment in Rockport, at the residence of Lew Dietz, his soon-to-be collabora-

tor of editorial features.[38] The tiny village, long a historic site of schooner launchings, included among its harbor-side business interests a sail loft, an icehouse, an opera house, a coffee shop, a Scandinavian shop, Union Hall, and the Maine Coast Artists Gallery.[39]

Ruohomaa would be out of town for weeks or months at a time during the mid-1950s.[40] He wrote notes and captions to Black Star on hotel writing paper, as he sometimes had to "be stationed," as he called it, near airports, such as the Bangor airport in Maine, and Logan in Boston. The Copley Square Hotel in Boston became his pied-à-terre when in town. Here he met Terri Turner, who worked at the Copley and was also secretary to George Wein, jazz pianist and founder of the renowned Storyville Jazz Festival.[41]

Terri Turner became Ruohomaa's steady date, according to his friend Mike Nevelson, and indicated in his personal photograph files. A great fan of jazz, Ruohomaa claimed to be a good friend of famed jazz drummer Gene Krupa.[42] Wein's Storyville, his first jazz club, was situated on the street level of the Copley Square Hotel. Storyville moved, but returned in 1953 to the Copley, located at the corner of Boston's Exeter Street and Huntington Avenue. It was at this time that Ruohomaa photographed New Orleans–born Sidney Bechet (1897–1959), jazz clarinetist and saxophonist, for Life magazine.[43] Bechet, in town to make recordings, lived in France during 1953. He often performed in the Mahogany Hall, the jazz club Wein organized downstairs in the Copley.

That year, contact sheets reflect that Ruohomaa also covered the first Storyville jazz concert at Boston's Symphony Hall.[44] Among the performers that night, the event brought to the stage jazz musician stars George Wein at the piano, Pee Wee Russell on clarinet, and Vic Dickerson on trombone.[45]

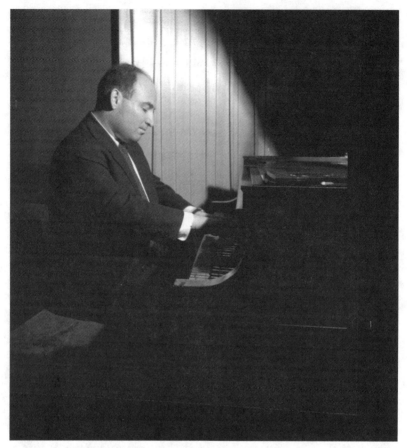

George Wein at the keyboard, Storyville Jazz Festival, Symphony Hall, Boston, 1953. (Lofman Collection, Maine State Museum)

Meeting Australian-born Terri Turner would result in the longest personal relationship Kosti Ruohomaa had ever had. Although he apparently stayed days at a time in Boston, his assignments still called him away. But knowing she was based there, Ruohomaa could be found at the Copley whenever he was in Boston.

Mike Nevelson related the story of one trip during a blizzard,

Kosti with Terri Turner, Boston, c. 1952 or 1953. (Lofman Collection, Maine State Museum)

when he and Ruohomaa barely made it to Boston on their way from Maine to New York.[46] They stayed that night in the Copley, where with one phone call, Nevelson recalled, Kosti could be found under the blankets with Terri. She accompanied the photographer on a New Mexico assignment, where he photographed a Navajo settlement, and he brought her to the coast of Maine, perhaps Kittery, but apparently not home to Dodge Mountain.

Terri's interests included contemporary art, pieces of which could be observed in her apartment. Though the date has not been found, Terri died as a result of injuries in an automobile accident.[47] Nevelson said Ruohomaa never mentioned her name after that.[48]

Returning to Rockland, Ruohomaa found a new business associate, the recently incorporated *Down East*, "the Magazine of Maine," their original offices located on Bayview Street in Camden. From the first issue in October 1954, Ruohomaa's work was featured, and the connection continued to be a lasting and positive relationship. His photography was not only promoted but given free interpretation in the pages of *Down East*, such as within the magazine's "North by East" opening full-page picture, an editorial preview.[49]

Soon after Ruohomaa met Rockport-based writer Lew Dietz, he began to coauthor stories with Dietz for the monthly.[50] The stories they created for *Down East* included photographs taken in Maine, as well as pictures previously taken during Ruohomaa's earlier New England and Canadian travels. Over the years the magazine's editors introduced Kosti Ruohomaa to its readers in masthead biography briefs that acclaimed his accomplishments: "Kosti Ruohomaa, a native of Rockland, is a distinguished photographer who has traveled all over the world on picture assignments for such magazines as *Holiday, Collier's*, and *Life.*"[51]

The first edition of *Down East* featured photographs Ruohomaa had produced in 1950 and which had appeared then in the *Boston Globe* weekend magazine.[52] Maine author Margaret Hammel provided the script for the *Down East* feature, "The One-Room School House."[53]

Like almost all of Ruohomaa's photographs reproduced in *Down East* pages over the years, during his life and after, little if any reference identified the who, what, where, and why of the pictured image. They were used as "art and illustration."[54] Ruohomaa wanted his work "to be seen," and apparently agreed to multiple uses of his pictures. One of the last Kosti Ruohomaa photographic sets

Fran Merritt, founder of Haystack Mountain School of Crafts, and family, 1955.
(Lofman Collection, Maine State Museum)

used during his lifetime was a story about "The Old Bragg Place,"
in which the photographer's dark, surreal views—among his last
black-and-white photographs, taken inside and outside of a bro-
ken-down, abandoned house—illustrated the article.[55]

The first issue, however, also featured a satirical editorial by an
unidentified author titled "Crowning Insult." The tongue-in-cheek
viewpoint referred to Kosti Ruohomaa's occasional and elusive
presence in his hometown region:

Kosti Ruohomaa, Maine's nationally famous photographer (whose pictures illustrate our feature, "The One-Room School House"), is still feeling a little rocky. The Maine Seafood Festival is over, and we don't want to beat a dead horse, but there's one more footnote to that fanned-up controversy over whether Kosti was myopic or just world-weary when he stated there were no lovelies in Maine worth a queen's crown, let alone a low-angle shot.

First off, let it be said that no one was more surprised than Ruohomaa when an innocent line in a letter to a friend was whipped up into a frothing *cause célèbre*. He returned to his hometown a few weeks ago to find the citizenry aroused and crying for his blood.

It was no good for Kosti to insist that he had never said there are no beautiful girls in Maine, that he had merely mentioned in passing that the best weren't coming out to peddle fish for the Rockland Chamber of Commerce.

A few days after he got home the harassed photographer decided that he would never find a better time to sail off into the wild blue yonder to shoot some pictures of herring schools from the air. He got a brother Finn, a herring spotter named Hugo Lehtinen, to fly him out to sea. That evening they landed near a herring carrier and taxied up alongside. Kosti was scarcely aboard the vessel when a fisherman ambled up. "So," the fellow muttered, "you're the guy who doesn't like our Maine women!"

Kosti took to the blueberry barrens, and hasn't been heard from since.[56]

Phyliss Spitz motors in Tenants Harbor, 1953. (Lofman Collection, Maine State Museum)

About this time Ruohomaa depicted on film his commonly acknowledged loose drinking habits.[57] In a set of private pictures that perhaps portrayed a darker mood, titled *Mae, the Bar Keeper*, one sees that the wall clock marks the time as eleven a.m. Ruohomaa, wearing black-rimmed glasses, a cap, and a sports jacket, sits alone in the tavern, conversing with the keeper, a whiskey bottle, glass, and newspaper resting on the counter.[58]

Before the end of 1954 Ruohomaa departed Maine to travel west, where for the better part of the next year he covered several features for *Life*—themes of winter, work, and sports in Grand Junction, Denver, and Fraser, Colorado. It was midwinter. In Fraser he followed woodsmen deep into tall forests in knee-high snow; he accompanied ranchers as they tossed hay to their snowbound

cattle. At night and at dawn he captured subjective moods and made abstractions of the desolate grandiose snow forms and spaces found in the frozen brutal cold of the West.

About this time *Life* editors gave Ruohomaa a distinctive assignment: a personal opportunity to create an essay that would interpret *Leaves of Grass* for the upcoming centennial in June 1955 of the American poet Walt Whitman's masterpiece. Ruohomaa photographed sites in New Jersey and Long Island, New York, then returned west to Colorado and Wyoming to locate views and compositions for phrases taken from the poem's narrative. His inspired lens produced fourteen selected images from the full body of work that appeared in an eight-page layout in the June 20 issue, eleven photographs published in the *Life International* edition.[59] The selected images captioned with lines from Whitman's poem suggest the depth of Ruohomaa's feeling for this project.[60]

In 1955, the notable Family of Man exhibition opened in the Museum of Modern Art, New York. Curated by Edward Steichen, the exhibition—with its theme, "All people are fundamentally the same"—was installed to somewhat resemble a photojournalism magazine layout, an entirely new way to display photographs. The photographs were oversize and multi-juxtaposed. With this approach the photographer's image had to be redesigned to suit the structure of the exhibition, as was Ruohomaa's portrayal of an elderly couple at a picnic outing, with the husband pushing his wife on a child's swing.

The photo, which Ruohomaa had taken at the Three-Quarter Century Club outing in Portland, Maine, in 1947, was printed and mounted almost life-size, and made to hang as a swing. Ruohomaa's photograph was placed in the exhibition section titled "The Endurance of Love," with the label simply relating the facts

about the happy couple: "Edward Rogers Castner, who ran a general store in Damariscotta, Maine, for sixty years, gives his wife a fine ride. Both husband and wife are eighty and have been married sixty years."

The public was unaware of these editorial nuances; only photographers were "less enthusiastic" about the use of their photographs. The Family of Man exhibition actually became an "artistic and enormous success," appealing to what would become a worldwide audience.[61] Still mentioned today, its influence on twentieth-century photography would be lasting, including the aspect of photographers' control over the integrity of their images in publication and exhibition.

Before the end of 1954, when he departed Dodge Mountain for an extended period of time due to his travel plans for work, Ruohomaa's assignments included a focus on news reportage in addition to his regularly expected features. The trip took him to Colorado, Wyoming, Oregon, and Washington states, and the west coast of Canada. Numerous and varied, and at great distances from each other, the projects entailed journalistic reportage: the Canadian pipeline, the elk migration, a Northwest plane crash off Vashon Island, the Seattle Jesuits, the Hell's Canyon Power Project, and politics, for both *Life* and *Fortune* magazines.[62]

Upon his return from this long journey, Ruohomaa made changes in his Black Star contract, giving him more time and space to follow ideas from his Dodge Mountain point of departure.[63] One of the first was a self-assignment: a series of photographs that documented a research laboratory situated on a coastal estate known as the Samoset. The property in Glen Cove, Maine, locally known as "Warrenton," was the site of a research center called the "Round Table Foundation." Established in 1948 as a center of

extrasensory perception (ESP) research and studies, the secluded sixty-five-acre property included a home with forty-five rooms and about twelve bathrooms.[64]

There, in 1958, Ruohomaa was introduced to Dr. Henry (Andrija) K. Puharich, researcher of electrobiology.[65] It is unclear how Ruohomaa earned an invitation to photograph at this somewhat clandestine and closed research center. "There were a lot of interesting people there, Andrija Puharich and Peter Hurkos," recalled Harry Stump, a scientist employed at the center who was also a weekend sculptor. "The natives [of the Midcoast area] never knew what was going on."[66]

Ruohomaa's photographs show people blindfolded with their hands on a type of board game (Ouija?), people having a discussion in a library setting, and numerous studies of a man seated inside a curious, large, copper-wire structure, which apparently gained the name "Faraday Cage."[67] Contact sheets and negatives were found in Ruohomaa's files.[68]

Ruohomaa met George Curtis of Owls Head at the studio of Mike Nevelson, around the same time he met Andrew Wyeth.[69] Their friendship eventually became a partnership in which Curtis coauthored articles with Ruohomaa, and played a role in Ruohomaa's folklore reenactments. Curtis had acquired welding skills while repairing helicopters at the Connecticut Sikorsky factory, a technique he later applied to his metal sculptures. On the side, Curtis piloted planes to spot herring runs, which in 1953 had placed Ruohomaa behind him, camera in hand, in the open cockpit of Curtis's Piper Cub, leading to a feature published in Life.[70] Curtis recalled, "Kosti handily tossed his beer bottles, one at a time as they were emptied, out of the plane into the sea."[71]

During 1959, Ruohomaa made a series of close studies in

Chinook Bering, Waldoboro, Maine, 1950. (Lofman Collection, Maine State Museum)

color as Curtis welded a sculptural form in his improvisational style. The remarkable results captured multicolored sparks spraying in every direction, their patterns and movements reflected in Curtis's goggles.

Ruohomaa's permanent return to the two-room camp actually served him well. Here he had the privacy to read from his library of literature; he could type at his portable Olivetti and depart to make photographs at will; and he could listen to his recordings, a taste that ranged from jazz to classical music, especially Jean Sibelius's *Finlandia*, music he had plans to interpret photographically.[72] His new studies—a series of white-on-white and black-on-white images composed from nature—edged on abstraction, and indicated a new focus.

NOTES

1. UNESCO, United Nations Educational, Scientific and Cultural Organization. General Dwight Eisenhower appointed to lead SHAPE in 1951 under NATO. Both agencies located in Paris.

2. Ibid.

3. Howland Sargeant.

4. Contact sheets from this work filed with the Lofman Collection, Maine State Museum. Publication of this work has not been found.

5. Robert Mottar later joined Black Star, lived on Lexington Avenue in New York for a while, and would also be represented in the 1955 Family of Man exhibition.

6. Robert Mottar listed as living in Paris in the 1960 ASMP Directory.

7. Mottar's picture story of Kosti Ruohomaa was published in Finland. The Finnish-language news magazine tear sheets found in Ruohomaa's papers are not identified; they represent the only intimate portrait of Ruohomaa at home ever found, except for a few color slides made by Time Inc.

8. Describing Kosti Ruohomaa's two-room home, the term *aerie* was used by Lew Dietz in *Night Train at Wiscasset Station*, 1978.

9. Interview: William and Helen Thon, Port Clyde, ME, 1993.

10. Interview: Bill and Stell Shevis, Camden, ME, June 1993.

11. Recollection: Casual conversation/interview with a Rockland accountant who worked part-time at the Thorndike as a waitress while attending business school in Rockland, 1993.

12 Caroline A. Jones, "Postwar Growth and New Directions: The Discovery of Modern Art during the Coolidge Years," *Modern Art at Harvard: The Formation of the Nineteenth- and Twentieth-Century Collections of the Harvard University Art Museums* (New York: Abbeville, 1985). Author Jones writes that Nevelson's works are "rooted in folk art assemblages," and within dada and surrealist aesthetics. "Total Totality II," 1959, p. 99, Fig. 95.

13. Letter: Camden, 1999. Maine artist Stell Shevis, wife of the late William Shevis, recalled where it was displayed. Photographic prints of the unidentified assemblage were found in the Lofman estate files.

14. Black-and-white prints by Mottar found in Ruohomaa files. Lofman Collection, Maine State Museum.

15. Denny Winters (1907–1985), Guggenheim recipient, wife of writer Lew Dietz.

16. Finnish newspaper tear sheets with selected pictures from Mottar's work, found in Ruohomaa's files.

17. Ibid.

18 Editorial feature, "Maine's Ambassador to the World," Rockland *Courier-Gazette*, April 3, 1952.

19. Photographer not identified.

20. *Courier-Gazette*, April 1952.

21. Interview: Sevari Aalto, 1998, Rauma, Finland. Kosti's cousin recalled seeing the film on Finnish television. This film has still not been found. Perhaps a copy exists in the American Embassy, Helsinki; not found in Finland Film Archives.

22. "Rockland Photo-journalist Maine's Ambassador to the World at Large," *Courier-Gazette*, vol. 107, no. 41, April 3, 1952. Noted Ruohomaa's scrapbooks filled with clippings, photographs from "all over the world." These scrapbooks were found in 1996 in a trunk of his files and pictures, having been packed and saved by his mother after Ruohomaa's death in November 1961.

23. *Amerika Illustrated*.

24. Former Time Inc. work sent Ruohomaa to Montreal. A museum in Toronto has a permanent exhibition of Ruohomaa's 1947–48 work for International Paper's Fiftieth Anniversary.

25. See Appendix III for Kosti Ruohomaa publications in *Life*; comprehensive listing (twenty-one index cards) in the Time Inc. file.

26. Tear sheets of these features were found in Ruohomaa's albums.

27. Face of America, *Saturday Evening Post*.

28. Tear sheets found in Ruohomaa's albums. Lofman Collection, Maine State Museum.

29. Preface, *A Photo Journal* by Ruth Orkin (New York: Viking, 1981).

30. Letter from Black Star, November 13, 1951; discussed these in detail. Lofman Collection, Maine State Museum.

31. Ruohomaa's Black Star: L.L. Bean captions to *True: The Man's Magazine*, St. Johnsbury, Vermont, January 13, 1952.

32. Winfred Given at work, stitching the hunting shoe. Given, L.L. Bean's oldest employee, started in 1917.

33. Perry Greene letters, Maine State Museum.

34. Ibid. Governor of Maine Frederick Payne and his wife were photographed by Ruohomaa with their new Chinook puppy, photographs that appeared nationally and illustrated Greene's self-published newsletter, *Chinook News*.

Governor Payne visited Dodge Mountain, indicated in his message in the guestbook, *Vieraskirja.*

35. "Mt. Katahdin Reserve," *Life*, 1951. Ruohomaa with Camden, Maine, art colleagues William and Stell Shevis, Lew and Denny (Winters) Dietz, also made the autumn climb to paint the radiant scenes of foliage, hiking up Mount Katahdin. "One brings one's own sleeping bag, cooking equipment and food."

36. Meeting: Peter Richards at the Maine State Museum, 2012.

37. Arthur Bartlett, "Cruising Down East," *Holiday.* Ruohomaa captions alone provided a wealth of cultural scenic material for each location that would have been of use for a publication.

38. Lew Dietz, photographs by Kosti Ruohomaa, made during the early spring log drive, Downeast Maine. *True: The Man's Magazine*, 1954. Tear sheet, Ruohomaa album, Lofman Collection, Maine State Museum.

39. See portfolio of plates.

40. See Appendix III for Time Inc. assignments for this period.

41. George Wein, Newport Jazz Festival founder, interviewed by Jerry Jazz Musician.com./linenotes/george_wein.html, June 18, 2003, 14 pp. Interview by phone. Roger Saunders, owner, Copley Square Hotel, June 1996. *Myself Among Others: A Life in Music* by George Wein, with Nate Chinen.

42. Also Interviews: Rauma, his friendship with Gene Krupa, noted in 1948 visit, 2004. Wein speaks of Storyville and Terri Turner, pp. 82, 133–34.

43. Kosti Ruohomaa, Time Inc. record card: *Life* # 40649, "Sidney Bechet, Negro Clarinet Player," 1953.

44. No publication found, but contact sheets in Ruohomaa files, Lofman Collection, Maine State Museum.

45. Contact sheets: Storyville at Symphony Hall, 1953. Lofman Collection, Maine State Museum.

46. Louise Nevelson, with whom they would go out to dinner, had a studio in the city.

47. Interview via phone: Roger Saunders, owner, Copley Square Hotel, Boston, June 1996.

48. Interview: Michael Nevelson, North Fairfield, CT, November 19, 1993; phone interview, Roger Saunders, June 1996.

49. *Down East* magazine was founded by Duane Doolittle, as the local story recounts, at his "kitchen table" in 1954. Margaret Hammel, "The One-Room School House," *Down East*, vol. I, no. 3, October 1954, used selected Rockville

pictures Ruohomaa had photographed in 1950. Since this period until his death in 1961, Down East cooperated with the Black Star Agency, which in turn supplied many vintage photographic prints to the publishing company. These were photographs Kosti had taken for himself or for Time Inc. and Black Star assignments. Down East thus accrued its own collection of Kosti Ruohomaa prints for their files.

50. Also for *Maine Coast Fisherman.*

51. *Down East,* vol. II, no. 6, April 1956, p. 9.

52. *Boston Globe,* 1950.

53. Hammel, "The One-Room School House," pp. 10–14.

54. Letter: Andrew Vietze, associate editor, *Down East,* Camden, 1994. Mr. Vietze kindly hosted this author's research visit, paging through *Down East* back issues.

55. Edwin D. Meury, "The Old Bragg Place," *Down East,* November 1961. Copies of photographic prints made in this set found in Lofman Collection, Maine State Museum.

56. Editor: "Crowning Insult," *Down East.* vol I, no. 3, October 1954, p. 9.

57. Interview: James Moore, 1993. Ruohomaa arrived at a Lobster Festival beauty contest, for which he was asked to be a judge, with liquor bottle handily kept in his jacket pocket. Made daily visits to Maine's local "Green Sign" liquor stores, at times unaware of family or friends. Interview: John Aldemen, 1994. Newspaper clipping, *Courier-Gazette,* August 1955: Ruohomaa fell while in the sauna bath onto hot rocks, causing second-degree burns on his leg and lower back. Following a hospital visit, the local newspaper caught up with him with the headline: "Today, Ruohomaa decided to have a Finnish bath, but it backfired a bit."

58. Possibly the Tavern at Crescent Beach, Owls Head, still there in 1978, but later demolished. Author spent summers in a nearby cottage, "Ship's Timbers."

59. Centennial: December 20, 1961, a month following his death, *Life* selected Ruohomaa's view of wildflowers in the foreground against the distant white-capped Colorado mountains for a special edition devoted to the environment, a two-page spread, pp.14–15.

60. Black Star's Howard Chapnick published *The Illustrated* Leaves of Grass *by Walt Whitman,* Introduction by William Carlos Williams, ed. Howard Chapnick (© Florence H. Williams) (New York: New Directions, 1971). A Black Star Book, profusely illustrated with Ruohomaa photographs.

61. John Szarkowski, Mirrors and Windows: American Photography since 1960. (New York: Museum of Modern Art / New York Graphic Society, 1978), pp. 16–17. Jacob Deschin noted this was "essentially a picture story to support a concept"; Eric J. Sandeen, Picturing an Exhibition: The Family of Man and 1950s America (Albuquerque: University of New Mexico Press, 1995). "Edward Steichen, curator, with Wayne Miller, sought images from photographic services such as Black Star and Magnum; more than 6 million images viewed," p. 41.

62. See Appendix III for assignment listings.

63. Kosti Ruohomaa's Time Inc. assignments are listed in Appendix III.

64. This, the old Samoset, burned. Today the property is known as the Samoset Resort Hotel. Harry Stump, scientist working there and weekend sculptor, was the contact. Interview: Harry Stump, Warren, ME, 1994.

65. Unclear how invited. Negatives and contact sheets. Lofman Collection, Maine State Museum.

66. Interview: Harry Stump, Warren, ME, 1994.

67. Eileen Garrett, Round Table Foundation. Study found at urigeller.com/books/maverick/maver4.htm. Interviews: Union, ME. Harry Stump, a weekend sculptor and a research scientist, hired by the Foundation. Mrs. Eileen Garrett (1893–1970), founder of the Parapsychological Foundation, New York.

68. Contact sheets in Ruohomaa's files, Lofman Collection, Maine State Museum.

69. Wyeth became a great influence on Curtis and actually guided his creative work. This eventually led Wyeth to introduce Curtis and his sculpture based on the subject "the Sea" to New York City's Knoedler Gallery, where his work met with success.

70. "Fish Spotter, Sardine Industry, Maine," Life #40352, 1953.

71. Interview: George Curtis, Cushing, ME, 1994.

72. Interview: Howard Chapnick, Somers, NY, 1993. This was recalled by CHapnick in his memoirs of Ruohomaa.

VIII.

Andrew Wyeth of Cushing

*Andrew Wyeth and Kosti Ruohomaa with the antique hearse Wyeth purchased,
Cushing, Maine, 1951. (Black Star)*

osti Ruohomaa first met Andrew Wyeth in 1947
through their mutual friendship with Owls Head–
based sculptor George Curtis and Myron "Mike"
Nevelson, whose sculpture studio and antiquarian
shop was located on Main Street in Rockland.[1]

The earliest Kosti Ruohomaa–Andrew Wyeth photo session
occurred sometime in the summer of 1947.[2] Wyeth recalled
how he lured a somewhat hesitant Ruohomaa to enter a deserted

Self-portrait: Kosti Ruohomaa reflected in dust-covered mirror located in the attic of an early-nineteenth-century abandoned house, owned by Christian Hoffses, Waldoboro, Maine, 1947. (Black Star)

nineteenth-century Waldoboro, Maine, house he had discovered, still furnished, essentially left intact, "as if the owner stepped out for a moment and never returned."[3]

"We crawled in a back window," Wyeth recalled, a first-floor window Wyeth had found that could be easily opened and closed.[4] Negatives from this occasion suggest that Ruohomaa's camera followed Wyeth's improvisational path to capture intimate moments of

Andrew Wyeth, his wife Betsey, their sons Nicholas and, Jamie, and pet dog Buffett pose at low tide on oversized boulder, Cushing, Maine, 1951. (Black Star)

the artist at work in the mysterious interiors. His lens framed Wyeth's concentration as he moved from one room to another and settled in to draw, apparently quite at home in the surroundings of furnished rooms, long abandoned. Using existing light available from the windows, the mood-filled portrait studies suggest silence and respect for the place and the privacy of the artist.[5] The picture story appeared in *Life* on May 17, 1948.[6] Ruohomaa was overseas

at the time, so this cooperative photo shoot must have occurred the summer before.

The deserted spaces filled with muted light inspired Ruohomaa to make a self-portrait. While in the attic, he found a dusty mirror and released the shutter, a somewhat surreal moment of self-reflection. He was, at the time, unaware of Wyeth's later intriguing self-image, The Revenant.[7] Wyeth recalled, "The day provided a year's inspiration for my painting."[8]

Wyeth recalled that four years later, during June and July the summer of 1951, Wyeth recalled "Kosti stayed with us for several days."[9] He made location photographs of Wyeth, including with his family on their Cushing property.[10]

The photo shoot of Wyeth at the site of his new spacious studio, a cozily placed bayside location near his summer home,[11] acted as a somewhat brief, casual, relaxed observation of the notable artist when published in both Life and Time in 1953.[12]

The summer of 1951, Ruohomaa studied Wyeth in the interior spaces and on the grounds of the Alvaro and Christina Olson house. The intimate, spare corners of the aged and weather-worn fourteen-room sea captain's domicile overlooked the St. George River. It became a site of Wyeth's exhaustive studies, drawings, and paintings.[13] It was here that Wyeth painted the now-famed Christina's World, a mystical portrayal of Christina Olson composed in the fields below the homestead, her fragile, limp form turned in a gesture, reaching toward the symbol of her heritage.[14]

A dramatic portrayal by Ruohomaa's lens depicted Andrew with Christina, posed in the homestead interior foreground, facing a forceful window light, as Alvaro stands in semi-shade behind.[15] Ruohomaa's personal attention to composing the setting is evidenced by his control of light and careful placement of the figures

and objects in both the background and the foreground. The figures of Christina and Andrew both turn to face the flood of window light, dramatically creating a statuesque profile of the two, while the shadowed image of Alvaro offers a sense of mystery to the scene.

Outdoors on in the grassy field filled with wildflowers, Ruohomaa continued to photograph, capturing Wyeth with farmer Alvaro Olson posed at the hay wagon, with the Olson homestead prominently located in the background atop the upper hillside that gently slopes to the water's edge. The contact sheet documents that Ruohomaa's tripod was set below the sunlit fields as he exposed views of the subject again and again, moving and changing his position, hoping the composition would capture the convincing pattern of natural gestures as the two figures engaged in conversation.

Through photographic sessions together, and subsequent mutually respectful acquaintanceship, Ruohomaa came to not only admire Andrew (Andy) Wyeth's brilliance as an artist, but also seemed to be inspired by the focused industry of the painter, so intense and fully engaged when at work. Ruohomaa's captions reflect the fact that he clearly enjoyed the clever personality of the man and his vivacious energy.[16] Ruohomaa's Black Star Agency narratives and captions are undated, so the exact Sunday is not known when "Andy" called to wake him to "hurry" because they were going to Louds Island.

The following story accompanied the photographs taken that day, and left a clue as to the year (probably 1951). Ruohomaa titled the introduction to the captioned set of photographs, "Andrew Wyeth Collects a Hearse."[17]

Andrew Wyeth, famed contemporary American painter, knows the Port Clyde, Cushing, and coastal islands region surrounding this area of Maine intimately. For this was the summer stamping grounds of his famed father, illustrator and painter N. C. Wyeth. The Wyeth family has always divided their time between two places—Chadds Ford, Pennsylvania, in winter and this area in summer—so as a result, Andrew grew up here, and knows the life of this area and its people well. The proof is in the many great paintings he has done here, which are now in the hands of key museums or outstanding collectors.

Wyeth's childish curiosity and enthusiasm are an inspiration to observe. In photography, it can be compared to Eisenstaedt.[18] So thus Andy gets a bee in his bonnet which he cannot resist; sometimes for serious purposes, at other times, just for the sheer hell of living and having a ball. So starts the hearse story.

Some time ago Andy was on this little coastal island, observing and sketching. The island is one of a group of lobster-fishing islands, several miles off the coast. Andy has a habit of poking his nose into everything, and at a small shack close by to an abandoned cemetery, he stuck his curious nose to the window. He saw the lonely dark shapes and forms of a latter-century hearse. Nothing to do but, at once, trace down who owned it and where it could be bought. This he found out, and acquired this hearse built in 18— for $25. Now this was all well and good, but how to get it off the island, which has a poor dock and can only be touched by even a small lobster boat for a short period during high tide. So Andy sat and let his purchase mellow.

A few weeks ago it happened that he had connected with the right lobsterman who would help him take it off on the forthcoming Sabbath. Having seen Andy several times this summer, he told me nothing of his wondrous purchase. Thus I was somewhat amazed when I scrambled out of bed at about 8:30 a.m. this Sabbath a few weeks past to hear Andy's excited voice—his phone voice is always excited—but this time more than usual. As I was a bit dopey from sleep yet, I wasn't at all sure what Andy was driving at.

He says, "Jeeze krist, by god by god, we [are] going to get the hearse—boy, what a beauty out there on Louds Island, sleek, dark, and beautiful lines. Want to come along? Haven't got much time. See you at Port Clyde in three-quarters of an hour (25 miles away.)" So I in my grogginess assume I misunderstood, though I thought he said *hearse*, but that couldn't be—what he must have said, was *nurse*.

"Okay, Andy, if you're going to pick up a sleek dark nurse off an island, I will be glad to come along; by the way, how long has she been out on this deserted place?"

"You won't believe it, Kosti," Andy said, "but ever since 1830, and in damn good shape, too."

"Andy, I seem to be confused. You said n-u-r-s-e, did you not?"

"Hell no, I said h-e-a-r-s-e."

"Oh, well, I thought it was something unusual," I said. "Andy, I'll come along anyway, Andy; see you at Port Clyde."

That morning, Ruohoma drove to Port Clyde, where, Leica in

hand, sports jacket pockets stuffed with twenty-five rolls of film, he met Andy at the home of Bill and Helen Thon. There, he "asked for" and accepted a couple of libations offered by his hosts before their departure.[19]

Ruohomaa's narrative continues:

> We met at Bill Thon's [Prix de Rome artist] home in Port Clyde. Andy had invited him along for the fun of the thing, and for the fact he needed an extra hand. The lobster boat of Dick Percy, Port Clyde lobsterman, was waiting for us at the dock; Dick was skippering. The other man was Ralph Cline, a wonderful character who runs a saw mill, a typical Yankee with the exception that he has humor and gets a kick out of life. Hell, sounds like fun, gotta get a laugh or two now and then.
>
> It had been some time since Andy had been on the island, and with the many islands around, there was a certain amount of guess work and searching as to which island was the right one. It was finally located, but the tide was too low to land at the dock, so we rowed ashore. Then we take off on a road overgrown with bush to this cemetery where the hearse was stationed in the equipment building. I suppose the distance must have been a good, three-quarters of a mile from the dock.
>
> Much, much worry about the tide condition on the skipper's part, though, because one can only land at the [Cushing] dock for a short period under ideal conditions. However, when we get to the dock, [the tide] situations were right. Then comes the strategy and operation of getting it aboard.

Andy, whose spirits are always high, just kept repeating, "Nothing to it, nothing to it." Of course his voice becomes louder and louder as he says this. When his voice hits soprano, then he is nervous and excited.[20] With much huffing and puffing, the four of them, Andy, Bill, Dick, and Ralph, pushed and pulled the hearse to the [Louds Island] dock."

We land in Cushing where Andy's wife Betsey was waiting with their Lincoln Continental.[21] The wagon hearse is hitched on the Continental and we drive it off to Andy's neighbor, farmer Olson, brother of Christina, she of Andy's famous painting, *Christina's World*. So there the hearse sits now in the Olsons' barn. Whether or not Wyeth uses this for a painting is not sure, but one thing is sure: He picked up a wonderful antique. It is a beauty.

Ruohomaa's photographs captured the spirit of child-like adventure and the group's sense of humor—a journey taken by four adult men on a crisp sunny Sunday, Andrew Wyeth dressed in his black Pennsylvania Dutch jacket, and Bill Thon, Prix de Rome painter, sporting his Greek fisherman's cap. Locals, farmer Dick Percy and lobsterman Ralph Cline, navigated the group from dinghy to lobster boat for the trip and its return.[22]

That summer's photographic sessions made of Wyeth by Ruohomaa were left in contact sheets and prints found in Ruohomaa's personal files. They recorded events such as Wyeth's sketching trips to study gravestones and to draw in fields of wild flowers. Ruohomaa found Wyeth working at his easel set up in a barn, and photographed him exploring the curious deep space of a barn loft.[23]

In 1953, Andrew Wyeth visited the Ruohomaa homestead, it was the one known occasion that Wyeth visited the Dodge Mountain farm, meeting Kosti's mother and father. This was documented with Wyeth's comments in the family guest book, the "*Vieraskirja*."

Wyeth remarked of the homestead mountain vista facing Penobscot Bay, the city of Rockland, the harbor, and the outer islands:[24] "I have never been more impressed by a view. Andrew Wyeth, October 5, 1953."

The years from 1955 to 1957 marked an active period for Ruohomaa's travels, especially for Time Inc., so it is not unusual that about five years had passed before the two resumed photography sessions in 1958, this time in Kodachrome color.[25] The spaces were located inside an unidentified barn and in the barn's loft, most likely in Cushing. Wyeth seemed to enjoy the photographic sequence. In the subdued light of the barn's interior spaces, Wyeth posed at his easel and other areas as Ruohomaa moved about, composing the scenes.

No photographic records of Wyeth by Ruohomaa have been found after this session, until the year 1961. A severe stroke in late January of 1961 took a huge toll on Ruohomaa's health, which had deteriorated considerably by the end of the summer. The setting for what appears to be their last meeting remains undetermined. Since hospitalization after the stroke, Ruohomaa had been cared for twenty-four hours a day by his nurse. On this occasion, confined to a wheelchair, he was able to manipulate his Rolleiflex camera to compose and make three color transparency exposures of Andrew Wyeth. Andy looked nattily handsome in a hand-knitted sweater. But one view expresses his pained feelings as he looked down toward the lens of the frail photographer.[26]

In 1973, twelve years after Ruohomaa's death, Wyeth accepted the invitation to provide a preface to the book *Night Train at Wiscasset Station*. Ruohomaa's photographs would illustrate the text by Lew Dietz, and the book would be produced by Howard

Wyeth and Ruohomaa with the antique hearse acquired after an adventurous trip by lobster boat to Loud's Island. Cushing, Maine, 1951. (Black Star)

Chapnick, Black Star.[27] Worthy to repeat are Wyeth's perceptive words that touched on the creative role of the photographer, an American Finn. "Kosti's Finnish heritage played an enormous part in his genius. Northern people like the Finns, withdrawn though they may appear, are capable of extreme passion."[28]

In a 1997 interview, Wyeth commented on Kosti Ruohomaa, the man and the photographer.[29] "He was ultra-sensitive, a very intelligent man. The photographs he made were *not luck*."

NOTES

1. Ruohomaa recalled in his narrative about Curtis that it was during these years that Andrew Wyeth successfully introduced Curtis's sculpture to the prestigious Knoedlers 's Gallery (East 57th Street, New York), where Curtis was eventually represented. Ruohomaa file, Black Star.

2. In 1944 Andrew Wyeth gave a lecture at the opening of a suite of water-colors at Colby College, invited by a family friend, Professor Samuel Green. At the time the Wyeths still lived in his father's home in Port Clyde. In 1947 when Kosti met Andrew, the Wyeths had moved to Cushing. "Waterville welcomes Port Clyde artist in first fall exhibit on Mayflower Hill," / Alice Frost Lord, . *Lewiston Journal*, October 14, 1944.

3. Christian Hoffses (b. 1785) house, South Waldoboro. Hoffses was known locally as the "Soldier of 76." Obituary clipping photographed by KR, found in his Black Star files.

4. Wyeth photographs made at the Hoffses house by Kosti Ruohomaa appeared in *Life, Magazine* May 17, 1948, pp. . 80–81. Ruohomaa was over-seas when this story was published, which places its event in the making at some time in the summer or fall of, 1947.

5. Interview: Andrew Wyeth. Cushing, ME, . October 27, 1997.

6. Views from the Christian Hoffses early-nineteenth-century house experi-ence. *Life*, May 17, 1948.

7. "For twenty-five years artist Andrew Wyeth has spent his summers tramping around Maine, painting its lonely cottages, boats and windy wasteland." *Life*, May 17, 1948, pp. 80–81.

8. *The Revenant*, Tempera, 30 x 20 inches, 1949. The New Britain Museum of American Art.

9. Interview: Andrew Wyeth, Cushing, ME, October 27, 1997.

10. Ibid.

11. Ibid. "Kosti spent several nights here and did several stories."

12. *Life* , July 27, 1953. Four photographs, pp. 80–82.

13 *Life* #34937, July 27, 1953; *Time*, same week.

14 Andrew Wyeth (1917–2009). See Betsy Wyeth's *Christina's World* (1982). Ruohomaa's photographs are documented with words and reproductions of Wyeth's drawings and paintings.

15 Eight Ruohomaa photographs from this day appear in Betsy James Wyeth's : *Christina's World: Paintings and Prestudies of Andrew Wyeth* (Boston:Houghton Mifflin, Boston, 1982).

16. See plates.

17. Captions: Kosti Ruohomaa, Black Star, "Andrew Wyeth Collects a Hearse."

18. Manuscript found at Black Star with captions. I shared this story with Andrew Wyeth the day of the interview; , he had no memory of reading it, but was clearly entertained by Kosti's narrative.

19. Alfred Eisenstaedt (1898–1995) established *Life* staff photographer, and Ruohomaa were somewhat acquainted, as noted with a "To Kosti from Eisie" signed publication found in Ruohomaa's library. Ruohomaa was first associated with PIX Inc. agency in New York, NY, until 1942, before Black Star. Pix Inc. was founded by Eisenstaedt. The two probably met at Disney, where Eisenstaedt photographed Disney for *Fortune* magazine, when Ruohomaa arrived there in 1938.

20. Interview: William and Helen Thon. July 1, 1993. Almost all of the photographs were made with a hand-held Leica.

21. Ruohomaa captions for "Andrew Wyeth Collects a Hearse." Kosti Ruohomaa files, Black Star.

22. Ruohomaa photographed it from lying inside the hearse; a few antics between the two men are pictured on the contact sheets.

23. The hearse was donated by the Cushing Historical Society to the Maine State Museum.

24. Ruohomaa later photographed at this site for color location portraits of Wyeth; slides found in the Lofman Estate Collection, Maine State Museum.

25. A small news clipping was pasted in the Ruohomaa guest book,

*Vieraskirja,*discussing the value of the painting, *"Christina'sWorld"* by Andrew Wyeth.
26. The date "1958" is impressed on the slides' edges. Site of the barn unknown; probably Cushing, Maine. Lofman Collection, Maine State Museum.
27. Interview: Howard Chapnick, Somers, NY, December 10, 1993. Chapnick, after years of reviewing Ruohomaa's body of work in the 1970s, assisted by Yukiko Launois, selected a collection of images, the bulk of which he included in the book. "I was responsible for *Night Train at Wiscasset Station."*
28. Lew Dietz, *Night Train at Wiscasset Station.* Photographs by Kosti Ruohomaa; foreword by Andrew Wyeth, afterword by Howard Chapnick (New York: Doubleday, 1977); Letter: Andrew Wyeth to Lew Dietz, 1973, author's collection.
29. Interview: Andrew Wyeth, Cushing, ME, November 1997. Graciously arranged and accompanied by Marianne Ahola of Cushing, Maine.

Self-portrait of Ruohomaa feeling reflective at Gettysburg battlefield. Gettysburg, Pennsylvania, 1957. (Black Star)

IX. WORK

Close to the Land, Close to the Sea

R eturning from an extended trip to the Northwest coast for Life in the fall of 1956, Ruohomaa changed his contract with Black Star so that he would no longer receive guaranteed weekly payments.[1] This new arrangement allowed him to work freely on personal projects without the pressure of New York deadlines.[2] His last assignment for Life, photographed in early spring, 1957, was of the newly launched tanker World Beauty, built in Quincy, Massachusetts.[3] His lens captured the massive body of the merchant vessel, almost in silhouette against the rich tones of a rising sun at dawn. The color image later appeared as an Epic record album cover.[4]

Beginning in 1957, Ruohomaa self-assigned photographic ventures to capture men at work in the challenging natural environments of land and sea. His subjects would be of the outdoor rugged breed—woodsmen, river drivers, fishermen, farmers, ice cutters—whose livelihood in Maine would be dependent on nature's resources and the conditions of seasonal weather. The "vicissitudes of nature's moods," he later wrote to a friend, would

Kosti Ruohomaa, New York State, 1945. (Black Star)

direct the focus of his photography.[5] His work, both day and night, and the resulting portfolio of images made of lobster fishing on Monhegan Island in January 1957, exemplify the photographer's personal quest to capture his subject with feeling and a poetic lens.

Ruohomaa proposed his first self-assignment to be carried

out in the new year of 1957 in a penciled essay, titled "Island Moods." It was late December 1956, and Ruohomaa wrote to Black Star, outlining his proposal to photographically cover Monhegan Island's winter lobster fishing: "Monhegan is a small fishing village ten miles off Maine's east coast. The year-round population, sixty, is made up of lobstermen and their families, though multiplied tremendously in the summer tourist months by artists and vacationers.

"During the winter months life is hard, for Monhegan is wide open to all the ferocity of the Atlantic weather. The people are a hardy lot, for they live and work with the forces, day in and day out. Life on the island in the winter is simple and quiet, though not lonely to these people, as most would want no other way."[6]

Ruohomaa continued: "The economy of Monhegan is lobstering, and for this reason the nineteen lobster fishermen on the island here have for years protected and watched this treasure."

He explained: "Though the state of Maine has a year-round lobster season, Monhegan has a seasonal law instituted by themselves, which limits their lobster fishing to six months, from January to June. The first of January is the starting day, and on this day each and every lobsterman starts together; there is a great hustle and bustle as traps are loaded on dories and transferred to the lobster boats in the harbor."

Black Star sent the requested film. Ruohomaa arranged to take the *Laura B* mailboat out of Port Clyde, an almost two-hour trip, a few days after Christmas. He stayed with longtime Monhegan Island residents and proprietors of the only general store on the island, brothers Douglas and Harry Odom, who turned into tough-skinned lobstermen after January 1.[7] Upon his arrival, the days were quiet according to Ruohomaa's photographic contact sheets.

He wandered the island, turned his lens on the surf pounding rocky shores, the quiet atmosphere of a church service, and activities at the post office. The sewing circle of women gathered at Marion Cundy's cottage inspired an interior midwinter image of communal warmth and peacefulness.[8]

He met up with Ernest DeRaps, the lighthouse keeper, who lived in the prominent 1824 structure on the hill above the village. He photographed the lighthouse from several vantage points during the dark hours of night, and made interior abstract studies of its incandescent lens.

Then, after a few days, a winter nor'easter blew in, transforming the island's setting into a landscape made intimate with a veil of heavy snow. Inspired by the event, Ruohomaa traced familiar pathways within windblown flakes, a "whiteout," photographing the village's paths, the cottages and waterfront structures transformed visually into a painterly and almost surreal setting. One frame followed the shape of a single figure, silhouetted as she walked, covered in heavy winter outerwear into the dense rain of falling snow, a photograph that would become one of Ruohomaa's most enduring visual poems.[9]

He noted in his captions: "The lobstermen of Monhegan work under rough winter conditions; I needed bad weather to show this." Made during the storm, Ruohomaa's photographs reflect the isolation and independence of people living on the island. He made a set of mood-filled frames of the lobstermen gathered in Dwight Stanley's fish house as they smoked, played cards, and waited out the storm. Then, according to the contact sheets, he documented the first day's setting-out activities in clear, bitter-cold weather. He followed the fishermen as they gathered rocks, intended to weigh down the wooden lobster traps, and then

Heading out on a heaving sea from Monhegan Island with fisherman Dwight Stanley, Ruohomaa captured a portrait of the Rockland-built lobster boat, the Dorothy M, at work in rough ocean waters, January 1957. (Lofman Collection, Maine State Museum)

as they rowed, each in his small dory stacked high with traps, out to their moored lobster boats. His lens followed the boats as they departed Monhegan harbor in brisk winds.

One morning he accompanied his hosts, Douglas and Harry Odom, as they set their traps in the water. From the somewhat-cramped cabin entrance, he photographed in close, as the fishermen, outfitted in their storm gear, baited and dropped traps.[10]

Ruohomaa later explained: "I found it almost impossible to move far enough away from my subject to get all I wished in the

viewfinder. If only the lens had been wider!" Although he used a 35mm wide-angle lens, he complained in an ASMP Infinity journal feature of the limited space for the viewfinder.[11] He turned his camera from horizontal to vertical. When hungry gulls appeared, he installed an orange filter to increase contrast. "I suddenly realized that the men themselves wouldn't make a very interesting picture, and that this was what I had been waiting for. I shot a lot—and fast—cursing and praying that the gulls might be in the right place at the right time."[12] The contact frames reflect an "otherworldly" look to this small series, in which the fisherman's form against a grainy black sky and shapes of white gulls seem locked into an ethereal space.

At first, the Maine Coast Fishermen subsidiary news journal of National Fisherman picked up the story and published a few images of the winter lobster-fishing feat. Then Black Star sent Ruohomaa's photographs from the week's work to National Geographic magazine. Two years later, "Maine's Lobster Island, Monhegan" would appear in the February 1959 issue.[13] Large photographic prints of the Monhegan feature were concurrently displayed in the National Geographic Washington, D.C., headquarters gallery.[14] Tear sheets kept by Ruohomaa in an album indicate that Black Star also sent Monhegan Island images to the USIA (United States Information Agency), where they appeared in Amerika Illustrated, a tabletop-size, finely printed glossy pictorial, distributed in Russia in the Russian language.[15]

Jim Moore, Rockland-based Portland Press Herald photojournalist, wrote to alert Ruohomaa that the Monhegan Island story had appeared in National Geographic. Vacationing with his parents that winter of 1959 in Lantana, Florida, Ruohomaa replied to Moore, revealing a telling piece of his personality—his attitude toward

"making his art," along with his depth of interest in the news and culture of the contemporary world:

507 Perry Street

Lantana, Fla

February 5, 1959

Dear Jim,

Thanks for the note on *Geographic*. I haven't seen it myself yet. You know how it is with the *Geographic*—not on newsstands, [so] one has to go either to a dentist or a doctor's office to see one. [I] haven't had cause to go to either one. I hate like hell to get a stroke or a heart attack as a reason to see my pictures. Seems too high a price to pay for one's art.

The worst part of this job, like all my other sea jobs, is that my sea legs are as inept on a boat in rough weather as a cat's on a hot tin roof; so much of my time is spent in trying to hang on to something for dear life with one hand and attempting to get a swinging and swaying camera pointed in the right direction with the other, and after that is maneuvered, a wave hits one smack dab in the face. Lobsterman Dwight Stanley suggested he lash me to the mast for security; I did not accept that old sea wolf's hospitable invitation. I had a sneaking suspicion he would have left me up there as a warning as to what happens to blueberry-picking photographers when they put out to sea. Photographically, [though], I cannot complain; calm seas make lousy pictures.

What impressed me most [about] Monhegan in

winter is the beautiful starkness, especially during a storm (these pictures were not used, I understand), within the town itself. Something rather poetic about the atmosphere, if I may be allowed the use of a corned-up phrase. In the summer it is a bit too idealistically beautiful; in the winter it has guts and drama and doesn't wear such a pretty face. Anyway, it has the kind of meat my camera likes.

As for the lobstermen, I couldn't ask for better cooperation, without which the pictures would be impossible. Of course they do their share of heckling an old landlubbing camera-toter of my type, but then so has every Maine lobsterman I ever was in contact with. Once they stop giving me a hard time I will have no use for them, and assume they have gone soft and joined the conformist world of bureaucracy. Heaven forbid.

I was out there five or six days and shot several hundred pictures, and when I got home and saw the developed photographs, I realized I had completely forgotten to take a picture of the product all this activity is centered on. So back to the wars went Kosti.

Incidentally, these pictures were also published in *Amerika*, the magazine printed in Russia by the U.S. Information Service and distributed in the Soviet [Union]. I don't know whether or not this is good propaganda; I can visualize Khrushchev holding up this magazine to his audience and saying, "Comrade, look see, America just like Siberia and full of vicious crustaceans, not like our pretty Volga, eh, what, comrade."

Kosti Ruohomaa

This letter captures not only a major artistic component of Ruohomaa's body of work, but also the humble quality of daily life for a small population secluded on an island in the North Atlantic during the harsh winter months. Exposures Ruohomaa made during day, night, dawn, and at sunset convey his sensitive and intelligent vision. Ruohomaa composed these images as an impressionist artist would, creating scenes that are filtered through light and atmospheric elements before being brushed onto the canvas. In some frames the settings, dramatically designed and portrayed, become almost like scenes in a documentary film.

Six months after the Monhegan Island lobster-fishing camerawork, another ocean-bound assignment materialized. It was the midsummer month of July, and Ruohomaa had an opportunity to follow the tough work of the Quincy, a steel-hulled, deep-sea commercial fishing trawler with a homeport of Portland, Maine. Skippered by Jim Farrell of Rockland,[16] the Quincy fished the grounds of the Atlantic Ocean's Grand Banks. The ten-day voyage fishing for redfish (also known as ocean perch) would present arresting challenges for Ruohomaa and his camera, both day and night.

A nor'easter erupted as fishing continued. Under extreme pressure, as foaming waves gushed over the ship's side, Ruohomaa—who, despite his "inept sea legs," never got seasick—managed in a few minutes to compose photographs with his 35mm Leica, somehow ensuring that he himself was safely secured. Three of these pictures "stopped" the fishermen as they rushed to pull and tug the heaving, swaying net, filled with a ton of fish, against a leaning ship, amid abusive stinging rain and gushing sprays of seawater. His camera documented the extreme oblique angle of the horizon as the vessel tilted and swayed and

rocked, back and forth, in a battle of the high seas. From his safe position he further captured the fishermen reaching to haul in their nets as waves broke over the vessel's side, rushing heavily onto the deck.

Ruohomaa followed the fishing operation at night under the ship's lights as one man cleared the immense catch from the deck into the hatch.

Having bunked below with three other fishermen, he spoke in his captions of this experience, living in such close quarters. "Deep-sea fishing requires a crew of seasoned men, born to the sea, men accustomed to working around the clock, handling gear in punishing seas, and sleeping dog-tired in wet clothes."

Ruohomaa's lens touched upon surrealism in his close portraits of the redfish; almost cartoon-like, they seem to resemble little out-of-this-world characters.

An ASMP *Infinity* editor noted: "Trawlermen on the Grand Banks, in which Kosti Ruohomaa of Black Star used natural light with dramatic artistry in an unusual picture story."[17,18] Ruohomaa's captions explain the technology of a "modern 110-foot trawler equipped with power winches and electronics," and the historical fishing lore of the "ancient Grand Banks, known locally as the Georges Banks fishing grounds that lay northeast of Cape Cod and extend to the southerly tip of Newfoundland, and Nova Scotia."

Pictures from this adventure, both black-and-white and color, appeared in National Fisherman, Chevrolet's Friends, and True: The Men's Magazine.[19]

The next year, in late winter of 1958, Ruohomaa returned to follow seasonal work deep in the Maine woods. Woodsmen and river drivers based near Machias, Maine, would need to control a

fifty-mile log drive downriver. This event occurred in the spring, "after the ice has about gone and the snows have melted."[20]

Four years earlier, in 1954, Ruohomaa had photographed this arduous, skilled labor for *Harvester World*.[21] The cover image captured the moment when a river driver leapt boldly yet gracefully from one log to another over a maze of tree lengths, floating, tightly embanked, on the open stream. He wrote to river boss Francis Healey at the St. Regis Paper Company to propose that he return. Healey explained that only certain areas would be accessible; most of the drive would follow the stream through the wilderness. To revisit the "pine long log drive on the Machias River and its branches," Ruohomaa would observe and follow "the one million feet of pine driven down the Oldstream River, then as it flowed into the Machias River to the St. Regis Paper Mill, located in Whitneyville, on the extremity of Maine's northeast coast."[22] The Oldstream River branch where the drive would originate had not hosted a log drive for more than thirty years; thus, it was of special interest to Ruohomaa for a new photographic pursuit in black-and-white and Kodachrome.

This drive would begin at the Canaan Dam, miles upstream. Detailed captions identify the crew boss, Albert St. Pierre, among the number of French-Canadian river drivers.

Ruohomaa used woodsmen's terms to describe the drive's management and tools, such as the "peavey" and the "pike pole."[23] Ruohomaa's vantage points were secured along riverbanks where his lens captured "the herding of logs," steering the shallow but sturdy bateau on rough segments of swollen streams, the agile leaps from log to log by individual men, and their skilled, forceful guidance of oversize pole logs from the shoreline to the moving river at center stream.[24]

His lens archived the challenges of river drivers' dangerous work as the last quarter-century of the log drive tradition approached.[25] Twenty-five years later, Maine river drives would permanently end.[26] Pictures from Ruohomaa's camerawork were featured in *True: The Man's Magazine*, with story by Rockport author, Lew Dietz.

Black Star continued to inform and update Ruohomaa of venues and feature ideas for him to cover for national monthlies such as Chevrolet's *Friends, Coronet, Pageant, Ford Times, True: The Man's Magazine,* and *Harvester World*, issued by Chicago-based International Harvester. These assignments were tough work for the photographer, but provided a steady "food on the table" income. At a point in his life's work when he had gained a highly regarded reputation in national photojournalism, Ruohomaa connected with locally based regional and national publications for proposed new projects. He stepped into the role of "roving photographer," as stated in the masthead of Owen Smith's Camden, Maine–based news magazine, *Outdoor Maine*, and he continued to provide images to Rockport's *Down East*.[27] His published work continued to be credited with "Kosti Ruohomaa from Black Star," and negatives were sent to his agency for filing.[28]

Sometime in this late-1950s period, Ruohomaa rented a house at a West Rockport address and had stationery printed, even though it turned out to be a temporary residence. He returned to photograph herring (sardine) fishing off the coast, where grounds in the Penobscot Bay were located.[29] Tenants Harbor sea pilot and fisherman Hugo Lehtinen piloted Ruohomaa to take these photographs in 1960. Ruohomaa's newly designed writing paper featured his penciled sketches that explained the method of creating a purse seine to trap the fish inside. Lehtinen's piloting services

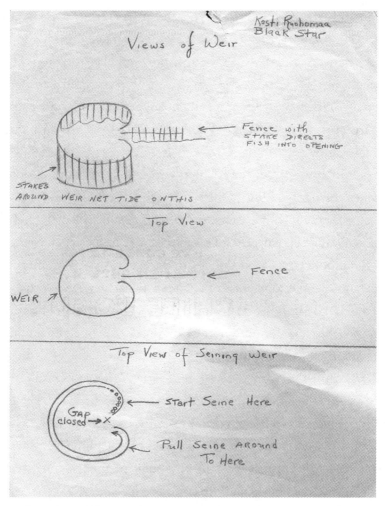

Ruohomaa's pencil diagram of purse seining on his personal West Rockport stationery, c. 1958. (Lofman Collection, Maine State Museum)

offered aerial views of the operation while Ruohomaa photographed from the open cockpit.

From air and sea he photographed sardine fishing off the coast of Vinalhaven, located ten miles off the Rockland shore; Dix

Island off Owls Head; at Port Clyde; and as far Downeast as Eastport and Grand Manan Island, Canada. He photographed from a Piper Cub, and sometimes went aboard fishing vessels. Working within earshot of the fishermen, he was able to capture their expressive remarks. When heavy fog blanked out any camerawork on one trip, he noted on an index card a fisherman's remark: "It's so durn thick ya kin hardly spit."[30]

Ruohomaa produced a large, varied body of work, a documentation of the sardine industry, from the description of the actual purse seining to the weirs, the coastal nets installed to capture the schools of herring. He followed the work to the actual canning of the product, this aspect done almost exclusively by women, an operation he photographed in a Port Clyde factory. These projects, detailed in descriptive captions, all required planning and preparation for travel, communication with the fishermen, and days photographing on and off the coast.[31]

During the winter of 1959, the ice harvest industry was actively pursued on pristine Lake Chickawaukie, Rockland. The F. J. O'Hara and Sons icehouse was located directly at the base of Dodge Mountain. Ruohomaa's views combined a new automated sawing technique with men working the old methods—long hand poles—to guide, push, and direct the ice block shelves to the icehouse elevator.

Maine Coastal Portrait, a book project Ruohomaa initiated with James Moore, Portland Press Herald photojournalist, and Carroll Thayer Berry, Rockport photographer, woodcut artist, and printmaker, jelled sometime in 1958. Their goal was a publication that would portray the character of coastal Maine people. Ruohomaa selected from his body of work portraits of harbor-side villagers, woodsmen, farmers, and fishermen. Choosing "coastal" as a

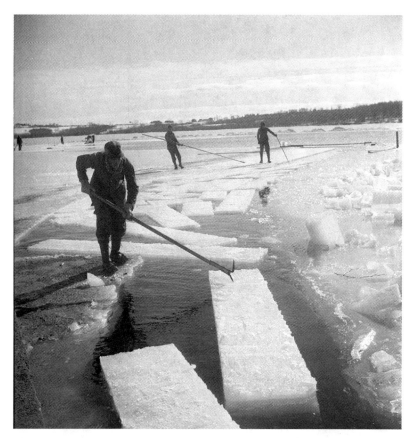

Ice harvest, Lake Chickawaukie, Rockland, Maine, 1959. (Lofman Collection, Maine State Museum)

theme, both Moore and Thayer contributed pictures reflecting year-round activities of the local people. The three dedicated their project, a picture book of photographs, "To all the wonderful coastal people we have ever met, those folks known to Out-of-Staters as 'Maine Characters.' "

Maine Coastal Portrait was published in August 1959 by Seth Low, Rockland, with a book signing at Rockland's Main Street Huston-

On the WGAN TV Portland Morning show with Jim Moore for the book Maine Coastal Portait, 1959. (Lofman Collection, Maine State Museum)

Tuttle Book Company.[32] Ruohomaa's portrait of a retired Owls Head sea captain in his study appeared as the title picture in the New York Times "Photography" column by Jacob Deschin, announcing the publishing event,[33] and Jim Moore and Kosti Ruohomaa appeared on Portland's WGAN-TV, Channel 13, in September 1959, to discuss the project.[34]

Again in January 1959 Ruohomaa traveled south to be with his parents in Lantana, Florida, where they had a seasonal home. Along with cameras and tripod, he also brought his portable Olivetti. He began to write editorial columns, having in mind to

illustrate the themes with his photographs. He sent a number of the writings, all one page, double-spaced, to Wilson Hicks, who had moved on from serving as *Life* picture editor to become an instructor at Miami University.

Hicks responded to the contents and writing style, telling Ruohomaa, "It's all you." Hicks suggested that they be syndicated through a central publisher, but noted that one a week would be too demanding. Topics ranged from "Old Traditions," "Keeping Maine Green" (i.e., keep highways free from billboards), "Highway Trash," "Nepotism," "Conversational Openings" (i.e., "The Weather," "TV Advertising," "Jute Boxes")—over twenty completed narratives marked with typically expressed Ruohomaa cynical conclusions were completed. A few had been published in *Portland Press Herald*'s "Letters to the Editor" column.[35] Photographs found in his files reflect that he had already initiated the picture search for new ideas.[36]

A June 1960 letter from Black Star to Ruohomaa connected him with Chevrolet's *Friends*' Frank Kepler, who wanted a travel story in color on the Poland Springs Resort, showing "its scenic and historic marvels." "The Lewiston Chevrolet dealership will see to it that the photographer is wined, dined, and flown into Poland Springs from Lewiston."

However, Black Star's concern over the health status of their photographer was echoed in a note from secretary Renate Benisch. "Please let us know when you plan to shoot this. Thanks very much. How are you? You have not asked for any negatives in ages. What happened?"[37]

Although he carried out this assignment, this was the period during which Ruohomaa lost his driver's license due to driving under the influence of alcohol.[38] This brief letter from Benisch

brings to the forefront Ruohomaa's problems, specifically, his drinking—to use his words, the "unmentionable evils" that continued to invade his daily life.

What might have provoked his need to drown his problems in alcohol remains to be deciphered. The ongoing curtain that remained between Ruohomaa and his father has to be acknowledged. Certain people referred to his father as "brutal," and others noted that even as the photographer was confined to a wheelchair in the last year of his life, his father would boldly state in the presence of others, "Kosti should be working with his hands."[39] Ruohomaa had also been devastated to learn that his father had a "girlfriend," and that while his mother wore a cloth coat, his father gave the object of his affair a fur coat.[40]

Kosti's affection for his mother comes through in the few portraits he made of her.

A last long-distance trip to the Canadian Maritimes began in the summer of 1960. Ruohomaa traveled with coauthor Lew Dietz on this ten-day Black Star assignment for the *Toronto Star Weekly*. On the way, the two stopped at Princeton and Grand Lake Stream, Maine, photographing outdoor sporting camps. Here they covered lake and stream fishing, the fly fisherman's sportive art.[41]

Ruohomaa photographed bayside views of the Canadian Maritimes at New Brunswick and on Prince Edward Island.[42] At Bentick Cove on Malpeque Bay, Prince Edward Island, Dietz recalled he stopped the car so Ruohomaa could photograph a fisherman fitting up the hull of his dry-docked boat nearby. The antique quilt hung to dry in the shoreline breeze also caught the photographer's attention. Ruohomaa's fascination encompassed the faded colors, intricate patterns, and numerous textures for a series of 4x5-inch color transparency studies he contrasted against the coastal gulf

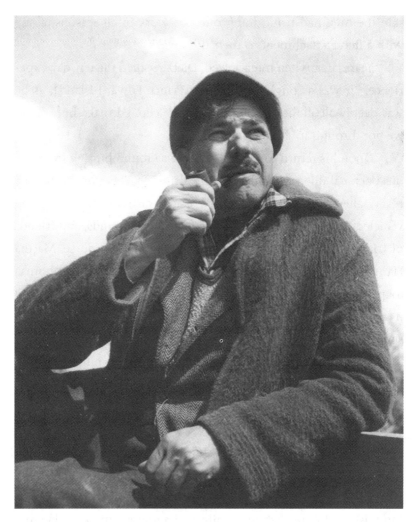

Lew Dietz in outboard canoe, "the Grand Laker," at Princeton, Maine, 1960. (Lofman Collection, Maine State Museum)

view. The *Toronto Star Weekly* feature was published a year later, in April 1961, with full-page reproductions in color of Ruohomaa's location portraits of fishermen on a pier and at the shore of a coastal cove. These portraits captured the lined faces and roughened

skin the men had from doing outdoor work in all seasons, along with a fierce attachment to their life's work.[43]

Years later, when interviewed, Dietz recalled the ten-day experience. "It was a rough trip for me [Prince Edward Island], as he was deeply alcoholic by then. It was his Jeep, I'd make him drive; we got through it."[44]

Upon his return to Maine, Ruohomaa found himself in a serious personal dilemma caused by his drinking. This time he faced a reality check: His car insurance coverage was reduced to "driving vehicles on the farm." Instead of depending on friends, and friends of friends, to drive him to assignments, he hired a nurse. Martha Hartshorn, a Camden, Maine, RN, not only chauffeured Ruohomaa to photographing assignments, but also attended to his alcohol intake, controlling how much he drank.[45] This idea may have been suggested by his doctor, who had advised the insurance company that drinking was something that only Ruohomaa himself "could control and cure."[46] At first, Hartshorn was hired on a weekly, part-time basis, but that would soon change.

Ruohomaa coauthored a few seasonal stories, beginning in 1958, for the *Skipper Boating* magazine with California native writer, Margaret Graham Neeson, who summered at Spruce Head Island.[47] The stories entailed the work of sea moss gathering, a Mink Island lobster-fishing family, and aerial spotting for herring fishing. Neeson's letter to Ruohomaa in October 1960, written from San Jose, acknowledged meeting "your nice nurse friend whose name escapes me." This verified that nurse Martha Hartshorn had begun to play a more constant role in Ruohomaa's life as he became more dependent on others.

In 1958 Dodge Mountain legally became Dodge Mountain Farm, Inc. Twice a year Kosti and his parents held meetings

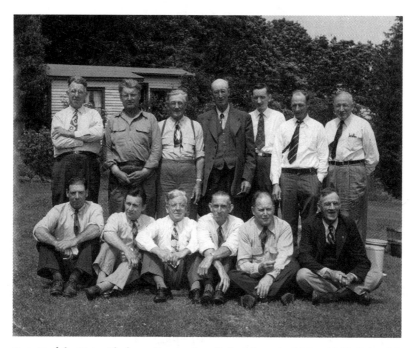

Portrait of the Maine Blueberry Growers, Inc., Dodge Mountain, Maine, 1952; Robert M. Mottar (1919–1969). (Lofman Collection, Maine State Museum)

concerning the farm business that included both Dodge Mountain and Hannah Mountain, their property in Washington, Maine. They discussed income, costs of harvesting labor, investments, and expenses. Shares of stock were sold for $20.00 each. His father was president and treasurer, and Kosti acted as secretary, typing the official reports.[48] The farm held membership in the West Rockport–located Maine Blueberry Growers, Inc., a cooperative that had been established for thirteen years as of 1961, with a mission to place the small farmer "in a position to bargain fairly with food chain giants."

Though he grew up on farms and intimately understood the

blueberry business, Ruohomaa refused to even consider becoming a farmer, owning a farm, or even land of his own. In place of that, his photographs had fully documented the seasonal work of the family farm since 1942, when his images, taken that summer, were published in the *State of Maine Department of Agriculture Quarterly*.[49] He left a full, detailed story of the entire process in the Black Star files. He composed the segregated work activities of the harvest and land preparation, such as burning, but as the years passed, in its place he made small intimate vignettes of this subject, views in color that were both painterly and almost abstract.

Ruohomaa photographed a full, detailed, black-and-white story with captions, "Blueberry Growing," based on "the Dodge Mountain, a Knox County, Maine, farm overlooking Rockland and the Penobscot Bay." His photographs of burning fields were made for the United States Department of Agriculture.[50]

Iconic visions in color also appeared in "New England," a major seasonal feature of *Look* magazine, in September 1960.[51] The burning of low-bush blueberry fields filled one page, captioned, "From Autumn's shimmering funeral pyre, the New England phoenix rises again." A double-page spread of snowdrifts was captioned: "It is too cold for anything except the snow-whipped wind, which only makes it colder." His close study of colored leaves introduced the essay.[52]

Then, by the end of 1960, he had to face the circumstances of his deteriorating health, and the fact that his increasing dependency on alcohol created a situation that preoccupied his every moment, and would certainly affect the future of his creative output. That same autumn he wrote an important, thought-provoking letter to Ernest Mayer, Black Star's accountant. It expressed, in retrospect, a concern for the posterity of his photographs and the

income derived from their distribution and publication. It was also an inquiry as to how to compose his will, and reveals Ruohomaa's inner thoughts about the value of his photography.[53]

Dodge Farm Inc., Dodge's Mountain
October 7, 1961

Dear Mr. Mayer:

In case something happens to me, such as an Electra plane dismissal of life, what happens to my file pictures? There is in the course of time a dollar or two made from them, and could be in the future. I, of course, would want the file to be handled by Black Star, and the benefits to go to my mother or father, but to no other relative. Just how do you handle this sort of thing?

Could I appoint Howard [Chapnick], let us say, to be executor of this estate? But if by some peculiarity Black Star went out of business, by, let us say, sale or decease or what have you, it would complicate matters more than somewhat.

Dear friend, I am not in the least contemplating death, but an accident can happen, and what would happen to my file negatives? Who would own them?

These negatives are my property, but of no worth if not in the hands of a New York agency. They are worthless in a storage house.

I have little to leave in case of death, which I do not predict for some years, but I would like to make a will—and about all I own is some seven hundred books and a file of bad and good pictures.

As to the books, they will go to a library or school; I would like to make some sort of an arrangement that should my father or mother die before I do, or I before them, that the income of varied file pictures first go to them in case of accident.

But if none of us in the Ruohomaa family were living, then whatever was made by file [pictures] should go to a young photographer, to help his training—perhaps to the Art Center School, in L.A., or some such place. How do you handle these things?

Kosti

NOTES

1. Black Star contracts. Law firm of Crandall, Hanscom & Collins, PA, Rockland, ME.

2. Ruohomaa files indicate that he continued magazine journalism through Black Star, and picked up local publication sources in Maine as well.

3. Color image made in April 1957; later became an Epic record album cover, *Up Anchor*, Lofman Collection, Maine State Museum.

4. Ibid. See color plates.

5. Letter to *Portland Press Herald* photojournalist James Moore, Rockland, ME, from Lantana, FL, 1959.

6. Undated letter, Black Star files. Kosti noted to Black Star editors, "For a complete story on Monhegan, refer to Charles Rawlings's 'Lobster Town' in *Saturday Evening Post*, August 15, 1953."

7. Interview: Harry and Douglas Odom, Monhegan Island, 1995.

8. Letter: Marion Cundy, January 21, 1957. Cundy responded to Ruohomaa's query to identify men and women in his Monhegan pictures. Ruohomaa files, Lofman Collection, Maine State Museum.

9. Selected as one of Kosti Ruohomaa's signature images by Black Star in their sixtieth anniversary volume (1996).

10. American Society of Magazine Photographers (ASMP's) *Infinity* magazine featured photographs from Monhegan Island, with a contact sheet print and Ruohomaa's personal notes. According to the editor, Ruohomaa noted that he was lucky, because he had been able to photograph during a blizzard, two days of snow and wind.

11. Ruohomaa joined ASMP in the year 1946—almost a founding member.

12. "Kosti Ruohomaa's Recipe for Drama," *Infinity*, 1959, pp. 84–89.

13. William P. E. Graves, "Maine's Lobster Island, Monhegan," *National Geographic*, February 1959, pp. 284–89.

14. The 1959 Monhegan Island *National Geographic* photographic prints were first exhibited at *National Geographic* headquarters, Washington, D.C., then deposited at the George Eastman House, Rochester, New York.

15. *Amerika Illustrated* tear sheets of the Monhegan Island self-assignment were found in Ruohomaa's personal album. Lofman Collection, Maine State Museum.

16. Letter to James Moore. Lofman Collection, Maine State Museum.

17. *Infinity*, September 1957, p. 7.

18. "Trawler on the Grand Banks." *Infinity* notes that this was published in Chevrolet's *Friends*. Also appeared: "Off to the Banks," by Lew Dietz; *National Fisherman's Maine Coast Fisherman*, July 1957, pp. 20–24; "The Toughest Bonanza in Fishing," by Lew Dietz; *True: The Man's Magazine*, color photographs, pp. 46–49.

19. Ibid.

20. Black Star captions.

21. "Log Drive," *Harvester World*, August 1954.

22. Letter from field manager Francis Healey, St. Regis Paper Company, to Kosti Ruohomaa, detailing the operation, April 1958.

23. Always interested in rural variations of language, he kept a list of short terms and phrases he had overheard. Commonly understood among the woodsmen were phrases like "river pig," to indicate an old-time driver; the "bunk beaver," for a newcomer; and "driving head," to signal that ice had melted to the level where a river has sufficient water to start the log drive.

24. "Log Drive," *Harvester World*, August 1954; the earlier photographic reportage. *Down East* featured Kosti's photographs of logging, with story by Lew Dietz.

25. Using the river as a vehicle to move objects to a destination eventually choked and polluted the waterways. See 1980s photography of last river drives on the Kennebec, by photographer Paul Fournier, Maine State Museum.

26. Lew Dietz, "Man-Handling the Log Stampede," *True: The Man's Magazine*, March 1960. The 1958 photographs in black-and-white and in color are by Kosti Ruohomaa.

27. Shad fishing, Bay of Fundy, for *Life* (#29879) in 1949; reappeared in *National Fisherman*.

28. An undated note from Black Star offered vacation site feature coverage to Ruohomaa, including airfare from Lewiston, Maine.

29. Spotting for herring by open cockpit was a subject he had covered in 1953 for *Life* magazine, with George Curtis as pilot.

30. Penciled on an index card while off Vinalhaven. Lofman Collection, Maine State Museum.

31. Published in *Maine Coast Fisherman*; negatives of this return to a former subject are held by the Penobscot Marine Museum, Searsport, Maine.

32. *Maine Coast Portrait* was typically 1950s in design and format. The characters portrayed were not named, but retained their identity as types.

33. *New York Times*, Jacob Deschin. Also noted in *Infinity* and *U.S. Camera* magazines.

34. Photograph of the WGAN-TV Channel 13 program included Moore, Ruohomaa, and a female host. Lofman Collection Maine State Museum.

35. File of typed columns found in Lofman Collection. Letters to the *Portland Press Herald* editors were regarding timely news topics, such as Maine's contribution of "sled dogs" to the Kennedy Inauguration parade.

36. This project never materialized in commercial production. A letter received from Black Star indicated that clients offered Ruohomaa Belgrade Lakes and Poland Spring vacation sights in exchange for feature coverage: "They will fly you there from Lewiston."

37. Letter June 14, 1960. Pencil notes on the letter suggest he made the Lewiston contact.

38 Notice, Dept. of Motor Vehicles. Lofman Collection, Maine State Museum.

39. Letter to author: Dec. 24, 1994. Dr. Donald and Mrs. Sylvia Hawkins. The word "brutal" was used by Andrew Wyeth; Kosti's father's exclamation recalled by Kosti's doctor.

40. Interviews: More than one source verified this.

41. "Summertime, Bass and Perch Fishing," ed. Owen Smith, *Outdoor Maine*, August 1960. Ruohomaa was listed as staff "roving photographer." Unusual full-page cover photograph by Ruohomaa viewed a fly fisherman's distorted but recognizable reflection in a stream. Negative not found.

42. "The Maritimes, Orphans of Canada's Industrial Age," *Toronto Star Weekly*, April 1, 1961.

43. Ibid.

44. Interview: Lew Dietz, July 1993.

45. Verified by canceled weekly checks, beginning August 1960, to Martha Hartshorn, RN.

46. Letter from insurance company. Lofman Collection, Maine State Museum.

47. *Skipper Boating* magazine series: "Living from the Sea," "The Moss Picker," December 1958, p. 23; "They Never Eat Lobster," May 1959. "He Fishes the Wild Blue," January 1960, vol. 20, no. 1, p. 18.

48. Kosti's annual typed records found in his files. Lofman Collection, Maine State Museum. His shares, noted in the appraisal of his estate in 1961, amounted to $100.00.

49. *Maine Department of Agriculture Quarterly.*

50. U.S. Department of Agriculture.

51. "New England," *Look* magazine, vol. 24, no. 19, September 13, 1960, pp. 19, 20, 21, 26.

52. State of Maine Agricultural Record. Undated tear sheet in Lofman Collection, Maine State Museum; Black Star files.

53. Although the letter resurfaced after he died, Black Star informed his father that Kosti apparently did not follow up on his concerns for the preservation and sale of his work. Until his parents' passing, Black Star sent annual checks.

X.

Surrealism into Abstraction, Black-and-White into Color

Throughout Kosti Ruohomaa's body of work appear images saturated with drama and mood. The medium of darkness—from night's last hour, mysterious obscure interiors, scenes in which a veil of fog becomes the subject— suggests the mind's eye of a surrealist.

On another level he composed images of extreme black-and-white contrast, figure-ground relationships that were inspired by nature's sudden winter-swept landscape. He approached color with the attitude of a contemporary painter to his abstract expressionist canvases.

Ruohomaa's photographic abstractions reveal his sensitive feelings but also the astute vision of an artist. Through his lens the immediate subject became form, shape, pattern, texture, color, and tone. Engaging a scene, he composed foreground and background, at the same time remaining conscious of the picture frame's edges. Close to nature, his photographs reveal a love of land and a passion to capture the atmosphere of the scene before his camera. He seemed at home in inclement weather. To work within night's dark-

Self-portrait: Mirror reflection idea, lighting cigarette, Dodge Mountain, n.d. (Lofman Collection, Maine State Museum)

ness brought isolation but also comfort to this photographer. When an idea inspired his lens, he usually followed it to create a series of studies, such as the ones he made with the theme of fog, or black-and-white patterns found in nature—even to his last images, the broken glass shards.

Ruohomaa's color work, published during the last years of his active camerawork (from 1958, until his death in November 1961) mirror his attraction to abstract from the greater view, filling his lens with a fragment of a larger scene, a painterly design.

The creative environment he experienced during his years at Disney Studios, as well as on sets, observing amateur moviemaking

Snow and shadow abstraction, location unknown, 1945. (Lofman Collection, Maine State Museum)

and professional Hollywood cinematography, reinforced Ruohomaa's sensitive, poetic camera expression. These experiences contributed to a keen awareness of the role of lighting to impart mood and atmosphere to a scene. The photography and teachings of Will Connell, West Coast editorial photojournalist, cannot be underestimated as an influential factor in Ruohomaa's thoughtful exploration of his camera's potential to create dramatic, surreal, and visual abstractions. However, being so visually sensitive, the canvases resulting from 1950s expressionist art movements likely galvanized his idea to frame abstractions of color, texture, and pattern from his surroundings.[1]

ABSTRACTION

Ruohomaa's experimental lens traced lively patterns in frosted windowpanes, abstracted compositions from man-made structures, and nature's transforming forces.[2] Sometimes he isolated a certain pattern or composed to frame a scene through the structure of a common object. Once well situated on the mountain after 1957, Ruohomaa's expressive photography derived from the Midcoast where he found much to inspire his camera.

Ruohomaa's color studies represented a totally new vision and approach to what a subject can be. His lens extracted shapes, forms, and textures taken from open fields of ice-encrusted snow, grooves created by plowed farmland, rain patterns on sand banks, and the shells and rocks along tidal water beaches. With color transparency his lens turned to compose collage-like images he extracted from buildings during demolition that revealed the shapes and textures of wood, brick, plaster, paint, and printed paper surfaces.[3] Subjects for this experimental work represented a scavenger's findings: a mind-set that looked for design in sections of aged, weather-worn marine artifacts and spaces of broken, deserted structures he found along back roads, harbors, shores, fields, and woodlands.

Though Kosti Ruohomaa and photographer Alvin Langdon Coburn (1882–1968) were never personally acquainted, Coburn's active years overlapped his own. Coburn's abstract works touched upon a deeply embedded philosophy important to Ruohomaa's photographic vision. "I can only say that photography demands great patience: waiting for the right hour, the right moment, and recognizing it when you see it. The artist-photographer must be constantly on the alert for the perfect moment, when a fragment of

the jumble of nature is located by the conditions of light and atmosphere, until every detail is just right."[4] Coburn's nature studies and light experiments suggest a similar approach to what the cameraman's perception could execute.

The experimental mode defined Ruohomaa's last active work in the late 1950s. It is revealed in the color transparencies he derived from familiar objects. For example, he sandwiched colored leaves between glass plates and made studies from clusters of shells and broken ice. His images began to show that he had an investigative interest in taking photographs at a close-up view, such as dew-covered grasses and blossoms. He made studies of stained-glass windows contrasted with rusted surfaces in the small Waldoboro, Maine, railroad station.

But he always controlled a composition before he released the shutter.

As early as 1949, one winter night at Moody's Diner in Waldoboro, Maine, he used the surrounding blackness, the headlights of a single truck, and a string of warm lights that fell from the roadside restaurant windows to capture a lively golden pattern on the ice-encrusted ground that led to his secured tripod and lens.[5] Here layers found from background to foreground played a role in the composition just as those found in abstract brushed areas of a painting.

Ruohomaa's intimate views of warm colored leaves and of burning blueberry fields appeared as introductory material in the autumn 1960 issue of *Look* magazine. This issue devoted an entire portfolio to the characteristic pictorial qualities of New England.[6] *Amerika Illustrated*, the elegant magazine printed in the Russian language, sent to Russian-speaking countries, produced a color feature of Ruohomaa's close autumn studies. In the English-language

insert, Ruohomaa's small iconic color studies of autumn leaves and fruits were compared to those of "an artist's palette."[7]

In an unusual approach, Ruohomaa directed his lens to sculptor George Curtis's acetylene torch to capture the rhapsody of incineration as traces of flashes and specks shoot out and fall. Torching varied metallic surfaces caused flying sparks, and the color variations were reflected in Curtis's protective goggles.[8] The resulting pictures inspired Ruohomaa to write to his colleague, "I love them!" He wrote to Life magazine's Tom Carmichael with examples of the "experimental color." "I am wondering if on the strength of this color which shows him [Curtis] at work, would there be a possibility of expanding this into a fuller story along the somewhat abstract theme suggested by this color?"

He mentioned that he already had a black-and-white story on Curtis at Black Star, but "not abstract, which I would like to try."[9] Although the images were not published, they are prime examples of Ruohomaa's quest to use his camera in new ways.

Curtis said of his friend, "Kosti, first, was an artist."[10] Curtis recalled Ruohomaa's enthusiasm for two of his contemporaries, color photographers Eliot Elisofon and Ernst Haas.[11] "Be an artist: every man is a mirror of himself and can only produce what is within him," said Eliot Elisofon (1911–1973), longtime Life staff photographer. Ruohomaa admired Elisofon, and photographed him at his seasonal home on Vinalhaven, Maine.[12] Elisofon had developed a strong interest in African culture, which led to his rich, color-saturated photographs on that continent of the people, their costumes, face painting, and accessories, such as hand-carved masks and weapons.

The color compositions Ernst Haas derived from New York City building surfaces, window reflections, and crowded city

streets attracted Ruohomaa's praise and intrigue. Curtis recalled that "Kosti was a great admirer of Haas." Haas's color work had appeared in 1953 as *Life* magazine's first color essay.[13]

Dawn, photographed in color, became the central feature for Ruohomaa's atmospheric Civil War battlefield studies made for *American Heritage*.[14] "Photographing the commonplace in unexpected ways" would become a focus of Ruohomaa's attitude and approach to abstraction here. He kept with the subject matter but composed through unusual, sometimes intimate, viewpoints.[15]

In his tidal pool studies, the material aspect of a pool's density incorporated reflections of sky and cloud from the water's surface, composed as part of a designed view.

Sometime during his last days, in October or November of 1961, Ruohomaa photographed transparencies and reflections combined in a maze of broken glass shards, beads, and glass panes, set up at his bedside. The lifting device provided by Black Star perhaps aided his ability to hold the camera to compose, a photographer's last inspired effort to interpret his inner world with an artist's expression.[16]

SURREALISM

In one of Ruohomaa's early studies of fog, the figure captured is barely viewed in his jacket and white helmet, walking toward the camera, pail in one hand and lighted oil lantern in the other. Head wear suggests it was during the late summer season, when his father wore the helmet to protect himself from long hours of exposure during the blueberry harvests. In the background, the barn's form looms, visually apparent but heavily absorbed by the weather-born atmosphere. Strange and mysterious, Ruohomaa

titled the photograph "Maine Fog." The image appeared in both *Life* and *Time*, November 3, 1947.[17]

The staying power of this unique photograph was revealed years later when the image was selected for the 1960 "Photography in the Fine Arts" traveling exhibition, produced by the Metropolitan Museum of Art.[18]

Upon returning to live at his Dodge Mountain studio-camp in 1957, Ruohomaa began new creative work. Fog, a subject he hadn't followed for almost ten years, once again became the focus of his lens. Heavily moistened fields, meadows, tidal water shorelines, and harbors were the natural spaces within which he searched to find forms that would express his visual ideas.[19] At the same time, being immersed in a veil of haze appeared to give comfort to this photographer. The presence of fog elevates the tone of every sound. In these early-morning quests for images, at the bay's edge, silence is broken only by the echoing call of a gull, the clear sound of an oar's lap that cuts into still water, a calm silence that must have imparted a certain inner peace to this man who kept his personal feelings and private life hidden.[20]

He wandered tidewater coasts, explored harbor-front villages, and set up his tripod at dew soaked meadows, where droplets rested on plants and wildflowers. At home, his mother's flowering poppies beckoned his camera's attention where brilliant red and yellow poppies, their delicate petals weighted down by heavy moisture were sealed in Kodachrome.[21, 22]

FOG

One ordinarily thinks of fog as an atmospheric condition detrimental to everyday living. It wreaks havoc on the automobile driver; it causes nightmares of anguish to ship captains who have to navigate through the impenetrable fog.

But *fog is beautiful; it is a mood that cannot be duplicated by any other variation of the elements. It is somber, gray, and mournful. It is quiet and peaceful.*

To the farmer it is an almost constant companion through his lonely chores during the fall season's predawn hours. It swallows him up with but the soft, diffused light of his lantern to bring him identity. It is a boon through long months of slight rainfall as he depends on fog's moisture, which makes things grow.

Even the garish, bawdy lights of a great city are dulled by the fog. One can find solitude amid blaring horns and scurrying people when fog brings down its curtain of inherent quietness on the city.

The short narrative on "Fog" was written by Kosti and found in his Black Star files. A sensitive photographer, Kosti Ruohomaa achieved this mood in his pictures of the fog of his native Maine.

Ruohomaa's surrealist edge is evident in a 1945 set photographed during a snow squall on the Dodge Mountain farm. He titled the enigmatic view simply *My Father Going to the Barn for Chores*. The picture captured the figure, husky in heavyweight winter jacket and cap, his back to the camera amid stinging, windblown swirls of snow that enveloped the event. Almost a silhouette, the posture of the figure depicts the feeling of aloneness, an iconic image of a farmer bound to his daily mundane chores, a somewhat desolate scene.[23]

Ruohomaa explored backlighting in nature to portray his dramatic approach, creating a somewhat out-of-this-world theatrical vision. He used the rising or setting sun's rays as a set designer would control the indoor studio lighting of a scene. He explored the cryptic views in curious interior spaces. *Children Playing in the Barn*, a completely directed image, reflects Ruohomaa's intuitive intelligence with timed action and lights, revealing his mastery of spatial composition.

His lens captured subjects with grander backlighting when the shutter was released at a critical moment of sunset or sunrise, creating a dramatic presence. This work is evidenced in photographs he made ranging from the extreme eastern shores of the United States to America's western landscape. Ruohomaa's theatrical imagery originated in scenes his camera grasped from the sometimes-precarious positions he placed himself in, whether it was stormy seas, winter blizzards, or merely night skies.

On another level Ruohomaa's perception embraced an artist's natural intuition.[24] He retained the technical aptitude he had honed during his years in Hollywood studios, creating convincing animated atmospheric effects within which the figurative elements acted.

Negatives reveal that he made photographic stills on amateur filmmaking sets and observed set and scene lighting, such as watching the lighting man in the movie production of *Of Mice and Men*, experiences that offered approaches to lighting that he later applied to his own photographic ideas.[25]

He employed lamps, bulbs, flash, and lights, not simply to illuminate a form, but also to set the mood in what would otherwise be an ordinary scene. His studio-lighting approach to both interior spaces and outdoor locations reveals Ruohomaa's technical skill and cinematographic sense. This command of lighting transformed a photographic scene from ordinary or passive to remarkably alive. A subject might be placed near a window or an oil lantern, but secondary (and unseen) photo lamps were added to soften, brighten, contrast, direct, dramatize, and/or balance a primary light source. He also used the natural backlighting of the sun, still low in its rising or setting, to dramatize a scene. Negatives reveal that this cameraman extended the application of lights to outdoor settings as well, especially in night photography.[26]

His backlit, enigmatic, figurative settings, using light to out-line a figure, would become one of the most recognizable styles found in Ruohomaa's work during the late 1950s. He would often find the most unlikely and obscure subjects in order to capture a setting in this mysterious manner. Such an example occurred when he accompanied worm diggers to the Wiscasset mudflats at Cod Cove, at night. Here he focused on the headlamps worn by the dig-gers, composed against grooved surfaces left wet by the tide, along with reflective puddles. His timed exposures sketched and traced abstract light patterns created by the lamps as the men stopped, bent over, and moved along the shallows, resulting in[27] almost musical, rhythmic light movements of the diggers' rakes.

Other examples include light breaking through an ancient, cracked window shade; the dim illumination of objects found in settings at the edge of darkness; and a still life reflecting droplets of moisture. All of these images reveal the photographer's presence, his feelings and imagination. For Ruohomaa, a person's distorted reflection seen in moving water represented an intriguing subject that could convey multiple meanings.[28] He applied this unique surrealist vision to all of his work during this period.

"Exist an artist: every man is a mirror of himself and can only produce what is within him," said Eliot Elisofon (1911–1973), longtime *Life* staff photographer. Ruohomaa admired Elisofon, and photographed him at his seasonal home on Vinalhaven, Maine.[29]

To capture the feeling of a scene, Kosti directed his lens into the light broken by a foreground tree as windswept snow blew through screaming sunlight on a street in Brunswick, Maine. Featured in *U.S. Camera, 1955: The 20th Anniversary Edition*, the caption described the pho-tograph: "A superb chronicler of the American scene, especially of New England, Ruohomaa photographed this town in Maine as part

Eliot Elisofon, Vinalhaven, Maine, c. 1958. (Lofman Collection, Maine State Museum)

of a story for Life. He works invariably in a story context which will express his love for the land and its people."[30]

When on a photographic journey, Ruohomaa sometimes became distracted and allowed his lens to stray from an assignment. This is evidenced by the fact that one or two frames at the end of a roll of film or set of negatives or transparencies sometimes indicate entire rolls of film were assigned to a single idea.

On assignment for Life at the Mount Rose, Nevada, ski resort, the editors commented, "Spectacular Pictures." "To get the night picture, photographer Kosti Ruohomaa, while standing in subzero temperatures blowing his freezing fingers, set his Rolleiflex for a long exposure as six skiers carrying flaming kerosene-soaked torches skimmed down the 4,000-foot mountain bowl."[31]

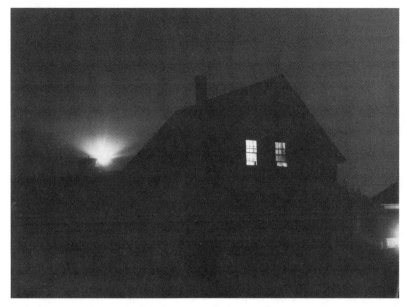

Light burst, Monhegan Island night, 1957. (Lofman Collection, Maine State Museum)

Ruohomaa's eye occasionally reflected the thinking of Minor White, an influential philosopher-photographer of the period, who expressed personal theorems in writings and photographic studies, one of which applies to this discussion: "One should photograph objects, not only for what they are, but for what else they are."[32]

Ruohomaa's abstractions and surrealist compositions in both black-and-white and color reveal the artist, and the photographer-poet.

NOTES

1. See Connell's *Picture This.*
2. "The Old Bragg Place," *Down East,* November 1961.
3. See Ernst Haas's 1953 *Life* New York City essay.
4. Helmut and Alison Gersheim, "Landscapes and Cityscapes," chapter IV, *Alvin Langdon Coburn, Photographer: An Autobiography* (London: Faber & Faber, 1966), p. 44. His early snow landscapes were patterns of black and white. Paris Exhibition, 2012.
5. Two exposures, Lofman Collection, Maine State Museum.
6. "New England," *Look,* vol. 24, September 13, 1960.
7. Lofman Collection, Maine State Museum. Tear sheets from *Amerika Illustrated* inserted in a scrapbook. United States Information Service (USIS), 1957–60.
8. The 1959 Anscochrome slides have faded from the original color. Color reproduced in printed magazines and books noted above have kept a truer view of the original color, even though interpreted through photo reproduction and printing inks and processes.
9. Letter to Tom Carmichael, *Life,* New York City, from Kosti; "Best Regards" on his Kosti Ruohomaa Photography, Dodge Mountain, Rockland, ME, stationery. December 22, 1957. This apparently did not materialize.
10. Interview: George Curtis, Cushing, ME, 1994.
11. Ruohomaa photographed Eliot Elisofon at his Vinalhaven home. Although he didn't meet Ernst Haas (1921–1986), Ruohomaa admired the reflection studies Haas made in New York City.
12. Photojournalism conference, University of Miami, May 6–8, 1959. *Infinity* magazine, 1959.
13. "Images of a Magic City" by Ernst Haas, *Life,* September 14, 1953.
14. *American Heritage* letter of thanks from the editor.
15. Weston Naef, *Experimental Photography: The Painter-Photographer.* J. Paul Getty Museum, 1989. Exhibition and paper of same title, July 5–September 17, 1989. Department of Photography. The year 1989 was the 150th anniversary of photography's invention, and brought forth histories of the medium in its celebration. The Beaumont-Newhall History of Photography remains the primary source.
16. Lew Dietz spoke of Ruohomaa's work photographed from his bedside in *Night Train in Wiscasset Station.* See p. 12. One sheet of Ruohomaa's color work of

glass shards was found at Black Star, thanks to a wonderful, tireless collections manager research assistant.

17. See Time Inc. listing in Appendix III.

18. "Photography in the Fine Arts": Exhibitions from 1959–1961, originating with Ivan Dmitri and curators at the Metropolitan Museum of Art, the exhibit traveled to venues from New England to the South. Ruohomaa apparently left no remarks concerning this recognition, but Black Star made him aware of the decision.

19. Coburn appeared to consistently use existing light, whereas Ruohomaa employed a variety of lighting techniques to achieve his sense of drama, applying lightbulbs to the landscape, or seeking the emotional effect of capturing sunrise or evening light, or using light sources ranging from streetlights to moonlight to the setting sun, especially as backlighting.

20. Interview: Lew Dietz; interview: Mike Nevelson.

21. *Friends* magazine published by Chevrolet; views of the barn and the pasture, in color. Franklin P. Lincoln, "Nothing but Nothing got him Nothing," *Portland Press Herald*, July 3, 1959.

22. See Gisele Freund, *Photography & Society* (Boston: David Godine, 1980), pp. 135–49. Ms. Freund gives an overview of the emergence of *Life* and its impact on photojournalism and the American audience. Naomi Rosenblum, *A World History of Photography* (New York: Abbeville, 1984), chapter 10. Ms. Rosenblum discusses photographs in the print media from 1920–1980. She gives a personal view of the greats as artists and reporters, the publication of their images in popular journals. Ruohomaa was intrigued with Ernst Haas's approach to color. William A. Ewing, *Ernst Haas Color Correction* (Gottingen, Germany: Steidl, 2011).

23. Is Ruohomaa's father Selim playing "the role of farmer" here, in cooperation with his son's request to create this picture, or is it Kosti, posing as his father, the farmer, wearing his father's jacket and distinctive white helmet-style hat? Interview: Neelo Lofman, 1994. Although his cousin studied the picture, the identity of the subject remained unclear. In consideration of the longtime strain between father and son, could the meaning of this and other photos in which the "father/farmer" subject appears, be viewed as a son's (unconscious?) quest to reach out and capture the figure, if not the person— the elusive father? The white helmet-style hat was used when spending full days in the blueberry fields.

24. When Kosti first wrote introductions to his Black Star captions, he some-

times concluded with a remark such as "Photographed by sensitive photographer, Kosti Ruohomaa."

25. Apart from the *Of Mice and Men* movie set, Kosti's scrapbook from the California years also contains prints made on location of amateur Western movies; perhaps he was also on a few professional sets, as he once made a portrait of actor Tom Mix, famed Western cowboy actor.

26. For example, he set bulbs in snowbanks. See the 1951 *Life* essay, "Maine Winter: Its Nights Evoke Poets' Praises," where he acts the farmer's role.

27. He surely saw "Drawing with Light: A Published Study of Pablo Picasso at Work," *Life*.

28. Owen Smith and Kosti Ruohomaa, "Bass Jump for Dragon Fly with Wobbly Rubber Legs," *Outdoor Maine*, August 1960, cover, pp. 12–13.

29. Photojournalism conference, University of Miami, May 6–8, 1959, *Infinity*, 1959.

30. "American Photography," Kosti Ruohomaa, "Maine Winter." *U.S. Camera 1935–1955: 20th Anniversary Edition.* Edited by Tom Maloney, New York City, 1954, p. 166.

31. "Speaking of Pictures." Mount Rose, Nevada, photographed 1946, appeared in *Life*, January 5, 1948, p. 5.

32. Dorothy Norman, "Alfred Stieglitz, An American Seer, 1960," *Photography in Print: Writings from 1816 to the Present* See query in earlier chapter where Haystack was mentioned, without any surrounding text/explanation.

XI. "FLOWER THROWERS"

The Last Year (1961)

There would not be many weeks of a normal life left for Ruohomaa as the year 1961 arrived. January was clearly documented with two events, a radio interview and a trip to New York City. Within days of returning to Maine from New York, Ruohomaa suffered a severe and paralyzing stroke which affected his strength and ability to handle a camera, and eventually, his ability to walk.

Fortunately his mental faculties remained undamaged. Upon his return to the camp from hospitalization and a period of rehabilitation, Black Star sent him a "lifting device." Although specific details about the accessory are unknown, it enabled him to continue taking photographs, especially from his Plymouth convertible. Ruohomaa traded some of his equipment for an Optika long-range telephoto lens, but was wheelchair-bound by the summer, and under twenty-four-hour care by a nurse who became somewhat of a companion for him.

He turned to painting on canvas, and during his last weeks, perhaps days, his camera's poetic eye took on a remarkably inventive last expression as he photographed, in color, window light

Kosti with Linhof, c. 1958, photographer unknown. (Lofman Collection, Maine State Museum)

entering broken glass shards placed in a glass tank at his bedside.

Kosti Ruohomaa died on November 4, 1961.

Ruohomaa often gave talks to the Knox County Camera Club when he was in town,[1] and in January 1961 he was invited to

appear on the local radio station, WRKD. The program, "Teens, Topics, and Tunes," sponsored by the Rockland High School Radio Club, was recorded on reel tape. The recording of the entire program has come to represent the only sound recording of this photographer's deep but patient, gentle-toned voice.[2]

During this interview Ruohomaa recalled *Life* magazine contemporaries, and discussed his thoughts concerning the preparation needed to embark on a photojournalist career.[3]

The host read the advertisements in a loud Down East–accented voice, noting, "It is almost the end of January," a message that helped to date the interview.[4] Introduced as "Mr. Kosti Ruohomaa, well-known photographer who has a home, I believe, on Dodge Mountain, is that right?," Ruohomaa replied, "That's right."

As the program progressed, Ruohomaa paged through a copy of the recently released twenty-fifth anniversary issue of *Life* magazine.[5] Although his work appeared here, for the interview he related the World War II *Life* story of Robert "Bob" Capa's landmark camerawork, made on the Normandy landing beaches, and the unfortunate loss of all of his films, except for five exposures in the London darkroom. He noted the *Life* covers by Philippe Halsman, and his admiration for the portraits by Canadian photographer Yousuf Karsh. Of Gjon Mili's sport and dance photographs, Ruohomaa commented: "Mili has an acute millionth-of-a-second timing of his own."[6]

He emphasized that those who sought to enter the photography field as a profession "needed to have a background in liberal arts," and then explained why: "Well, I can tell you from one point, certainly if you know geography and history—let's say if you are traveling in Europe someplace, if you were assigned to do a job or were covering a European or foreign country, the more you know

about the languages, the customs, the history of the nation, the better equipped you are to interpret this photographically, so it would be well understood by the people who see it in magazines."

Asked how one makes an "eye-catching" picture, Ruohomaa responded: "It's comparable to an artist doing a painting or a writer doing a novel, I suppose—something [where] you are required to dramatize a certain thing, and rather than shoot, let us say, straight, head-on or something, you find a low angle, a high angle, or a dark mood—a twist that will emphasize the point you're trying to bring over. . . . Yeah, it dramatizes more, gives it more strength, impact, so that when the reader opens the page, he stops and looks at it."

The host asked, "When you take a picture, you must know your camera pretty well?"

Ruohomaa replied, "Generally speaking, cameras are so good these days that if you buy a moderately good camera and you know how to use it, you don't have to worry. I mean, cameras will work once you press the button, but you have to figure out your own timing of it so you get it at its peak—that's the responsibility of the photographer. A camera can do only so much. It needs a director, an engineer behind it, you know."

"Actually, what makes a good photographer?" asked the host. "Is it intuition to snap the picture at the right time, such as the picture of the boxer planting a nice right jab on his opponent's chin, or how is that?"

Ruohomaa explained: "Intuition helps a great deal, luck helps a great deal, professional ability helps a great deal. Will Connell, who's a great photographer on the West Coast—I studied a little bit under him when I was training at Disney—has one expression that sort of applies; it isn't an overall rule, but it sort of applies."

(Ruohomaa laughed quietly here.) "When the rabbit's nose twitches, click the clicker.[7] So when taking a portrait, or say, any of these photographs, if you were taking a picture of an activity at high school, the basketball game, getting the peak of action is getting the picture—that's when you snap it . . . when the rabbit's nose twitches.

"Try to get people when they're most expressive, the lowest sadness or the point of gaiety—those are some of the things that one has to look for. All in all, this is still a surface discussion. The photographer has to catch whatever he is trying to interpret on the scene. Generally speaking, the essence—the body, or the guts of the picture—has to be photographed right at that split second you're shooting it."[8]

Shortly after the radio interview, Ruohomaa traveled to New York, flying out of Owls Head Airport, Rockland. It would be a weeklong visit with friends, during which they all went to Broadway shows, dined together, drank together, and indulged in vibrant conversation. But upon his return via flights from New York to Boston to Owls Head, and a taxi ride from the airport to his studio-camp, Ruohomaa did not feel well. He napped, then watched President Kennedy's televised press conference.

After the TV program, Ruohomaa apparently sat down at his portable Olivetti to type a letter to "Good K," a personal term he used to view his better, untroubled self. One may speculate that this time, he *really* wasn't feeling well; it was more than a hangover. He had first used the initials "KR" or "K" in California to refer to himself in picture captions. Here, at age forty-seven, he admits that he has a weak side by speaking directly to his strong self, words that almost read as an introspective diary:

Angora rabbit, Hollywood, 1942.
The Angora rabbit's fur was used to
line parachutes in World War II.
(Lofman Collection, Maine State
Museum)

Rockland, Maine
February 15, 1961

Good K: Thanks so much for putting up with an old bastard like me. I am tired of making excuses; the way it is, is the way it is. My excuses do not make it better or worse. I did have the best week I have ever had in New York; I just about killed myself, but I do remember how I did it, which is more than I can say for some of my escapades.

Thank God I saw three great shows, had four fine dinners, and hours and hours of stimulating talk with you and a half-dozen other exciting young men and a half-dozen

Self-portrait, Boston,
Massachusetts, c. 1944. (Lofman
Collection, Maine State Museum)

pleasant ladies. My sex life was but one evening, and bor-
ing at that; however, I regret [it] not. I really wanted to eat,
drink, and talk and see, rather than sex.

He complained about the "held-up" flight on which he was
"one of two passengers." Departure from New York had begun
early that morning. "That goddamned Northeast Airlines north of
Boston was as usual all fouled up."

I arrived home at 2 p.m., sick and worn. I took a nap and
awoke in time to hear our friend Mr. K (the one whose first
name is John) at a press conference. Yes, as we discussed

last night, again, the Soviet [Union] has created a problem. This time our Washington Mr. K was rather strained and unhappy; I do not blame him. Were I, he, I would not have made this live TV at this exact moment. He did carry it off admirably. I was so afraid that under tension a wrong phrase could have come out. Without consulting tomorrow's political pundits, he soft tiptoed around it the best way possible. A most difficult job; I praise him for not throwing out war-making statements.

I must say that since leaving you at 6 a.m. this morn the news at the UN is really hot. I felt that Adlai [President Kennedy had appointed Adlai Stevenson as ambassador to the UN] did not want the UN job because it was lesser than his stature, or what he deserved. Now he has the world headlines and a problem. This, I think, will make him happy, as Adlai wants to go down in history as another Abraham Lincoln. He will not, but let him have fun trying. You know I like him, but now I am [beginning] to realize what I long suspected: He loves to make poetic and literal speeches, which, like myself, [he is] unable to put into action. Sometimes he falls in love with his own words, as I do. This at times is a calamity.

Dear K (Tudor City K), seeing as you are next door to the UN, run over and give Adlai some advice; you know more about political and social diplomacy than he does. He has not done anything wrong yet, but without the right hand on his shoulder and a keen advisor by his side, I doubt if his leadership is strong.

Sure, his speech today was fine, but it was not his, it was from Kennedy and company, stating the official principles. I do think Mr. K was wise in hiring a vaudeville

Hamlet like Adlai, to orate the speeches written for him.

Signed,

Kosti

Here is revealed a very private Kosti, a lonely person at this juncture of his life, though as an artist, the camera in his hand surely yielded him some form of companionship, and his photographic ideas were personally self-motivating. His words reflect the intellectual isolation he found in his life, especially in Maine, where he had artist acquaintances but few, if any, close friends with whom he could discuss politics and world affairs, as he had in New York. He also had no lasting personal relationships at this time.

During the summer of 1960 he had lost his driver's license, except to drive vehicles on his father's farm.[9] Following a visit to his doctor, Ruohomaa had hired a nurse, part-time, but she did not accompany him on trips away.[10] Martha E. Hartshorn, RN, drove him around to local photographic sites and to visit friends, and monitored his alcoholic intake.

Whatever the connection, she was called again when on February 18, three days after his return from New York, "Kosti had a shock," to use his mother's expressed reaction, when she called his friend Jim Moore, and "a severe stroke," to quote his doctor.[11] The details of how, when, and exactly where the event happened remains unknown. Immediately after the stroke, Ruohomaa was taken to the local Camden Community Hospital. Three days later, with his mother and attending nurse, Martha Hartshorn, he was transported by ambulance to Massachusetts General Hospital, Boston. Here he was attended and examined by three doctors. His mother and nurse Martha stayed in the nearby Hotel Bellevue on Beacon Hill, a short walking distance from the hospital.[12]

On March 1, Ruohomaa was transported by ambulance to the

Camden hospital again, for rehabilitation, before returning to his studio-camp on March 25.[13] While still at the hospital, Sylvia Harjula of Thomaston encountered Ruohomaa, who knew and had worked with her father, a notable local herring-spotting pilot and fisherman.

"He was in a wheelchair in the hallway," she recalled. Knowing his philosophic bent, she asked him what he liked to read, and offered to get him a book or magazine. When interviewed, Sylvia remembered clearly: "Kosti kind of looked into the distance" when he responded, "There's always a trip between cup and the lip," and, "Oh, I subscribe to the intellectual digest."[14]

Upon return to the mountain camp, Martha would become a permanent part of Kosti Ruohomaa's life from this point forward. A few years older and a somewhat "big" woman physically, Martha stepped into his life as a private caregiver. Although his mental state was unchanged, he had become partially paralyzed on one side, gradually losing his ability to walk.[15] It appears that during the months ahead, the two would become roommates when Martha moved into his studio dwelling.

The new companion in their son's life greatly pleased his parents. Martha wrote in the family guestbook, *Vieraskirja*: "Dodge's Mountain, the place I'd rather be. Selim, Sofia, Kosti, the people I most want to be with. Here's hoping we can all be together for a long, long time. Martha Hartshorn, RN, April 1961." These words suggest that it was more than a nurse-patient relationship—at least, from her point of view. Martha was paid weekly, and was with Kosti twenty-four hours a day. Kosti's parents became very fond of her, and the relationship between all four of them remained on an even keel.

Ruohomaa seemed to become stronger, but just for a short

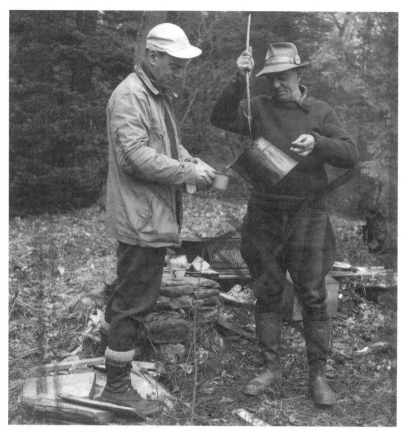

Kosti at a sporting-camp site, in the wilds of northwestern Maine, near Rangeley, April 1961. He is sharing beans from the pit with Rangeley guide Ed DeMar. The camera was set on a tripod so someone could trip the shutter release. (Lofman Collection, Maine State Museum)

while.[16] Martha drove him to local photographing sites. He had ordered an Opteka telephoto zoom lens, plus Pentax and Contax 35mm cameras. Black Star sent him a "lifting device," "rigged" so that he could handle the camera from the car with ease, and later, from the wheelchair. Black Star wanted to be kept abreast of how

he was recuperating, and if this aid "helped." The company kept him regularly supplied with film, both black-and-white and color transparency. At this time he occasionally used a local photography outlet to develop his film, but also continued to send black-and-white and color film to Modernage, New York.

Two dated documents tell us Ruohomaa returned to photographing assignments, at least for a short while. Found in his personal files, the photographs included typed, detailed background and introductory material. Captions accompanied contact sheets for one particular story, where Ruohomaa took photos at a sporting camp in Rangeley, with guide Ed DeMar.

For this story Ruohomaa followed Rangeley guide Ed DeMar through a typical day as he led two out-of-state visitors, instructing them on fly-fishing techniques and life in the wild, and camping out in the woods. The lakes were still frozen at the time, although the ice had broken on the streams.

This event is important because in this sole picture, taken from a contact sheet, the story and captions clearly identified people, activities, and places, describing DeMar's background as a longtime native with official Rangeley, Maine, guide qualifications. Martha E. Hartshorn, RN, as "witness," filled out and signed the photograph publication release on April 9, 1961, which was also signed by DeMar and dated for Black Star.

This one photograph provides singular evidence of Kosti Ruohomaa enjoying a brief rehabilitated lifestyle in 1961. It is the last known image of the photographer standing.[17]

Later that month, April 25, Black Star's Kurt Kornfeld's visit at the homestead on Dodge Mountain was documented in film. He signed the guestbook: "I came to visit my friend Kosti; enjoying his parents' hospitality. Many thanks, Kurt Kornfeld." Kornfeld is seen

with another unidentified man in one picture, but no other people were included in the interior scene, the homestead living room. No lighting or composition went into this roll of film, and Ruohomaa himself is not present in any of the pictures, which appear to have been made from a stationary position across the living room from the two visitors.

Beginning in March of that year, Ruohomaa started to collect ASMP Special Group Disability Insurance payments. He initially received a monthly income of $150.00, followed by $130.00 per month from April through October. He greatly respected the ASMP organization. In December of 1960 he had sent a letter to the editor to comment on problems with lack of publication photo credits. He received the following reply: "Dear Kosti: Thank you very much for the essay regarding credit lines, which came in yesterday, just in time for the Editorial Board meeting. The developed theme has been assigned to Jay Maisel; results should be forthcoming in Infinity. . . . He's for better and bigger credits."[18]

Photographers were notably independent. By mid-century, the ASMP had become a recognized association for professional photojournalists and serious amateur photographers, and had expanded across the country and overseas.[19] So when Ruohomaa received the annual notice in June, expecting to renew his ASMP membership, Kosti instead received a single-paragraph letter stating "that until you are able to return to photograph professionally again, your membership is terminated."

This letter and the unsigned card, which Ruohomaa kept in its envelope, had to be an "in your face" reality, indicating that it was unlikely he would ever be able to work again as he had done before the stroke. Clearly, his days as a professional were numbered.

No doubt this notice came as a blow, and dampened his already-depressed spirits.[20]

Martha became very possessive. "He was her Kosti," close friends recalled.[21] By this time she had moved into the camp so she would be there twenty-four hours a day. He made one photograph of her sleeping on a couch.

Martha drove the wheelchair-bound patient to see the Curtises at Owls Head, Crescent Beach, and Mike Nevelson, at his Rockland sculpture studio and antique shop. Ruohomaa took photographs from the car, a 1956 Plymouth convertible, having adapted the Pentax with the new long-range lens. He navigated as his caregiver drove them along narrow coastal roads to scenic working waterfronts and dead-end private ways and beaches. Some 35mm negatives were found from these months, documenting these visits.[22]

Although Ruohomaa's sense of composition and perception remained vital, his limitations, despite the "lifting device," restricted the spontaneity of his photographic expression.[23]

It seems that until the beginning of June, he may have been able to walk somewhat, with assistance, but by then, a special hospital bed had been ordered. It is not clear exactly what medical setbacks he endured, but it is known that Ruohomaa was experiencing a worsening condition of arteriosclerosis.[24] Lucille Curtis recalled that there was "talk of amputation."[25] It was clear he was visibly depressed, depicted in a Jim Moore photo taken one night with Martha. Friends attempted to keep up his spirits; in fact, the obvious change in his appearance in this photo reflects the stress he was going through. There is a certain physical puffiness to his visage which reveals deeply felt fatigue and depression. Though mentally alert, an inability to cope long term with this new state of health began to show, contrasting greatly with the man's former easy, welcoming smile.

Oil on canvas: pond and blueberry hills, West Rockport, viewed from Route 17. Signed Kosti Ruohomaa, 1961. (Collection of the author)

He continued photographing, but also returned to painting on canvas. He ordered supplies (canvas, gesso, oil colors, brushes, etc.) from New York. Now the driving trips with Martha led to places he had formerly photographed: the granite quarry, tidal marshes, an old mill, blueberry hills, and lakeside sites. At these places he brushed interpretive strokes of a scene. A creative process he had left behind since art school days, Ruohomaa worked modestly, probably to accommodate an easel and his wheelchair, and to finish a painting in one sitting. Ruohomaa approached painting with loose but assured brushwork, and occasionally palette-knife applications. It was expressive, direct painting, but an interpretive and representative record, not impressionist, nor abstract.[26]

Howard Chapnick sent Kosti a tear sheet from the August 10 issue of the *New Orleans Times-Picayune* Sunday magazine. The feature

article, the traveling 1960 "Photography in the Fine Arts" exhibition that originated in the Metropolitan Museum of Art, had opened in the New Orleans Museum of Art. Kosti's *Fog* photograph, where he had perhaps posed as his father walking from the barn, was one of three images that appeared in the article, "People at Peace." "I thought this would interest you," noted Chapnick.[27]

By the end of the summer, Ruohomaa had begun to consider a change from Maine for the winter months, planning to take Martha with him. Black Star thought it a good idea, and encouraged them to plan the move to a place where he might benefit from warmer weather. At first they thought of Florida, but Ruohomaa also wrote to former photography professionals and friends in California. He was somewhat given a brush-off response in a lackluster friendly manner, as to how to find a place for "a wheelchair-bound" cameraman.

Ruohomaa and his nurse ended up staying on in Maine. Since Kosti was spending more time in a reclining position, he was moved to the main house at the homestead, where his hospital bed was set up overlooking the view facing east, in the glassed-in porch. Here he could observe the blueberry fields, Penobscot Bay, the sunrise and evening moon—subjects that had played so strongly in his photographs.[28]

The column "Brush Strokes" by Berniece Cram Gill in the October 8, 1961, *Portland Sunday Telegram* announced the "Photography in the Fine Arts" exhibition, the second of its kind, would be opening October 18 at the Portland Museum of Art. Kosti had two works in this show of 176 contemporary photographs, selected by a jury of twelve from over 800 entries. The purpose of the traveling exhibit, which originated in the Metropolitan Museum of Art, was to "further encourage art museums to purchase, preserve and exhibit

great photographs of our time and to extend the knowledge, the vision and the purpose of photography to the student and all others interested in art."

A copy of the article, found in Kosti Ruohomaa's papers, noted that the two photographs of Ruohomaa's included in the exhibition were *Monhegan Island in Winter* and *Woman and Tree Trunk*. The Monhegan image dated from 1957, whereas Kosti made the latter location portrait in Cape Hatteras, in 1947. Gill wrote: "Last winter Ruohomaa was stricken with a shock. Somewhat paralyzed, the talented man in recent weeks has experimented with oil painting and experimental color photography. This work will soon be published as a new medium for the Rockland man."[29]

In an article Lew Dietz wrote for *Down East* in the late 1960s, Dietz recalled the last time he saw his former colleague in October of 1961, a few weeks before he died: "He was a shattered man, bedridden, paralyzed. He was propped up before a box filled with broken glass. With effort he was able to articulate one hand and arm. He managed to operate his camera as he sought abstract beauty in the light refractions of the shards beside his bed."[30]

The table-level glass structure—perhaps a tank?—next to his bed held loosely arranged, broken colored-glass shards, transparent glass beads, sea glass, and larger panes of cracked glass. He photographed in color with 35mm Kodachrome. The resulting compositions, transparent overlapping color planes and shapes, revealed a wholly new and intimate visual world. In just one view he captured a patch of dawn's first warm sunlight as it touched upon the cream woodwork and wallpaper, a white-flowered pattern on a deep blue field conveying the closeness of that moment.[31]

Apparently ecstatic when he had first seen the images, Kosti sent a set of them to Edward K. Thompson at *Life*. Howard Chapnick

got immediate word from Thompson and wanted to know about this work, writing to Kosti in October 1961: "What is this? . . . *Life* [wants] to do something with this work; you know we will do all we can for you." But events would prevent this new work from being pursued—a fragment of art left behind from an unfinished poetic perception.

Kosti Ruohomaa died Saturday morning, November 4, of a second stroke and heart attack.

Everyone at Black Star, including Howard Chapnick, had realized their photographer would not recover; it was just a matter of time.[32] Kurt Kornfeld made the trip to Kosti's funeral in Rockland, as did Wilbur Streech, Mike Nevelson, George A. Curtis, and James A. Moore. Among the attendants and pallbearers, Curtis recalled the last decision he made for his friend: "I decided to face him towards the mountain, the homestead seen in the western view from Achorn Cemetery, Rockland."[33]

On November 8, his father wrote to ASMP's Yvonne Freund, to notify them of Kosti's last days and his passing. This message indicated a deep understanding of his son, and respect which perhaps was never expressed to him personally. "I want to personally thank you for all the many kindnesses you have shown Kosti. He mentioned many times how much the ASMP was doing for Magazine Photographers. He also was most pleased that you gave him the courtesy membership."[34]

Portland Press Herald critic Franklin P. Lincoln wrote posthumously of Ruohomaa:

None of Kosti Ruohomaa's friends would wish him back. True, he was somewhat young to die at age forty-seven. But he had always been so vital, so active physically as well as

mentally, that he never could have adjusted himself to his paralysis. The last year of his life had been far from happy, despite friends' best efforts to keep him cheered up. Not that he complained or sulked. But the hurt in his eyes bespoke his frustration over a body unable to respond to a still quick and imaginative mind. His manner, the studied indifference with which he tried to mask distasteful disciplines, bespoke that frustration too.

For Kosti Ruohomaa had little relish for disciplines other than those imposed on him by lenses and films, light and darkroom. He thought freely and boldly, widely and wildly, sometimes quite inarticulately when bending a convivial elbow. Next to making beauty with his camera, that was probably what Kosti liked best—making long talk with friends over a bottle. Stimulated by alcohol, his mind could race off on philosophical tangents, and he, with a scowl, would grope for words to express the emotions that obviously moved him so profoundly.

He liked to face up to things, to dissect them the better to understand them. That was true even concerning the great personal problem that clouded his later years. He'd talk as objectively as about the appetite for the grape. He'd try to explain to friends why he could find no help from methods which had helped others. His friends didn't have to be told. They knew he was too independent, too much Kosti Ruohomaa the individual to benefit from mass therapy, even to submit to it.

Therein lies the paradoxical great tragedy of his life. He gave the world so much beauty. It sprang from his own fertile imagination and quick, sure sense of the shape of

things. He could have given the world even more beauty but for the very weakness that was nurtured by the temperament and vision that made him an artist.[35]

Black Star produced a Kosti Ruohomaa retrospective that opened in January 1962 at the New York Public Library, sponsored by the New York City Camera Club. Howard Chapnick composed an essay for the catalog in the January issue of *Contemporary Photographer*. Excerpts from Chapnick's essay, "Farewell to a Gentle Fellow," read as recollections that capture the value Black Star placed on Kosti's photography, and reveal the agency's respect for him personally. Speaking of Kosti's honesty as a person, Chapnick wrote:

The same quality of honesty was in Kosti's photographs, which were enhanced by magnificent composition and an intimate understanding of the people and the country he pictured.

To Kosti the going out and doing a thorough story on your own is the way to prove things and to satisfy the creative urge if any exists, not only to the new photographer, but to the old buck. The old buck needs to do it even more; assignments dull the pro, for so many are routine bread-and-butter jobs that the full spirit doesn't come through.

How he wished he had gone to college! "Instruct your young photographers," he said, "that any one can learn to use a camera, but an empty head can't do a damn thing with a camera." Kosti pleaded for "photographers to get thorough training in the arts, philosophy, history, literature, and other disciplines that make for a perceptive mind.[36]

Kosti leaves studio-camp for a photographing session, 1952, Robert M. Mottar. (Lofman Collection, Maine State Museum)

Kosti, whose side enjoyment was to write letters to the editor, especially to Maine's *Portland Press Herald*, usually embedded opinion-charged phrases within his letters. In one article he wrote, about two years before his death, Kosti sent in his "obituary," accompanied by a portrait photograph made by James A. Moore. He commented somewhat darkly on his ultimate fate, imagining how he would be remembered. He closed with these words: "I knew this was coming sooner or later. Thank heaven none of the flower throwers are weeping, but why are they laughing?"

Kosti wrote in a message to a friend that he wanted to know where his friend was going after death—up, or down? "I wish," Kosti added, "that you would go down, for then we would have much time for philosophy. I fear I have not the ticket for up, and anyway, none of my friends would be there."[37]

NOTES

1. Interview: William Cross (deceased), photographer for the Maine State Fish and Game Department.

2. Thanks to technicians at WRKD, Main Street, Rockland, the reel was transcribed to audiotape.

3. In 1959 Ruohomaa and James Moore were interviewed on Portland's television station morning show following their collaborative publication of *Maine Coastal Portrait*. This author has not been able to locate a tape of this TV program, but there are 35mm frames portraying the two with their morning program hostess in the Lofman Collection.

4. Intervening advertisements announced by the host, who spoke in a sharp version of the "Down East" tonal accent, centered on the upcoming high school Valentine Dance and Kippy Carnival. The host said, "It is almost the end of January," which helped to date this interview.

5. *Life*'s twenty-fifth anniversary issue. This appeared on newsstands in late December of 1960.

6. Ibid.

7. A comment by Will Connell; probably reflected his critique of Kosti's studies of Angora rabbits. Their fur was used in parachute linings, and Kosti photographed some at a breeding farm near Los Angeles. Black Star published a few of these images.

8. "Take the Time," *Modern Photography*, February 1961. In the article, Ruohomaa shared his technical details for the making of *Hog on Ice*. When in Colorado, in contrast to regular assignments, Kosti photographed a championship high school basketball game and its cheerleaders. These photos were later used in *Amerika Illustrated*.

9. Letter: State of Maine, Bureau of Motor Vehicles. Lofman Collection, Maine State Museum.

10. Letter: Dr. Donald Hawkins, Ruohomaa's Rockland physician.

11. Interview: James Moore, Glen Cove, ME, 1994.

12. Hospital bills, hotel record, and local map found in Ruohomaa papers. Crandall, Hanscom & Collins, PA, Rockland, ME.

13. Hospital records were acquired only as they related to testing costs, not diagnosis records. All found in the Ruohomaa records at the family lawyer's office, Crandall, Hanscom & Collins, PA, Rockland, ME.

14. Interview: Sylvia Harjula, August 1994. Harjula is a Finn whose pilot

father was photographed by Kosti, the stories published in *Maine Coast Fisherman*, 1958–59.

15. Generalized arteriosclerosis had set in, a result of his alcoholism.

16. A set of contact sheets, captions, and a picture release for publication, dated April 1961, filled out and signed by Martha Hartshorn as witness, represented photographing Ed DeMar, a Rangeley guide who oversaw a camping and fly-fishing trip for two out-of-state men. Kosti Ruohomaa is seen standing in one frame, having a cup of beans for dinner from the bean hole with DeMar.

17. No published reference to this, or the Maine Game Warden picture story, has been located.

18. Letter: Response to Kosti Ruohomaa from Yvonne Freund, executive secretary, ASMP, December 8, 1960. Found in original envelope with card. Lofman Collection, Maine State Museum.

19. See ASMP membership catalog for 1961. Lofman Collection, Maine State Museum.

20. However, according to his father's letter, sent to ASMP the day after Kosti died, there must have been a change of heart on ASMP's part, as Selim acknowledged how "much it meant to Kosti to have the ASMP courtesy membership."

21. Interview: Lucille Curtis, Owls Head, ME, 1994.

22. Negatives turned up, owned by Mrs. Templeton, Newcastle. Contacts were made from scanned strips.

23. Strips of 35mm loaned by Mrs. Templeton; she had found them years later at an auction.

24 Telephone interview: Dr. Donald Hawkins, Kosti Ruohomaa's physician, 1994.

25 Interview: Lucille Curtis, Owls Head, ME, 1994.

26. "Photography in the Fine Arts," *Portland Press Herald* exhibition opened in the Portland Art Museum. Remarks were made that "The photographer has returned to painting and was anticipating an exhibition of his works soon."

27. Kosti Ruohomaa's photographs appeared in PFA I and PFA II, the subject here. Photography in the Fine Arts, part II opened at the Metropolitan Museum of Art on May 20, 1960, with hosts James Rorimer and A. Hyatt Mayor.

28. A former neighbor, Helen de Rochemont, visiting while Ruohomaa was bedridden recalled that Kosti apologized for not being able to get up to greet her. Rockland Historical Society, 2011.

29. "Brush Strokes" by Berniece Cram Gill, *Sunday Telegram*, Portland, Maine, October 8, 1961, p. 16D.

30. "Kosti Ruohomaa's Maine," by Lew Dietz, *Down East*, October 1969, pp. 26–27, 28–31, 58, 60, 65. One slide image of one of his last sets shows a close but blurred view of his friend George Curtis. Lofman Collection, Maine State Museum.

31. This author studied the slide at Black Star, but it was subsequently lost.

32. Franklin P. Lincoln, "Posthumous Focus on a True Camera Artist," *Portland Press Herald*, November 28, 1961; "Kosti Ruohomaa, 47, Famed as Photo-Journalist, Dies," *Maine Sunday Telegram*, November 5, 1961; "Noted Maine Lensman Dead at 47," *Courier-Gazette*, Rockland, November 6, 1961; Kosti Ruohomaa, Deaths, *Camden Herald*, November 9, 1961; Larry Masidlover, "Late Quincy-Born Photographer Focused Nature's Wild Beauty," *Patriot Ledger*, Boston; Kosti S. Ruohomaa, *New York Times*, November 5, 1961.

33. Interview: George Curtis, Cushing, ME, 1994.

34. Letter: Dodge Farm, Inc. to Yvonne Freund, ASMP. "From yours truly, Kosti's father, Selim Ruohomaa," November 8, 1961. Copy sent to author. Courtesy ASMP Archives.

35. Franklin P. Lincoln, "Posthumous Focus on a True Camera Artist," *Portland Press Herald*, November 28, 1961.

36. "Farewell to a Gentle Fellow" by Howard Chapnick, president, Black Star, c. December 1961–January 1962. Reproduced in *Contemporary Photographer*, January 1962.

37. Franklin P. Lincoln, "Posthumous Focus on a True Camera Artist," *Portland Press Herald*, November 28, 1961.

APPENDIX I

Letter of Introduction to the Finnish People by Howard Chapnick

I n the spring of 1994, before leaving on a long-planned trip to Finland, I contacted Howard Chapnick, then retired former president of Black Star. For almost twenty years, the photography of Kosti Ruohomaa was represented by the Black Star Publishing Company, as it was known in the 1950s.

I had met with Mr. Chapnick at his Somers, New York, home for an interview concerning Kosti. He graciously prepared the following letter for the Finnish audience.

April 12, 1994

Dear Ms. Bonner-Ganter:

Thank you very much for keeping me informed about your forthcoming trip to Finland and your efforts to develop greater interest in the photographic work of Kosti Ruohomaa. As you know, I worked with and for Mr. Ruohomaa during most of his career as a photographer,

and anything that can be done to acquaint the world with this most remarkable photographer is important to me.

First, my credentials. My work in photojournalism spanned fifty years before my retirement in 1991. All of those years were spent working at Black Star, the world-famous photography agency representing photographers in the distribution of their work and development of assignments in their behalf. In 1963, I became the president of the company. Kosti Ruohomaa was a staff photographer for Black Star starting in the 1940s. This gave me the opportunity to work with him during his most creative years, before his untimely death.

I am sending you a segment from my soon-to-be-published book on photojournalism that is titled, Truth Needs No Ally: Inside Photojournalism. I have written about Kosti Ruohomaa. It reflects my respect for his work and under-lines my special friendship and personal relationship [with him]. Of the hundreds of photographers represented by Black Star, I consider Kosti to have been one of the great photographic artists of this century. His legacy is a body of work that recorded the special quality of life that could only be found in his beloved Maine.

I was responsible for the book Night Train at Wiscasset Station, which speaks about Kosti's life and work and shows some of his best work. He is included in the book published by Time Inc. as having produced one of the ten greatest essays. This shy and gentle Finn contributed great-ly to our photographic heritage.

I wish you great success in your undertaking to convince the Finnish people that the artistic contribution of

one of their sons is of monumental importance in the
world of photography.

Sincerely yours,
Howard Chapnick
Somers, New York

*Howard Chapnick, Somers, New York, 1993, Deanna Bonner-Ganter.
(Collection of the author)*

APPENDIX II

Remembering Kosti: A Memoir by Alfred Gescheidt

For two years I was a contract photographer in the early 1950s for the Black Star Publishing Company, headquartered in New York City—when Howard Chapnick was a young salesman working under the founders, Ernest Mayer, Kurt Kornfield, and Kurt Safranski. It was a very crucial and formative two years in my life because of the photographers I'd meet there. One of them (though I saw him far too little) was Kosti Ruohomaa.

I was twenty-four or twenty-five years of age at that time, just starting my career and surrounded by other "photojournalists," although I don't recall that term being actively used. I had just come out of the Art Center School in Los Angeles, and was anxious to learn the practical ways of making a living as a photographer in New York City. (I particularly liked dreaming up my own ideas for picture stories or single illustration.) Life magazine was my ultimate publishing bible, with Look and other news and feature magazines like Colliers, The Saturday Evening Post, and the newspaper Sunday supplements, Parade and This Week. They were our showcases for published work; television was not a factor in those days, print was everything.

I was not without ego. I was, in fact, a hot-shot photographer and felt in my bones that although I may have lacked practical experience, I had a vision of what I wanted to shoot and knew that once I learned the business my own talent and vision would at least equal those around me—although it didn't take me long to realize that assignment photojournalism (with lots of traveling) wasn't my strong suit. Still, I loved picture stories and my heroes were W. Eugene Smith and most of the *Life* staffers. Henri Cartier-Bresson and Robert Frank, with their quirky and personal vision, were my ultimate photographic heroes.

I learned from the other Black Star staffers, and we shared a run-down "photographer's room" as part of Black Star's offices in the Greybar Building at 420 Lexington Avenue. I especially learned from three staffers: Werner Wolff (not the TV sportscaster), Marvin Koner, and Joe Covello, who were also under contract at that time. For me they were pros down to their fingernails (or to the bottoms of their camera bags filled with Leica, Canon, or Nikon equipment.) They were savvy, traveling journalists, sometimes competitively secretive, other times sharing of their knowledge. In either case, I kept my eyes open. Each of them had their own style and was a dedicated and respected professional photographer and I greatly admired their work.

There were also "stringers" under contract who did not work in New York and only came to Black Star's office occasionally, but their names were important. Two that come to mind: Archie Lieberman out of Chicago and Carol Seighers out of Miami. And then there was Kosti Ruohomaa. We all knew he lived in Maine but covered all of New England. I can't say I was a personal friend of Kosti's—I wish I was. He was considerably older than I was and frankly, I held him in awe. Still, I knew nothing about his personal

life; I only heard that he "lived with his family on a blueberry farm in Maine."

When Kosti did come to town and visited us at Black Star, I observed him closely: he was open, frank, friendly, and honest. As I remember, I never had lunch with him or sat down and talked to him alone. For me he was one of Black Star's superstars, but he was not a city person—that I knew for sure.

Recollections:

On one of his office visits, I remember Kosti looking down a row of wooden desks in the Black Star office. Kosti wanted help drafting a letter, but office personnel were busily doing things and no one was available. At some point I heard him yell out, "Is there anybody here not too busy to help me write a letter? I mean help me with a business letter that will get me an assignment that you people will then take almost fifty percent of? Anybody?" Silence. Again, "Can someone help me?" (now louder and with obvious frustration.) Eventually, Mr. Mayer came out of his office and directed one of the secretaries to stop what she was doing and help Kosti. I felt compassion for him—here was one of our photographic stars being ignored, and he felt justifiably slighted.

On another one of Kosti's visits (we never knew when he was coming into town) a delicate situation ensued. Elizabeth Timberman (who was one of the early women photojournalists) was also in town. Someone at Black Star was to make a phone call so they might meet that

evening—a date. Kosti was a bachelor and "Timmy" was either single or divorced. There was a screw-up in communication and the call was never made, so the two never met. Kosti went back to Maine without seeing Elizabeth and, as far as I know, they never did meet. So much for romance in the big city.

Kosti was asked by *Life* to illustrate with photography the phrase, "As helpless as a hog on ice," which was to show a huge sow splayed out on a frozen pond, helpless and unable to get up or even move. Kosti carried out the assignment, but had personal doubts in doing it. He took a train (a sleeper car) from New York to Maine and spoke about feeling guilty, "wasting not only my time but the services of so many others on such a frivolous assignment." He asked other passengers what they were doing on the train rather than discuss what he was up to. When he arrived in Maine he found a pig farmer with a giant hog, worked out a fee to use the animal (including delivery to a frozen pond,) and made the photo. But he story was full of "God knows what the farmer thought of all this." Kosti was sensitive enough to feel the craziness of such a photo assignment in rural New England. The result was a wonderful photo that ran as a double page in "Speaking of Pictures." Yet Kosti was aware that he had carried out an assignment that had been the brainchild of a desk-sitting editor, and he wondered out loud whether "it was all worth the effort." To me, it absolutely was, as I was schooled in outlandish, created situations.

Kosti told me that if you really want privacy, real privacy—forget about living in Maine. He went into great detail describing how, when he returned home from assignments and drove to his house, at least five or six people knew of his arrival. He said there was no way he could drive home without a lot of people knowing it—even in sparsely settled rural Maine.

On the other hand, he told me, if you want total privacy, here's what you do: Check into any large hotel in New York City, take your bag up to your room, double lock the door, put your bag down, and sit on the bed. Now you're alone—really alone. You can die in that room or have three concubines with you. No one knows or cares what you do. Forget about going to Maine for anonymity.

One of Kosti's best picture stories shows what a little boy does after he leaves school and walks home one winter afternoon. All the visual subtleties are photographed before he reaches his house. I thought it was remarkable in its simplicity; it was charming and memorable. Of course, Kosti is remembered for plain country folks sitting around huge pot-bellied stoves or men playing checkers in country stores. Or people at town meetings. Or one memorable picture of his father "going to the barn for chores" on a winter morning. Many were Grant Wood types, with or without pitchforks, photographed inside or outside their houses.

Kosti once told me (maybe I did have a personal conversation with him after all) that he never got over how

ignorant people were about the size of New England. Editors would call him up and say, "Kosti, I have an assignment in your area. Can you pop up to Presque Isle, then, on the way back, stop at Stowe, Vermont, then to Manchester, New Hampshire. Oh, and then can you shoot something the next day in Boston?" This kind of talk irritated him and he'd say, "What do they think New England is, Rhode Island?"

Finally, as a young photographer, I was impressed with Kosti's equipment. He had a fancy leather case fitted for two Rolleiflexes, with all the accessories in separate compartments. He was, I thought, a superb photographic technician as well. I admired his black and white print quality, whether he used flash bulbs, strobe, or shot in natural light. And much of his superb pictorialism was taken with no additional lighting.

Many years after Kosti's death, Howard Chapnick still promoted his work, put up displays of his photos in the halls at Black Star. I remember getting off the elevator at their offices and seeing Kosti's black and white pictures matted and framed on the walls. Howard tried to keep Kosti's legend alive.

For me Kosti was a gentleman, lived away from the frenzy of New York, a photographer who recorded New England life—whether he dreamed up all these picture stories himself or editors made suggestions. He was a sensitive recorder of country life in New England. After I left Black Star, I opened up my own studio and never saw him again. I never knew his personal life—his relationships, his drinking habits, and other human traits that we all

have as fallible human beings—and something in me tells me I'm glad I didn't.

He was unique. I loved his work and, from the little I knew of him, his humanness.

Alfred Gescheidt
New York, August 1996

(Reproduced with permission of estate of Alfred Gescheidt.)

Maine
by Kosti Ruohomaa

Photographing the state of Maine has been an attempt to portray traditional characteristics within the mood of the terrain or in whatever shack was hiding them at the moment. Much is hidden in the off-beat nooks and crannies, for this is the way of life that is fast vanishing. It is somewhat regrettable that the traditional individuality and nonconformity of the Maine man is a disappearing trait. He, like everyone else in the nation, is subjected to the caste system and taste standards expounded by the gospel singers of togetherness, liver-bile pills, filters to filter filters, and other propagandists for the new and better life.

I started photographing the end of an era in a regional way of life ten years ago. I barely caught the last caboose of the last train before it was all gone.

Circumstance makes it necessary for some Maine people to

battle out a living among the storms of the sea and biting winter winds of the land, and the vicissitudes that rocky soil and rough water bring about. For the camera, nature's mean elements have been good, for it is those raw winds and those icy seas that have wielded a sculpting chisel which scratches through the propaganda whims of the mold-makers of togetherness and leaves an enduring mark of strength and character on a few.

Fortunately, too, there remain in the state, a number of cantankerous, stubborn individuals who spit with disdain at the notion of being vitaminized into conformity. Theirs is the stuff that puts life blood into dead hypo and ointment in the camera shutter.

Soon this will be historical folklore. The jet-propelled orbits are souring the cider and putting out the fire in the pot-bellied stove."

(Originally published in Picture, ASMP Annual, 1959. Reprinted with permission of ASMP.)

APPENDIX III

Time Inc. Assignments

Black and white photo assignments Kosti Ruohomaa undertook for the following magazines: Time, Life, Fortune, Artforum, House and Home, Sports Illustrated, New York Times, Life Overseas, Life International, Life Espanol. **Kosti's assignments that did not appear in Time Inc. publications were distributed by Black Star nationally and overseas.**

Returning Hero, Fliers of Essex, 1944, Life (also cover photo)and
 Life Overseas 5/1/44

Bowdoin Graduation, 1944

Pennsylvania Barns, 1944

Jones Beach Vacation, 1944

Negro Children in Vermont, 1944, Life 11/12/45 and Time
 8/25/45

Harvest, 1944, Life and Life Overseas 9/25/44

War Signs, 1944, Life 9/25/44

Allentown Fair, 1944

Future Farmers of America, 1944

Augustus Bennett, 1944, Life and Life Overseas 10/30/44

Ozark Preacher, 1944, Life 12/25/44

Piper Cub Factory, 1944, Life 10/29/45

Federation of Churches, 1944

Picatinny Arsenal, 1944, Life and Life Overseas 1/1/45

Andy Lone, 1944

Hal W. Trovillion Private Press, 1944

Maine Winter, 1945, Life and Life Overseas 2/12/45

Forcing Flowers, 1945, Life 2/12/45

Middlebury College, 1945

Trapping, 1945, Life 3/12/45

Arma Plant,electrical appliances, 1945

Books for Servicemen, 1945

FDR Funeral, Hyde Park, NY, 1945

Dream House and Hyde Park, 1945

Burt's Philadelphia, 1945

Farm Almanac, Culpepper, VA, 1945, Life 4/2/45

New Harmony, IN, 1945, Life 9/17/45

Junior Assembly, Kansas City, 1945

Desert of Maine, 1945, Life 7/9/45

Blessing of the Fishing Fleet, Gloucester, MA, 1945

Veterans Gas Station, 1945 (1948 Promotional)

Vermont Bridges, 1945

Parker Controversy, Clam Diggers, 1945, Life and Life Overseas
 7/16/45

Scribners Old Book Collection, 1945

James River Country, VA, 1945, Life 7/5/68

Veterans Gas Station, 1945 (1948 Promotion)

Tobacco Harvest, CT, 1945

Scottish Kaber Toss, Caledonian Club, Boston, 1945

Joe Kennedy Tours New England, 1945, Life, Life Overseas 10/1/45
 and Time 9/24/45

Phillips Lord Radio Producer, 1945 (1949 Promotion), Time
 6/20/49 and New York Times 8/29/50

Dr. Nicholas Murray Butler, 1945, Life 11/12/45, Time 3/15/54,
 and Silver Burdett Book, Illustrated America:Jane Addams, n.d.

Mohawk Valley, Schenectady-Rome, 1945, Life and Life Overseas

11/12/45

Fall Landscape, 1945, Life (also cover photo)

White Children in Harlem, 1945, Life 11/12/45

American Architecture, 1945

Evolution of American Architecture, 1945, Artforum 2/1957, Art
 Forum 12/1957, and House & Home 4/1957

4-H Catch-it-Calf Contest, 1946

Skiing: Sugar Bowl, CA; Mt.Rose, NV, 1946, Life 1/5/48

Provo, Utah, 1946

Rio Grande Rail Views, 1946

Galloping Goose, Rio Grande Rails, 1946

Mardi Gras, New Orleans, 1946, Life Overseas 3/12/46

Paul Revere's Ride, Lexington to Boston, 1946, Life and Life Overseas
 4/22/46

Richmond, VA, 1946

Ozark Farmer, 1946, Life (also cover photo)

Leonard Hall at Possum Trot Farm, 1946, Life, Life Overseas 5/27/46,
 and Silver Burdett Book, Science n.d.

God Made the Country, 1946

The Lees of Virginia, 1946, Life Overseas 8/19/46

Vermont Veterinary, 1946

Harpist Colony, Camden, ME, 1946, Life 9/2/46

Industrial Plant Production, 1946

Princeton, NJ, 1946, Life 9/23/46

Robert Frost, 1946

Bayonne Shipyard Radar, 1946

Pennsyvania Turnpike, 1946, Life 11/25/45

James Mason & Wife Arrive in NYC, 1946, Life

Filling Station, Phoenixville, PA, 1946

Charlestown, WV, 1946

Dr. Hiram A. Tuttle, 1947

Grafton, NY, Granville Hicks, 1947, Life 3/17/47

Bon Voyage Shop, 1947

Henry Morgan, 1947

Divorce Dr. E. Murray, U Denver, CO, 1947

Sauk Center Revisited, MN, 1947, Life 6/23/47

How to Buy a Farm, 1947

Cape Hatteras, NC, 1947, Life 6/16/47 (also cover photo) and (1950
 Promotion)

Deerfield, MA, 1947

Old Doctors, James Whaley, 1947, Life International n.d.

Maine Fog, 1947, Life 3/11/47, Time 3/11/47, and Life International
 11/24/47

Maine's Three Quarter Century Club, 1947, Life 9/22/47 and Life
 International 10/13/47

Maine Handtub Muster Firemen Contest, 1947

Firemen's Field Day, ME, 1947

New England Folklore, Enactment of Sayings, 1947, Life
 3/13/1950

Boy Walks Home from School, 1948, Life 2/2/48 (also cover photo)

Home Workshops, 1948, Fortune, n.d.

Age of Exploration, Roanoke, VA, 1948

Age of Exploration, Jamestown, VA, 1948

Age of Exploration, Montreal, Canada, 1948, Time 2/4/1952

Visit to Finnish Relatives, 1948, Time 8/18/1967

Cologne, Cathedral's 700th Anniversary, 1948

Ireland (Yeats, Dublin), 1948, Life 10/25/48 and Life International
 11/8/48

Munich Zoo, Germany, 1948, Life 12/6/48 and Life International
 1/17/49

Winter Night, ME Night Scenes, 1949, Life 5/21/1951 and Life
 International 6/4/51

"Lost Boundaries," on location in Rockland, ME, 1949, *Life*
7/4/49

Dublin (Ireland) Horse, 1948

Shad Fishing, Nova Scotia, 1949, *Life* 5/21/51 and *Life International*
6/4/51

Ghost Ship. Chaleur Bay, 1949

Jackson Memorial Lab, Cancer Research, ME, 1949

New England Stone Walls Concord to Lexington, 1949

Whoolly Bears, 1950, *Life* 11/6/50 and *Sports Illustrated* 11/23/55

Mt. Kahtadhin Reserve, 1951

Andrew Wyeth, 1951, *Life*, 7/27/53

Maine State Fair, 1951, *Life* 10/22/51and *Life International* 11/5/51

Hunting in the US, 1951, *Life* 11/19/51 and *Life International*
12/3/51

Confederate Army Reunion, Norfolk, VA, 1951

Mark Kahn Day, Manchester, NH, 1951

Coal Technology; Coal III, 1947, *Life* 3/1947 and *Fortune* 4/1947 and
8/1953

Paramount Pictures, Inc., 1951

NH Ministers, Congregational Christian Church 1952, *Life* 3/3/52

Young College Presidents Round-Up, 1952

Fred Rugg, Trailor Family, 1952

Frederick Payne, Maine Governor, 1952

Camp Wyonoke, Lake Winnepesauke, NH, 1952

Lobster Festival, Rockland, ME, 1952, *Life* 8/18/52

An Evening with Bea Lillie, 1952, *Life*, 10/20/52

Ann French Bush, 1952, *Life* 9/8/52

Senator Nixon in Maine, 1952

Maine Politics, 1952

Fred Scribner, Maine Economy Issue, 1952

Maine Tide, 1952

Vermont and Indians, 1952, Life 12/29/52 and Art Forum 12/56

Polaroid Plant, Maine, 1953

Woodsmen's Weekend at U. of Maine, 1953

Newington, NH Air Base Controversy, 1953, Life 6/15/53

Camden, ME Bell, 1953

Seven Steeples, Rockport, ME Woman Minister, 1953, Life
 10/19/53

Fish Spotter, Sardine Industry, Maine, 1953

Sydney Bechet, Negro Clarinet Player, 1953

Reverend Smith, 1953

Harry Dexter White, Fitzwilliams Caretaker, 1953, 11/23/53

Norman Flyer, CBS Hytron, 1953, Life 1/4/54

College Boy Fashion, 1954, Life 1/25/54

Pint-sized Critics Meet Authors, 1954

New Hampshire Quilting Bee, Lower Intervale, 1954

Herbert Brownell Lincoln Day Speech, 1954, Life 2/22/54

Weather Service, 1954, Life 10/4/54

Dr. Marek S. Korowicz, 1954

Pedro Albizu-Campos, 1954, Life 3/15/54

Worm Harvest in Maine, 1954

Zoltan Haraszti, Curator of Rare Books, Boston Public Library,
 1954, Life 11/22/54

Edwards Family, Orphaned, Maine, 1954

"Comedy of Errors" Western State College Players, Grand
 Junction, CO, 1954 (possibly 1955)

Fred Schwartzwalder, Janiter Turned Uraniumaire, Golden, CO,
 1954 (possibly 1955)

Ski Family Outing, Denver, CO, 1955

Gold Frying Pans, Denver, CO, 1955

Teachers' Play Night Denver, CO, 1955

Kenneth Drake, Basketball Giant, 1955

Winter at Fraser, CO, 1955, Life 2/14/55

Walt Whitman's Centennial, 1955, Life 6/20/55

Old Tree, Thermopolis, WY (Whitman), 1955

Elk Invasion, 1956

Bachelor Story, 1956

Edgar Eisenhower at Home, 1956

Gov. Langlie Listens to Ike's Address on TV, 1956

Pre-Yakima Flood, 1956

Sinking of Washington Mail in Gulf of Alaska, 1956

Seattle Jesuits, 1956

Crash of Northwest Flight 2 Off Vashon Island, 1956

Operation Home Improvement, 1956

Hell's Canyon Power Project, 1956, Life 9/10/56 and Fortune 12/56

National Merit Scholarship Winners, Seattle, Tacoma, 1956, Life
 5/14/56

Adlai Stevenson, Kefauver, and Senator Morse, OR, 1956, Time
 5/28/56

Douglas McKay, Philip Hitchcock, Oregon Primaries, 1956, Time
 5/28/56

Seattle Nike Site, 1956, Life 6/4/56, Life International 6/25/56, and
 Life Espanol 7/2/56

Air Age Boeing Engineer, Vaughn Blumenthal, Boeing Corp.,
 1956, Life 6/18/56, Life International 7/23/56 and Life Espanol
 7/16/56

Canadian Pipeline, 1956

Air Age, 24 Hrs at Seattle-Tacoma Airport, 1956

Democrats Victors Muskie & Coffin, Maine, 1956

46,000-ton Tanker, World Beauty, 1957 (last recorded assignment)

APPENDIX IV

Exhibitions and Collections

EXHIBITIONS

1952 **New England: A Photographic Interpretation**
Group Exhibition, deCordova and Dana Museum,
Jules Aarons, chairman
Lincoln, Massachusetts, May 4–June 8

1955 **The Family of Man**
Museum of Modern Art, Edward Steichen, curator
New York, New York
Traveled to eighteen countries, permanently installed in
Luxembourg

1960 **Photography in the Fine Arts**
Metropolitan Museum of Art, Ivan Dmitri, project
director; Norris Harkness, director
New York, New York

1961 **Photography in the Fine Arts II**
Art Center School (Art Center College of Design)
Ivan Dmitri, project director; James J. Rorimer, director
Pasadena, California

Isaac Delgado Museum of Art
New Orleans, Louisiana, July 16–August 16

The Portland Museum of Art (six images)
Portland, Maine, October 18–28

1962 **Country Cameraman: A Memorial Tribute**
New York Public Library, Camera Club of New York
Howard Chapnick, curator, Black Star Publishing
Company

Contemporary Photography Magazine, January 1962
"Farewell to a Gentle Fellow," by Howard Chapnick

"Country Cameraman," by Jacob Deschin
New York Times Sunday Magazine, January 1962

Kosti Ruohomaa
The Portland Museum of Art
Portland, Maine, August

Kosti Ruohomaa
Lincoln County Historical Museum, Wiscasset, Maine,
Mildred G. Burrage, director

1963 The Photographer and the American Landscape
The Museum of Modern Art, John Szarkowski, curator
New York, New York, September 24–November 28
Catalog, brief biography, and portrait; six images; one of
nineteen photographers selected from the history of
American landscape photography

1964 Photographs by Kosti Ruohomaa
Museum of Arts and Industries, Eugene Ostroff, curator
Smithsonian Institution, Washington, D.C., February
15–March 20

1965 The Photo Essay
Forty-nine selected essays from worldwide publications
Museum of Modern Art, John Szarkowski, curator
New York, New York

"Maine Winter," *Life*, February 12, 1945

1965 Photography in the Fine Arts
World's Fair, James J. Rorimer, director
Long Island, New York, opened May 20, 1965

1967 The Camera as Witness
EXPO '67, Philip Pocock, curator
International Exhibition of Photography

1969 Kosti Ruohomaa
Produced by the United States Information Agency
(USIA)

Maine Coast Artists, opened September 14 (traveling exhibition)

Rockport, Maine, Mildred Cummings, director

1972 Kosti Ruohomaa, 27th Annual Finland-America Days

Pauli Talvio, chairman, in Rauma, Finland; Theme: "The Sea"

"A Tribute to Kosti Ruohomaa," introduced by James Lewis from the American Embassy, produced by USIA, organized by James Lewis and Val Peterson

Rauman Suomi-Amerikka Yhdistys (Finnish-American Exhibition)

Rauma, Finland, October

1977 Kosti Ruohomaa

Maine Festival of the Arts, Bowdoin College

David Lyman, founder and director; Kate Carter, exhibition director

Maine Photographic Workshops, Rockport, Maine

Wider Availability Travel Exhibition; Maine State Commission on the Arts

Eighty black-and-white photographs printed from vintage negatives by Craig Stevens

Kosti Ruohomaa

International Center of Photography, New York, New York

Forty images selected from Maine Photographic Workshops

Collection printed in conjunction with the publication of *Night Train at Wiscasset Station* by Lew Dietz; foreword by

Andrew Wyeth; produced by Black Star Agency, New York
Opening remarks by Howard Chapnick, president, Black
Star, and John Morris, photojournalist, editor, and author,
Paris, France, and Waldoboro, Maine
Weekend of October 12

1979 Kosti Ruohomaa
Farnsworth Art Museum and Library, Marius Peladeau,
director, Rockland, Maine
Selected from 1978 gift of Ruohomaa photographs from
Jim Moore, Glen Cove, Maine
January 16–February 25

1984 Kosti Ruohomaa
Barridoff Art Gallery, Kate Carter, guest curator, Portland,
Maine
Maine Photographic Workshops, Wider Availability Travel
Exhibition

1989 Kosti Ruohomaa
Farnsworth Art Museum, Marilyn Solvay, curator,
Rockland, Maine
Selected photographs from the Jim Moore 1978 gift
Assisted by curatorial volunteer Deanna Bonner-Ganter

1997 One Hundred Years of Maine at Work
Farnsworth Art Museum, Susan Larsen, chief curator,
Rockland, Maine
Three photographs

1998 **Kosti Ruohomaa: Photographer as Poet**
Porin Taidemuseo, Marketta Seppala, director, Pori, Finland
Deanna Bonner-Ganter, guest curator; April 22–May 31
Supported by Porin Taidemuseo; Finnair; Finnish Cultural Agency; Black Star; Time Inc.; Modern Age, New York; College of Natural Resources, University of Maine; Farnsworth Art Museum, Rockland, Maine; Neelo Lofman Estate, Rockville, Maine; and private donations

1999 **Mood Poems: Selected Photographs by Kosti Ruohomaa, 1939–60**
Farnsworth Art Museum, Chris Crosman, director, Rockland, Maine
Deanna Bonner-Ganter, guest curator; February 6–April 4
Photographs selected from the Neelo Lofman Private Collection
Vernon Hunter loan of a vintage portrait, Sid Barrows
Generous support given by the Wyeth Foundation of American Art
Illustrated lecture by Deanna Bonner-Ganter

2000 **Photographing Maine: 1840–2000**
Center for Contemporary Art, Rockport, Maine
Catalog: *Photographing Maine: 1840–2000*, by Bruce Brown and John Chandler

2007 **Kosti Ruohomaa**
Farnsworth Art Museum, Michael Komanecky, chief curator, Rockland, Maine November 2007–April 2008

Acknowledgment for providing background information to Deanna Bonner-Ganter

2015 The Passionate Photographer: Kosti Ruohomaa's Maine and Magazine Photojournalism
The Maine Photo Project
Maine State Museum, Augusta, Maine
July 2015–July 2016

2015 Andy and Kosti
Farnsworth Art Museum, Rockland, Maine
Summer

MUSEUM HOLDINGS AND PRIVATE COLLECTIONS

Institutional Collections with Substantial Holdings

Black Star Agency and Publishing Company (privately owned)
116 East Twenty-Seventh Street
New York, NY 10016
Holds the Ruohomaa archives as generated by the photographer from 1944 until his death in 1961; selected images executed while Ruohomaa resided in California, 1940–43.

George Eastman House
900 East Avenue
Rochester, NY 14607-2298
Monhegan Island photographs, 1957; National Geographic Collection

William A. Farnsworth Library and Museum
19 Elm Street
Rockland, ME 04841
Photographs donated by Jim Moore (friend of Ruohomaa, d. 2000), Glen Cove,
Maine, 1978

Maine State Museum
83 State House Station
Augusta, ME 04333
Gift from Neelo Lofman Estate, 2012

National Museum of American History
Division of Photographic History
Smithsonian Institution
Washington, DC 20560
Photographs (115), from 1962 New York Camera Club Memorial Exhibition,
donated by Howard Chapnick

Time Incorporated
Time & Life Building
Rockefeller Center
New York, NY 10016
Photographic prints representing his published and unpublished freelance work
beginning in 1944, from Life, Time, Art Forum, Fortune, Sports
Illustrated, New York Times, and Time-Life Books

Ryerson University
Toronto, Canada
Gift of several hundred photographic prints from Black Star, 2010

Collections with Modest Holdings

Annenberg Rare Book & Manuscript Library
University of Pennsylvania
Philadelphia, PA
Marian Anderson Collection

Center for Creative Photography
University of Arizona
Tucson, AZ 85721
One photograph in the Eugene Smith Collection

The Museum of Modern Art
11 West Fifty-Third Street
New York, NY 10010
Photographs printed for the exhibition, The Photographer and the American Landscape

Philadelphia Museum of Art
Benjamin Franklin Parkway
Philadelphia, PA 19101-7646
One photograph, acquired from the Photography in the Fine Arts exhibition

Porin Taidemuseo (Museum of Art)
Etelaranta
Pori, Finland 28100

Portland Museum of Art
Portland, Maine

Private Collections

Joanne Blanchard, Carrabassett Valley, Maine (artwork)

Charles Cawley, Camden, Maine

Howard and Jeanette Chapnick, Somers, New York

Robert Cowan, Woodland Park, Colorado

George Curtis Estate, Cushing, Maine

Down East Magazine, Rockport, Maine

Ronald S. Gamage, Thomaston, Maine

Neelo M. Lofman family, Maine

Tapio Rosendahl, Harjavallan-Kaupunki, Finland

ACKNOWLEDGMENTS

n 1993, I started taping interviews with Kosti Ruohomaa's professional peers, family members, school friends, acquaintances, working colleagues, members of the Finnish community, the subjects of his lens, and others who knew the family on Dodge Mountain farm in Rockland, Maine. The interviews provided insight into the "local legend," and offered diverse personal and professional opinions of the elusive photographer, whose pictures appeared in Life and other popular pictorials. Most of the meetings were in person, but a few were telephone conversations, and a number included follow-up letters.

These thoughtful, honest recollections helped to develop a more complete picture of Kosti Ruohomaa, the man, beyond the words used to describe him, such as "genius," "beyond college-educated folks," "the artist," "a distinguished photographer," "son of Finnish immigrants" "philosophic," and "he only seriously associated with creative people."

The other side of the story is the tragic one: the adult man, inebriated, who had to be driven to destinations or dropped off at the mountaintop farm, unable to control a dependency on alcohol

that may have had its roots in his late teens, and which took his life at the age of forty-seven.

The first personal interview took place in the summer garden of William and Stell Shevis, Kosti's Camden friends, both artists. The Shevises sent me to David Hamalainen, a Finn, who introduced me to his longtime friend Neelo Lofman, Kosti's cousin. I visited Neelo on nineteen occasions before he passed away in 1996, learning about the Ruohomaa family's immigration and their early years in Massachusetts, Vermont, Maine, and New York City.

The Lofman family entrusted the Kosti Ruohomaa archives to me for study and research before they generously donated the collection to the Maine State Museum. This biography would not have been possible without those records, created and accrued by Kosti and packed by his mother in a trunk, which was only found when the family began the task of clearing out Neelo's Rockville, Maine, farmhouse. I am hugely grateful to the Lofman family, Janice Lachance, Joanne Jones, and Michael Lofman for their trust, patience, and long-lasting friendship.

I thank all of the people who freely shared their memories of Kosti, including his local friends: Mike Nevelson, Jim Moore, George Curtis, Lew Dietz, William and Helen Thon, William and Stell Shevis, Fran Merritt, Harry Stump, William Cross, Margaret Neeson, architect Cooper Millikin, and University of Maine professor of art, Vincent Hartigan. Also from the Midcoast were Bill Ingraham, John La Cross, Edwin Witham, Lynwood Alyard, Rose Matlin, Merle Overlock, Aino Kangas, David Hamalainen, Vernon Hunter, his cousin Leah Lofman, nieces Janice Lachance, Joanne Jones, Saga Ambegaokar (Ithaca), and acquaintances Polly La Cross and Phyliss Spitz.

I am grateful to Norman Tate, subject animator from Port

Clyde, whose clear recollections of years with the Walt Disney Studios before and after the strike helped set the scene for the animators' lifestyle and drawing-board experiences.

I thank Roger Saunders for his memories of the Newport Jazz Festival years in the mid-1950s, when he owned the Copley Square Hotel in Boston and Kosti photographed at the hotel's Mahogany Hall.

I am hugely grateful for the recollections of John Godfrey Morris of Paris, France, and Waldoboro, Maine. John recalled Ruohomaa's work at *Ladies' Home Journal* when he edited the "How America Lives" series, and recollected Black Star's close relationship with *Life* editors.

I appreciate immensely the messages from professionals and photojournalists from the 1940s and '50s era of bonanza magazine publications: Warren Trabant, Peter Stackpole, Carl Mydans, and Harry Amdur (Modernage), who provided views of Ruohomaa's photographic vision and the magazine photojournalism years.

I thank all of the others who may have been overlooked who have also offered their recollections of Kosti Ruohomaa.

I heartily thank my valuable first reader and advisor, Allen Durling, who encouraged me to stay with the project, and other important readers of the manuscript: Mary Orear, Cathy Yeo Kelly, Robert Sargent Fay, Nicholas Wyeth, Dale Kuhnert, and John Gibson, for their straightforward commentary and encouragement.

I thank Susan Davis in Portland and former Farnsworth Art Museum curators Suzette McAvoy, Sarah Fasoldt, and Susan Larsen, and former directors Marius Peladeau and Chris Crosman, for realizing the value of the project and supporting the endeavor of taking the Kosti Ruohomaa project to his homeland, Finland. I thank former Farnsworth registrar, Edith Murphy, who, sadly, has passed

on; she granted time and space to study the Ruohomaa-related collections at the Farnsworth during the years I volunteered with the curatorial department. I thank the Farnsworth administration for the opportunity to share the Lofman Collection as guest curator in a public talk, in concert with the 1999 exhibition, Mood Poems, for which I was guest curator. I am grateful to chief curator Michael Komanecky for his ongoing support of the Kosti Ruohomaa project.

I thank Helena Lumme (especially for her persistence) and Mika Manninen for organizing and hosting my first trip to Finland to present the photography of Kosti Ruohomaa. I am grateful to Mr. Veikko Kunnas, Ministry of Culture and Education, for financially sponsoring the tightly scheduled weeklong trip to Finnish museums. I am hugely grateful to former director Marketta Seppala, Porin Taidemuseo, Pori, Finland, who organized and supported the outstanding exhibition of 1998, Kosti Ruohomaa: Photographer as Poet, for which I was invited to be guest curator and speaker. I thank the wonderful, thoughtful Porin museum curators and staff who made this fine exhibition possible, and welcomed us with open arms.

I am grateful for the Ruohomaa family records, recollections, kindness, and hospitality, given to me by Heimo Outula, Tapio Rosendahl and his family, Sevari Aalto, and Terttu Sievi, and for other family members' recollections during my trips to Finland, seeking a venue for the Kosti Ruohomaa exhibition.

I thank the collections curators and staffs of the following museums and organizations for their interest and support: ICP, New York; the New York Public Library; the Museum of Modern Art; the Farnsworth Art Museum, Rockland, Maine; the University of California, Riverside; the Art Center School of Design, Pasadena;

the University of Pennsylvania; the George Eastman House, Rochester Institute of Technology; the Museum of American History; the Smithsonian; and Ryerson University, Toronto, which hosted my research and provided valuable information. The American Society of Media Photographers (ASMP) has supported in-house research and provided ongoing information from their Kosti Ruohomaa files, for which I am hugely grateful.

I am thankful to the staffs at the Maine State Library, Bangor Public Library, Fogler Library at the University of Maine, Colby College Library, and the Rockland Public Library and Rockland Historical Society, who have generously assisted my research of Kosti Ruohomaa and magazine photojournalism.

I thank the civic groups in Maine, who provided me with opportunities to give talks on Kosti Ruohomaa and his work, and the Knox County Finn-Am Society and their members, for ongoing support and encouragement of the Kosti Ruohomaa project. I give special thanks to Arthur Jura, who made his manuscript on "Sisu" available for study; to Marianne Ahola, for hosting the visit to meet Andrew Wyeth; and to many friends of the Society for their generous ongoing support.

I thank Helen Gates for her insightful recollections of Ruohomaa's years with Art Gates. I thank Joanne Blanchard for the opportunity to study Ruohomaa's artwork from her collection.

My thanks to Betsy Wyeth, Andrew Wyeth, Nicholas Wyeth, and Jamie Wyeth (whom I have yet to meet) for their kindness and encouragement. It was an honor to receive the generous award from the Wyeth Foundation of American Art in support of the project.

I thank Ben Chapnick, president, Ahn Stack, and all of the staff at Black Star, who, since 1993, have hosted me and assisted my

research of the Kosti Ruohomaa files. My special thanks to Robert Stevens, who kindly hosted my research at Time Inc. and *Life* magazine. I thank the staff and my colleagues at the Maine State Museum for their interest and their energy in producing a Kosti Ruohomaa exhibition in 2015.

And I thank my editor, Michael Steere, for his ongoing interest and enthusiasm for this project.

SELECTED BIBLIOGRAPHY

Abbott, Berenice. *A Guide to Better Photography.* New York: Crown, 1941.

American Museum of the Moving Image. *History of the American Museum of the Moving Image,* 2004. http://www.movingimage.us/about/history.

Army Times, editors. *A History of the United States Signal Corps.* New York: G. P. Putnam's Sons, 1961.

(The) Art Center School, editors. *The Art Center School.* Los Angeles: The Art Center School, 1941.

Bajac, Quentin. *La Photographie: L'Epoque Moderne 1880–1960.* Paris, France: Gallimard, 2005.

Bartholomew, Charles L. *Chalk Talk and Crayon Presentation.* Chicago: Frederick J. Drake and Co., 1922.

Binnewies, Esther, and Muriel Davisson. *A History of Bartlett's Island: Mount Desert, Maine.* Mount Desert, ME: Peggy and David Rockefeller, 1981.

Burton, Walter E. "Still Laffs and How to Make Them." *Minicam Photography,* vol. 5, no. 7, March 1942. Cincinnati: Minicam Photography, 1942.

Chamberlain, Samuel. *Ever New England.* New York: Chanticleer Press, 1944.

Chapnick, Howard. "Farewell to a Gentle Fellow," manuscript, 6 pp., 1962. Howard Chapnick, president, Black Star. *U.S. Camera,* vol. 25, February 1962.

Chapnick, Howard. *The Illustrated Leaves of Grass by Walt Whitman.* New York: Grosset & Dunlap, 1971.

Coffin, Robert P. Tristram. "Maine Winter Poems," photographic essay by Kosti Ruohomaa, *Life,* vol. 18, no. 7, February 12, 1945. Coauthors, biographical portrait and note "Life's Pictures."

Coleman, A. D. "The Directorial Mode: Notes toward a Definition,"

Artforum. vol. XV, no.1, September 1976. New York: Artforum, 1976.

Cornwell, Regina. "Emperor of Animation," Art in America, no.1, December 1981. New York: Art in America, Inc., 1981.

Cousins, Norman. Saturday Review: Photography in the Fine Arts. "SR's Portfolio of Great Photographs: A New Project," directed by Ivan Dmitri, May 16, 1959. New York: J. R. Cominsky, 1959.

Culhane, John. Walt Disney's Fantasia. New York: Abradale / Harry N. Abrams, 1983.

Davis, Harry Meyer, and F. G. Fassett Jr. What You Should Know about the Signal Corps. New York: W. W. Norton, 1961.

Deschin, Jacob. Rollei Photography: Handbook of the Rolleiflex and Rolleicord Cameras, 2nd ed. 108, ill. 90, 91, 98. San Francisco: Camera Craft Publishing Company, 1945.

———. "Country Cameraman." New York Times Magazine. October 28, 1962.

Dietz, Lew. Night Train at Wiscasset Station. Photographs by Kosti Ruohomaa, foreword by Andrew Wyeth. New York: Doubleday & Company, 1977.

Disney, Walt. "Animation and the Disney Studios," The Encyclopedia of Photography, vol. I. Willard D. Morgan. New York: The Greystone Press, 1963, 1965.

Dmitri, Ivan. "Photography in the Fine Arts: SR's Portfolio of Great Photographs, a New Project directed by Ivan Dmitri," Saturday Review, vol. XLII, no. 20, May 16, 1959.

Doty, Robert M. The Photo-Secession. Manchester, NH: Currier Gallery of Art, 1983.

Edey, Maitland, and Constance Sullivan. Great Photographic Essays from Life. Boston: Little, Brown and Co., 1978.

Ellmann, Richard. The Identity of Yeats. New York: Oxford University Press, 1954.

Everson, William K. *The Films of Hal Roach.* New York: Museum of Modern Art, 1971.

Fitchburgin ja ympariston Suomen Avustustoimikunta. Tyossa Suomen hyvaksi Muistoalbumi Suomen Avustustoiminnast UUDEN Englannin Valtiossa [At Work for the Good of Finland, New England States], 1939–1941. "Mainen Valtio" [State of Maine], The Finnish Relief Committee of Rockland and Vicinity.

Fraprie, Frank R., and Franklin I. Jordan. *The American Annual of Photography 1940,* vol. 54. Boston: American Photographic Publishing Co. / London: Chapman and Hall, 1939.

Freund, Gisele. *Photography & Society,* first English translation. Boston: David Godine, 1980.

Funk, Charles Earle. *A Hog on Ice and Other Curious Expressions,* 1st ed. New York: Harper & Brothers Publishers, 1948.

———. *2,107 Curious Word Origins, Sayings & Expressions from White Elephants to a Song & Dance.* New York: Galahad Books, 1993.

Gersheim, Helmut, and Alison Gersheim. *Alvin Langdon Coburn, Photographer: An Autobiography.* London: Faber & Faber, 1966.

Gescheidt, Alfred. "Remembering Kosti: From the Recollections of Alfred Gescheidt—A Memoir." New York: Alfred Gescheidt, 1996.

Guimond, James. *American Photography and the American Dream.* Chapel Hill: University of North Carolina Press, 1991.

Hicks, Wilson. *Words and Pictures.* (Series: The Literature of Photography) New York: Arno Press, 1952.

Hinman, John H., and Richard J. Cullen. *International Paper Company: After Fifty Years,* 1898–1948. New York: The International Paper Company, 1948.

Holiday, editors. *The U.S.A. in Color.* Philadelphia: Curtis Publishing Company, 1956.

Huss, Roy, and Norman Silverstein. *The Film Experience: Elements of Motion Picture Art,* 4th printing. New York: Dell, 1968.

Jeffrey, Ian. *Photography: A Concise History*. London: Thames and Hudson, 1981.

Johnson, Drew Heath, ed. *Capturing Light: Masterpieces of California Photography, 1850 to the Present*. New York: Oakland Museum of California in association with W. W. Norton, 2001.

Kanfer, Stefan. *Serious Business: The Art and Commerce of Animation in America from Betty Boop to Toy Story*. New York: Scribner, 1997.

Keller, Judith. *Experimental Photography: The Machine Age*. Malibu: The J. Paul Getty Museum, 1989.

Ketchum, Richard, and Bruce Catton. *Great Historic Places. An American Heritage Book*. New York: Simon & Schuster, 1957.

Lincoln, Franklin P. "Fog," *Portland Press Herald*, July 23, 1959.

Lindgren, Ernest. *The Art of the Film and an Introduction to Film Appreciation*. London: George Allen and Unwin Limited, 1948.

Lord, Phillips H. *Seth Parker and His Jonesport Folks: Way Back Home*. Philadelphia: John C. Winston Company, 1932.

McCarroll, Stacy. *California Dreamin': Camera Clubs and the Pictorial Photography Tradition*. Boston: Trustees of Boston University, 2004.

McCarthy, Joe. *New England: Connecticut, Maine, Massachusetts, New Hampshire, Rhode Island, Vermont*. Time-Life Library of America. New York: Time Inc., 1967.

Maloney, Tom J., ed. *U.S. Camera Annual 1947: Great News Pictures, Finest Pictures*. New York: U.S. Camera Publishers, 1946.

Mann, Margery. *California Pictorialism*. San Francisco: San Francisco Museum of Modern Art, 1977.

Manville, Roger. *Film*. London: Penguin, 1946.

Moore, James. "Kosti Ruohomaa," manuscript. Lecture given to the Lincoln County Historical Society, 1962.

Moore, James, Kosti Ruohomaa, and Carroll Thayer Berry. *Maine Coastal Portrait by Three Maine Photographers*. Rockland, ME: Seth Low Press, 1959.

Morgan, Willard D., and Henry M. Lester. *Miniature Camera Work: Emphasizing the Entire Field of Photography with Modern Miniature Cameras*. New York: Morgan & Lester, 1938.

Morrissey, Thomas F. "Todd Walker: An Interview with Todd Walker," 1 9 7 8 . http://personal.riverusers.com/~jdf/todd_walker/intvw.html, accessed July 26, 2000.

Mulligan, Theresa, and David Wooters. *Photography from 1839 to Today*. Rochester, NY: George Eastman House / Cologne: Taschen, 1999.

Naef, Weston. *Experimental Photography: The Painter-Photographer*. Malibu: The J. Paul Getty Museum, 1989.

Neubauer, Hendrik. *Black Star: 60 Years of Photojournalism*. Koln (Cologne), Germany: Konemann Verlagsgesellschaft mbH, 1997.

Newhall, Beaumont. "Work in a Museum of Photography," lecture, Museum of Modern Art Conference. New York City, Biltmore Hotel, February 9, 1940.

————. *Focus: Memoirs of a Life in Photography*. Boston: Bulfinch-Little, Brown and Co., 1993.

Orkin, Ruth. *A Photo Journal*. New York: Viking Press, 1981.

Parker, Seth [Phillips H. Lord]. *Seth Parker and His Jonesport Folks:Way Back Home*. Philadelphia: John C. Winston Company, 1932.

Patrick, Ted. *The U.S.A. in Color: by the Editors of Holiday*. Philadelphia: Curtis Publishing Company, 1956.

Peary, Gerald and Roger Shatzkin. *The Modern American Novel and the Movies*. New York: Frederick Ungar Publishing Co., 1978.

Rockland Bicentennial Committee. *Kosti Ruohomaa, 1913–1961*, no. 449. Rockland, ME: Courier-Gazette, 1976.

Rosenblum, Naomi. *A World History of Photography*. New York: Abbeville Press, 1984.

Rotha, Paul. *The Film till Now: A Survey of World Cinema*. London: Spring Books, 1930, 1967.

Rothstein, Arthur. "Creative Thinking in Feature Photographs," *Photojournalism: Pictures for Magazines and Newspapers*. New York: American Photographic Book Publishing Co. / Philadelphia: Chilton Books, 1956, 1965.

Ruohomaa, Kosti S. "The Rollei at Work: Farm Photography," *Rollei Photography: Handbook of the Rolleiflex and Rolleicord Cameras*. Jacob Deschin. San Francisco: Camera Craft, 1945.

Sandeen, Eric J. *Picturing an Exhibition: The Family of Man and 1950s America*. Albuquerque: University of New Mexico Press, 1995.

Schickel, Richard. "Bringing Forth the Mouse" and "Walt Disney: Myth and Reality," *American Heritage: The Magazine of History*, vol. XIX, no. 3, April 1968. New York: American Heritage Publishing Company, 1968.

Shipman, David. *The Story of Cinema: A Complete Narrative History*, 1st US ed. New York: St. Martin's Press, 1984.

Smith, C. Zoe. "Émigré Photography in America: Contributions of German Photojournalism from Black Star Picture Agency to *Life* Magazine, 1933–1938." A thesis submitted in partial fulfillment of the requirements for the degree of doctor of philosophy in mass communications in the graduate college of the University of Iowa, December 1983.

Soldan-Brofeldt, V. *Suomi on Kaunis: Finnland ist Schon* [Beautiful Finland]. Helsinki, Finland: Werner Soderstrom Osakeyhtio, 1931.

Steichen, Edward. *The Family of Man*. New York: Museum of Modern Art, 1955.

Thompson, George Raynor, and Dixie R. Harris. *The Signal Corps: The Outcome: Mid-1943 through 1945*. Washington, DC: US Army, Office of Chief of Military History, 1966, U.P.O.

Tower, Fred L. "Companies," *Maine Register, 1959–1960*. Augusta, ME: Tower, 1960.

U.S. Camera, eds. "Hollywood Hobby," *U.S. Camera*, October 1940.

———. "Human Interest Gallery, "The Pool." Roye. *U.S. Camera*, no II, October 1940.

———. *U.S. Camera International Annual* 1963.

Vickery, James Berry III. *A History of the Town of Unity, Maine*. Manchester, ME: Falmouth Publishing House, 1967.

Weaver, Mike. *The Art of Photography: 1839–1989*. New Haven and London: Yale University Press / The Royal Academy of Arts, 1989.

White, E. B. *One Man's Meat*. New York: Harper & Row, 1944.

Williams, William Carlos. *A Recognizable Image:William Carlos Williams on Art and Artists*. Edited and with introduction by Bram Dijkstra. New York: New Directions, 1978.

Wilson, Michael G., and Dennis Reed. *Pictorialism in California: Photographs 1900–1940*. Malibu: J. Paul Getty Museum and San Marino: The Henry E. Huntington Library and Art Gallery, 1994.

Wyeth, Betsy James. *Christina's World: Paintings and Prestudies of Andrew Wyeth*. Boston: Houghton Mifflin, 1982.

INDEX